THE LATTER DAY SAINT CHURCHES

SECTS AND CULTS IN AMERICA
BIBLIOGRAPHICAL GUIDES
(General Editor: J. Gordon Melton)
(VOL. 11)

GARLAND REFERENCE LIBRARY
OF SOCIAL SCIENCE
(VOL. 337)

BIBLIOGRAPHIES ON SECTS AND CULTS IN AMERICA
(General Editor: J. Gordon Melton)

1. *Magic, Witchcraft, and Paganism in America: A Bibliography*
 by J. Gordon Melton
2. *The Anti-Cult Movement in America: A Bibliography and Historical Survey*
 by Anson D. Shupe, Jr., David G. Bromley, and Donna L. Oliver
3. *The Old Catholic Sourcebook*
 by Karl Pruter and J. Gordon Melton
4. *Jehovah's Witnesses and Kindred Groups: A Historical Compendium and Bibliography*
 by Jerry Bergman
5. *The Children of God/Family of Love: An Annotated Bibliography*
 by W. Douglas Pritchett
6. *The Baha'i Faith: A Historical Bibliography*
 by Joel Bjorling
7. *Jewish Christians in the United States: A Bibliography*
 by Karl Pruter
8. *The Churches of God, Seventh Day: A Bibliography*
 by Joel Bjorling
9. *The Unification Church in America: A Bibliography and Research Guide*
 by Michael L. Mickler
10. *Psychiatry and the Cults: An Annotated Bibliography*
 by John A. Saliba
11. *The Latter Day Saint Churches: An Annotated Bibliography*
 by Steven L. Shields

THE LATTER DAY SAINT CHURCHES
An Annotated Bibliography

Steven L. Shields

GARLAND PUBLISHING, INC. • NEW YORK & LONDON
1987

Library of Congress Cataloging-in-Publication Data

Shields, Steven L.
 The Latter Day Saint Churches: An Annotated Bibliography / Steven
L. Shields.
 p. cm.—(Bibliographies on Sects and Cults in America;
vol. 11) (Garland Reference Library of Social Science; vol. 337)
 Bibliography: p.
 Includes index.
 ISBN 0-8240-8582-5
 1. Mormon Church–History–Indexes. I. Title. II. Series: Sects
and Cults in America. Bibliographical guides; v. 11. III. Series:
Garland Reference Library of Social Science; v. 337.

Z7845.M8S53 1987 [BX8611] 016.2893—dc19 87-19835 CIP

Printed on acid-free, 250-year-life paper
Manufactured in the United States of America

To Christopher

CONTENTS

PREFACE

Compiling a bibliography of the Latter Day Saint churches is at best an awesome task. We must refer to church in the plural. Since the Latter Day Saint movement officially began in 1830, there have been more than 100 different church organizations and other peripheral movements and activists emerge. In addition to the well-known Church of Jesus Christ of Latter-day Saints (most commonly referred to as the "Mormon Church") which came to Utah under the leadership of Brigham Young in the 1840s, and the second largest of the Latter Day Saint churches, the Reorganized Church of Jesus Christ of Latter Day Saints (or RLDS Church) which was formed by many original church members and organized branches which remained in the U. S. midwest after the death of Joseph Smith, Jr., who believed his son Joseph Smith III, to be the proper leader, there are more than 50 distinct Latter Day Saint movements currently functioning. With the advent of modern technology in the printing industry, it has become very easy to "publish" books, tracts, and other printed materials.

Chad J. Flake, complier of *A Mormon Bibliography: 1830-1930*, lists more than 10,000 publications that were issued by the various churches comprising the Latter Day Saint movement during its first one hundred years. Since 1931, however, the number of publications issued by the various church presses is many times the number issued during that first century. The sheer volume of printed materials makes a bibliographic work a huge task--to compose an exhaustive annotated bibliography of these publications would be virtually a never ending task.

In this book "Mormon Church" or "Mormon" will be used to refer generally to the LDS Church headquartered in Utah. RLDS means the Reorganized Church of Jesus Christ of Latter Day Saints, which is headquartered in Missouri. Latter Day Saints, or other forms of those words, will be used in reference to the movement as a whole, or to the original 1830-1844 church when specifically noted.

One would naturally expect the size of an organization to have an effect on the volume of printed materials issued. With only a few exceptions this has indeed been the case. The Utah-based Mormon Church has its own printing facility in Salt Lake City to produce official church texts and materials. The church also has a number of printing facilities in nations around to world to produce church publications in a variety of languages besides English.

The church produces scriptures, church school materials for all age groups, lesson manuals for men, women and youth, missionary tracts, magazines and official handbooks for various church organizations and officers.

In addition to the official church press, the large numbers of members of the Mormon church has led to the establishment of many independent presses. These firms publish a variety of materials for sale through privately-owned bookstores established specifically to cater to church members. Although a specific survey has not been conducted, a conservative estimate would place the number of new books or other printed materials in the English language being issued annually by these independent organizations at between 200 to 300 items.

Although its membership population has not given rise to a quasi-official publishing market, the RLDS church, based in Independence, Missouri is the second largest Latter Day Saint church organization. Its official publishing operation issues between 50 and 100 English-language items annually, in addition to the official church periodical. There are a number of publishing operations oriented to the RLDS market, but these are mainly considered to be of a fundamentalist persuasion and their publications are not generally representative of the mainstream church membership. In fact, most are critical of the official church.

All the other Latter Day Saint churches are mainly served by their own official church press--even if it is a photocopier--with an occasional independent publication issued by an individual member.

Besides the official church organizations, there have been a number of other organizations founded for specific purposes of research and study. These have added to the volume of materials available on the topic.

The publisher of this work has imposed its specifications and limitations on the size of this volume for good reason. In view of the foregoing, the approach that has been taken in compiling the materials to be listed here has been one of selectivity. A selective bibliography poses certain problems of its own--that is, what to include and what to leave out. Not all readers will be pleased with the selections in this volume. Nothing has been ignored intentionally. And certainly, other items could have been included.

A determination was made by the author, in view of the publishers continuing bibliographic reference program, that the potential users of this volume would most likely be persons involved in research about the Latter Day Saint movement, and perhaps would be unfamiliar with the movement in general or at least, with its specific sub-movements. The largest user base will most likely not be Latter Day Saints themselves.

With these parameters in mind, items selected for the two largest churches--the LDS and RLDS--are books and periodicals which are, in the opinion

of the author, generally representative of the history and theology of each church. Works for children--such as storybooks and church school lessons--are not included. Indeed, a main focus, although not an exclusive one, for these two movements have been items issued in the past decade. Theological and historical scholarship--which has been emerging in recent years--will be among the most useful materials for the general researcher or student. Representative literature and other materials have also been included. Often the most recent edition of a work is the one that has been selected for inclusion, rather than the first, in an effort to provide the user with access to the most current materials.

Listings for the churches other than the LDS or RLDS are more comprehensive in their scope. Again, not every single edition of a work has been listed, unless there are major differences of a significance worth noting. In addition, it is expected that the user will also utilize Flake's bibliographic volume, which has not been duplicated. There are a few instances when items appearing in that work are included.

The main goal of this work has been to provide the user the most comprehensive information base possible, within the space limitations, with which to conduct his or her research or studies. Items are confined mainly to printed books or pamphlets. An occasional article or thesis is included due to a particular bibliographic relationship. Periodicals included are official church organs, as well as independent historical or theologically oriented publications--the indexes of which the researcher can access for specific topics. Because the periodicals included in the listings have usually had several editors, no attempt has been made to list all the individuals serving in the editorial capacity. Rather, the periodical is listed alphabetically--within its relative category--by the name of the periodical.

Only those items published in English have been included. With very few exceptions most foreign language publications issued by the various churches are translations of English-language items.

The manner by which to organize this volume was a challenging decision. Some would prefer a completely alphabetical listing, by author, while others might prefer books organized by church, with the church name listed in alphabetical order. Neither method seemed well-suited to the nature of this work. An alphabetical listing by author would have caused all publications, from all the different organizations, to be grouped together. The user would have had difficulty, or would have needed a fairly complex cross-referencing system in order to identify which publications belonged to which of the churches. Alphabetizing by church name first also would have also posed problems because many of the churches have the same name--even though they are distinctly separate organizations.

The history of the Latter Day Saint movement lends itself quite well to a number of chronological divisions. This method has thus been used in formatting this presentation, and researchers will be able to find publications relating to specific organizations under one heading. The chronological format is only general, as some movements or churches evolved over a period of several years before becoming officially organized. An author index is provided so that publications may be identified by a specific writer.

The book is divided into five basic sections. The first is a general section, which includes those materials providing information about the movement as a whole. The second section includes materials published during or about the original Latter Day Saint church founded in 1830 by Joseph Smith, Jr. up to his death in 1844. Section three covers the dissident movements founded during Smith's presidency. Upon his death, the church became fragmented into a number of different movements and organizations. Section four presents materials published by or about those movements founded during what has been termed the "fragmentation" period, from 1844 to the mid-1860s, but have not survived to the present day. Section five includes the six church organizations founded during the twenty year fragmentation period which are still functional movements. Virtually all other Latter Day Saint churches have come from a background based in one of the six major organizations. Thus, section five is divided into six sub-sections, with the various organizations and movements classified by genre.

In the interest of time and space, those churches for which no publications could be identified have not been included.

The collections of the Harold B. Lee Library at Brigham Young University and the Library-Archives of the Reorganized Church of Jesus Christ of Latter Day Saints, in addition to the author's own extensive collection, have been the main sources of materials for this work. Additional input was provided by representatives, both official and unofficial, of various church groups.

In all but a very few instances, the publication being listed was personally inspected by the author, and the annotation prepared based on that examination. In those instances where, due to various circumstances, the author was unable to examine an item, the annotation provided will be in quotation marks with a reference to the source. Occasionally, an entry was not deemed important enough for annotation, or the title of the entry itself was descriptive of its contents.

ACKNOWLEDGMENTS

Few books are the sole work of one person alone. This book is no exception. Without the help of many people, the work of compiling this bibliography would have been much more difficult, and its contents not nearly so comprehensive. I appreciate the patience of my son Christopher. There have been many afternoons and evenings when he has had to entertain himself while I worked. Even at the age of nine, he understands the amount of work that goes into a book.

Although much of the basic information gathering for this work was completed a number of years ago while working on another project, Chad J. Flake, at the Harold B. Lee Library, Brigham Young University, and his staff in the special collections room have been most helpful. Sara Hallier and Madelon Brunson, at the Library-Archives of the Reorganized Church of Jesus Christ of Latter Day Saints in Independence, Missouri have been generous in their assistance by providing photocopies and many hours of personal efforts, correspondence and telephone consultation.

Many church representatives and friends have scoured the lists which I composed for their organizations and have added to and corrected information. Their help has been valuable and very much appreciated: Raymond Bronson, Charlotte K. LeBaron, H. Michael Marquardt, James W. Savage, William A. Sheldon, Julian Whiting, Olive Wilcox, and Albert J. Van Nest.

Although they may not have been mentioned, there are many other friends and acquaintences who have helped in various ways. For their assistance I will always be grateful.

INTRODUCTION

Very few people would probably guess that a scarcely educated farm boy could found a religious movement that today is one of the fastest growing and most talked about movements in American society. True, the largest church in the movement--the Utah-based Mormon Church--is generally the focal point of the attention. However, the movement that Joseph Smith, Jr. founded in Fayette, New York in 1830, has been comprised of more than 100 separate denominations, of which more than 50 are functioning as of this writing.

The reasons that the movement has become so fragmented are many, and each of the different church organizations has its own unique identity, beliefs and reasons for existing. The membership bases of these churches ranges from the Mormon Church's claim of 6 million, to a number of small organizations with no more than two or three. The gap between each group is wide. The second largest church, the RLDS (Reorganized Church of Jesus Christ of Latter Day Saints) church in Missouri has about 250,000, then the membership numbers drop to the low 5-digit figures, then digress from there quite rapidly.

Researchers desiring to know more about the Latter Day Saint movement will most likely find materials about the Mormon church in many local libraries. This is useful, but one can never know the complete picture of the church begun by Joseph Smith, Jr. unless they know about all the other Latter Day Saint churches as well. The materials published by and about the lesser known groups are virtually impossible to find, unless the researcher is utilizing the facilities of the official church institutions and colleges. And so, for these reasons, this bibliography has been prepared.

From its very inception, the Latter Day Saint church has been shaken from time to time by various individuals claiming to have a new interpretation of the scriptures, or a newer and better "divine" authority than the existing leader. Several theories for this are possible. Foremost, perhaps, would be Joseph Smith, Jr.'s claim that the heavens were once again opened, and God was speaking to his creation. Add to this the concept of additional scripture, and the "lay" leadership principles so important to the movement. These were reasonably bold ideas in church administration for their time, yet may not have been sufficient enough for the strong leadership personalities which we find coming up in the movement over the years.

During the fourteen year administration of Joseph Smith, Jr., from 1830-1844, there were some very serious divisions in the church--some of which were quite threatening. Joseph and those faithful to his leadership weathered the storms. There may have been some damage suffered, but the church as an organization was able to stay together.

At least ten identifiable movements disassociated themselves from the church during its first fourteen years and attempted to form independendent organizations. None of these movements survived Smith's death. At least four of these groups claimed independent revelation which appointed their leader to be the prophet. They all denounced Joseph Smith, and made attempts to set up their own churches. Two of the groups appear to have renounced all scripture except the Bible. All of them had some disagreement with either Smith's leadership methods or his teachings.

Two of these were very serious movements. One was led by Warren Parrish during what some Latter Day Saint historians have termed the "great apostasy" of 1837-1838. Parrish had been the cashier of the church's bank, the Kirtland Safety Society, and was accused by the church leadership of embezzlement. Three members of the Twelve Apostles (a leading ecclesiastical body), and several other prominent church leaders left the church and united with the Parrish movement. Nothing much came of this church, and within five years Parrish was found preaching as a Baptist minister.

The other movement was established in Nauvoo, Illinois--then church headquarters--in 1844. William Law, a one-time counselor in the First Presidency, with several others established an opposition church with Law as the new prophet. This group was behind the publication of the *Nauvoo Expositor*--a proposed newspaper, of which only the first issue was published, that attempted to expose what its publishers felt were wrongdoings on the part of Joseph Smith, Jr. The incidents surrounding the destruction of the *Expositor* press undoubtedly contributed to the strong public opinion against Joseph Smith, which brought about his untimely death at Carthage, Illinois.

After the prophet's death in June, 1844, the church no longer existed as a unified body. Regardless of some opinions to the contrary, it is very difficult after reading contemporary accounts to believe that the transition from Joseph Smith, Jr. to the leadership of the Twelve Apostles, and then to Brigham Young as president of a unified church, was smooth. No, indeed. It appears that Young fought an uphill battle just to retain the core of believers that followed him to Utah. No one was really certain what should be done. William Smith, one of the Twelve Apostles, and brother of Joseph Smith, leaves a very interesting account of those days in Nauvoo, which probably should be considered more seriously by historians of the period.

Several potential leaders emerged, each with his own particular claims. Of the several movements evolving from that period (1844–1865), there are but six functioning today. With almost no exceptions, all Latter Day Saint churches founded since the mid-1860s, have a basis historically, theologically, or both, in one of those six "parent" organizations.

The six major movements which had their beginnings during the twenty year fragmentation period of 1844 to the mid-1860s are: The Church of Jesus Christ of Latter Day Saints (Strangite, James J. Strang's movement); The Church of Jesus Christ of Latter-day Saints (LDS or Mormon, Brigham Young's movement); The Church of Jesus Christ (Alpheus Cutler); The Reorganized Church of Jesus Christ of Latter Day Saints; The Church of Christ (Temple Lot); and The Church of Jesus Christ (William Bickerton).

Space cannot permit a complete review of the histories and beliefs of each of these movements and those other groups founded since this period of fragmentation. A brief overview follows, and brief comments will be provided at the beginning of each section in this book. For more detailed background information, the reader is referred to this author's book, *Divergent Paths of the Restoration.*

Each of the six church movements came about due to the need of many faithful members for leadership after Joseph Smith's death. Three, the movements of Strang, Cutler and the RLDS church, claim appointment by Smith for successorship. Strang received a "letter of appointment" and also claimed that an angel ordained him to the prophetic office at about the very moment of Smith's death. Alpheus Cutler, who had been a prominent local leader in the church at Nauvoo, claimed to have been designated by Joseph Smith as a member of a secret and special council of seven high priest apostles--set aside to maintain continuity in priesthood authority and divine commission in the event the church went astray or its leaders absent. The RLDS Church accepts the leadership of Joseph Smith III as the one having been designated in blessing by his father as the next prophet-president of the church.

Brigham Young's claim to the prophetic office seems to have developed over the years between 1844 and 1847, when he finally determined to reorganize the church, with the approval of those members of the Twelve Apostles who had followed him.

The Temple Lot church (Granville Hedrick's movement) bases its claims to authority on a similar principle, in this case, that the church branches which comprised the foundations of this movement had been duly appointed, ordained and organized, along with their priesthood leaders. Since the church as a general organization no longer existed, it was proper for a reorganization to take effect under the leadership of Granville Hedrick, whom they considered the highest duly ordained priesthood officer.

William Bickerton organized his Church of Jesus Christ in 1862 after pray-
ing about the fragmented situation of the Latter Day Saints and being called
in a heavenly vision. Many branches had been organized prior to the actual
organization of a general church, though. Although never a member of the
original church, Bickerton had been active in Sidney Rigdon's church, but
felt a need for formality in the church organization after Rigdon's move-
ment dissolved.

Each one of these leadership claims is rational and logical, based on the
data available--both to the present-day analyst, as well as the church member-
ship at the time the leadership claims were being presented.

The Mormons, Strangites and Cutlerites are all, with some slight varia-
tions, most representative of the church as it was functioning in Nauvoo during
the last year of two of Joseph Smith's life. The Mormons under Brigham
Young, went a few steps beyond, and more recently have digressed in some
areas. For example, their temple ceremonies were originally a lengthy af-
fair, but over the years have been reduced to less than two hours. The Mor-
mon church's denial of full membership rights to those of negroid racial
background was not a policy of Joseph Smith, but rather evolved after the
saints became established in Utah. Finally, in 1978, the policy was abolished.

James J. Strang's movement probably ended up with the most detailed doc-
trinal statement of all the churches. James J. Strang was a prolific writer
who quickly produced numerous recorded revelations, an entire volume of
additional scripture (The Book of the Law of the Lord--in addition to the
Bible, Book of Mormon and Smith's Doctrine and Covenants), along with
numerous other commentaries and documents.

Cutler's movement, as being representative of the 1844 Nauvoo church,
would probably fall somewhere in between the Mormons and Strang. While
they never accepted polygamy (as the other two did), they continued a ver-
sion of the temple ceremonies. In addition, they were mildly successful at
their attempts to live the "law of consecration"--the Latter Day Saint ver-
sion of a communal lifestyle.

The RLDS church has been termed by some historians to be most represen-
tative of the original church as it was during the Kirtland, Ohio era of the
mid-1830s. Regular legislative conferences, which fell by the wayside dur-
ing the Nauvoo era (c. 1836-1846), are still the predominant governing factor-
-and the *Doctrine and Covenants* is added to regularly by conference vote,
as revelations are presented to the church by its prophet.

The Church of Christ (Temple Lot) is perhaps representative of the 1831
period of the church. This is based primarily on that church's preference
of the *Book of Commandments* (predecessor to the *Doctrine and Covenants*),
instead of the *Doctrine and Covenants*. Also this church believes that the

offices of First Presidency and High Priests are not valid ecclesiastical of-
fices. Neither of these offices was present in the structure of the church in
early 1831.

The Church of Jesus Christ, formed in 1862 by William Bickerton, can
be considered a sort of spiritual descendant of Sidney Rigdon's movement.
It is representative of the 1830 church. The *Bible* and *Book of Mormon* are
the only accepted scriptures, and the church is headed by the apostles.

The Mormon Church bears the burden of the largest number of schismatic
organizations--due perhaps to its tremendous numerical growth and its high
degree of intolerance of deviant opinion.

Those who are considered to be "fundamentalists" number about 30,000--
most of whom still acknowledge the Mormon church as the official church
organization, but claim a higher priesthood authority which authorizes them
to continue practicing polygamy. Mainly due to disagreements over authori-
ty, the fundamentalists have become fragmented into a number of organiza-
tions. Some of these have formally organized as separate churches--denying
the claims of the Mormon Church. Most notable in this category is the
LeBaron family, of whom three brothers--Joel, Ross and Ervil--organized
three separate churches. Several of the leaders of these various organiza-
tions have claimed to be the "one mighty and strong," who was prophesied
by Joseph Smith to come in the last days to "set the house of God in order"
in preparation for the second coming of Christ.

Some of the organizations coming out of the Mormon Church have been
"united order" or communal lifestyle movements. One group, the Order
of Aaron, has been quite successful in colonizing the barren western deserts
of Utah and has established several agricultural communities there.

The Church of Christ (Temple Lot), though vastly smaller in numbers than
the Mormon Church, has provided the roots for several separate church
organizations. The Temple Lot organization does not appear to have been
quite as strict as the Mormons regarding dissenting voices. In fact, it was
not until several years after former apostle Otto Fetting led a split from that
group that the church officially rejected the revelations he brought to them.

The RLDS Church is perhaps the most tolerant of differing opinions and
interpretations. The church has had its share of difficulties over the years,
but has attempted to create such good feelings within the ranks that people
with many different perspectives are generally able to find a place for
themselves.

Alpheus Cutler's Church of Jesus Christ is the smallest of the six fragments
of the original church. They do not actively seek new members. In fact, it
is said that Cutler once prophesied that the church would be left with just
two members--but that God would use them as a "righteous branch." So

the smallness of numbers do not appear to be a concern to the membership. Even though there are presently only about 30 members of the church, it has provided the roots for two different movements over the years.

James J. Strang's church is a significant organization, but presently small in numbers. A firm base for a highly organized church was established by Strang early in his career--but since he did not appoint a successor and met an untimely death, much of this organizational structure has been dormant for decades. There have been a number of movements organized over the past century and a half with roots in this organization.

There are many similarities of belief in each of the many Latter Day Saint churches, but there are also many differences. Detailed studies of the Latter Day Saint movements are continually revealing new ideas and perceptions of the past, and are assisting many in conceptualizing possibilities for the future. Only through a study of each smaller movement, in the context of the overall movement, can full understandings be developed.

The Latter Day Saint Churches

SECTION ONE
General Reference

There are a number of publications which provide information about the Latter Day Saint movement in general. Although some of the items listed in this section may focus more on one church, they often include articles about other churches within the broader context of the movement. Other items included in this section are broader in their scope.

1. Arbaugh, George B. *Revelation in Mormonism.* Chicago: University of Chicago Press, 1932. 260 pp.

 Attempts to characterize the Latter Day Saint religion, through a scientific study of the doctrine of revelation, and presents the story of the historical process by which the faith of Mormonism was given divine sanction. Presents interesting analyses of revelations and movements promulgated by various leaders after the death of Joseph Smith, Jr.

2. *Brigham Young University Studies.* Provo, Utah: Brigham Young University, 1959. 75 pp.

 One of the first scholarly journals to be published in the Latter Day Saint movement. Publication has been quarterly; different number of pages and format since inception; Clinton F. Larson, first editor; many different editors have served since. Contains articles discussing the history of the Latter Day Saint movement, generally sympathetic to the Mormon church, as well as important discussions of beliefs. At this writing journal continues to be published.

3. *Dialogue: A Journal of Mormon Thought.* Stanford, California: Dialogue Foundation, 1966. 165 pp.

 Eugene England and G. Wesley Johnson served as the founding editors of this independent quarterly. Important theological and historical issues, mainly concerning the Mormon church, are explored. The number of pages, editors and editorial offices have changed since inception. Currently published in Salt Lake City, Utah.

4. Flake, Chad J. *A Mormon Bibliography: 1830-1930*. Salt Lake City: University of Utah Press, 1978. 825 pp.

Lists more than 10,000 items published in various languages during the first century of the Latter Day Saint movement. All church organizations are included making this a comprehesively exhaustive bibliography. Author makes few comments, but includes references for the user to locate copies in major institutions.

5. *John Whitmer Historical Association Journal*. Lamoni, Iowa: John Whitmer Historical Association, 1981. 64 pp.

Annual journal published by an association comprised mainly of RLDS church members interested in the scholarly examination of Latter Day Saint history. Imogene Goodyear, first editor. Several persons have served as editor; number of pages changes. An important co-partner in the examination of Latter Day Saint history with the *Journal of Mormon History*. (See item 6).

6. *Journal of Mormon History*. Ogden, Utah: Mormon History Association, 1974. 72 pp.

Richard W. Sadler served as first editor of this major scholarly journal. Focus is general in nature, and provides examinations of various facets of LDS history. The number of pages has been increased; different persons have served as editor. Publication is maintained on an annual basis, with offices currently located in Provo, Utah.

7. Morgan, Dale L. "Bibliography of The Church of Jesus Christ." *Western Humanities Review* 4 (Winter 1949-50): 1-28.

Extensively annotated reference to all known publications of William Bickerton's movement, from 1855 to 1949.

8. ————. "A Bibliography of the Churches of the Dispersion." *Western Humanities Review* 7 (Summer 1953): 107-181.

This final installment of Morgan's three part series includes 82 items, extensively annotated, published by several of the minor LDS churches. Many items listed have no extant copies.

9. ————. "Church of Jesus Christ of Latter Day Saints (Strangite)." *Western Humanities Review* 5 (Winter 1950-51):

31-102.

The second in Morgan's series provides extensive descriptions of all known publications of James J. Strang's movement from 1846 to 1950. Includes a number of works published by Strang's dissenters.

10. *The New Messenger and Advocate.* Provo, Utah: Guild of Mormon Writers, 1977. 30 pp.

Attempted to be an outlet for theologically liberal Mormon church members. Only the preliminary issue and volume 1, number 1, dated September 1977, were published. Publication merged with *Sunstone*.

11. Peabody, Velton. *Mormonia.* Williamsville, New York: author, 1972. 24 pp.

Quarterly annotated bibliography of works on Mormonism, mainly those published by independent Mormon church related publishing houses. Publication ceased with volume 2, number 3 and 4, Fall 1973.

12. *Restoration.* Bountiful, Utah: Restoration Research, 1982. 16 pp.

Quarterly journal presenting news, views, history and theological analyses of the Latter Day Saint movement in its broadest perspective with particular focus on the lesser known movements. Steven L. Shields, founding editor. Number of pages changes.

13. *Restoration Reporter.* Janesville, Wisconsin: David C. Martin, 1970. 4 pp.

Martin was founding editor. Publication continued through volume 4, number 4, November 1975 at Nauvoo, Illinois. Publication frequency and format was sporadic. Provided current news and events of Latter Day Saint movement, especially focusing on minor church organizations.

14. *Restoration Review.* Macomb, Illinois: David C. Martin, 1978. 4 pp.

A revival of *Restoration Reporter*, mainly reporting and reviewing current events in various Latter Day Saint churches. First issue,

volume 1, number 1, September 1978; final issue, volume 1, number 4, October 15, 1978.

15. Shields, Steven L. *Divergent Paths of the Restoration.* Third Edition. Bountiful, Utah: Restoration Research, 1982. 282 pp.

First edition published at Provo, Utah, 1975, second edition, Nauvoo, Illinois, 1975. Third edition completely revised and enlarged. The most comprehensive and detailed encyclopedic-type reference work on all Latter Day Saint churches.

16. —————. *The Latter Day Saints: 1830 to Today.* Bountiful, Utah: Restoration Research, 1984. 24 pp.

Overview of the history of the Latter Day Saint movement, focusing on the fragmentation of the church in Nauvoo at the death of Joseph Smith, Jr. in 1844. Particular attention is given to a review of the churches currently functioning. Includes an annotated bibliography of current publications from the lesser known church organizations.

17. *Sunstone.* Berkeley, California: Sunstone Foundation, 1975. 104 pp.

Originally envisioned as a journal of thought and scholarship for Mormon youth, this has become an influential theological journal, taking a more liberal viewpoint than mainstream Mormonism. Scott Kenney, founding editor. Publication offices moved to Salt Lake City with volume 2, number 2, Fall 1977, after a brief sojourn in Provo, Utah. Publication frequency, as well as the format and number of pages has been sporadic.

18. Van Nest, Albert J. *A Directory to the "Restored Gospel" Churches.* Evanston, Illinois: Institute for the Study of American Religion, 1983. 32 pp.

Alphabetical directory of all known Latter Day Saint church organizations, cross-referenced by names of leaders. Includes current addresses, at time of publication, for then-existing church organizations.

SECTION TWO
The Original Church

According to the history of the Latter Day Saint movement, Joseph Smith, Jr. became aware of his mission in life sometime in the spring of 1820. Just a boy of 14, he is said to have retired to a grove of trees near his family's farm in the Palmyra, New York area, to pray to God about matters of religion. Although there are a number of records of the event presenting conflicting details, Joseph experienced a spiritual manifestation of grand proportion. During the ten succeeding years Joseph received a number of visitations and revelations, and produced *The Book of Mormon*, which most Latter Day Saints view as a companion volume to the Bible. When the church was formally organized on April 6, 1830, it was known as the "Church of Christ." A few years later, in 1834, the name was amended to "The Church of the Latter Day Saints" to avoid confusion with other Christian denominations. The name "Church of Jesus Christ of Latter Day Saints" was finally established in 1838.

Due to the confusion which disrupted the church at Joseph Smith's death in 1844, the original church organization ceased to exist as a unified body. No single church organization which came from that fragmented body can claim to be the sole representative of the original church--rather, all of the churches coming from the fragmentation period must be considered as representative of the original organization. This section will consider materials relating specifically to the original movement up to the time of Smith's death.

19. Alexander, Thomas G. and James B. Allen. *Manchester Mormons: The Journal of William Clayton, 1840-1842.* Santa Barbara, California and Salt Lake City, Utah: Peregrine Smith, Inc., 1974. 248 pp.

 Clayton, a prominent leader in the early church, was a skilled record keeper. His various diaries and journals have proven to be a virtual goldmine for documentation of historical events for students and researchers in Mormon history and the theological development of the movement.

20. Anderson, Richard Lloyd. *Investigating the Book of Mormon Witnesses.* Salt Lake City: Deseret Book Company, 1981. 221 pp.

 Based on careful analyses of the backgrounds and characters of the eleven men who, in addition to Joseph Smith, claimed to have

seen the "golden plates" from which the Book of Mormon is said to have been translated. Argues that their printed testimonies, as found in all printings of the Book of Mormon, are true. Claims that the research reported verfies their testimonies.

21. —————. *Joseph Smith's New England Heritage.* Salt Lake City: Deseret Book Company, 1971. 249 pp.

Contains detailed biographies and extensive references on Joseph Smith's ancestors in New England. Utilizes then newly discovered manuscripts, town and church records pertaining to the family.

22. Andrus, Hyrum L. *Joseph Smith and World Government.* Salt Lake City: Hawkes Publishing, Inc., 1972. 127 pp.

Argues that Joseph Smith was attempting to establish a new world order to be governed by Latter Day Saint ministers. Claims Smith revealed political principles that proposed separation of church and state, but both under church leadership. Includes historical information on Smith's "council of fifty" which was to implement his political agenda.

23. —————. *Joseph Smith: The Man and the Seer.* Salt Lake City: Deseret Book Company, 1960. 152 pp.

Attempts to provide irrefutable evidence of the truthfulness of Latter Day Saint claims, especially those of the Mormon Church, to Joseph Smith's divine call as prophet of God. First hand accounts by people associated with Smith during his lifetime are used to provide information regarding Smith's appearance, personal traits and spiritual powers.

24. ————— and Helen Mae Andrus. *They Knew the Prophet.* Salt Lake City, Deseret Book Company, 1960. 152 pp.

Compilation of dozens of incidents involving Joseph Smith, Jr., recorded by first-hand witnesses who relate Smith's personal attributes and characteristics. Similar to #23, but focuses more on his personal interactions with others.

25. Backman, Milton V., Jr. *Eyewitness Accounts of the Restoration.* Orem, Utah: Grandin Book Company, 1983. 247 pp.

Collection of first-hand accounts of most all those persons who participated in the coming forth of the Latter Day Saint movement.

Topics range from the boyhood of Joseph Smith, Jr. to his many spiritual experiences and manifestations, to the organization of the church in 1830.

26. ————. *The Heavens Resound*. Salt Lake City: Deseret Book Company, 1983. 493 pp.

A comprehensive history of the Latter Day Saints in Ohio during the years 1830 to 1838. Originally intended to be one of a multi-volume history of the church sponsored by the Mormon Church for the 1980 sesquicentennial of the movement, but later canceled by church officials, this history provides extensive documentation, using contemporary secular and church-related resource material.

27. ————. *Joseph Smith's First Vision*. Salt Lake City: Bookcraft, Inc., 1971. 223 pp.

Argues the veracity of Smith's first vision experience which took place in the spring of 1820, based on an extensive survey of information pertaining to the origins and development of the Palmyra, New York area. Analyzes the religious climate of that area in detail.

28. ————. *A Profile of Latter-day Saints of Kirtland, Ohio and Members of Zion's Camp, 1830-1839*. Provo, Utah: Department of Church History and Doctrine, Brigham Young University, 1982. 166 pp.

Provides detailed vital statistics of the known members of the Latter Day Saint church in Kirtland, Ohio during 1830-1839. Includes those who marched with "Zion's Camp," a quasi-military expeditionary force raised by Joseph Smith in 1834 to seek redress for persecutions in Missouri.

29. Barrett, Ivan J. *Joseph Smith and the Restoration*. Provo, Utah: Young House/Brigham Young University Press, 1973. 675 pp.

Extensively referenced narrative history of the Latter Day Saint movement from its inception up to 1846. Includes an essay setting forth the theological basis, from a Mormon point of view, of the need for a "restoration" of the church of Christ. This is a revised edition. The first edition was published in 1967.

30. ————. *Young Joseph*. Salt Lake City: RIC Publishing, Inc., 1981. 82 pp.

Narrative biography of Joseph Smith, Jr.'s youth.

31. Blake, Reed. *24 Hours to Martyrdom.* Salt Lake City: Bookcraft, Inc., 1973. 172 pp.

Documents, in narrative form, the events of the last 24 hours of Joseph Smith, Jr.'s life. Includes material describing events leading up to the death of Smith, as well as events taking place immediately following.

32. Brodie, Fawn M. *No Man Knows My History.* New York: Alfred A. Knopf, Inc., 1971, 2nd ed. 532 pp.

Argues that current religious thought and literature influenced the Book of Mormon and the theological base upon which Joseph Smith founded his church. Extensively documented, this biography of the founder of the Latter Day Saint movement has become a classic in portraying Smith's life and times. First edition was published in 1945. The second edition was revised and enlarged, utilizing additional resource material that was not previously available to the author.

33. Bushman, Richard L. *Joseph Smith and the Beginnings of Mormonism.* Urbana and Chicago, Illinois: University of Illinois Press, 1984. 262 pp.

Focuses on the first 25 years of Smith's life, from his birth, through the events leading up to the organization of the church and concluding with Smith's move to Ohio in 1831. Argues that the Latter Day Saint movement was influenced by the rural New England culture, including revivalism, Christian rationalism and folk magic, but was also an independent creation based on the revelations received by Smith. Originally intended as the first volume of the cancelled sesquicentennial history project of the Mormon Church.

34. Campbell, Alexander. *Delusions.* Boston: Benjamin H. Greene, 1832. 16 pp.

In this first published critique of the Book of Mormon, Campbell, the well-known minister, carefully examines the contents of the book and provides his analysis that the Book of Mormon was nothing more than a human creation, based upon commonly known events and social thoughts.

35. Cannon, Donald Q. and Lyndon W. Cook, editors. *Far West Record.* Salt Lake City: Deseret Book Company, 1983. 333 pp.

 Contains the text of the volume recording the minutes of many official church meetings during the years 1830 to 1844. These original records are valuable resource materials for the researcher. Events of the church, and individuals involved, are recorded firsthand.

36. Cannon, George Q. *The Life of Joseph Smith the Prophet.* Salt Lake City: The Deseret News, 1907. 550 pages.

 Sympathetic, but readable biography of Smith, written by Cannon while he was serving a sentence in the Utah Penitentiary in 1888 for unlawful cohabitation. The first edition was published in 1888. Unfortunately devoid of detailed documentation and index.

37. Carmer, Carl. *The Farm Boy and the Angel.* Garden City, New York: Doubleday and Company, Inc., 1970. 237 pp.

 Narrative history of the founding of the Latter Day Saint movement and its growth since that time. An objective analysis by a non-Mormon writer.

38. Cheville, Roy A. *Joseph and Emma, Companions.* Independence, Missouri: Herald Publishing House, 1977. 206 pp.

 Provides a study of the relationship of Joseph Smith, Jr. with his wife Emma Hale, including a history of their marriage and family. Suggests a definition of their marital "companionship" in terms of the Latin roots of the word.

39. Clayton, William. *Clayton's Secret Writings Uncovered.* Salt Lake City: Modern Microfilm Company, 1982. 88 pp.

 Purports to be a typescript of a journal kept by Clayton which has been kept locked in a private vault by the Mormon church leadership, inaccesible to the public. Contains entries considered in some circles to be potentially damaging to current Mormon church beliefs about founder Joseph Smith. Includes an introduction by Jerald and Sandra Tanner.

40. Conkling, J. Christopher. *Joseph Smith: A Chronology.* Salt Lake City: Deseret Book Company, 1979. 285 pp.

Prepared for a Los Angeles-based film producer as the outline of a film on the life of Joseph Smith, this volume provides a day-by-day commentary of the events of his life and his ancestors from 1771 to 1844.

41. Cook, Lyndon W. *Joseph Smith and the Law of Consecration.* Provo, Utah: Grandin Book Company, 1985. 99 pp.

Documents the early Latter Day Saint economic programs and business ventures. Provides explanations that the law of consecration was intended to provide assistance to the poor, but was later replaced by the financial law of tithing, where members contributed one-tenth of their increase, or net income, to the church to finance its programs.

42. ——————— and Milton V. Backman, Jr., editors. *Kirtland Elders' Quorum Record, 1836-1841.* Provo, Utah: Grandin Book Company, 1985. 134 pp.

A transcription of the minute book recording official meetings of the elders administering the affairs of the church in Kirtland, Ohio.

43. ——————— and Donald Q. Cannon, editors. *A New Light Breaks Forth.* Salt Lake City: Hawkes Publishing, Inc., 1980. 242 pp.

Presents 11 essays on the history of the Latter Day Saint movement fom New England to Nauvoo. Writers are recognized authorities in LDS history.

44. Corbett, Pearson H. *Hyrum Smith: Patriarch.* Salt Lake City: Deseret Book Company, 1963. 494 pp.

Argues that Hyrum Smith, older brother of Joseph Smith, Jr., performed a role in the development of the church second only to that of Joseph. Presents evidence supporting the author's thesis that Joseph never did anything of importance without first consulting Hyrum. Inseparable companions, Hyrum met his death at Carthage jail in 1844 with his brother Joseph.

45. Crawley, Peter. "A Bibliography of The Church of Jesus Christ of Latter-day Saints in New York, Ohio and Missouri." *Brigham Young University Studies* 12 (Number 4, 1972): 72 pp.

Contains 51 entries, comprising the known publications of the

original church up to the Nauvoo period. Extensive annotations provide specifically detailed synopses of contents.

46. Ehat, Andrew F. and Lyndon W. Cook, editors. *The Words of Joseph Smith.* Provo, Utah: Religious Studies Center, Brigham Young University, 1980. 472 pp.

Reconstructs Joseph Smith, Jr.'s complete discourses, delivered during the Nauvoo period (1839-1844), from contemporary accounts. Contextual settings are included. Provides a one-of-a-kind source for most of Smith's more esoteric teachings.

47. *Elder's Journal of the Church of Latter Day Saints.* Kirtland, Ohio: Thomas B. Marsh, Proprietor, 1837. 16 pp.

One of the most short-lived Latter Day Saint periodicals, the first edition was dated October, 1837, with an issue number of volume 1, number 1. A second number was issued in November. Publication was suspended until July 1838, with issue number 3 from Far West, Missouri. The final number was 4, August, 1838, also from Far West. Contains mainly letters forwarded to church headquarters by missionaries in various parts of the country.

48. *The Evening and The Morning Star.* Independence, Missouri: W. W. Phelps and Company, 1832. 8 pp.

The first periodical to be published by the church is one of the most important source documents relating to its first few years of history. Many of Joseph Smith's revelations were published in its pages for the first time. Also contained news of the church, doctrinal dissertations and hymns. After the saints were expelled from Jackson County, Missouri in 1833, publication was moved to Kirtland, Ohio. Final number was volume 2, number 24, dated September 1834. W. W. Phelps was the founding editor.

49. Flanders, Robert Bruce. *Nauvoo: Kingdom on the Mississippi.* Urbana, Illinois: University of Illinois Press, 1965. 371 pp.

Documents the establishment, the rise and the eventual fall of the Latter Day Saint capital at Nauvoo, Illinois in the early 1840s. Focuses on the temporal aspects of life in Nauvoo: Joseph Smith, Jr. not only as a church leader, but also as a business venturer. Argues that Smith was in actuality establishing a literal kingdom, himself at its helm, complete with military, educational, enterprise and religious institutions.

50. Gibbons, Francis M. *Joseph Smith: Martyr, Prophet of God.* Salt
 Lake City: Deseret Book Company, 1977. 386 pp.

 Argues that "while there is room for debate about the character
 of Joseph Smith, depending upon whose testimony one is willing
 to accept, there can be no dispute about the character and accom-
 plishments of the religious organization he brought into being..."
 (Statement of the author). Shows Joseph Smith, Jr. from a decidedly
 faith-promoting and Mormon Church perspective.

51. Gibson, Margaret Wilson. *Emma Smith: The Elect Lady.*
 Independence, Missouri: Herald Publishing House, 1954. 322 pp.

 From an RLDS perspective, this historical novel portrays Emma
 Smith not only as wife of a prophet, but also as the founding
 matriarch of the Smith family which has been a leading force in
 the Reorganized LDS Church.

52. Gregg, Thomas. *The Prophet of Palmyra.* New York: John B. Alden,
 1890. 552 pp.

 Argues that Mormonism is based on the work of Solomon
 Spalding, and that Joseph Smith's motives were prompted not by
 spiritual guidance but an inner feeling of "the world owes me a
 living." Gregg compares Smith to Mahomet, and traces the entire
 history of Mormonism from its inception to the publication date.
 Although negative in its presentation, the book offers interesting
 insights into the death of Smith, the subsequent break up of the
 church, and the various doctrines which became public knowledge
 thereafter: especially polygamy and blood atonement.

53. Gunn, Stanley R. *Oliver Cowdery: Second Elder and Scribe.* Salt
 Lake City: Bookcraft, Inc., 1962. 281 pp.

 A reasonably well-documented biography of the most important
 man in the founding of the Latter Day Saint movement next to
 Joseph Smith. Cowdery's activities in the coming forth of the
 Book of Mormon and the establishment of the church, his
 disaffection with Smith and leaving the church, as well as his
 eventual reuniting with the saints under Brigham Young's leader-
 ship are chronicled.

54. Ham, Wayne. *Publish Glad Tidings.* Independence, Missouri: Herald
 Publishing House, 1970. 444 pp.

The periodical publications of the church during Joseph Smith's administration are chronicled. Includes many excerpts from those publications to form an interesting narrative history of the first 14 years of the Latter Day Saint movement.

55. Hartshorn, Leon R. *Joseph Smith: Prophet of the Restoration.* Salt Lake City: Deseret Book Company, 1970. 124 pp.

Using many of Smith's personal writings, the author attempts to evaluate the impact Joseph Smith has had on the world. Based mostly on testimonies of faith, the author argues a case for Brigham Young as being the only legitimate successor of Smith.

56. Hill, Donna. *Joseph Smith: The First Mormon.* Garden City, New York: Doubleday and Company, Inc., 1977. 541 pp.

The first major biography on Joseph Smith since Fawn Brodie's 1945 volume. This book is written from a decidedly Mormon Church viewpoint, but provides interesting details of Smith's life gleaned from many sources not previously available to researchers.

57. Hogan, Mervin B. *Mormonism and Freemasonry: The Illinois Episode.* Salt Lake City: Campus Graphics, 1980. 60 pp.

A reprint from the *Little Masonic Library*, this volume begins with page 267. Chronicles Joseph Smith's involvement with Freemasonry, with extensive documentation from Masonic sources. Argues that the teachings of Mormonism are compatible with the tenets of Freemasonry. Proposes that the then-current code of the Utah Grand Lodge which prohibited Mormons from joining was biased and without justification.

58. Jackson, Ronald Vern. *The Seer: Joseph Smith.* Salt Lake City: Hawkes Publishing, Inc., 1977. 248 pp.

This expanded third edition contains a selection of accounts from first-hand sources, relating to the numerous angelic visitations claimed by Joseph Smith. Argues that Christ communicates with mortals via visitations, and that Smith was visited by all the prophets who ever lived.

59. Jessee, Dean C. *The Personal Writings of Joseph Smith.* Salt Lake City: Deseret Book Company, 1984. 764 pp.

In chronological order, this book presents most of the known writings (mainly letters) in Joseph Smith's own hand. Original documents have been transcribed retaining original spelling. Brief commentary places documents in context.

60. *Latter Day Saints' Messenger and Advocate*. Kirtland, Ohio: F. G. Williams and Company, 1834. 16 pp.

This monthly periodical served as the official organ of the church from volume 1, number 1, dated October 1834 to volume 3, number 12, September 1837. Letters, news and doctrinal commentary provide valuable source documentation. Oliver Cowdery was first editor, John Whitmer succeeded in June 1835, Oliver Cowdery reassumed the editorship in April 1836, and Warren A. Cowdery became editor in February 1837 and served until the final issue. The church printing establishment changed hands several times during this period also.

61. Launius, Roger D. *The Kirtland Temple: A Historical Narrative*. Independence, Missouri: Herald Publishing House, 1986. 216 pp.

Presents a readable, yet extensively documented history of the Kirtland (Ohio) Temple from its construction in the early 1830s, its abandonment when the church broke up in the mid-1840s, and its eventual recovery and restoration by the RLDS Church, which currently owns and maintains the building. The temple was the focal point of Latter Day Saint spiritual life in the mid-1830s. It was the site of many manifestations witnessed by Joseph Smith and others.

62. —————. *Zion's Camp: Expedition to Missouri, 1834*. Independence, Missouri: Herald Publishing House, 1984. 206 pp.

Argues that Zion's Camp, a quasi-military force raised by Joseph Smith, Jr. in an effort to recover church properties in Jackson County, Missouri by force, served to promote a more powerful and efficient church organization, even though it failed in its primary objective. Extensively documented and indexed.

63. ————— and F. Mark McKiernan. *Joseph Smith, Jr.'s Red Brick Store*. Macomb, Illinois: Western Illinois University, 1985. 87 pp.

Provides a documented history of Smith's business ventures in

Nauvoo focusing on the building from which he ran the church and the community, from its construction in 1842 to its demolition and finally its restoration in 1978. Includes a copy of part of the daybook recording business transactions in the store.

64. Lundwall, N. B. *The Fate of the Persecutors of the Prophet Joseph Smith.* Salt Lake City: Bookcraft, Inc., 1952. 365 pp.

 Argues that Smith was conspired against and persecuted because he was a "true" prophet. Claims that his persecutors met with unfortunate life circumstances and deaths.

65. Martin, David C., editor. *Mormon History.* Mt. Prospect, Illinois: David C. Martin, 1968. 4 pp.

 Four-page prospectus of a proposed history periodical. First issue, volume 1, number 1, dated March 1969, with 54 pages. Contains mostly reprints of earlier publications focusing on the original church. Publication ceased with volume 2, number 2, October, 1970.

66. McKiernan, F. Mark. *The Voice of One Crying in the Wilderness: Sidney Rigdon, Religious Reformer, 1793 to 1876.* Lawrence, Kansas: Coronado Press, 1971. 190 pp.

 Extensively documented biography of Sidney Rigdon, prominent in the leadership of the Latter Day Saint movement from 1831. Rigdon was the sole surviving member of the first presidency of the church at Joseph Smith's death in 1844. Unsuccessful in his attempt at leading the church at Nauvoo, he organized a separate movement in Pennsylvania.

67. —————— and Roger D. Launius, editors. *An Early Latter Day Saint History: The Book of John Whitmer.* Independence, Missouri: Herald Publishing House, 1980. 213 pp.

 John Whitmer was called to be historian of the Latter Day Saint church in a revelation from Joseph Smith in 1831. This volume contains the text of Whitmer's historical log, with contextual notes and documentation added by the editors.

68. Miller, David E. and Della S. Miller. *Nauvoo: The City of Joseph.* Santa Barbara, California and Salt Lake City, Utah: Peregrine Smith, Inc., 1974. 273 pp.

Argues that Brigham Young was the legitimate successor of
Joseph Smith, Jr. Provides a well-documented narrative history
of the rise and fall of Nauvoo, with insight into Smith's attempts
at establishing a church-operated state, as well as lifestyles in the
city in the early 1840s.

69. Morgan, D. J. *Temples: Important Facts About the Building of
 Temples by Latter Day Saints.* Independence, Missouri: author,
 n.d. 24 pp.

 Argues that the church was in error to attempt to build temples
 of a physical nature, but should have viewed temples only in the
 spiritual sense. Provides a brief history of temple building by the
 early church.

70. Nelson, Leland R., compiler. *The Journal of Joseph.* Provo, Utah:
 Council Press, 1979. 257 pp.

 Although the book claims to be the personal diary of Joseph Smith,
 Jr., its contents are, in fact, entries from the *History of the Church,*
 published by the Mormon Church. Smith's clerks recorded events
 in the first person, as if it were Smith himself speaking.

71. Newell, Linda King and Valeen Tippetts Avery. *Mormon Enigma:
 Emma Hale Smith, Prophet's Wife, "Elect Lady," Polygamy's
 Foe.* Garden City, New York: Doubleday and Company, Inc.,
 1984. 407 pp.

 Argues that Emma Smith has been misrepresented and misunder-
 stood in the past. Presents a new, comprehensive and extensively
 documented biography of the wife of Joseph Smith, Jr. Provides
 insights into her personal life, as well as life on the American
 frontier.

72. Nibley, Hugh. *No, Ma'am, That's Not History.* Salt Lake City:
 Bookcraft, Inc., 1946. 62 pp.

 Argues that Fawn M. Brodie, author of *No Man Knows My
 History,* is in error—not just in her research methods, but in her
 thesis and conclusions. Presents a rebuttal to Brodie, based on the
 author's personal faith in Joseph Smith's claims.

73. Nibley, Preston. *The Witnesses of the Book of Mormon.* Salt Lake
 City: Deseret Book Company, 1953. 208 pp.

A collection of accounts relating to the 11 men who claim to have handled the "golden plates" from which the Book of Mormon is said to have been translated. The use of early documents and writings provide a unified source book of information.

74. Oaks, Dallin H. and Marvin S. Hill. *Carthage Conspiracy: The Trial of the Accused Assassins of Joseph Smith.* Urbana and Chicago, Illinois and London: University of Illinois Press, 1975. 262 pp.

Argues that the trial was a sham, and that the citizens of Hancock County, Illinois were glad to be rid of the "Mormon problem." Documents the general concepts of the Mormon—non-Mormon conflict of the mid-1840s.

75. Petersen, LaMar. *Hearts Made Glad.* Salt Lake City: author, 1975. 258 pp.

Argues that Joseph Smith was fond of alcoholic beverage, and presents a somewhat irreverent biography of Smith, with his views on drinking as a a focus. Extensive documentation provides an interesting perspective on Smith as a religious leader.

76. Roberts, B. H., editor. *History of the Church of Jesus Christ of Latter-day Saints, Period I.* Salt Lake City: LDS Church, 1951. 7 volumes, plus index.

Records the events of the church as they happened, written by clerks employed for this purpose by Joseph Smith, Jr. These records were published in different formats in various church periodicals, until they were finally compiled, prepared and published in this series. The writing style is in the first person, implying that Smith himself was either writing or dictating. This is not the case, and has caused some confusion for readers. The editing process produced an account favorable to the Mormon Church, but the series in an excellent and important source.

77. ————. *Joseph Smith: The Prophet-Teacher.* Princeton, New Jersey: The Deseret Club of Princeton University, 1967. 77 pp.

Text of a discourse delivered by Roberts at the Salt Lake Tabernacle in 1907. Argues that although a prophet is a predictor of future events, his primary duty is as a teacher of men. This discourse enumerates many of Smith's doctrinal teachings.

78. Smith, Emma. *A Collection of Sacred Hymns, for the Church of the Latter Day Saints.* Kirtland, Ohio: F. G. Williams and Company, 1835. 127 pp.

The first hymnal of the church contains 90 hymns, some by Latter Day Saint writers, many compiled from then-popular Christian hymnody.

79. Smith, Joseph, Jr. *A Book of Commandments, for the Government of the Church of Christ.* Zion (Independence), Missouri: W. W. Phelps and Company, 1833. 160 pp.

This first attempt by the church to publish Smith's revelations in one volume was foiled by the citizens of Jackson County, Missouri. Provoked to armed conflict by the saints, the Missourians attacked the properties of the church in 1833, one of which was the printing house. The book was then in the process of being printed, but had not been completed. A few sheets were saved, and a few volumes bound by their owners. This volume has caused considerable controversy in the movement. Two years later the revelations were finally published, but with numerous changes in their texts.

80. —————. *The Book of Mormon.* Palmyra, New York: author, 1830. 590 pp.

The first edition of the Book of Mormon was printed at the establishment of E. B. Grandin. Smith borrowed the funds to print 5,000 copies of the book from Martin Harris, a prominent farmer in the Palmyra area, and also a believer in Smith's work.

81. —————. *The Book of Mormon.* Kirtland, Ohio: P. P. Pratt and J. Goodson, 1837. 621 pages.

The second edition of the Book of Mormon was printed in a smaller, more compact format than the first, but its outstanding feature is the many changes Smith made in its text.

82. —————. *Doctrine and Covenants of The Church of the Latter Day Saints.* Kirtland, Ohio: F. G. Williams and Company, 1835. 282 pp.

The first successful attempt at publishing Smith's revelations in one volume contains 102 selections of inspired messages, teachings

and church policy. This edition of the book, as well as subsequent editions published later by various branches of the church until the turn of the century, contained seven "lectures on faith." These lectures were utilized in the ministerial training schools of the early church. Both the Mormon Church and the RLDS Church publish their own editions of the *Doctrine and Covenants*, under the same title. There are about 100 sections common to both books, but each church has organized them differently and has added other materials, unique to the particular organization.

83. ――――――. *Joseph Smith's Kirtland Revelation Book*. Salt Lake City: Modern Microfilm Company, 1979. 126 pp.

This is a photographic reproduction of the holograph document containing the original texts of most of Smith's revelations. An important resource for exploring the development of Latter Day Saint theology.

84. ――――――. *Lectures on Faith*. Salt Lake City: Deseret Book Company, 1985. 96 pp.

This is a new edition of the original lessons as used in the 1830s, and published in the early editions of the Doctrine and Covenants. Footnotes and scriptural cross-references have been adjusted to correspond with the 1981 editions of the scriptures published by the Mormon Church.

85. Smith, Lucy Mack. *History of Joseph Smith by His Mother*. Salt Lake City: Bookcraft, Inc., 1958. 369 pp.

The original edition of this book, first published in England in 1853, was highly criticized by leaders of the church in Utah based on their disagreement with statements made by Smith in her narrative. This edition has been edited by Preston Nibley, to reflect the position of the Mormon Church.

86. Stewart, John J. *Joseph Smith: The Mormon Prophet*. Salt Lake City: Mercury Publishing Company, 1966. 257 pp.

Argues that Joseph Smith puzzles all observers except those who believe he was a true prophet of God. Utilizes extensive documentation to present a readable, yet faith-promoting biography of Smith from a Mormon point of view.

87. Taylor, Samuel W. *Nightfall at Nauvoo.* New York: MacMillan and Company, 1971. 403 pp.

 Highly acclaimed novelized history of the rise and fall of the Mormon capital at Nauvoo, Illinois. Taylor's careful research and extensive documentation provide valuable insights into what has been viewed Mormonism's most crucial phase.

88. *Times and Seasons.* Commerce, Illinois: Robinson and Smith, 1839. 16 pp.

 The official church paper from its inception until the final issue in 1846, the Times and Seasons is unsurpassed in its value as a resource in church history and theology. A number of persons served as editor, including Joseph Smith, Jr. The name of the city was changed to Nauvoo and reflected in the May, 1840 issue. Publication frequency was changed to twice monthly in November, 1840, with the commencement of volume 2. The final issue was volume 6, number 23, dated February 15, 1846.

89. Walker, John P., editor. *Dale Morgan on Early Mormonism.* Salt Lake City: Signature Books, 1986. 423 pp.

 Morgan is viewed by many as one of America's premier historians. This volume contains important correspondence with a variety of individuals on matters pertaining mostly to Mormon history. At his untimely death in 1971, Morgan was working on what would have been a multi-volumed definitive history of the Mormon church —a project which occupied him over a thirty year period. The first seven chapters and two appendices are all that Morgan completed. They are the main portion of this volume, and provide valuable insights and documentation on the founding of the Latter Day Saint movement.

90. Wilcox, Pearl G. *The Latter Day Saints on the Missouri Frontier.* Independence, Missouri: author, 1972. 367 pp.

 Although this volume will not satisfy the serious scholar, the author provides the only full-length volume available that narrates and documents the history of the Latter Day Saints in Missouri from their first attempts at colonization in 1831 to their expulsion in 1838.

91. Wilson, Lycurgus A. *Life of David W. Patten.* Salt Lake City:

The Deseret News, 1904. 72 pp.

David W. Patten was a member of the first group of men to serve the Latter Day Saint church as apostles. He was killed in 1838 at the Battle of Crooked River, during the Missouri difficulties, thus making him the first apostlic martyr of Mormonism. Although little is known of Patten, the author has obtained many first-hand accounts to provide an interesting narrative.

92. Wood, Wilford C. *Joseph Smith Begins His Work, Volume 1.* np: author, 1958. 650 pp.

This photo-reprint of the 1830 (first edition) Book of Mormon includes notes and photos by Wood.

93. ————. *Joseph Smith Begins His Work, Volume 2.* np: author, 1962. 486 pp.

Contains photo-reprints of the 1833 Book of Commandments and the 1835 Doctrine and Covenants, with photos illustrating sites of Latter Day Saint history added by Wood.

94. Youngreen, Buddy. *Reflections of Emma: Joseph Smith's Wife.* Orem, Utah: Grandin Book Company, 1982. 156 pp.

Contains 75 photos, interviews with grandchildren and ten biographical essays about Emma Smith. Provides unique personal insights into the life of Emma.

SECTION 3
Dissident Movements Founded Between
1830 and 1844

At least ten different movements separated themselves from the main body of the Latter Day Saint church during the fourteen years of Joseph Smith's administration. Most of these movements were short-lived, and even fewer were successful in publishing any materials which have become part of the bibliographic record. Those who did publish materials are presented in this section, organized by church or movement. Some bibliographers have listed publications for which no known copy exists—only references from other publications had provided clues to additional items. These are not included. Although a serious effort has been exerted to provide church names as accurately as possible, often the exact name of the church is disputed, or not made clear by the publications themselves.

The Church of Jesus Christ, The Bride, The Lamb's Wife
George M. Hinkle founded this movement on June 24, 1840, but by mid-1845 he had merged with Sidney Rigdon's movement. When Rigdon's first church organization failed, Hinkle's movement was revived for a short period.

95. *The Ensign.* Buffalo, Scott County, Iowa Territory: George M. Hinkle, William E. McLellin, 1855. 16 pp.

Monthly publication, beginning July 15, 1855 with volume 1, number 1. One full volume, twelve numbers, was published. Matters of church history and doctrine occupied the editorial content of the paper, although local news events were also included.

Oliver H. Olney
Olney was excommunicated from the LDS church on March 17, 1842 on charges of having set himself up as a prophet. He claimed to have been "set apart" by the "ancient of days" as a prophet and attempted to gather followers to a gathering place designated at Squaw Grove, Illinois. Although two publications are said to have been issued, only one is extant.

96. Olney, Oliver H. *The Absurdities of Mormonism Portrayed.* Hancock

24

County, Illinois: author, 1843. 32 pp.

Recites Latter Day Saint history from the troubles at Kirtland, Ohio, through the difficulties in Missouri and finally to the morals in Nauvoo, with a focus on the then-rumored practice of polygamy.

Church of Jesus Christ of Latter Day Saints

Francis Gladden Bishop was removed from the Latter Day Saint church in 1842 at Nauvoo on charges of claiming to receive revelations which were not consistent with the teachings of the church. The movement continued until Bishop's death in 1878, when many of the remaining members united with the RLDS Church.

97. Bishop, Francis Gladden. *An Address to the Sons and Daughters of Zion, scattered abroad, through all the earth.* Kirtland, Ohio (?), 1851. 50 pp.

"The address has the character of a general epistle, and provides some biographical details. There are also a few remarks 'On Spirits' (spiritualism), followed by a revelation given at Kirtland June 15, 1851, and another given in the temple at Kirtland March 16, 1851 (a description of the golden plates, the interpreters, and the sword of Laban). The last two pages are devoted to a 'wonderful vision' derived from an old MS of 1792." (Morgan).

98. ————. *The Ensign. Light of Zion. Shepherd of Israel! and "Book of Remembrance."* Kanesville, Iowa: Francis Gladden Bishop, 1852. 42 pp.

"...made up almost entirely of revelations given at Kanesville between October 9 and November 27, 1852. Joseph Smith is declared to have been a fallen prophet who for that reason was given into the hands of his enemies. God is purifying the flock and has found a new Shepherd for it in the person of his servant David (Bishop)." (Morgan)

99. Shearer, Joel. *Mysteries Revealed.* Council Bluffs, Iowa, 1856. 32 pp.

Expounds the theology of the church, based mainly on the belief that Joseph Smith was a fallen prophet.

100. ————. *The Plan of Salvation According to the Gospel of Jesus Christ.* Council Bluffs, Iowa: Babbitt and Carpenter,

printers, 1858. 19 pp.

Doctrinal work arguing that Mormonism as interpreted by Bishop and his followers, is the true church.

101. —————— and William Swett. *Comments on the Kingdom of God and the Gospel.* Council Bluffs, Iowa, 1854. 30 pp.

Proclaims the Bishop movement to be the new church designed for those who were Latter Day Saints.

Church of Jesus Christ of Latter Day Saints

In the spring of 1844, a new church movement began forming at Nauvoo, with William Law, a former counselor to Joseph Smith in the First Presidency, and others. They were opposed to the practice of polygamy, for which uncounted rumors and some reasonably clear evidence existed. The movement does not appear to have survived Smith's assassination.

102. Law, William, Wilson Law, Charles A. Foster, et al. *Nauvoo Expositor.* Nauvoo, Illinois, 1844. 4 pp.

Only the first issue of this paper was ever published, Friday, June 7, 1844. The paper took a stand against Joseph Smith's campaign for the presidency of the United States. More particularly it proposed to crusade for moral reform in Nauvoo and against the abuse of power. Joseph Smith, as mayor of the city, acting upon an ordinance passed by the city council, was directed to put a stop to what was seen as a public nuisance. On June 10, the marshal reported that he had destroyed the press, type and supplies of the *Expositor* printing office.

SECTION 4
Non-extant Movements Founded During the Fragmentation Period, 1844-mid 1860s

As faithful Latter Day Saints attempted to discern just how to approach their church affiliation after the death of Joseph Smith, Jr., a number of leaders presented themselves before the saints. The organizations included in this section are first generation movements. That is, their first Latter Day Saint affiliation was with the original church. These organizations were an outgrowth of the searching which characterized the fragmentation period. More than 25 of these first generation movements have been identified--some very small, family-oriented groups; others more significant. Only six of these first-generation movements survive to the present. Those will be presented in Section 5.

Church of Jesus Christ of Latter Day Saints

Sidney Rigdon served as Joseph Smith's counselor in the first presidency of the original church for all but a few months of Smith's administration. At the time of Smith's death, Rigdon was living in self-imposed exile in Pennsylvania, having essentially been rejected by Smith about one year earlier. He returned to Nauvoo, Illinois and attempted to persuade the Saints that as the sole surviving member of the church's leading administrative body he should be the new leader of the church. When the church members residing in that city voted to uphold the Twelve Apostles, with Brigham Young at their helm, Rigdon proceeded to re-organize the church. Initially using the name of the church as it was in 1844, the church members following Rigdon changed the name in April 1845 to "Church of Christ" under which Smith had originally organized. This first movement began to disintegrate in 1846, but was revived and reorganized in 1863 under the name "Church of Jesus Christ of the Children of Zion." It continued until a short time after Rigdon's death in 1876.

103. James, Samuel. *To the Members of the Church of Jesus Christ of Latter Day Saints.* Nauvoo, Illinois: Samuel James, et. al., 1844. 1 p.

 Two-column broadside issued September 8, 1844, the evening of the day Brigham Young and the Twelve Apostles excommunicated Sidney Rigdon. "The signatories protest the 'illegal and unwarrantable' assumption of authority by the Twelve, decry the character assassination to which Rigdon has been subjected, and declare their conviction 'that in rejecting Sidney Rigdon, the Church of Jesus Christ of Latter Day Saints no longer exists, except in connection with him.'" (Morgan)

104. *The Latter Day Saint's Messenger and Advocate.* Pittsburgh, Pennsylvania: church, 1844. 16 pp.

> Periodical issued with volume 1, number 1 dated October 15, 1844. Frequency was semi-monthly to begin, but was later changed to monthly. Occasional issues were skipped. Name was changed, in accordance with the change of the church name in 1845 to "Messenger and Advocate of the Church of Christ." Publication was suspended in the late summer of 1846. Prime source of data on the Rigdon movement. Includes letters, minutes of meetings, doctrinal essays.

* McKiernan, F. Mark. *The Voice of One Crying in the Wilderness: Sidney Rigdon, Religious Reformer, 1793-1876.* Cited above as item 66.

105. Newton, Joseph H., William Richards and William Stanley. *An Appeal to the Latter-Day Saints.* Philadelphia: Printed for the Authors, 1863. 72 pp.

> "...denotes...the commencement of the late renaissance of the Rigdonite church....The Lord is declared to have manifested to Joseph H. Newton that his former priesthood authority was still valid and that he should act upon it." (Morgan) Promotes Rigdon as a "powerful leader who commands the authority of God."

106. Post, Stephen. *A Treatise on the Melchisedek Priesthood and the Callings of God.* Council Bluffs, Iowa: Nonpareil Printing Co., 1873. 22 pp.

> "...the text is addressed to a Mormon audience, for it employs the Book of Mormon and Doctrine and Covenants as of equal authority with the Bible. There are seven chapters, of which the fourth provides a slight autobiography of Post from 1835, when he became associated with the Mormon Church. Post goes on to argue the case for Rigdon as prophet, seer and revelator, and disputes the validity of lineal or birthright priesthood. Stephen Post was the last important champion of Rigdon, and the wasting away of Rigdonite Mormonism really begins with Post's death, which occurred sometime before 1880." (Morgan)

107. —————— and William Hamilton. *Zion's Messenger.* Erie, Pennsylvania: Sterret and Gara, Printers, 1864. 16 pp.

"The pamphlet commences with an open letter addressed to the Saints in their scattered condition, continuing the argument of the 'Appeal.'" It includes a letter by Stephen Post dated November 14, 1863 to Joseph Smith III, "arguing that Rigdon is the only true successor and his followers the only true church. The Melchisedek priesthood is not hereditary, and Joseph Smith III is therefore mistaken in having yielded to the importunities of the elders and taken his place at the head of the Reorganization..." (Morgan)

108. Rigdon, Sidney. *A Collection of Sacred Hymns. For the Church of Jesus Christ of Latter Day Saints.* Pittsburgh, Pennsylvania: Printed by E. Robinson, 1845. 224 pp.

"Hymnals of their own were a pressing need of all the Mormon churches, and this was the earliest published by any of the factions." (Morgan)

Church of Christ

David Whitmer had been one of the original members of the church, and was a witness of the plates from which the Book of Mormon was said to have been translated. After he separated from the church in the 1830s over various disagreements with Joseph Smith, he does not appear to have been active in promoting religion. In 1847 he was called upon by a number of members to take the lead of a group which had been organized. His right to leadership was based on an early designation made by Smith as to who his successor might be. Whitmer does not appear to have joined with the little group, but advocated a less formal "non-organized" church. His small band of followers held together long after his death, leaving a number of items in the bibliographic record. The group merged with the Church of Christ (Temple Lot) in 1926.

109. Brown, W. P. *Defense of the Church of Christ, and Exposure of the Errors of Mormonism.* Newton, Kansas: Democrat Publishing House, 1887. 30 pp.

Maintains that David Whitmer was the sole possessor of rightful authority. Discusses the claims of the RLDS Church to authority and the Book of Commandments versus the Doctrine and Covenants. The Whitmer movement also rejected the High Priesthood as error.

110. ——————. *Exposure of the Errors of Mormonism and Defense of the Church of Christ.* Newton, Kansas: Republican Printing

House, 1887. 52 pp.

"The cover title is the same as the regular title, except that 'Pamphlet No. 2' is added. Brown again addresses himself 'To Latter-Day Saints Everywhere,' and his pamphlet is more or less a serial argument with the 'Saint's Herald' from May through July 1887, on matters in dispute between the churches..." (Morgan)

111. —————. *Exposure of the Errors of Mormonism and Defense of the Church of Christ.* Newton, Kansas: Reynolds Bros.' Printing House, 1888. 103 pp.

Cover denotes this as pamphlet number 3. "Brown resumes his intermittent argument with the Reorganized Church, replying to various remarks printed in the 'Saint's Herald' between September 24, 1887 and February 11, 1888....The pamphlet is also of interest for reprinting two affidavits, dated 1873 and 1885, in which Ebenezer Robinson swore that Hyrum Smith had avowed plural marriage in Nauvoo days, and for a brief account of a visit by Brown to the Bickertonite church in Pennsylvania, of which he had been a member in 1864." (Morgan)

112. *The Gospel Monitor.* Hannibal, Missouri: J. J. Cranmer, 1880. 4 pp.

Periodical advocating the Whitmerite point of view, edited and published by J. J. Cranmer, a one-time member of the RLDS Church. No full file is extant. It is not known if Whitmer endorsed this publication.

113. Herstine, Mrs. C. M. *Nature of the Apostacy.* Davis City, Iowa: The Return, 1896. 8 pp.

"The text of this tract was published in 'The Return', July 1896, and immediately reprinted as a separate, announced in 'The Return' for August 1896. Its interest is purely theological." (Morgan)

114. *The Return.* Davis City, Iowa: Church of Christ, 1889. 16 pp.

"...commenced in the interests of the Church of Christ by Ebenezer Robinson, and was published by him at Davis City until his death in January 1891. The twenty-six numbers Robinson got out are especially valuable historically for the 'Items of Personal History' Robinson printed..." (Morgan) Publication was suspended

with Robinson's death, but was begun again in October 1892. Publication was again suspended in August 1893, and restored in 1895. The publication continued through October 1900. Due to a number of internal disagreements, the issue numbering is occasionally confused.

115. Smith, Joseph, Jr. *A Book of Commandments, for the Government of the Church of Christ. Organized According to Law on the 6th of April, 1830. Zion: Published by W. W. Phelps and Co. 1833.* Lamoni, Iowa: Reprinted verbatim by C. A. Wickes, 1903. 133 pp.

A reprint of the original 1833 attempt at publishing Smith's revelations.

116. ————. *The Nephite Records, An Account Written by the Hand of Mormon upon Plates Taken from the Plates of Nephi.* Kansas City, Missouri: Church of Christ, 1899. 721 pp.

A reprint of the original 1830 edition of the "Book of Mormon" which had been published at Palmyra, New York.

117. Snyder, John J. *Glad Tidings. The fulfillment of the Covenant or promises of God to Israel—Prophecy that has been fulfilled, and to be fulfilled—The gathering of Israel to their promised lands— The American Indians are a remnant of the house of Israel; they were once a white race, and will again become a white race.* Kansas City, Missouri: Church of Christ, 1920. 192 pp.

Consists of 12 chapters, which includes a reprint of David Whitmer's "An Address to all Believers in Christ." Argues the truth of the "Record of the Nephites" (Book of Mormon). Snyder indicates his authorship of a series of pamphlets (below) which were originally published anonymously.

118. ————. *Glad Tidings (No. 1) How to Obtain Happiness and Health.* Chicago?: author, 1905. 103 pp.

A work on faith-healing containing very little on Mormonism.

119. ————. *Glad Tidings (No. 2) Jesus is Coming.* Kansas City, Missouri: Truth Publishing Company, 1918. 47 pp.

Contains material on prophecy, the world war and the signs

of the times.

120. ————. *Glad Tidings (No. 3) The Restoration of Israel.*
Kansas City, Missouri: Truth Publishing Company, 1918. 16 pp.

121. ————. *Glad Tidings (No. 4) The Lord Is to establish the
Church again in perfect order.* Kansas City, Missouri: Truth
Publishing Company, 1918. 20 pp.

122. ————. *The Solution of the Mormon Problem.* Independence,
Missouri: Zion's Advocate, 1926. 16 pp.

Argues that Whitmer's comments in "An Address to Believers
in the Book of Mormon" contain the solution to the Mormon
problem. The specifics of the problem are not clearly defined.

123. ————. *Truth Number 1.* Davis City, Iowa: Church of Christ,
1895. 41 pp.

Generalized theological discussion.

124. ————. *Truth Number 2.* Chicago: author, 1896. 197 pp.

Argues the truthfulness of the Book of Mormon.

125. Whitmer, David. *An Address to All Believers in Christ. By A Witness
to the divine Authenticity of The Book of Mormon.* Richmond,
Missouri: author, 1887. 75 pp.

Describes the process of the translation of the Book of Mormon
and provides important details about Latter Day Saint history
during the years 1829-1830. Whitmer also argues a number of
crucial theological issues, among which the changing of Smith's
revelations seems paramount. Argues that Smith had been called
by God to translate the Book of Mormon and preach the gospel,
but not to lead a church or receive revelations. One of the most
important works produced by any of the smaller groups. Whitmer
was intimately associated with Joseph Smith in the early years of
the movement.

126. ————. *An Address to all Believers in the Book of Mormon.*
Richmond, Missouri: author, 1887. 7 pp.

Rebuts articles published in the RLDS paper, the "Saint's Herald."

127. Wickes, Charles A. *Sabbath or Sunday?* Davis City, Iowa: Church of Christ, 1896. 8 pp.

> Expounds the long-debated question as to the proper day of worship.

Church of Jesus Christ of Latter Day Saints

William Smith, younger brother of Joseph Smith, Jr., was a member of the original church's twelve apostles. After Joseph's death, William suggested to church leaders that he be appointed as the "guardian" over the church. Brigham Young rejected William's suggestion, and the two eventually excommunicated each other from the church. Although Smith was associated with James J. Strang for a short period, he announced in 1847 that he was the prophet and president of the church. William's movement gathered a few followers and issued several publications. By the mid-1850s the church had disintegrated and Smith later became a member of the Reorganized Church of Jesus Christ of Latter Day Saints.

128. *Aaronic Herald.* Covinginton, Kentucky: Isaac Sheen, volume 1, number 1, February 1, 1849. 2 pp.

> Official organ of Smith's church. Sheen published the first number before he became formally associated with Smith. Revelations and articles condemning Brigham Young and those who followed him, are included. With the May 1849 issue, volume 1, number 3, the paper was increased to four pages. The name of the periodical was changed to *Melchisedic and Aaronic Herald* with the second issue, dated March. Subsequent issues have several variations in the spelling and punctuation of the paper's name. The final number was issued April 1850, volume 1, number 9.

129. Smith, William. *A Proclamation and Faithful Warning to all the Saints Scattered around in Boston, Philadelphia, New York, Salem, New Bedford, Lowell, Peterborough, Gilsom, St. Louis, Nauvoo, and elsewhere in the United States; Also, to those residing in the different parts of Europe and in the Islands of the seas.* Bountiful, Utah: Restoration Research, 1983. 23 pp.

> Contends that Brigham Young is a usurper, Joseph Smith III proclaimed as the rightful leader of the church. Smith urges church members to cease paying tithing. This is a reprint of Smith's 1845 publication. No original copies of the pamphlet have been located, although Smith stated that he had 500 copies of a 16 page booklet printed. The complete text of the proclamation

was published in the *Warsaw Signal*, October 29, 1845, from which this booklet is taken.

130. —————. *A Revelation Given to William Smith, in 1847, on the Apostasy of the Church and the Pruning of the Vineyard of the Lord.* Philadelphia: William Smith, 1848. 8 pp.

Enunciates a law of inheritance in church leadership by lineage.

131. ————— and Aaron Hook. *William Smith, Patriarch & Prophet of the Most High God. Latter Day Saints, Beware of Imposition!* Ottawa, Illinois: Smith and Hook, 1847. 1 pp.

Advises that Brigham Young and the Twelve have been removed from the church and that they hold no authority. Includes a revelation dated August 28, 1847, commanding Smith to "do the work God has appointed him to do."

132. ————— and Isaac Sheen. *Deseret. Remonstrance of William Smith et. al., of Covington, Kentucky, against the Admission of Deseret into the Union.* Washington, D. C.: William M. Belt, 1850. 3 pp.

Accuses the church under Brigham Young in Utah of "seeking to obtain a state government by false representations and fallacious pretensions, calls Salt Lake Mormonism diametrically opposed to the pure principles of virtue, liberty, and equality, accuses their rulers of treasonable designs and of intending to establish a new order of political popery in the recesses of the mountains, declares that more than 1,500 Salt Lake Mormons took a treasonable oath against the United States government in the temple at Nauvoo, and calls their leaders hypocritical apostates..." (Morgan). This was presented to the United States House of Representatives on December 31, 1849, the 31st Congress, 1st Session, and was ordered printed by the Committee on Territories.

133. Wood, Joseph. *Epistle of the Twelve.* Milwaukee, Wisconsin: Sentinal and Gazette Steam Press Print, 1851. 26 pp.

Proclaims Joseph Wood as "God's Spokesman for, and Counsellor to...William Smith, President of the Quorum of Twelve Apostles ...also, a Prophet, Seer, Revelator, and Translator; holding the keys of the ministry jointly with...William Smith." Rehearses Latter Day Saint history and argues the succession question,

proclaiming Smith to be the true successor.

134. *Zion's Standard.* Palestine Grove, Illinois: William Smith, 1848. 1 p.

A statement from Smith proclaiming his leadership of the church.

Jehovah's Presbytery of Zion

Charles Blancher Thompson was an early convert to the Latter Day Saint movement, and joined with James J. Strang after Joseph Smith, Jr. was assassinated. However, by the fall of 1847 he was in St. Louis, and his first publication was issued early in 1848 in which he announced that he had been commanded by God to provide the leadership for the church; that the original church had been rejected.

Thompson experienced some success, but his leadership in the temporal affairs of the group was challenged by some of his members in 1858--a litigation which lasted almost ten years. He moved to Philadelphia and was apparently unsuccessful in his attempt to organize another movement.

135. *Cyipz Herald and IABBA's Evangel.* Philadelphia: Charles Blancher Thompson, 1888.

Assumed periodical of Thompson's revival organization. No copy extant. RLDS Church History, volume 4, page 604, makes a brief remark--the only known information.

136. *The Nachashlogian.* St. Louis: Charles Blancher Thompson, 1860. 10 pp.

Periodical issued in August 1860, volume 1, number 1. Thompson attempted to promote this periodical to disseminate his views that the negro race was created to be slaves to the white race.

137. *Preparation News.* Preparation, Iowa: Jehovah's Presbytery of Zion, 1855. Volume 1, Number 1, January 3, 1855. 4 pp.

Periodical of Thompson's movement, later merged with a previous religious periodical (Zion's Harbinger, below). Continued into 1856.

138. *Preparation News. and Ephraim's Messenger, Extra.* Preparation City of Ephraim: Jehovah's Presbytery of Zion, 1855. 2 pp.

Contains the articles of incorporation of Thompson's movement, including the articles of his "Sacred Treasury."

139. Thompson, Charles Blancher. *Great Divine Charter and Sacred Constitution of IABBA's Universal and Everlasting Kingdom.* Philadelphia: Charles Blancher Thompson, 1873. 64 pp.

Only known copy is missing the first two leaves. Publication place and date is assumed. Argues the white race alone descended from Adam, and provides guidelines and rules for members to unite with Thompson's movement.

140. ————. *The Laws and Covenants of Israel; Written to Ephraim, from Jehovah, the Mighty God of Jacob. Also, Ephraim and Baneemy's Proclamations.* Preparation, Iowa: Printed at the Book and Periodical Office of Zion's Presbytery, 1857. 208 pp.

Contains thirty chapters comprised of Thompson's proclamations dated between 1848 and 1857, a vision, and various revelations.

141. ————. *The Nachash Origin of the Black and Mixed Races.* St. Louis: George Knapp & Co., Printers and Binders, 1860. 84 pp.

Argues "that the negro race was created to occupy the position of subjects to the white race, and were on creation indelibly marked with the insignia of their position, the color of their skin." (Morgan)

142. ————. *The Voice of Him!! That Crieth in the Wilderness, Prepare Ye the Way of the Lord!!!* St. Louis: Jehovah's Presbytery of Zion, 1848. 4 pp.

Proclaims for the first time Thompson's claim to leadership of the Latter Day Saint movement. "The leaflet declares that 'Baneemy' (a sort of separate identity of Thompson's) has been commanded to lift up his voice and make proclamation that the church was rejected of the Lord with her dead on June 27, 1844, and was that day partially disorganized by the martyrdom of the Prophet and Patriarch....So Baneemy...was given the key words of authority and a commandment to organize and cleanse the priesthood." (Morgan)

143. *Western Nucleus, and Democratic Echo.* Preparation, Monona Co., Iowa: Thompson and Butts, 1857. 4 pp.

Additional periodical for Thompson's movement could have begun earlier. First extant copy is volume 1, number 17, June 3,1857.

144. *Zion's Harbinger and Baneemy's Organ.* St. Louis: Jehovah's Presbytery of Zion, 1849. 4 pp.

First periodical of Thompson's movement, issued January 1849, volume 1, number 1. The second number was not issued until April 1850 and continued sporadically through 1855 when publication ceased. The periodical provides the essential and primary source of information relating to this movement.

Church of Christ

In 1836, when only 10 years old, James Colin Brewster announced that he was in communication with the ancient American prophet Moroni (from the *Book of Mormon*) and had proceeded to write the Book of Moroni. Latter Day Saint church leaders quickly removed him from full fellowship in the church, but Brewster continued writing. By 1848 a separate church was organized and continued for several years. The movement eventually broke up by 1851 over leadership disagreements.

145. Brewster, James Colin. *An Address to the Church of Christ, and Latter Day Saints.* Springfield, Illinois: author, 1848. 24 pp.

Critical discussion of Joseph Smith's revelations as well as Latter Day Saint attempts to gather and build a temporal kingdom.

146. ————. *Very Important! to the Mormon Money diggers. Why do the Mormons rage, and the People imagine a vain thing?* Springfield, Illinois: author, 1843. 12 pp.

Angry rebuttal to a criticism of Brewster's first work (a purported translation of one of the lost books of the Bible), which had appeared in the Mormon press at Nauvoo.

147. ————. *A Warning to the Latter Day Saints, Generally Called Mormons. An Abridgement of the Ninth Book of Esdras.* Springfield, Illinois: author, 1845. 16 pp.

"...presented as prophecy and instruction by Esdras, but is freely annotated to show that present history is its topic. The 'Idle City' (Nauvoo) is to be destroyed, though Brewster qualifies this by saying that this means merely those in the city who profess to serve God but do not." (Morgan)

148. ————. *The Words of Righteousness to All Men, Written from One of the Books of Esaras, Which Was Written by the Five*

Ready Writers, In the Forty Days, Which Was Spoken of by Esaras, in His Second Book, Fourteenth Chapter of the Apocrypha, Being One of the Books Which Was Lost and Has Now Come Forth, by the Gift of God, in the Last Days. Springfield, Illinois: Ballad and Roberts, Printers, 1842. 48 pp.

Claims to be an abridgement made by Brewster, published before his 16th birthday, of one of the lost books of the Bible. Although Brewster later rendered the name "Esdras" it is printed as "Esaras" in this publication.

149. *The Olive Branch, or, Herald of Peace and Truth to all Saints.* Kirtland, Ohio: Church of Christ, volume 1, number 1, August 1848. 16 pp.

Official publication of church containing essential historical and theological information regarding the movement. Publication was moved to Springfield, Illinois in June, 1849; ceased in January 1852.

Church of Jesus Christ of Latter Day Saints

Lyman Wight was a member of the Twelve Apostles at the time of the death of Joseph Smith, and had previously been commissioned to lead a group of church members to Texas to seek a place for colonization. Although Brigham Young tried to dissuade Wight from going, Wight led about 150 people to Texas. On January 1, 1849, Wight formally organized his colony as a church, but later that year they joined forces with William Smith's movement; a union which was short-lived. When Wight died in 1858 most of his colony united with the RLDS Church.

150. Bitton, Davis, editor. *Reminiscences and Civil War Letters of Levi Lamoni Wight.* Salt Lake City, Utah: University of Utah Press, 1970. 191 pp.

Provides first-hand insights into life in Lyman Wight's colony, written by his son.

151. Hunter, J. Marvin. *The Lyman Wight Colony in Texas.* Bandera, Texas: author, nd. 37 pp.

Provides a brief history of the Wight movement, with biographical notes on Wight.

152. Wight, Lyman. *An Address by way of an abridged account and*

journal of my life from February 1844 up to April 1848, with an appeal to the Latter Day Saints, scattered abroad in the earth.... Austin, Texas?, 1848. 16 pp.

Seeks to explain Wight's position in relationship to the Latter Day Saint church.

Church of Jesus Christ of Latter Day Saints

After a brief association with James J. Strang and then in 1848 with William Smith, Jacob Syfritt began producing revelations and apparently attempted to establish a church of his own, but very little information is known, indeed, even the name of the church is assumed.

153. Justice, G. C. *Lines written on the departure of brother Jacob Syfrit (sic) to Jackson County, Missouri; the land for the saints of the most high God, to inherit Zion forever.* Philadelphia?: 1850? 1 p.

Contains a November 1850 revelation given by Syfritt, announcing that it is God's will that His church should be established on the earth.

154. Syfritt, Jacob. *Revelations given unto the messenger of the covenant, for the salvation of the world.* Philadelphia?, 1849? 22 pp.

Sixteen revelations by Syfritt dated from March 8, 1848 to December, 1849. Three witnesses provide a statement attesting the truthfulness of Syfritt's claim as a prophet. In addition, a patriarchal blessing given to Syfritt by William Smith in Nauvoo, April 18, 1846, is included.

Moses R. Norris

An apparent attempt at a separate church movement was made by M. R. Norris in April, 1851 at Kirtland, Ohio. Nothing further is known except the one publication left for the bibliographic record.

155. *Ensign to the Nations. To Gather Israel.* Kirtland, Ohio: M. R. Norris, 1851. 14 pp.

Numbered volume 1, number 1, April, 1851, is the only issue known to have been published. Norris states that the purpose of the publication is "to comfort and console the scattered lambs of Christ's flock." He announced a special meeting to be held at the Kirtland Temple for June 28, 1851.

Church of Christ

Zadoc Brooks and his followers had control of the temple at Kirtland, Ohio for a short time in the mid-1850s, until the demise of the movement and the incorporation of its remaining members into the RLDS Church at its official organization in 1860.

156. Smith, Joseph, Jr. *The Book of Mormon.* New York: Jas. O. Wright and Company, c. 1859. 380 pp.

"This is one of the more curious editions of the *Book of Mormon.* The copyright on the book having expired, and public attention being focused on Utah...the James O. Wright firm in New York late in 1858 undertook to place on the market a commercial edition. ...Commercially the book may not have been a success, for when they were approached by the Brooks faction, the publishers sold or leased the plates for a new printing with different front matter. (Or perhaps sold the remainder of their own edition in sheets.)" (Morgan). The Brooks edition was paid for by Russell Huntley, a wealthy church member, and subsequently has become known as the Brooks/Huntley edition. Brooks wrote an introduction which was included. When the Brooks movement merged with the RLDS Church, this edition of the Book of Mormon provided for the early needs of that church. This edition was reproduced from the third American edition which had been published in the early 1840s by the original church.

SECTION 5
Extant Movements Founded During the Fragmentation Period, 1844 to mid-1860s

Of the many movements emerging from those turbulent twenty years after Joseph Smith's death, only six have survived to the present day. Each of these six churches are, in the author's opinion, collectively the successors of the original church. Practically all other Latter Day Saint movements attempted since the mid-1860s have descended from these six churches.

This section will be divided into six parts--each part being one of the six main movements. In each case, the main movement will be presented first, then all other movements whose traditions are based in the main movement and for which we have identified bibliographic materials, will be presented in chronological order. The reader should clearly understand that the groupings are for purposes of reference only. Many churches claim original revelation.

PART ONE
Church of Jesus Christ of Latter Day Saints (Strangite)

James J. Strang offered perhaps the first viable and reasonably well-founded opposition to Brigham Young's leadership. At almost the precise moment of Joseph Smith, Jr.'s death, Strang claims to have been ordained to the prophetic office in order to carry on the work begun by Smith. Thus, the organization date of this movement—or the date of first continuance of the original church—is June 27, 1844.

A number of movements have been formed based upon the Strangite tradition over the years. Those for which bibliographic material is listed will be presented after the materials for the main movement.

157. Adams, George J. *A True History of the Rise of the Church of Jesus Christ of Latter Day Saints—and of the Restoration of the Holy Priesthood. And of the Late Discovery of Ancient American Records Collected from the Most Authentic Sources Ever Published to the World, Which Unfold the History of this Continent from the Earliest Ages after the Flood, to the Beginning of the Fifth Century of the Christian Era. With a Sketch of the Faith and*

Doctrine of the Church of Jesus Christ of Latter Day Saints. Also a Brief Outline of Their Persecution, and Martyrdom of Their Prophet, Joseph Smith, and the Appointment of His Successor James J. Strang. Baltimore: Hoffman, Printer, 1849? 44 pp.

"Primarily the pamphlet is an adaptation of Orson Pratt's *An Interesting Account of Several Remarkable Visions, and of the Late Discovery of Ancient American Records,* of which half a dozen editions were printed between 1840 and 1849....The only internal evidence as to the date of the publication appears in the introduction..." (Morgan)

158. *Articles of Faith Of The Church of Jesus Christ Of Latter Day Saints.* Burlington, Wisconsin: Voree Press, 1948. 4 pp.

"This leaflet, of which 2,000 copies were printed, contains 13 articles of faith attributed to Joseph Smith and 4 paragraphs of comment unsigned but by Stephen West." (Morgan)

159. *A Collection of Sacred Hymns; adapted to the faith and views of the Church of Jesus Christ of Latter Day Saints.* Voree, Wisconsin: Gospel Press, 1849. 172 pp.

The first hymnal of the Strangite church, containing 120 hymns.

160. Couch, Edward T. *The Everlasting Covenant or Prophets of God Teach Alike.* Boyne City, Michigan: np, 1906. 56 pp.

"...undertakes to show as harmonious the teachings of the Biblical prophets and those of the New Dispensation." (Morgan)

161. ————. *Evidences of Inspiration.* Boyne, Michigan?, np, 1890. 38 pp.

"...argues that the two Latter Day Prophets, Joseph Smith and James J. Strang, were men inspired from on high." (Morgan) Based on texts from Isaiah 8:20 and 1 Thes. 5:20.

162. ————. *The Prophetic Office.* Boyne City, Michigan: np, 1908. 67 pp.

"...reviews the claims of Brigham Young, Joseph Smith III, and James J. Strang to the prophetic office..." (Morgan)

163. —————. *The Sabbath and the Restitution.* Boyne, Michigan: np, 1891. 51 pp.

 Theological argument of the two topics of the title.

164. —————. *The Teachings of Jesus.* Boyne City, Michigan: np, 1913. 44 pp.

 Argues that the Strangite church is the only true church based on the claim that it follows all the teachings of Christ and fulfills numerous Biblical prophecies.

165. —————. *The Two Bibles or Scholarship and Inspiration Compared.* Boyne City, Michigan: np, 1907. 71 pp.

 Contrasts the King James Version with Joseph Smith's "Inspired Version." Suggests that Smith added useful information to the Bible which helps clarify the meanings.

166. Cowdery, Oliver. *Cowdery's Letters, on the Bringing In of the New Dispensation.* Milwaukee, Wisconsin: Macrorie and Pitcher, 1880. 33 pp.

 "A new printing of the letters by Cowdery on the early history of the Church. This is not precisely a reprint of the edition of 1854, for it lacks Strang's preface and appendix." (Morgan)

167. —————. *Cowdery's Letters on the Bringing In of the New Dispensation.* Burlington, Wisconsin: Free Press Print, 1899. 31 pp.

 "...main text is given over to the eight letters by Cowdery. Watson's preface, signed at Spring Prairie Jan. 13, 1899, quotes liberally from Strang's remarks in the 1854 edition, and adds some comments of his own contradicting the idea that revelation has ceased" (Morgan)

168. —————. *The Epistles of Oliver Cowdery, on the bringing in of a New Dispensation.* Saint James: Cooper and Chidester, 1854. 56 pp.

 Contains the letters written by Cowdery, with commentary written by James J. Strang. Perhaps the most important of the three editions.

169. Cumming, John. *Wingfield Watson—The Loyal Disciple of James J. Strang.* np, nd. 12 pp.

 This reprint of Cumming's paper, which originally appeared in *Michigan History* in December, 1963, was apparently done by family members as the booklet contains a tribute written and signed by Mrs. C. G. Lewis "Daughter of Wingfield Watson."

170. *Daily Northern Islander.* Saint James: Cooper and Chidester, 1856. 4 pp.

 First issue appeared April 1, 1856, volume 1, number 1. The final number appears to have been issued June 20, 1856, which contains an account of the assault on Strang's life, from which Strang died.

171. *Facts for Thinkers.* Pueblo, Colorado?, 1930? 1 p.

 Circular advertising various publications of the church. The page is signed "H. C. Anderson, 1636 E. 7th St., Pueblo, Colo." Anderson's home was used as the mailing point for Strangite missionary activity in the west during the 1930s.

172. Fitzpatrick, Doyle. *The King Strang Story.* Lansing, Michigan: National Heritage, 1970. 289 pp.

 An important biography of James J. Strang with a history of the movement. Fitzpatrick, not a Strangite himself, provides a reasonably well-written and documented view.

173. Flanders, Bruce B. *Basic Theology: A Strangite Mormon Discusses the Original View of the Godhead.* Burlington, Wisconsin: Voree Press, 1983. 24 pp.

 Argues that Jesus Christ was a mortal person, literally the son of Joseph and Mary, who upon completion of his ministry and the mission he was called to, died on the cross as a mortal, and was later appointed and ordained to Godhood.

174. Flanders, Chester K. *Infant Baptism.* Kansas City, Kansas: Latter Day Precept, 1931. 8 pp.

 Discusses the Strangite beliefs regarding the baptism of infants, and includes a second article on idolatry.

175. Flanders, John. *Prophetic Controversy No. 14. James J. Strang's Memorial to the Nation and An Open Letter to Rudger Clawson, President of the Quorum of the Twelve, (Utah) Church of Jesus Christ of Latter Day Saints, written in reply to a false and misleading statement against "Strangites" which was published in "Quorum Bulletin," Vol. 1, No. 2, of their 1935 Sunday School Quarterly, on pages 20 and 21.* Pueblo, Colorado?: np, 1936? 16 pp.

Reprints Strang's April 6, 1850 "Memorial." "The rest of the pamphlet is given over to the open letter challenging Clawson in his dismissal of Strang's claims to succession." (Morgan)

176. *The Gospel Herald.* Bay City, Michigan: church, 1941. 4 pp.

First issue of this periodical dated April 1941, volume 1, number 1. Stanley L. Johnston was editor. Only six issues published between April 1941 and March 1942 when Johnston was inducted into the army. Mostly contains assorted doctrinal articles.

177. *The Gospel Herald.* Burlington, Wisconsin: Voree Press, 1969? 16 pp.

This new series began quarterly, but publication later became quite sporadic until the final number was issued July 1980, volume 12, numbers 2/3, due to medical concerns of the editor, Bruce B. Flanders. Contains important minutes of meetings, history of the church and doctrinal discussions.

178. Hickey, L. D. *A Card to the Kind and Brave People of Utah.* Monte Vista, Colorado?: author, 1896? 8 pp.

Contains Strang's letter of appointment, Strang's rebuttal to arguments against it, and the text of Strang's July 8, 1846 revelation.

179. ——————. *Rejection of the Church at Nauvoo.* Coldwater, Michigan: church, 1892. 8 pp.

Affirms the claims of J. J. Strang as the legal successor to the original church and the prophetic office.

180. ——————. *Who was the Successor of Joseph Smith?* Coldwater, Michigan?: author, 1891. 5 pp.

"...insists upon the validity of Strang's claims to the Succession, but sets forth the terms upon which he is prepared to accept Joseph Smith III as President. ... This tract was written during a period when L. D. Hickey, the last surviving apostle of the church, was not fellowshiped by it, and the tract advocates the views which had led to action against him. ...Hickey sought strenuously to bring his fellow Strangites into the Reorganized Church." (Morgan)

181. —————— and D. B. Alvord. *A Card To The Public—Defending Hon. James J. Strang*. Monte Vista, Colorado?: author, 1896? 4 pp.

A reprint of an 1894 leaflet of the same title but with additional material by John Wake. Contains testimonials regarding Strang's claims.

182. Horton, Thomas. *A True History of the Rise of the Church of Jesus Christ of Latter Day Saints...* Geneva, New York: Gazette Print, 1849? 47 pp.

See number 157. Identical except that it is set in a different typeface, and contains some minor textual differences. The author of no. 157 is not mentioned in this version.

183. Hutchins, James. *An Earnest Appeal for Justice*. Black River Falls, Wisconsin: author, 1876. 62 pp.

Text of an appeal written to the President of the United States rehearsing the difficulties of the original church in the state of Missouri in the 1830s.

184. ——————. *The Messenger, a Timely Warning, to a Thoughtless World*. (Independence, Missouri): author, 1879. 23 pp.

"A discourse on 'the way of righteousness,' about which the pamphlet is insistent because written in 'these last days.'" (Morgan)

185. ——————. *An Outline Sketch of the Travels of James Hutchins*. np: 1871?. 123 pp.

"Although it does not appear from his narrative, Hutchins was a member of the Strangite Quorum of the Twelve at the time of Strang's death. His pamphlet is in part a sketchy autobiography

and in part a collection of what might be called sermons....Of greater interest is an account of a missionary tour made to Utah in August, 1870....Doubtless this was the first Strangite mission to Utah.'' (Morgan)

186. —————. *Truth Developed and Falsehood Shown.* np, 1881. 14 pp.

 "Another of Hutchins' 'sermons in print,' having no material specific to the history of doctrinal system of the Strangite church.'' (Morgan)

187. *The Latter Day Precept.* Kansas City, Missouri: church, 1919. 8 pp.

 First issue volume 1, number 1, August 1919, edited by John Flanders. Complete files are not known, but probably ceased publication in the fall of 1920.

188. Foster, Lawrence. "James J. Strang: The Prophet Who Failed." *Church History* 50 (June 1981): 182-192.

 An important paper analyzing the leadership skills of Strang and his influence on the church he established. Argues that Strang was unsuccessful in establishing a base for the completion of the goals of his "kingdom."

189. Martin, Samuel H. *(Tract without title.)* Kansas City, Kansas?: author, 1926? 4 pp.

 Discusses divine authority, church organization, principles and doctrines of the true church, repentance, baptism, the laying on of hands and the resurrection of the dead.

190. *Memorial. To the President and Congress of the United States, and to all the People of the Nation—We, James J. Strang, George J. Adams, and William Marks, Presidents of the Church of the Saints, Apostles of the Lord Jesus Christ, and Witnesses of His Name Unto all Nations, and others, our Fellow Servants, send Greeting:* Voree: Gospel Press, 1850. 4 pp.

 Dated April 6, 1850. "...rehearses the historic wrongs of the Saints in Missouri and appeals for redress..." (Morgan)

191. Miller, George. *Correspondence of Bishop George Miller.*

Burlington, Wisconsin?, 1916? 50 pp.

Compilation of seven letters Miller contributed to the Strangite paper, the *Northern Islander* in 1855. Miller provides insightful details about the last years of Joseph Smith's administration of the church from his position as a member of the presiding bishop's office.

192. Miller, Reuben. *A Defence of the Claims of James J. Strang to the Authority now Usurped by The Twelve; And Shewing him to be the True Successor of Joseph Smith, as First President of the High Priesthood.* Keokuk, Iowa: author, 1846. 16 pp.

First known pamphlet published in advocacy of Strang's claims. Contains the June 18, 1844 letter of appointment, and a December 25, 1845 "pastoral" letter of James J. Strang, along with an assortment of other items pertinent to the Strangite claims.

193. Nichols, Reuben T. *The Ministerial Labors of Reuben T. Nichols in the Church of Jesus Christ of Latter Day Saints.* np, 1886? 11 pp.

A narrative of Nichols' missionary labors for the church from the time he joined the original church in 1833, through his uniting with Strang, and continuing to the mid-1860s.

194. *Northern Islander.* Saint James, Beaver Island, Lake Michigan: Cooper and Chidester, 1850.

A successor of sorts to the *Gospel Herald* (listed below; originally named the *Voree Herald*), this was the first paper to be published in northern Michigan. Volume 1, number 1 was dated December 12, 1850. The paper served as the official organ of the church until the dispersion after Strang's death in 1856. The final issue of the paper was June 19, 1856.

195. *Northern Islander Extra.* Saint James: Northern Islander, 1853. 1 p. broadside.

Contains an account of an assault upon the Strangites by fishermen. Six men were wounded. The date on the extra is July 14, 1853.

196. *Prospectus of the Independent Inquirer, and Journal of the Times.* Boston: H. L. Southworth, 1846. 1 p.

Dated November 20, 1846. A proposed paper advocating the Strangite position, to be edited by Charles P. Bosson, George J. Adams and H. L. Southworth. No issues were apparently ever printed.

197. Quaife, Milo Milton. *The Kingdom of Saint James.* New Haven, Connecticut: Yale University Press; London: Humphrey Milford, Oxford University Press, 1930. 284 pp.

Scholarly study of James J. Strang, and the church he founded.

198. Riegel, O. W. *Crown of Glory: A Moses of the Mormons.* New Haven: Yale University Press, 1935. 281 pp.

A detailed narrative biography of Strang, focusing on his church leadership and the movement which followed him. The author admits to having "yielded to the temptation to emphasize those traits of character which, in my opinion, reveal the emotional qualities of the man as an American of the middle years of the nineteenth century."

199. Shepard, William. *Loss of the Gospel.* Honey Creek, Wisconsin: Author, nd. 26 pp.

Argues that although the Strangite movement is void of wealth and large membership, it holds the true priesthood. Argues that all other Latter Day Saint churches, except the Strangite movement, have lost this true priesthood and the true gospel. Calls members of churches to heed the prophecies and come to the small church that offers truth.

200. ⸺⸺. *Loss of the Gospel.* Honey Creek, Wisconsin: author, nd. 30 pp.

Differs from item 199. Argues that most churches have changed from teaching the gospel by substituting the teachings of man, thus becoming temporal churches.

201. ⸺⸺. *What Must We Do to be Saved?* Honey Creek, Wisconsin: author, nd. 12 pp.

Argues that although humans are saved by grace, they must also have faith and receive properly and authoritatively administered ordinances of the gospel.

202. —————. *Was Jesus Born God?* Honey Creek, Wisconsin: author, nd. 23 pp.

Argues the Strangite position that the common interpretations of the Bible regarding Christ are in error; that the virgin birth concept is a heresy, and that Christ was elevated to the Messiahship after he demonstrated that He could withstand the sins of this world.

203. —————, Donna Falk, and Thelma Lewis. *James J. Strang: Teachings of a Mormon Prophet.* Burlington, Wisconsin: Church of Jesus Christ of Latter Day Saints (Strangite), 1977. 335 pp.

Compilation of the significant teachings of Strang taken from various sources, including Strang's *Book of the Law of the Lord.*

204. *The Star in the East.* Boston: H. L. Southworth, 1846. 24 pp.

Volume 1, number 1 is dated November, 1846 and proposed a monthly publication in the interests of the Strangite movement. Apparently only two numbers were issued.

205. *Star Over Zion, Prospectus.* Lyons, Wisconsin: Church of Jesus Christ of Latter Day Saints (Strangite), nd (1983), 4 pp.

Proposes a periodical to be published bi-monthly as a vehicle for expounding the beliefs of the church.

206. *Star Over Zion.* Lyons, Wisconsin: Church of Jesus Christ of Latter Day Saints (Strangite), 1983. 4 pp.

Volume 1, number 1 carries a date of February, 1983 but the final number was volume 1, number 3, June, 1983. Contains interesting debates with other Latter Day Saint leaders. Publication apparently ceased when editor David Rees became separated from the church.

207. Strang, James J. *Ancient and Modern Michilimackinac including an account of the controversy between Mackinac and the Mormons.* Saint James: Cooper and Chidester, 1854. 48 pp.

"...surveys the geography and history of Mackinac and the surrounding region, particularly the islands of Lake Michigan,

and after giving an account of the Mormon settlement upon Big Beaver Island, addresses himself to the bitter controversies between the people of Mackinac and the Mormons.'' (Morgan)

208. ——————. *Ancient and Modern Michilimackinac as published in 1854, with Supplement.* St. Ignace, Michigan: The News and Free Press, 1885. 52 pp.

A reprint of the earlier edition, with additional material added telling the story of Strang's assassination and bringing the history to date.

209. ——————. *The Book of the Law of the Lord, consisting of an inspired translation of some of the most important parts of the law given to Moses, and a very few additional commandments, with brief notes and references.* Saint James: Printed by command of the King at the Royal Press, A. R. I. 1851. 80 pp.

The first book ''published after the establishment of the press on Beaver Island, and its odd dating, which apparently means Anno Regio I (in the First Year of the King) reflects the circumstance that Strang's followers had crowned him a 'king in Zion' ...on July 8, 1850.'' Strang claimed to have been shown a collection of ancient records by an angel from which this book was translated. These records were purported to be copies of those which had been anciently kept in the ark of the covenant.

210. ——————. *The Book of the Law of the Lord.* Saint James: Church, 1856. 336 pp.

This second edition of no. 209 is greatly enlarged and contains detailed explanations of the complex doctrinal and church leadership system established by Strang. Three variant issues have been identified by Morgan. ''The principal difference between the expanded *Book of the Law* of 1856 and the original edition of 1851 is the great elaboration of the notes. The chapter which comprises the revelation on 'Baptism for the Dead' is materially altered, and nine chapters, on 'Oaths,' 'Benedictions,' 'Maledictions,' 'Prayer,' 'Thanksgiving,' 'Sacrifice,' 'Monuments,' 'High Priest,' and 'Priesthood' are added.'' (Morgan) This edition was reprinted in 1948, and used by the church until the supply was exhausted.

211. ——————. *Catholic Discussion.* Voree, Wisconsin: Gospel

Herald Print, 1848. 60 pp.

"The material was published originally as a letter from a Catholic layman, Charles Rafferty, dated Wellsville, Ohio, August 30, 1847, and six letters in reply by Strang, *Gospel Herald*, September 23-October 14, October 28-November 25, 1847. To this was added an appendix in which Strang discusses a question at issue between John Gaylord and himself, relative to the lineage of Christ....Strang's followers have always regarded this discussion as putting 'a full end' to the Catholic claim to priesthood.'' (Morgan)

212. —————. *Catholic Discussion.* Burlington, Wisconsin?: 1902. 24 pp.

Differs markedly from the 1848 publication. Wingfield Watson apparently reprinted this directly from the columns in the newspaper, rather than the previous edition, deleting the Gaylord material and adding his own comments on the discussion.

213. —————. *The Diamond: Being the Law of Prophetic Succession and a Defense of the Calling of James J. Strang as Successor to Joseph Smith, and A Full Exposition of the Law of God Touching the Succession of Prophets Holding the Presidency of the True Church.* Burlington, Wisconsin: Voree Press, 1950. 19 pp.

Contains the letter of appointment dated June 18, 1844, said to have been written by Joseph Smith designating Strang as prophet, various items written by Strang regarding his claims to leadership, and a commentary by Wingfield Watson on the letter of appointment. Several editions of this booklet have been printed, beginning with the first in 1848.

214. —————. *A Few Historical Facts Concerning the Murderous Assault at Pine River. Also the Life, Ministry, Ancestry and Childhood of James J. Strang.* Lansing, Michigan: Charles J. Strang, 1892. 7 pp.

"This pamphlet consists of a reprint of the *Northern Islander Extra* of July 14, 1853, and a sketch of the 'Ancestry and Childhood of James J. Strang Written by Himself 1855,' the latter certified by Charles J. Strang, Lansing, April 3, 1892.'' (Morgan)

215. —————. *The Prophetic Controversy. A Letter from James J. Strang to Mrs. Corey.* Saint James: Cooper and Chidester,

1856? 44 pp.

"Strang's letter (dated September 26, 1854) to 'Mrs. Corey' (i.e., Mrs. Howard Coray) was first published in the *Islander* in the four issues beginning September 28, 1854....The 'Letter' itself is an eloquent restatement of the grounds on which Strang based his claims to authority, and recounts in considerable detail his efforts to establish his rights to the Succession, with attention to the shifting position taken by the Twelve between 1844 and 1847." (Morgan) The pamphlet has been reprinted numerous times, with only slight variations.

216. —————. *The Revelations of James J. Strang.* np: Published by Direction of Church Conference, 1939. 28 pp.

At least two different editions of the revelations were printed over the years, but this edition is the latest, containing a collection of visions, revelations and testimonies by many of Strang's followers.

217. —————. *Traveling Theatre Royal, Late from Beaver Island. Adams' New Drama. The Famous Original Five Act Drama, "Improving the Household," by Mr. G. J. Adams, Author, Manager and Star Actor.* Saint James: Cooper and Chidester, 1850. 1 p.

A vicious attack on George J. Adams, one-time confidante of Strang. "Attacking Adams at one of his most vulnerable points, his proclivity for the stage, the broadside is made up of five letters dealing with his tangled marital affairs, each constituting one act in this 'famous original five act drama.'" (Morgan)

218. —————. *Warning to All People.* Jefferson County, New York?: Ebenezer Page, 1846. 1 p.

Broadside. Contains Page's letter of appointment as presiding high priest for the Black River District of western New York, as well as four of Strang's revelations.

219. Van Deusen, Increase and Maria Van Deusen. *Positively True. A Dialogue between Adam and Eve, the Lord and the Devil, called the Endowments as was acted by Twelve or Fifteen Thousand, in secret, in the Nauvoo Temple, said to be revealed from God, as a Reward for building that Splendid Edifice, and*

the Express Object for which it was built. Albany, New York: Printed by C. Killmer, 1847. 24 pp.

"The pamphlet describes seven degrees taken by Van Deusen and his wife in the Nauvoo Temple, more factual and less sensational than in later editions, comments on Brigham Young in highly critical vein, and goes on to say, 'The following is designed to show the foundation and claims of the Second Mormon Prophet, now actively engaged in Wisconsin, by the Name of JAMES J. STRANG, a lawyer, formerly of the state of New-York.' There follows an abridgment of Strang's Letter of Appointment from Joseph Smith and 'a Sketch of Joseph Smith's Origin and First Vision,' this latter derived from Orson Pratt's *An Interesting Account of Several Remarkable Visions.*" (Morgan)

220. *Voree Herald.* Voree, Wisconsin: Church, 1846. 4 pp.

Official organ of the Strangite church, first issue volume 1, number 1, dated January 1846. Ten issues were printed under the original name. With the November 1846 issue, the name was changed to *Voree Reveille,* which had been suggested by John C. Bennett. When Bennett was removed from membership by Strang, the name of the paper was changed to the *Gospel Herald,* with the September 23, 1847 issue, volume 2, number 27. The publication continued under this name until it ceased sometime in 1850.

221. Watson, Wingfield. *Baptism. What is It Designed For? How is It Administered? Is It a Saving Ordinance? And is It a Commandment of God?* Burlington, Wisconsin?: Church of Jesus Christ of Latter Day Saints, 1899? 32 pp.

Explains the Strangite beliefs regarding baptism by discussing views on the sacrifice of Christ and authority to act in the name of God. Signed by the author at Spring Prairie, Wisconsin, and dated by him December 26, 1899, this booklet might have been published in 1900.

222. ————. *The Book of Mormon. An Essay on its Claims and Prophecies.* Boyne, Michigan?: Church of Jesus Christ of Latter Day Saints, 1884. 16 pp.

Discusses Watson's belief that the Book of Mormon is scripture.

223. ————. *The Book of Mormon. An Essay on Its Claims and*

Prophecies. Burlington, Wisconsin?: Church of Jesus Christ of Latter Day Saints, 1899? 18 pp.

An enlarged version of no. 221. The article is dated at Spring Prairie, Wisconsin, March 24, 1899.

224. ――――――. *A Friendly Admonition.* Nauvoo, Illinois: Rustler Print, 1913. 7 pp.

Reaffirmation of the author's belief in the Book of Mormon.

225. ――――――. *The "One Mighty and Strong."* Burlington, Wisconsin?: author, 1915. 12 pp.

Disputes arguments that Jesus was the "One Mighty and Strong" who was prophesied to come to set the House of God in order. Argues that this person is, as yet, unidentifiable.

226. ――――――. *An Open Letter to B. H. Roberts, Salt Lake City, Utah.* Spring Prairie, Wisconsin: author, 1894. 18 pp.

"...attacks the claims made for Brigham Young, and tells Roberts that the whole people who went to Utah were rejected, with their dead, when they crossed the Mississippi to follow Brigham Young, 'for God never called them to go there, or to follow any such man or men'; Young and his associates, Watson points out, were tried and found guilty at Voree on April 6, 1846 by a court 'having lawful jurisdiction of the case,' as usurpers, teachers of false doctrine, and men guilty of tyrany, oppression, robbery of the Saints, and other crimes, whereupon their priesthood and membership had been taken from them, and they 'delivered over to the buffetings of Satan.'" (Morgan)

227. ――――――. *An Open Letter to B. H. Roberts, Salt Lake City, Utah.* Burlington, Wisconsin?: author, 1896? 30 pp.

Reprint of number 225, but includes two additional items. First is "A Word to George Q. Cannon," a member of the leadership in Salt Lake City, rebuking him for some unkind comments about George Miller. Second is "A Full History of the letter of appointment written by the Prophet, Joseph Smith, to James J. Strang, and its reception at Burlington, Wisconsin, as kept by the appointed church scribe."

228. ——————. *Latter Day Signs.* Burlington, Wisconsin?: church,
 1897. 15 pp.

 Contains two articles, "Latter Day Signs," pp. 1-10, and "The
 Book of Mormon," pp. 11-15. "...argues that these are indeed
 the last days, that we are living in the generation immediately
 preceding 'the second coming of the Lord Jesus Christ,'..." and the
 second article "...adopts the point of view that harmonious with
 the Bible as the Book of Mormon may be, it has a place of its own
 to fill, because it sets forth the gospel so much more plainly than
 does the New Testament." (Morgan)

229. ——————. *Modern Christianity. A Dialogue between a Baptist
 and an Infidel.* Boyne, Michigan?: author, 1884? 10 pp.

 Watson adds comments to an article originally published in
 1850 in the *Millennial Star*, volume 12, January 1, 1850 written
 by John Hyde. Illustrates the differences between the Latter Day
 Saint religion and that taught by other Christians.

230. ——————. *Necessity of Baptism; and of Having Authority from
 God to Preach the Gospel.* Plano, Illinois: Printed at the Herald
 Steam Book and Job Office, 1877. 8 pp.

 Broad theological argument, from a Strangite viewpoint on the
 topics of the title.

231. ——————. *Prophetic Controversy, No. 2; Extracted from the
 Writings and Criticisms of John E. Page, James J. Strang,
 William Marks and Hyrum P. Brown, to which are added A
 Few Notes in Brackets, and a Short Commentary by the Tran-
 scriber, Wingfield Watson.* Boyne, Michigan?: author, 1887.
 28 pp.

 A series of extracts from the *Gospel Herald* (the early Strangite
 paper) in which the men named uphold Strang's claim to the
 Succession. Watson includes his argument that although Joseph
 Smith and James J. Strang were dead, someone on the earth
 held the prophetic office and would yet appear with evidence of
 his calling.

232. ——————. *Prophetic Controversy, No. 3 or the Even Balances
 by which Isaac Scott, Chancy Loomis, and the Founders of the
 Reorganization are Weighed and Found Wanting.* Bay Springs,

Michigan: author, 1889. 44 pp.

Defends James J. Strang against charges put forth by various members of the Reorganized Church. Two issues are known: one with plain wrappers, and others with an article entitled "Reflections" printed on the inside of the front and back, as well as on the back of the wrapper. Watson argues that the claims made by the RLDS Church against the followers of Brigham Young apply to themselves equally.

233. ——————. *Prophetic Controversy No. 4. Mr. Strang Proved To Have Been Always an Honorable Man. The Theory that the Prophetic Office Goes by Lineal Right, and the Doctrine that Lesser Offices in the Priesthood Can Ordain to the Greater, Utterly Exploded.* Spring Prairie, Wisconsin: author, 1897. 38 pp.

Attacks the RLDS Church and disputes the validity of that organization's claim to the Succession. Also includes a defense of Strang.

234. ——————. *Prophetic Controversy No. 5.* Lyons, Wisconsin: author, 1903. 27 pp.

Defends Strang in regards to plural marriage and disputes the RLDS Church's views on the succession.

235. ——————. *Prophetic Controversy No. 6, or "Facts" for the Anti-Mormons Located at Grayson, Kentucky, Being an Answer to the Following Letter of Inquiry.* Lyons, Wisconsin: author, 1905. 14 pp.

Outlines Strang's claims in response to a letter written to Watson by R. B. Neal of Grayson, Kentucky dated June 3, 1905. Watson comments that Neal, as an anti-Mormon, is attempting to crush the truth, but that the more Mormonism is opposed the more it will prosper.

236. ——————. *Prophetic Controversy No. 7.* Lyons, Wisconsin: author, 1906. 9 pp.

Another letter written to R. B. Neal of Grayson, Kentucky. The discussion deals with the Strangite denial of the claim that "Jesus, the anointed, was without human father."

237. ————. *Prophetic Controversy No. 8.* Burlington, Wisconsin: author, 1907. 7 pp.

Replies to a comment critical of James J. Strang that was made in an article published in the *Liahona*, a mission publication of the Mormon Church, in the July 13, 1907 issue.

238. ————. *Prophetic Controversy No. 9.* Burlington, Wisconsin: author, 1907. 5 pp.

A third letter to R. B. Neal, begun in July and apparently finished in September of 1907. Argues that Mormonism cannot be judged by the behavior of former believers after their apostasy, in specific reference to Oliver Cowdery.

239. ————. *Prophetic Controversy No. 10.* Burlington, Wisconsin?: author, 1908. 10 pp.

An extension of the arguments between Watson and the RLDS Church over the question of Strang's authority. The question of ordination is the focus of this article.

240. ————. *Prophetic Controversy No. 11.* Burlington, Wisconsin?: author, 1908? 4 pp.

"Though labeled 'No. 11,' this is in effect a supplement to No. 10. It must have been printed in rather a small edition, since Watson two years later published another and quite different No. 11." Watson insists that his correspondent, E. W. Nunley, point out "the man who was appointed by revelation through Joseph, who was to be ordained as Joseph." If this was not Strang, who was it?

241. ————. *Prophetic Controversy No. 11.* Burlington, Wisconsin?: author, 1910. 13 pp.

"In an open letter to John R. Haldeman, editor of the Hedrickite *Evening and Morning Star,* Watson ...asks the 'big broad question,' what is going to be done with that temple lot? Isn't it about time 'that it was put to the use intended for it by Revelation in the early thirties—1831?' With the temple unbuilt, the enemy can cry 'failure of prophecy,' inasmuch as it had been prophesied 'that it would be built before all the generation who were on the earth in 1832 would have passed away.' There must be something wrong somewhere, Watson argues, and he finds this error to

consist in the rejection of Strang by the several Latter Day Saint churches. He is critical of what he terms the defective revelations of Granville Hedrick but finds 'no difference between Hedrickites, Reorganized, or Brighamites. They are all apostates.''' (Morgan)

242. ————. *Prophetic Controversy No. 12.* Burlington, Wisconsin?: author, 1912. 20 pp.

An open letter to John R. Haldeman, arguing "against the thesis that the ancient churches of Christ were apostolic in organization, and that the First Presidency over the Church in these latter days was 'a creation of Joseph Smith for his own special benefit and aggrandizement.' Watson also devotes attention to the righteousness and Scriptural warrant for plural marriage, with animadversions upon the contrary views held by the Reorganized Church." (Morgan)

243. ————. *Prophetic Controversy No. 13.* Burlington, Wisconsin?: author, 1918. 14 pp.

"This last of Watson's 'controversies' replies to an attack on Strangism by R. S. Salyards in the *Saints' Herald* (RLDS publication) of June 5, 1918." (Morgan)

244. ————. *The True Gospel. A Comparison of the Primitive, and True Gospel, and the Modern Sectarian Interpretation if (sic) It.* Kansas City, Missouri?: author, 1920? 8 pp.

Argues that most so-called Christian churches are not teaching the gospel but the teachings of man, from which they must repent. All must accept the Book of Mormon if they hope to gain salvation.

245. ———— and W. W. Blair. *The Watson-Blair Debate which took place at East Jordan, Mich., commencing Oct. 22nd and ending Oct. 26th, 1891.* Clifford, Ontario: Printed at the Glad Tidings Office, 1892. 244 pp.

The preface states "The debate was the result of repeated challenges by Mr. Watson to the leading officials of the Reorganized Church, and then to Mr. Blair in particular, to meet him in public discussion of the relative merits of the claims made that James J. Strang on the one hand, and Young Joseph Smith, on the other, was the rightful, lawfully ordained president of the Church of Jesus Christ of Latter Day Saints."

246. West, Stephen. *A Faith to Live By.* Burlington, Wisconsin: Voree Press, 1956. 10 pp.

247. ————. *Prophetic Controversy No. 15.* Burlington, Wisconsin: Voree Press, 1957. 8 pp.

Reuben Miller

One of Strang's first important converts, Miller was also one of the earliest to leave. Upon publication of this pamphlet, Miller turned his back on Strang and later united with Brigham Young's movement.

248. Miller, Reuben. *James J. Strang, Weighed in the Balance of Truth, and Found Wanting. His claims as first President of the Melchisedek Priesthood Refuted.* Burlington, Wisconsin: author, 1846. 26 pp.

"...a long argument against the validity of Strang's claims." (Morgan)

Church of Christ (Voree)

Aaron Smith, James J. Strang's brother-in-law and a member of Strang's First Presidency, led a short-lived split from the group in 1846. He became disenchanted during a dispute involving John C. Bennett, in which Strang sided with Bennett.

249. *The New Era, and Herald of Zion's Watchmen.* Voree, Wisconsin: Church of Christ, 1847. 4 pp.

Two issues, dated January and February, 1847, are all that were published. The first issue contains articles against Strang, and the second issue a treatise on the doctrine of Priesthood.

Church of the Messiah

George J. Adams, one time confidante of Strang, was removed from the church in 1856 on charges of immorality. Adams had been a member of the original church. The Church of the Messiah was organized in January 1861 at Springfield, Massachusetts. The distinctive feature of this movement was their attempt to colonize Palestine in 1866 in order to prepare the way for the return of the Jews. The church failed a short time later, with most members uniting with the RLDS Church. Adams died on May 11, 1880 at Philadelphia.

250. Adams, George J. *Lecture on the Destiny and Mission of America, and the True Origin of the Indians.* Kingston, New York: Romeyn's Power Presses, 1860. 16 pp.

"...declares that the Indians are the descendants of Joseph's youngest son, Ephraim, whose mother was an Egyptian woman of the royal line of Egypt....On p. 14 of the pamphlet Adams abandons the subject of the Indians to expound 'The Author's Faith,' which turns out to be Mormonism with the Mormonism excised." (Morgan)

251. Holmes, Reed M. *The Forerunners.* Independence, Missouri: Herald Publishing House, 1981. 280 pp.

 Narrative biography of Adams and history of his ill-fated attempt at colonizing Palestine. Also provides valuable information regarding the early efforts of the RLDS Church in that land. Includes rare photos.

252. *The Sword of Truth, and Harbinger of Peace.* South Lebanon, Maine: Church of the Messiah, 1862. 8 pp.

 Official organ of the church, issued monthly, with a few lapses in regularity. Continued into 1866. Contains important articles on the unique beliefs of Adams' church.

The Holy Church of Jesus Christ

In 1963 a Frenchman, Alexandre R. Caffiaux, visited Wisconsin in order to learn more of the Strangite movement. In November of that year he was baptized into that church. After his return home, he claimed to have been ordained as a prophet under the hands of the archangel Raphael on January 22, 1964 near Meshah, Iran. Although the main body of the church in the United States initially accepted his calling, when Caffiaux held a conference in France and changed the name of the church, the U. S. body could no longer acknowledge his membership. The present status of this organization is unknown.

253. *The Gospel Informer.* France: The Holy Church of Jesus Christ, 1967. 16 pp.

 Official periodical of the Caffiaux movement. Apparently bilingual. Complete file not located.

254. Johnston, Stanley L. *The Call and Ordination of Alexander Roger Caffiaux.* np: author, 1966. 41 pp.

 Argues the validity of Caffiaux's claim to the prophetic office. Contains important historical information on Caffiaux, and this

period of church history.

True Church of Jesus Christ of Latter Day Saints

David L. Roberts was affiliated with a number of Latter Day Saint movements, the latest of which was the Strangite organization (until 1974). This has been and continues to be a major influence Roberts' theology. He claims he was directed in 1974, in a visitation from the Prophet Elijah, to organize the *True Church of Jesus Christ Restored.* The name was officially changed on May 15, 1981. At the time of publication, this church is headquartered in Columbus, Ohio. Roberts maintains that he is the legal successor of James J. Strang.

255. *Articles of Faith.* Nashport, Ohio: The True Church of Jesus Christ Restored, nd. 1 p.

 Contains 17 points of belief of the church, based on the articles of faith expounded by Joseph Smith, Jr. in the mid-1840s.

256. *Articles of Faith of the True Church of Jesus Christ Restored.* Independence, Missouri: First Presidency, nd. 6 pp.

 Contains a total of 21 points of belief, incorporating the points included in number 252, with some additional remarks.

257. *Articles of Faith.* Independence, Missouri: The True Church of Jesus Christ of Latter Day Saints, nd. 6 pp.

 Essentially the same as number 256, but with 2 additional points of belief. Published in 1981 or later.

258. *Easter.* Independence, Missouri: The True Church of Jesus Christ Restored, nd. 4 pp.

 Condemns the Christian observance of "Easter" as a religious holiday. Argues that it is pagan in its nature and origin.

259. *Missing Scripture.* Independence, Missouri: The True Church of Jesus Christ Restored, nd. 1 p.

 Prints quotations from scripture which mention possible books that belong to the Bible, but are not extant.

260. *Reasons Why We Should Observe the Seventh Day Sabbath.* Belton, Missouri: The True Church of Jesus Christ Restored, nd. 8 pp.

261. *The Resurrection of Christ Not on Sunday.* Independence, Missouri: The True Church of Jesus Christ Restored, nd. 8 pp.

Argues that Christ was crucified on Wednesday and resurrected on Saturday, the Sabbath.

262. Roberts, David L. *All Things Common.* Independence, Missouri: The True Church of Jesus Christ Restored, nd. 21 pp.

Explains the financial laws of the church, based on teachings by Joseph Smith, Jr. and James J. Strang, proposing that members donate all their possessions to the church then receive back that portion they need for their well-being, with the surplus being used to assist the poor. Pamphlet number 15 of the True Doctrine of Christ Restored series (hereafter referred to as "doctrine series)."

263. —————. *The Angel Nephi Appears to David L. Roberts.* Nashport, Ohio: The True Church of Jesus Christ Restored, nd. 8 pp.

Brief autobiography of Roberts, focusing on his testimony regarding the 1967 visitation from Nephi—a prophet in the Book of Mormon. Includes a statement on the 1974 visitation from Elijah, when Roberts was ordained to the prophetic office. Doctrine series number 8.

264. —————. *The Call and Ordination of James J. Strang.* Independence, Missouri: The True Church of Jesus Christ Restored, nd. 12 pp.

Reprints an early Strangite publication including selections from the Doctrine and Covenants regarding the law of succession, a statement rehearsing a brief history of Strang, and a verbatim copy of the letter of appointment of June, 1844, with Strang's comments regarding it. Contains no material written by Roberts himself. Doctrine series number 7A.

265. —————. *Divine Authority.* Nashport, Ohio: The True Church of Jesus Christ Restored, nd. 8 pp.

Argues that a minister must receive specific authority from God in order for the ordinances he performs to be valid. Based on a publication by Charles Penrose of the Mormon Church entitled "Rays of Living Light" published c. 1898. Doctrine series number 5.

266. —————. *The Everlasting Marriage Covenant.* Gallatin, Missouri:
The True Church of Jesus Christ Restored, nd. 12 pp.

Argues that Jesus Christ taught the eternal nature of the marriage
covenant. Prints the text of Mormon Doctrine and Covenants,
section 132, which contains this teaching alleging Joseph Smith,
Jr. as the source. Roberts has modified this "revelation" and
deleted the portions which deal with plural marriage. Doctrine
series number 14.

267. —————. *Faith in Jesus Christ.* Blacklick, Ohio: The True Church
of Jesus Christ Restored, 1974. 6 pp.

Argues that belief and faith are not the same. Based on Penrose.
Doctrine series number 2.

268. —————. *The Falling Away of the True Church of Jesus Christ.*
Nashport, Ohio: The True Church of Jesus Christ Restored,
nd. 7 pp.

Argues that both the Old and New Testaments provide predictions,
proven true, that the church established by Christ would renounce
the true gospel, necessitating a restoration. Doctrine series
number 6.

269. —————. *The Gift of the Holy Spirit.* Blacklick, Ohio: The True
Church of Jesus Christ Restored, 1974. 9 pp.

Argues that the gift of the holy spirit is a sacred ordinance
which gives a person the ability to know God and Christ. Revised
from Penrose. Doctrine series number 4.

270. —————. *God's Holy Feasts.* Independence, Missouri: The True
Church of Jesus Christ Restored, nd. 26 pp.

Argues that the various Jewish feasts were not abolished by
Christ and must be observed by the "true" church bearing his
name. Provides a basis in the scriptures to support the thesis.
However, rather than the methods used by the Jewish faith in
observance, this church performs the sacrament of the Lord's
Supper. Doctrine series number 11.

271. —————. *God's Laws of Health.* Belton, Missouri: The True
Church of Jesus Christ Restored, nd. 12 pp.

Promotes the Jewish health codes, with additional material produced by Joseph Smith, Jr. known as the "Word of Wisdom." Doctrine series number 12.

272. ————. *How to Find True Salvation.* Independence, Missouri: The True Church of Jesus Christ Restored, nd. 16 pp.

Persons must acknowledge their sin, repent, have faith in Christ and be baptized by authority and afterwards receive the gift of the Holy Ghost in order to be saved. Doctrine series number 1A.

273. ————. *The Miracle of The Holy Consubstantiation Communion.* Independence, Missouri: The True Church of Jesus Christ of Latter Day Saints, 1984. 14 pp.

Rehearses the story of the Last Supper, and the initiation of the communion both in the old world, as well as the Book of Mormon world. Argues that the bread and wine are united with the resurrected Christ through the power of the priesthood.

274. ————. *The Nephite Record.* Blacklick, Ohio: The True Church of Jesus Christ Restored, 1974. 8 pp.

Briefly reviews the story of the Book of Mormon. A revision of Penrose. Doctrine series number 1.

275. ————. *The Oracles of God Book.* Independence, Missouri: The True Church of Jesus Christ Restored, nd. 12 pp.

Contains the texts of seven revelations received by Roberts from 1967 to 1981.

276. ————. *Repentance and Baptism for the Remission of Sins.* Blacklick, Ohio: The True Church of Jesus Christ Restored, 1974. 8 pp.

Proclaims the need for sinners to repent and receive baptism from one having proper authority. Revision of Penrose. Doctrine series number 3.

277. ————. *The Restoration of the True Church of Jesus Christ.* Blacklick, Ohio: The True Church of Jesus Christ Restored, 1974. 16 pp.

Rehearses the history of Joseph Smith, basically as contained in the *Pearl of Great Price* of the Mormon Church. Doctrine series number 7.

278. —————. *Salvation for the Dead.* Gallatin, Missouri: The True Church of Jesus Christ Restored, nd. 13 pp.

Argues that Christ taught the gospel to those who had died. Based on Christ's teaching that all must be baptized, Roberts claims that dead persons must be baptized by proxy. Doctrine series number 13.

279. —————. *The Spirit of Prophecy.* Belton, Missouri: The True Church of Jesus Christ Restored, nd. 8 pp.

Argues that revelations continue and that the Bible supports this belief. Doctrine series number 9.

280. —————. *The Ten Commandments Restored.* Kingston, Missouri: The True Church of Jesus Christ of Latter Day Saints, 1984. 10 pp.

Compares the ten commandments as found in the King James Version of the Bible with those found in James J. Strang's *Book of the Law of the Lord.* Doctrine series number 10.

281. —————. *The True Church.* Independence, Missouri: The True Church of Jesus Christ Restored, nd. 20 pp.

Argues that authentic prophets and apostles, as well as the true church were restored through Joseph Smith in 1830, and that Strang was the legal successor of Smith. Roberts and his church are proclaimed as Strang's legal successor. Doctrine series number 1B.

282. Roberts, Denise. *The Sabbath in Early Mormon History.* Independence, Missouri: The True Church of Jesus Christ Restored, nd. 8 pp.

Argues that both Joseph Smith, Jr. and James J. Strang believed the true Sabbath to be Saturday, but in public they practiced the Sabbath on Sunday.

283. ——————. *Where Eve Went Wrong.* Independence, Missouri: The True Church of Jesus Christ of Latter Day Saints, nd. 5 pp.

Argues that Eve erred in not asking the serpent if what it was telling her was true. Thus the whole human race does not want to believe God, and feels that belief in God is not essential to salvation.

284. *Salvation.* Independence, Missouri: The True Church of Jesus Christ Restored, nd. 1 p.

Quotes two Book of Mormon scriptures on the topic, and asks the readers if they have made their decision.

285. Smith, Joseph, Jr. *The Book of Abraham.* Nashport, Ohio: The True Church of Jesus Christ Restored, nd. 16 pp.

A reprint from the *Times and Seasons*, 1842.

286. ——————. *The Book of the Lord's Commandments, volume 2.* Gallatin, Missouri: The True Church of Jesus Christ Restored, nd. 160 pp.

Contains 46 of Smith's revelations, dated from 1831 to 1834.

287. ——————. *The Plain Truth About the Godhead.* Independence, Missouri: The True Church of Jesus Christ of Latter Day Saints, nd. 8 pp.

A reprint of the fifth lecture on faith, originally published in the 1835 edition of the Doctrine and Covenants, in which God is proclaimed to be a personage of spirit.

288. ——————. *The Revelations of Jesus Christ Through His Holy Prophets and Apostles (The Book of the Lord's Commandments, volume 3).* Independence, Missouri: The True Church of Jesus Christ of Latter Day Saints, nd. 148 pp.

Contains 49 of Smith's revelations, from 1835 to 1844, with additional historical comments from the early records of the church.

289. Strang, James J. *The Book of the Law of the Lord.* Independence,

Missouri: The True Church of Jesus Christ Restored, nd. 63 pp.

Republication of the first edition of Strang's translation from metallic plates found in Wisconsin.

290. ————. *Loss of the Priesthood.* Independence, Missouri: The True Church of Jesus Christ of Latter Day Saints, nd. 18 pp.

Catholicism is the victim of the great apostasy as foretold in the scriptures and holds no true priesthood authority. Because of their Catholic parentage, the Protestant churches are equally wrong.

291. ————. *Necessity of a Priesthood.* Independence, Missouri: The True Church of Jesus Christ of Latter Day Saints, nd. 4 pp.

Argues that God gave His laws, and established the priesthood to administer them. No one is able to interpret the scriptures without the priesthood.

292. ————. *Polygamy.* Independence, Missouri: The True Church of Jesus Christ of Latter Day Saints, nd. 12 pp.

Argues that polygamy has existed from the earliest ages as a commandment from God; that the doctrine and its practice can be supported by scripture.

293. ————. *Restoration of the Priesthood.* Independence, Missouri: The True Church of Jesus Christ of Latter Day Saints, nd. 16 pp.

Argues that the scriptures provide ample evidence in prophecy supporting the restoration of the gospel and the true priesthood authority through Joseph Smith, Jr.; that the Book of Mormon was the most extraordinary product of the 19th century and that it would be easy to identify the cities mentioned in the volume—they being the ruins extant in Mexico and Central America.

294. ————. *The Revelations of the Prophet James J. Strang.* Independence, Missouri: The True Church of Jesus Christ of Latter Day Saints, 1982. 36 pp.

Contains 11 revelations issued by Strang. Includes Strang's letter of appointment.

295. ————. *The Sacrifice of Christ.* Kingston, Missouri: The True

Church of Jesus Christ of Latter Day Saints, nd. 12 pp.

Argues that Christ was but a mortal and offered a natural, not a sacredotal, sacrifice.

296. —————. *Voree Plates Translated Thru Urim and Thummim.* Independence, Missouri: The True Church of Jesus Christ Restored, nd. 4 pp.

Contains the text of Strang's September 18, 1845 translation of some metal plates found at Voree (Burlington), Wisconsin.

297. *The Voice of Eternal Life.* Independence, Missouri: The True Church of Jesus Christ Restored, nd. 12 pp.

Official periodical of the church of which only two or three issues appear to have been published.

298. *What is Holy Ghost Fire.* Nashport, Ohio: The True Church of Jesus Christ Restored, nd. 8 pp.

Argues that the physical body, not just the spiritual, can also receive salvation through the baptism of the Holy Ghost.

299. *Why We Should Observe the Seventh-Day Sabbath.* Independence, Missouri: The True Church of Jesus Christ Restored, nd. 8 pp.

Presents scriptures and commentary from different Protestant churches in support of the Saturday Sabbath.

Church of Jesus Christ of Latter Day Saints
John J. Hajicek and others separated themselves from the main body of Strangites sometime in 1981 or 1982 after being convinced that the church was to be an independent association rather than a formal organization.

300. *A True History of the Rise of the Church of Jesus Christ of Latter Day Saints—of the Restoration of the Holy Priesthood and of the Late Discovery of Ancient American Records, collected from the most authentic sources ever published to the world, which unfold the history of this continent from the earliest ages after the flood, to the beginning of the Fifth Century of the Christian Era. With a Sketch of the Faith and Doctrine of the Church of Jesus Christ of Latter Day Saints; also a Brief Outline of their Persecution, and Martyrdom of their prophet, Joseph Smith, and*

the appointment of his successor, James J. Strang. Voree,
Wisconsin: Church of Jesus Christ of Latter Day Saints, 1982.
48 pp.

Reprint of an 1849 Strangite publication. See item number 157.

PART TWO
The Church of Jesus Christ of Latter-day Saints

Although he did not assume the prophetic office until December of 1847, Brigham Young had been leading the church at Nauvoo, Illinois since shortly after the death of Joseph Smith, Jr. Brigham Young's claim to the leadership of the church was based on the assumption that as president of the Quorum of Twelve Apostles, he held the necessary authority to succeed to the presidency of the church. This view is supported by the contents of section 107 of the Mormon *Doctrine and Covenants* (RLDS 104).

By far the largest of all the Latter Day Saint churches, the Mormon Church, as it is commonly known, seems also the least tolerant of divergent opinion. More than 80 different movements trace their roots to the Mormon Church.

301. *After Baptism, What?* Salt Lake City: The Church of Jesus Christ of Latter-day Saints, 1971. 22 pp.

Argues that persons must make plans to become active in church after they have been baptized. Enumerates specific items of practice of the church, such as tithing, the word of wisdom, fasting, profanity, morality, temple work.

302. Alexander, Thomas G. *Mormonism in Transition: A History of the Latter-day Saints, 1890-1930.* Urbana/Chicago: University of Illinois Press, 1986. 393 pp.

Chronicles the church's transformation from a small, rural organization to a dynamic 20th century movement. Considers church administration, the role of women, cultural attitudes, missionary work, doctrinal development, and religious practices (including polygamy). Based on the correspondence of the first presidency and diaries of important church leaders. Originally intended as one volume of the sesquicentennial history series.

303. ————, editor. *The Mormon People: Their Character and Traditions.* Provo, Utah: Brigham Young University Press, 1980. 135 pp.

Collection of essays illustrating various facets of the Mormon people: literature, polygamy, children's organizations, temples.

304. ————— and James B. Allen. *Mormons and Gentiles: A History of Salt Lake City.* Boulder, Colorado: Pruett Publishing Company, 1984. 360 pp.

General history of Salt Lake City, volume 5 of Pruett's Western Urban History Series, chronicles the development of what has become both a religious capital and a significant regional center.

305. Allen, James B. and Glen M. Leonard. *The Story of the Latter-day Saints.* Salt Lake City: Deseret Book Company, 1976. 733 pp.

First major scholarly one volume history of the Mormon church —done from a perspective of excellent scholarship as well as sympathetic faith. Although church leaders "allowed" this book to go out of print after only one printing, it was permitted to be reprinted with no changes in 1986.

306. Allred, Gordon. *God the Father.* Salt Lake City: Deseret Book Company, 1979. 325 pp.

Compilation, from original sources, of clear and authoritative statements made by prominent church leaders regarding the nature and personality of God. Presents the Mormon view that God is the literal father of the spirits of the human race.

307. Anderson, Richard Lloyd. *Understanding Paul.* Salt Lake City: Deseret Book Company, 1983. 463 pp.

Commentary and explanation, from a Mormon theological perspective, of Paul's life and the letters ascribed to him as recorded in the New Testament.

308. Andrus, Hyrum L. *Doctrines of the Kingdom.* Salt Lake City: Bookcraft, 1973. 597 pp.

Sets forth the Mormon understanding of the principles of the law of consecration, stewardship, the City of Zion, and God's government. Mainly a historical treatment of Joseph Smith's teachings on the topics considered, the author relates them to the imminent second coming of Christ. Volume 3 in the "Foundations of the Millennial Kingdom of Christ" series.

309. —————. *God, Man and the Universe.* Salt Lake City: Bookcraft, 1968. 530 pp.

Explains and analyzes Joseph Smith's teachings about God, the role of Christ, the creation and the nature of man. Volume 1 in the "Foundations" series.

310. ————. *Principles of Perfection*. Salt Lake City: Bookcraft, 1970. 548 pp.

Explains Mormon beliefs on justification, sanctification, the patriarchal order, the role and mission of the second comforter. Based on Joseph Smith's teachings. Volume 2 in the "Foundations" series.

311. Arrington, Leonard J. *Brigham Young: American Moses*. New York: Alfred A. Knopf, 1985. 539 pp.

Drawing on documents, diaries and letters never before available, the author provides a well-balanced biography of Brigham Young. Readable, extensively documented.

312. ————. *Charles C. Rich: Mormon General and Western Frontiersman*. Provo, Utah: Brigham Young University Press, 1974. 403 pp.

Based on original documents in the Mormon Church archives, the author provides a detailed biography of this little known, but important leader.

313. ————. *From Quaker to Latter-day Saint: Bishop Edwin D. Woolley*. Salt Lake City: Deseret Book Company, 1976. 592 pp.

Expertly written chronicle of this important, but little known Mormon leader.

314. ————. *Great Basin Kingdom*. Lincoln, Nebraska: University of Nebraska Press, 1966. 300 pp.

An economic history of the Mormon church from 1830-1900. Focuses mainly on the developments in Utah and surrounding areas under Brigham Young's leadership, with later developments.

315. ————, editor. *The Presidents of the Church*. Salt Lake City: Deseret Book Company, 1986. 468 pp.

Eleven prominent Mormon historians present biographical essays

on the thirteen men who have led the Mormon church from 1830 to 1986.

316. ———————— and Davis Bitton. *The Mormon Experience.* New York: Alfred A. Knopf, Inc., 1979. 404 pp.

Expertly written one-volume history of the Mormon church. Intended audience is the general reader, rather than the faithful convert. Covers the founding of the church to the present. This volume is based on current historical research and documents. Both authors served as official church historians in the 1970s.

317. ———————— and ————————. *Saints Without Halos.* Salt Lake City: Signature Books, 1981. 166 pp.

Treatment of the human side of Mormon history, rather than the institutional. Based on the diaries and journals of seventeen ordinary early church members.

318. ————————, Feramorz Y. Fox, and Dean L. May. *Building the City of God.* Salt Lake City: Deseret Book Company, 1976. 497 pp.

Traces the development of Mormon communitarianism and cooperative experiments from 1831 to present welfare programs promoted by the Mormon church.

319. Bailey, Jack S. *Genuine Mormons Don't Shoot Seagulls.* Bountiful, Utah: Horizon Publishers, 1984. 106 pp.

Collection of current Mormon humor.

320. Bailey, Paul. *The Armies of God.* Garden City, New York: Doubleday and Company, 1968. 300 pp.

321. *Baptism, How and by whom administered?* Salt Lake City: The Church of Jesus Christ of Latter-day Saints, 1973. 5 pp.

Argues that in order for baptism to be valid it must be administered by immersion, and only by a properly ordained Mormon minister.

322. Barber, Ian. *What Mormonism Isn't.* Auckland, New Zealand: Pioneer Books, 1981. 60 pp.

Rebuttal to the works of noted anti-Mormons Jerald and Sandra Tanner. Several Mormons in New Zealand had obtained the Tanner's material and as a result left the Mormon Church. Argues that the Tanners use faulty methods in presenting their case.

323. Barker, James. *Apostasy from the Divine Church.* Salt Lake City: Bookcraft, Inc., 1984. 813 pp.

Exhaustive analysis of the Mormon claim to being the only true church. Argues that all other churches do not have the full gospel due to apostasy that occurred after Christ's apostles' deaths. First printing by the author in 1960. This edition is a reprint.

*. Barrett, Ivan J. *Joseph Smith and the Restoration.* Cited above as item 29.

324. Bennion, Samuel O. *Faith in the Lord Jesus Christ.* Salt Lake City: The Church of Jesus Christ of Latter-day Saints, 1971. 14 pp.

Presents the Mormon belief that faith is a saving principle, and that salvation comes only through Jesus Christ. Many different printings, earlier than this citation, are also extant.

325. Bergera, Gary James and Ronald Priddis. *Brigham Young University: A House of Faith.* Salt Lake City: Signature Books, 1985. 526 pp.

Controversial history of the Mormon church university located in Provo, Utah. The book focuses on the struggle the church has encountered in its attempts to blend academics and faith, and in trying to reconcile church standards with norms at other American universities. A thematic approach, rather than chronological. Extensively documented.

326. Berrett, LaMar C. *Discovering the World of the Bible.* Provo, Utah: Young House/Brigham Young University Press, 1973. 720 pp.

Encyclopedic handbook of middle eastern nations, focusing on Israel.

327. Berrett, William E. *The Latter-day Saints: A Contemporary History of the Church of Jesus Christ.* Salt Lake City: Deseret Book Company, 1985. 431 pp.

Scantily documented, one-sided history of the Mormon church.

Promotes the concept that faith, not fact, is the key issue in considering the history of the church.

328. Billeter, Julius C. *The Temple of Promise*. Independence, Missouri: Zion's Printing and Publishing Company, 1946. 155 pp.

Briefly reviews, from a Mormon perspective, the history of the Latter Day Saint movement in Independence, Missouri, with a focus on the temple that was projected as early as 1831. Considers the attempt by the Church of Christ (Temple Lot) to build a temple in the late 1920s.

329. Bitton, Davis. *Guide to Mormon Diaries and Autobiographies*. Provo, Utah: Brigham Young University Press, 1977. 416 pp.

Cites more than 2800 items located in a number of major institutions as of 1973.

330. Bluth, John V. *Concordance to the Docrine and Covenants*. Salt Lake City, Deseret Book Company, 1945. 501 pp.

Organized before the advent of computers, this volume indexes every major word of the Mormon edition of the Doctrine and Covenants.

331. *Book of Mormon Critical Text*. Provo, Utah: Foundation for Ancient Research and Mormon Studies, 1984. 319 pp.

Utilizes the various extant manuscripts, as well as 16 different printings of the Book of Mormon, including editions by the RLDS Church. First volume covers 1 Nephi through the Words of Mormon.

332. *Book of Mormon Critical Text, Volume 2*. Provo, Utah: Foundation for Ancient Research and Mormon Studies, 1986. 527 pp.

Pages numbered 301-828. Covers Mosiah through Alma.

333. Bringhurst, Newell G. *Brigham Young and the Expanding American Frontier*. Boston/Toronto: Little, Brown and Company, 1986. 246 pp.

Focuses on Brigham Young's leadership skills and his accompanying successes as well as his failures. This volume is part of the

publisher's "Library of American Biography Series."

334. Britsch, R. Lanier. *Unto the Islands of the Sea.* Salt Lake City: Deseret Book Company, 1986. 600 pp.

One of the sesquicentennial history series, this volume details the history of the Mormon Church in the South Pacific. Extensively documented.

335. Brockbank, Bernard P. *Commandments and Promises of God.* Salt Lake City: Deseret Book Company, 1983. 691 pp.

Encyclopedia of over 4300 entries from Mormon scriptures, divided into 120 topics, explaining what is required of Mormons and enumerating the various commandments they are required to keep.

336. Brooks, Juanita. *Jacob Hamblin: Mormon Apostle to the Indians.* Salt Lake City/Chicago: Westwater Press, 1980. 136 pp.

Narrative biography of this early Mormon leader from his entry into Utah until his death in 1886. Hamblin figured prominently in the early Mormon missionary efforts among the native Americans in southern Utah.

337. ————. *John D. Lee: Zealot, Pioneer Builder, Scapegoat.* Glendale, California: Arthur H. Clark Company, 1972. 404 pp.

Traces the life of the man who was blamed for the Mountain Meadows Massacre. Important for its material discussing various Mormon practices: the council of fifty, the Mormon reformation, the law of adoption, marriage customs, healings, relations with the Indians and life and customs in early Utah. First edition in 1961, this edition is corrected.

338. ————. *The Mountain Meadows Massacre.* Norman, Oklahoma: University of Oklahoma Press, 1962. 341 pp.

Traces the background, the emotional climate and the military and social organization in Utah at the time of the massacre: September 7, 1857. Some 120 California-bound emigrants were killed. First edition published in 1950 at Stanford University. This is a revised, updated edition.

339. Brough, R. Clayton. *The Lost Tribes.* Bountiful, Utah: Horizon Publishers, 1979. 117 pp.

Defines and clarifies several theories among the Mormon church members and leaders regarding the whereabouts of the ten lost tribes of Israel, and their prophesied future.

340. ————. *They Who Tarry: The Doctrine of Translated Beings.* Bountiful, Utah: Horizon Publishers, 1976. 97 pp.

Argues that certain individuals since the time of Adam have been permitted by God to become "translated": or changed into resurrected beings without having first died. Presents Mormon beliefs regarding this doctrine, as well as discussions of various persons believed to have been translated.

341. ———— and Thomas W. Grassley. *Understanding Patriarchal Blessings.* Bountiful, Utah: Horizon Publishers, 1984. 81 pp.

Explains the Mormon beliefs regarding the office of a patriarch, and the attendant blessings given to faithful church members by the patriarchs. Argues that Mormon patriarchs are able to discern possibilities for the future of a particular member, as well as determine which tribe of Israel a particular member belongs to. Mormons believe that all church members belong to one of the 12 tribes of Israel, either by direct lineage or by adoption.

342. Brown, Hugh B. *The LDS Concept of Marriage.* Salt Lake City: The Church of Jesus Christ of Latter-day Saints, 1972. 12 pp.

Argues that without marriage in a Mormon temple persons cannot achieve a Godlike stature. Explains that unmarried persons are not whole persons and cannot have a fulness of joy.

343. Brown, Robert L. and Rosemary Brown. *They Lie in Wait to Deceive, Volume 1.* Mesa, Arizona: Brownsworth Publishing Company, 1982. 290 pp.

Attempts to expose what the authors perceive as untruths and deliberate misrepresentations by "anti-Mormons." This volume presents material about one Dee Jay Nelson who was representing himself as a highly educated Egyptologist and lecturing against Joseph Smith. The authors have documented that Nelson's degrees

werc purchased from a mail order house. This book and the succeeding volume are important in showing how many Mormons deal with problems in their history and theology. Nowhere do the authors discuss the questions raised by Nelson, regardless of his lack of credentials. The main issue—the truthfulness of the "Book of Abraham"—is still unanswered.

344. ———— and ————. *They Lie in Wait to Deceive, Volume 2*. Mesa, Arizona: Brownsworth Publishing Company, 1984. 464 pp.

Discusses new questions raised by Walter Martin, Wayne Cowdery, Howard Davis and Donald Scales, regarding the Spaulding manuscript theory of the Book of Mormon. Rather than answer the questions, though, the authors cast aspersions on the integrity of the men under examination.

345. Bunker, Gary L. and Davis Bitton. *The Mormon Graphic Image, 1834-1914*. Salt Lake City: University of Utah Press, 1983. 154 pp.

A history of the national image of Mormonism as seen through the cartoons, caricatures and illustrations from national magazines and newspapers.

346. Burton, Alma P. *Discourses of the Prophet Joseph Smith*. Salt Lake City: Deseret Book Company, 1965. 288 pp.

Compilation of doctrinal statements from numerous sources, as proclaimed by Joseph Smith, on more than 20 different topics. This is the third edition, revised and enlarged.

347. ————. *Toward the New Jerusalem*. Salt Lake City: Deseret Book Company, 1985. 171 pp.

Explains the history of Mormon thought regarding the building of the prophesied New Jerusalem in Jackson County, Missouri. Argues that the Mormon church will do this, and will gather to that place under the direction of their first presidency in order to meet Christ at His Second Coming.

348. Burton, Richard F. *The City of the Saints*. New York: Harper and Brothers, Publishers, 1862. 574 pp.

Presents an early outsider's view of the Mormon capital at Salt Lake City, along with his observations regarding unique Mormon beliefs and practices. Burton was a well-known traveler and writer.

349. Bush, Lester E., Jr. and Armand L. Mauss. *Neither White nor Black*. Midvale, Utah: Signature Books, 1984. 249 pp.

Collection of articles by Mormon scholars tracing the history of the race issue in the church.

350. Cannon, Donald Q. and David J. Whittaker, editors. *Supporting Saints: Life Stories of Nineteenth-Century Mormons*. Provo, Utah: Religious Studies Center, Brigham Young University, 1985. 429 pp.

Biographies of thirteen little-known Mormon personalities.

351. Card, Orson Scott. *Saintspeak: The Mormon Dictionary*. Salt Lake City: Orion Books, 1981. 64 pp.

Tongue-in-cheek definitions of uniquely Mormon vocabulary. Offers insights into Mormon culture.

352. Cheesman, Paul R. *The Keystone of Mormonism*. Salt Lake City: Deseret Book Company, 1973. 176 pp.

Proclaiming the Book of Mormon a great historical work, this volume provides a detailed and well-documented history of the coming forth of that book, and the work of Joseph Smith, Jr.

353. —————. *These Early Americans*. Salt Lake City: Deseret Book Company, 1974. 298 pp.

Correlates the Book of Mormon story to archaeological discoveries in Central and South America.

354. —————. *The World of the Book of Mormon*. Bountiful, Utah: Horizon Publishers, 1984. 219 pp.

Provides details from archaeological research about the peoples inhabiting the Americas during the time period of the Book of Mormon, and correlates details from that book with scholarly discoveries. Although not mentioned in this edition, the work is actually a revised edition of an earlier volume of the same title

title published by Deseret Book Company in 1978.

355. —————— and C. Wilfred Griggs, editors. *Scriptures for the Modern World.* Provo, Utah: Religious Studies Center, Brigham Young University, 1984. 160 pp.

Contains eight lectures discussing recent academic analyses of records that evidence the gospel, both in its antiquity and restoration, according to Mormon belief.

356. Clark, J. Reuben, Jr. *Why The King James Version.* Salt Lake City: Deseret Book Company, 1979. 475 pp.

Argues that with the exception of Joseph Smith's Inspired Version of the Bible, the King James Version most accurately renders the original texts into the English language. This is a second edition, the first having been published in 1956.

357. Clark, James R., compiler. *Messages of the First Presidency,* in six volumes. Salt Lake City: Bookcraft, Inc., 1965-1975. 2297 pp.

Reproduces verbatim official documents issued by the leading quorum of the Mormon church between the years 1833 and 1951. Early volumes contain a number of non-canonized revelations; later volumes contain official announcements or clarification of policy and procedure.

358. Collier, Fred C., editor. *Unpublished Revelations, Volume 1.* Salt Lake City: Collier's Publishing Company, 1979. 174 pp.

Contains 90 non-canonized revelations issued by Joseph Smith, Jr. as well as several other persons in the Mormon church, such as John Taylor and Wilford Woodruff.

359. ——————. *Unpublished Revelations, Volume 1.* Salt Lake City: Collier's Publishing Company, 1981. 206 pp.

This second edition of item 358 contains additional appendices, as well as minor corrections.

360. Cook, Lyndon W. *The Revelations of the Prophet Joseph Smith.* Provo, Utah: Seventy's Mission Bookstore, 1981. 399 pp.

Investigates the historical settings of the revelations issued by

Joseph Smith, as contained in the *Doctrine and Covenants*. Commentary on their background and implications, as well as people mentioned in them is included.

361. —————— and Donald Q. Cannon. *The Exodus and Beyond.* Salt Lake City: Hawkes Publishing, Inc., 1980. 264 pp.

Fourteen noted Mormon scholars present essays on important themes of church history from Nauvoo to the present.

362. Cook, M. Garfield. *Everlasting Burnings.* Salt Lake City: Phoenix Publishing, Inc., 1981. 147 pp.

Describes the Mormon theology of the creation and eternal existence of man from a scientific basis.

363. Corbett, Pearson H. *Jacob Hamblin, Peacemaker.* Salt Lake City: Deseret Book Company, 1952. 538 pp.

Detailed and extensively documented biography of one of the most important early leaders in Utah's southwestern region.

364. Cooley, Everett L., editor. *Diary of Brigham Young, 1857.* Salt Lake City: Tanner Trust Fund, University of Utah Library, 1980. 105 pp.

This transcript of Young's diary provides his personal insights into the events taking place in Utah during what has become known as the "Utah War."

365. Cornwall, J. Spencer. *Stories of Our Mormon Hymns.* Salt Lake City: Deseret Book Company, 1963. 328 pp.

Presents historical background for 340 of the hymns contained in the Mormon hymnbook of 1948 (in use until 1985). This printing is the fourth, enlarged edition. Cornwall was conductor of the Mormon Tabernacle Choir from 1935 to 1957.

366. Covey, Stephen R. *The Divine Center.* Salt Lake City: Bookcraft, 1982. 318 pp.

Explains the purpose of centering one's life on Christ. Provides the theological basis as well as a step-by-step guide for accomplishing this goal.

367. Cowan, Richard O. *The Church in the Twentieth Century.* Salt Lake City: Bookcraft, Inc., 1985. 480 pp.

History of the Mormon church from 1900 to 1985, chronicling the administrations of eight church presidents, and the tremendous growth of the church during their years in office. Originally intended as a volume in the sesquicentennial history series.

368. —————. *The Doctrine and Covenants: Our Modern Scripture.* Salt Lake City: Bookcraft, Inc., 1984. 227 pp.

Concise commentary on the 138 sections of the *Doctrine and Covenants*, Mormon church edition. Explains Mormon beliefs, as well as exploring the historical backgrounds of the revelations. This is a revised and enlarged edition of a 1978 book of the same title issued by Brigham Young University Press.

369. Cowdery, Wayne L., Howard A. Davis, and Donald R. Scales. *Who Really Wrote the Book of Mormon?* Santa Ana, California: Vision House Publishers, 1980. 257 pp.

Based on handwriting and historical analysis, argues that Solomon Spaulding, a New England novelist in a theory prevalent before the turn of the century, was plagiarized by Joseph Smith and others in fabricating what is known today as the *Book of Mormon.*

370. Cracroft, Richard H. and Neal E. Lambert. *A Believing People.* Provo, Utah: Brigham Young University Press, 1974. 338 pp.

Anthology of Mormon literature from the earliest years of the movement to modern times. Includes representative selections of biography, letters, journals, essays, poetry, fiction and novels, from dozens of Mormon writers.

371. Crowther, Duane S. *Doctrinal Dimensions: New Perspectives on Gospel Principles.* Bountiful, Utah: Horizon Publishers, 1986. 322 pp.

Defends Mormon beliefs in the light of "anti-Mormon" criticisms. Contains nine chapters, expounding beliefs on salvation, the Book of Mormon, the restoration of the church, and others. One chapter argues that "anti-Mormons" deliberately use deceptive techniques in their writing.

372. ————. *Gifts of the Spirit.* Salt Lake City: Bookcraft, 1965. 363 pp.

Describes the Mormon belief regarding the manner in which the Holy Ghost functions among members of the church; explains the nature of revelation in Mormon theology.

373. ———— ——. *Life Everlasting.* Salt Lake City: Bookcraft, 1967. 418 pp.

Detailed examination of man's future life from the time of death until entry into the heavenly kingdom. Argues that many persons have come back from the dead to reveal details about the afterlife.

374. ————. *The Prophecies of Joseph Smith.* Salt Lake City: Bookcraft, 1963. 413 pp.

Argues that hundreds of prophecies made by Joseph Smith have been fulfilled, thus evidencing that Smith was indeed a true prophet.

375. ————. *Prophecy: Key to the Future.* Salt Lake City: Bookcraft, 1962. 355 pp.

Describes in modern terms the events of the "last days" as proclaimed in ancient scripture. Argues that only members of the Mormon church will be spared from suffering and destruction during the "third world war."

376. ————. *Prophetic Warnings to Modern America.* Bountiful, Utah: Horizon Publishers, 1977. 415 pp.

Declares that America will not escape God's wrath unless it repents and accepts the Mormon gospel. Examines many social problems in present-day America and relates them to scriptural prophecy.

377. ————. *Thus Saith the Lord: The Role of Prophets and Revelation in the Kingdom of God.* Bountiful, Utah: Horizon Publishers, 1980. 340 pp.

Argues that the prophet of the church does not always speak for God; that there are special ways of discerning the characteristics of true prophecy. Mormon church leaders forced this book

out of print because it appeared to question their authority.

378. Decker, J. Edward. *To Moroni With Love.* Seattle, Washington: Life Messengers, nd. 48 pp.

Briefly points out the author's opinion of several falsehoods in the Mormon church's theology. A former Mormon high priest, Decker invites fellow Mormons to come to Christ, by renouncing their faith in Mormonism..

379. —————— and Dave Hunt. *The God Makers.* Eugene, Oregon: Harvest House, 1984. 272 pp.

Argues that the Mormon church believes entirely different principles than what is publicly known. This is one of the major "anti-Mormon" works in recent years. Elaborates on and extensively documents most of the major teachings of Mormonism.

380. Divett, Robert T. *Medicine and the Mormons.* Bountiful, Utah: Horizon Publishers, 1981. 222 pp.

Chronicles the history of health care among the Mormons from the 1830s to the present day.

381. Doxey, Roy M. *Latter-day Prophets and the Doctrine and Covenants,* in four volumes. Salt Lake City: Deseret Book Company, 1978. 1941 pp.

Compiled from discourses, writings and sermons by prominent Mormon church leaders, the author constructs a unique and extremely detailed commentary on this important book of Mormon scripture.

382. ——————. *Prophecies and Prophetic Promises from the Doctrine and Covenants.* Salt Lake City: Deseret Book Company, 1969. 362 pp.

105 different prophecies and promises given to Joseph Smith are categorized into 50 different subject areas.

383. ——————. *Tithing: The Lord's Law.* Salt Lake City: Deseret Book Company, 1976. 110 pp.

Explains the theological basis for the Mormon practice of contri-

buting 10% of one's total income to the church.

384. Durham, Reed C. and Steven H. Heath. *Succession in the Church.*
Salt Lake City: Bookcraft, 1970. 207 pp.

Explains the Mormon practice of choosing the next president of
the body from the Twelve Apostles. Argues that the practice of
choosing the president of the twelve as the next prophet is divinely
appointed.

385. Dyer, Alvin R. *The Fallacy.* Salt Lake City: Deseret Book Company,
1964. 153 pp.

Argues that the Reorganized Church of Jesus Christ of Latter
Day Saints has misunderstood the 'truth'' and is in error—the
Mormon church being the "true" church.

386. ————. *The Refiner's Fire.* Salt Lake City: Deseret Book
Company, 1972. 344 pp.

Proclaims the Mormon belief that Jackson County, Missouri
is the place designated by God for the New Jerusalem to which
Christ will return at His Second Coming. Rehearses the history
of the Mormons in that place, as well as analyzing their beliefs
regarding the future. The first edition was issued in 1960. This
is a revised, third edition.

387. ————. *Who Am I?* Salt Lake City: Deseret Book Company,
1966. 618 pp.

Expounds Mormon beliefs on the purpose of life, the concept
of a pre-earth life, priesthood, creation, the atonement of Christ
and attendant salvation, and life after death. Argues that Adam was
the archangel Michael in pre-earth life; that man can become as
God; and that by performing ordinances on behalf of the deceased
they, too, may receive salvation.

388. England, Breck. *The Life and Thought of Orson Pratt.* Salt Lake
City: University of Utah Press, 1985. 370 pp.

Major biography of Pratt, an early apostle, who was a key
theologian and scholar during the time of Brigham Young. Pratt
was the first to publicly announce the practice of polygamy.
Extensive documentation from journals and letters.

389. England, Eugene. *Brother Brigham.* Salt Lake City: Bookcraft, Inc., 1980. 265 pp.

 Narrative biography of Brigham Young, utilizing source documents not previously available.

390. *The Ensign of The Church of Jesus Christ of Latter-day Saints.* Salt Lake City: The Church of Jesus Christ of Latter-day Saints, 1971. 96 pp.

 Volume 1, Number 1 issued January 1971. Continues monthly as the official magazine of the church.

391. *Exponent II.* Arlington, Massachussetts: Mormon Sisters, Inc., 1974. 8 pp.

 Independent quarterly publication, volume 1, number 1 issued July 1974, advocating and concerned with Mormon women's issues. Continues to present.

392. *Follow the Leader!* Concord, California: Pacific Publishing Company, 1981. 16 pp.

 Argues that Mormons obey their leaders without thinking. Presents Ezra Taft Benson's February 26, 1980 speech at Brigham Young University "Fourteen Fundamentals of Following the Prophets" as evidence.

393. Fox, Frank W. *J. Reuben Clark: The Public Years.* Provo, Utah/ Salt Lake City: Brigham Young University Press/Deseret Book Company, 1980. 720 pp.

 Clark, a long-time member of the first presidency of the Mormon Church, was prominent in the U.S. State Department before entering church service. This detailed biography chronicles his life from 1903 to 1933.

394. Freeman, Joseph. *In the Lord's Due Time.* Salt Lake City: Bookcraft, 1979. 116 pp.

 Autobiography of the first black Mormon to receive the priesthood in 1978 after the church announced it would have an open policy. Freeman shares his struggles with this church policy.

395. Gibbons, Francis M. *Brigham Young: Modern Moses, Prophet of God.* Salt Lake City: Deseret Book Company, 1981. 286 pp.

Argues that Brigham Young was the greatest colonizer of all time, and compares him to Moses. This biography chronicles Young's entire life.

396. ————. *David O. McKay: Apostle to the World, Prophet of God.* Salt Lake City: Deseret Book Company, 1986. 454 pp.

Detailed biography of the ninth president of the Mormon Church. McKay was one of the first Mormon leaders to travel extensively throughout the world.

397. ————. *Heber J. Grant: Man of Steel, Prophet of God.* Salt Lake City: Deseret Book Company, 1979. 252 pp.

Grant, seventh president of the Mormon church, played an important role in the development of the church from a small, rural sect to a worldwide organization.

398. ————. *John Taylor: Mormon Philosopher, Prophet of God.* Salt Lake City: Deseret Book Company, 1985. 311 pp.

The third president of the Mormon church, Taylor was with Joseph Smith at Carthage, Illinois, when Smith was assassinated. Although seriously wounded, he survived to become an astute theologian. Taylor ran the church from hiding in the 1880s during the time when federal officials were jailing Mormon leaders on charges relating to polygamy.

399. ————. *Joseph F. Smith: Patriarch and Preacher, Prophet of God.* Salt Lake City: Deseret Book Company, 1984. 351 pp.

Smith was a son of Hyrum Smith, brother of Joseph, and served as the Mormon church's sixth president. He went on his first mission for the church at age fifteen.

400. ————. *Lorenzo Snow: Spiritual Giant, Prophet of God.* Salt Lake City: Deseret Book Company, 1982. 255 pp.

Snow is best remembered for his renewed emphasis on the church's practice of tithing, which is credited for saving the church from financial ruin in the late 1890s.

401. Gileadi, Avraham. *The Apocalyptic Book of Isaiah.* Provo, Utah: Hebraeus Press, 1982. 207 pp.

Claims to be an accurate translation of the book of Isaiah, with commentary by this Jewish convert to Mormonism. Of particular note is his rendering of Isaiah 2:1-3, which many Mormons have used to support their belief that Salt Lake City was foreseen by Isaiah. The King James Version, at the critical point reads: "...in the last days, that the mountain of the Lord's house shall be established in the top of the mountains..." Gileadi's translation reads: "In the latter days the mountain of the Lord's house shall become established as the head of the mountains..."

402. Godfrey, Kenneth W., Audrey M. Godfrey, Jill Mulvay Derr. *Women's Voices: An Untold History of The Latter-day Saints, 1830-1900.* Salt Lake City: Deseret Book Company, 1982. 456 pp.

A chronicle of church history taken from the writings and other documents of twenty-five first generation Mormon women. Provides insights not available in traditional institutional histories.

403. *Gospel Principles.* Salt Lake City: The Church of Jesus Christ of Latter-day Saints, 1979. 362 pp.

Basic handbook of church beliefs and practices. First edition in 1978. This is a revised version.

404. Gottlieb, Robert and Peter Wiley. *America's Saints: The Rise of Mormon Power.* New York: G. P. Putnam's Sons, 1984. 278 pp.

Chronicles the Mormon church's rapid rise to national prominence since World War II. Includes a detailed examination of church wealth, finances and influence in the government.

405. Graffam, Merle H., editor. *Salt Lake School of the Prophets Minute Book 1883.* Palm Desert, California: ULC Press, 1981. 80 pp.

Transcript of the minutes of this unique Mormon ministerial education program.

406. Hackney, W. Gordon. *That Adam-God Doctrine.* Salt Lake City: author, nd. 22 pp.

407. Hafen, LeRoy R. and Ann W. Hafen. *Handcarts to Zion.* Glendale, California: Arthur H. Clark Company, 1960. 328 pp.

A history of the ten groups of pioneers, from 1856-1860, who traveled from Iowa to Utah by handcart. Utilizes contemporary journals, accounts, reports and official rosters of the companies.

408. Hamson, Robert L. *The Signature of God.* Solana Beach, California: Sandpiper Press, 1982. 111 pp.

Contends that Christ is indeed the author of the documents appearing in the *Doctrine and Covenants.* Utilizing computer word prints, the author compares the New Testament records of Christ's words with those in the revelations.

409. *Handbook of the Restoration.* Independence, Missouri: Zion's Printing and Publishing Company, 1944. 720 pp.

Selection of discourses by prominent church leaders on a wide array of church belief and practice.

410. Hansen, Klaus J. *Quest for Empire.* Lincoln: University of Nebraska Press, 1974. 237 pp.

Detailed analysis of the Mormon concept of the political kingdom of God and the "council of fifty" in Mormon history. First edition published in 1967 by Michigan State University Press.

411. —————. *Mormonism and the American Experience.* Chicago/London: University of Chicago Press, 1981. 257 pp.

412. Harrison, G. T. *Mormonism: Now and Then.* Helper, Utah: Harrison, 1961. 368 pp.

Argues that the Mormon church has changed, modified or reversed every principle of its beliefs; and that it wields tremendous power over its members.

413. —————. *Mormons Are Peculiar People.* New York: Vantage Press, Inc., 1954. 180 pp.

Argues that Mormons have been misled by their leaders; enumerates the "false" prophecies issued by Joseph Smith.

414. —————. *That Mormon Book.* (Orem, Utah): Harrison, 1981.
 172 pp.

 Argues that the *Book of Mormon* is a hoax. Compares Mormon
 teachings with the Book of Mormon, pointing out inconsistencies.

415. Harrison, Grant Von. *Every Missionary Can Baptize.* Provo, Utah:
 Ensign Publishing Company, 1981. 36 pp.

 Argues that the church's full-time missionaries have been "called"
 to be successful, and that finding and baptizing converts is a
 matter of attitude.

416. —————. *Tools for Missionaries.* Provo, Utah: The Ensign
 Publishing Company, 1979. 338 pp.

 A detailed handbook to help the church's full-time missionaries
 become more successful and learn the principles of "harvesting
 the Lord's Way."

417. Hawkes, John D. *Book of Mormon Digest.* Salt Lake City: Hawkes
 Publishing, Inc., 1970. 240 pp.

 Paraphrased and condensed version of the Book of Mormon,
 with charts, diagrams and study aids. This is the third edition,
 revised and improved. First edition published in 1966.

418. —————. *Doctrine and Covenants/Pearl of Great Price Digest.*
 Salt Lake City: Hawkes Publishing, Inc., 1977. 278 pp.

 Condensed form of these two books of Mormon scripture, with
 study aids.

419. —————. *New Testament Digest.* Salt Lake City: Hawkes
 Publishing, Inc., 1968. 160 pp.

 Condensed version of the New Testament, with study aids.

420. *Hearken, O Ye People.* Sandy, Utah: Randall Book Company,
 1984. 297 pp.

 Collection of nineteen major discourses on the *Doctrine and
 Covenants* by Mormon church leaders and prominent Mormon
 theologians.

421. Heinerman, John and Anson Shupe. *The Mormon Corporate Empire.*
 Boston: Beacon Press, 1985. 307 pp.

Detailed analysis of the vast financial holdings of the Mormon church; its presence in the military and the CIA; its behind-the-scenes efforts to affect the outcome of various domestic and foreign policy issues.

422. Heinerman, Joseph. *Eternal Testimonies.* Manti, Utah: Mountain Valley Publishers, 1974. 192 pp.

Argues that a testimony is a prophetic gift. Explains in detail the importance of a testimony and illustrates with experiences of various church members who have received testimonies from deceased persons, through revelation and visions, through dreams and from the Holy Ghost.

423. ⸺⸺⸺. *Manifestations of Faith.* Salt Lake City: Magazine Printing and Publishing, 1979. 254 pp.

Argues that as a person experiences God, he will gain faith. This detailed analysis of the concept of faith is illustrated with stories of faith exhibited by church members in various circumstances.

424. ⸺⸺⸺. *Spirit World Manifestations.* Salt Lake City: Magazine Printing and Publishing, 1978. 286 pp.

Argues that deceased persons have returned to this existence, manifested themselves to church members, and assisted them in doing genealogy work in order that rituals on behalf of the deceased could be performed in the church's temples.

425. ⸺⸺⸺. *Temple Manifestations.* Salt Lake City: Magazine Printing and Publishing, 1974. 185 pp.

Discusses the purpose of Mormon temples; then presents experiences recorded by various church members claiming that angels, and other persons from the spirit world, appeared to them in the temple. Experiences cover the years 1836 to 1930.

426. Hinckley, Gordon B. *What of the Mormons?* Salt Lake City: The Church of Jesus Christ of Latter-day Saints, 1974. 24 pp.

Brief introduction to the practical aspects of the Mormon church.

427. Hirshson, Stanley P. *The Lion of the Lord.* New York: Alfred A.

Knopf, Inc., 1969. 437 pp.

Critical biography of Brigham Young, written in spite of the refusal of Mormon church officials to give the author access to archival materials. Author contends that more can be learned about Young from collections at Yale University, New York Public Library and other major east coast institutions, than in the Rocky Mountains. Documentation comes from wide use of contemporary newspapers who kept correspondents in Salt Lake City during Brigham Young's times.

428. Hogan, Mervin B. *The Origin and Growth of Utah Masonry and Its Conflict with Mormonism.* Salt Lake City: Campus Graphics, 1978. 120 pp.

Chronicles the Utah Masonic lodges' official rules and reasons for barring Mormons from joining.

429. Holley, Vernal. *Book of Mormon Authorship: A Closer Look.* Ogden, Utah: Zenos Publications, 1983. 45 pp.

Comprehensive study of similarities between the Book of Mormon and the writings of Solomon Spaulding.

430. *The Holy Bible: Authorized King James Version.* Salt Lake City: The Church of Jesus Christ of Latter-day Saints, 1979. 1590 pp.

First edition of the Bible to be published directly by the church. Includes footnotes to Joseph Smith's Inspired Version, new chapter headings, and 827 pages of topical guides, maps and Bible study aids.

431. Horowitz, Jerome. *The Elders of Israel and the Constitution.* Salt Lake City: Parliament Publishers, 1970. 212 pp.

Argues that the Mormon priesthood will save the United States from destruction in the last days. Sets forth a claim that this was prophesied in scripture.

432. Howick, E. Keith. *The Miracles of Jesus the Messiah.* Salt Lake City: Bookcraft, Inc., 1985. 249 pp.

Detailed examination of thirty-seven miracles performed by Jesus, with commentary on the historical background and doctrinal

implications for Mormons.

433. Hullinger, Robert N. *The Mormon Answer to Skepticism*. St. Louis: Clayton Publishing House, 1980. 201 pp.

434. Hunter, Milton R. *Pearl of Great Price Commentary*. Salt Lake City: Bookcraft, 1951. 276 pp.

Detailed history of how the *Pearl of Great Price* became a book of Mormon scripture, with exhaustive commentary on the teachings contained in that book.

435. *Hymns-The Church of Jesus Christ of Latter-day Saints*. Salt Lake City: Deseret Book Company, 1948.

Contains 389 hymns. Pages are not numbered.

436. *Hymns of The Church of Jesus Christ of Latter-day Saints*. Salt Lake City: The Church of Jesus Christ of Latter-day Saints, 1985. 434 pp.

First major hymnal revision since 1948. Contains 341 hymns, with many by contemporary church musicians and authors. Includes conducting guide, indexes. Latter-day Saint authors and composers are identified in the indexes.

437. Jackson, Kent P. and Robert L. Millet, editors. *The Old Testament. Studies in Scripture, Volume 3*. Salt Lake City: Randall Book Company, 1985. 345 pp.

Collection of twenty detailed papers on Old Testament topics contained in Genesis through 2 Samuel.

438. Jackson, Richard H., editor. *The Mormon Role in the Settlement of the West*. Provo, Utah: Brigham Young University Press, 1978. 182 pp.

Seven essays by various Mormon scholars.

439. Jenson, Andrew. *Church Chronology*. Salt Lake City: Deseret News, 1899. 259 pp.

Important events in church history from 1805 to 1898. This second edition is revised and enlarged.

440. ————. *Latter-day Saint Biographical Encyclopedia,* in four volumes. Salt Lake City: Andrew Jenson History Company, 1901-1936. 3307 pp.

Brief biographies of hundreds of Mormon leaders, from the top echelon to the rank-and-file.

441. Jessee, Dean C., editor. *Letters of Brigham Young to His Sons.* Salt Lake City: Deseret Book Company, 1974. 419 pp.

Personal insights into Brigham Young's personality and philosophy, through letters written to his sons.

442. Jewish Members. *Why I Joined the Mormon Church.* Salt Lake City: The Church of Jesus Christ of Latter-day Saints, nd. 16 pp.

Argues that Jews once practiced the same things as Mormonism. Anonymously written.

443. Johansen, Jerald R. *A Commentary on the Pearl of Great Price.* Bountiful, Utah: Horizon Publishers, 1985. 183 pp.

Argues that the *Pearl of Great Price* contains more profound insights into the truths of eternity than any other book. This new commentary utilizes the most current scholarship. Includes a history of how this book came to be.

444. Johnson, Sonia. *From Housewife to Heretic.* Garden City, New York: Doubleday and Company, Inc., 1981. 406 pp.

Excommunicated from the Mormon church for her out-spoken criticism of their stance against the Equal Rights Ammendment, Johnson chronicles her life and struggle for equal rights.

445. Jones, Gerald E. and Scott S. Smith. *Animals and the Gospel.* Thousand Oaks, California: Millennial Productions, 1980. 38 pp.

Chronicles and explains Mormon doctrine on the animal kingdom.

446. Kimball, Edward L., editor. *The Teachings of Spencer W. Kimball.* Salt Lake City: Bookcraft, 1982. 688 pp.

Compilation of discourses and writings on almost all Mormon beliefs and practices.

447. —————— and Andrew E. Kimball, Jr. *Spencer W. Kimball.*
 Salt Lake City: Bookcraft, 1977. 448 pp.

 Detailed biography of the twelfth president of the Mormon church.

448. Kimball, Heber C. *Heber C. Kimball's Journal: November 21, 1845
 to January 7, 1846.* Salt Lake City: Modern Microfilm
 Company, 1982. 190 pp.

 Photograph of holograph original, this volume provides first-hand
 accounts of temple ceremonies conducted by Brigham Young in
 Nauvoo. According to the preface, the original of this journal is
 in a restricted file in the Mormon church historian's office.

449. Kimball, Stanley B. *Heber C. Kimball: Mormon Patriarch and
 Pioneer.* Urbana/Chicago/London: University of Illinois Press,
 1981. 358 pp.

 Major extensively documented biography of this early Mormon
 apostle, from his birth through his death in 1868. This is the
 first comprehensive biography since 1888.

450. ——————, editor. *The Latter-day Saints' Emigrants' Guide, by
 William Clayton.* Gerald, Missouri: The Patrice Press, 1983.
 107 pp.

 Originally published in 1848, with 24 pages, this book guided
 Mormon pioneers from Iowa to Utah. In this new edition, the
 editor provides commentary and photographs, relating the original
 to the present day topography.

451. Kinard, J. Spencer. *The Worth of a Smile: Spoken Words for Daily
 Living.* Englewood Cliffs, New Jersey: Prentice-Hall, Inc., 1976.
 217 pp.

 The texts of several years of "The Spoken Word" sermonettes
 given in conjunction with the weekly Mormon Tabernacle Choir
 radio and television broadcasts.

452. Kirkham, Francis W. *A New Witness for Christ in America, Volume
 1.* Provo, Utah: Brigham Young University, 1960. 516 pp.

 Argues that because scholars have been unable to answer the
 enigma of the Mormon church, the church and more especially

the Book of Mormon is of a divine nature. The first edition was published in 1942, and subsequently revised twice.

453. —————. *A New Witness for Christ in America, volume 2.* Provo, Utah: Brigham Young University, 1959. 507 pp.

Analyzes many attempts by critics who have tried to prove the Book of Mormon of man-made origins. The first edition was published in 1951. This is a revised edition.

454. Kjelgaard, Jim. *The Coming of the Mormons.* New York: Random House, 1953. 183 pp.

455. Kraut, Ogden. *A Response to the Ex-Mormons for Jesus.* Salt Lake City: Pioneer Press, nd. 21 pp.

Rebuts the claims made by the "Ex-Mormons for Jesus" in their booklet, "Mormonism: Christian or Cult?"

456. Larson, Anthony E. *And the Earth Shall Reel To and Fro.* Orem, Utah: Zedek Books, 1983. 179 pp.

Argues that scientific theory and evidence support the scriptures as the revealed word of God. Focuses on signs of the end of the world.

457. —————. *And the Moon Shall Turn to Blood.* Orem, Utah: Crown Summit Books, 1981. 147 pp.

Claims that scientific findings clarify prophesies from the Old Testament about the end of the world.

458. Lee, Rex E. *A Lawyer Looks at the Equal Rights Amendment.* Provo, Utah: Brigham Young University Press, 1980. 154 pp.

Argues that the "Equal Rights Amendment" is not sufficiently clear and would cause untold problems in American society if it became law.

459. Lefgren, John C. *April Sixth.* Salt Lake City: Deseret Book Company, 1980. 88 pp.

Argues that April 6, the date the church was officially organized, is linked to the birth, death and resurrection of Christ.

460. Leone, Mark P. *Roots of Modern Mormonism.* Cambridge, Massachussetts/London: Harvard University Press, 1979. 250 pp.

Anthropological study of Mormonism, using the Mormon settlements in eastern Arizona as his study model. Leone identifies the features that have "allowed an outcast utopia of the nineteenth century to achieve worldwide success in the twentieth."

461. Ludlow, Daniel H. *A Companion to Your Study of the Book of Mormon.* Salt Lake City: Deseret Book Company, 1976. 396 pp.

Historical commentary and study guide of the Book of Mormon.

462. ———————. *A Companion to Your Study of the Doctrine and Covenants,* in two volumes. Salt Lake City: Deseret Book Company, 1978. 1123 pp.

Detailed commentary on the Doctrine and Covenants, with historical background.

463. ———————. *A Companion to Your Study of the New Testament.* Salt Lake City: Deseret Book Company, 1982. 454 pp.

Study guide and commentary on the four gospels.

464. ———————. *A Companion to Your Study of the Old Testament.* Salt Lake City: Deseret Book Company, 1981. 450 pp.

Commentary and study guide; includes overviews of the beliefs, customs and lives of major Old Testament families. Quotations from Mormon church presidents on the fulfillment of major Old Testament prophecies provide a uniquely Mormon view.

465. Lund, Gerald N. *The Coming of the Lord.* Salt Lake City: Bookcraft, 1971. 255 pp.

Focuses on the events which will precede and accompany the Second Coming of Christ. Argues that the book is not speculative, but based on scripture and comments made by church leaders.

466. Lund, John L. *The Church and the Negro.* Author, 1967. 129 pp.

Examines the Mormon policy of excluding blacks from its priesthood. Includes official church statements which at the time

were taken as tantamount to revelation. Since the 1978 reversal of the policy, this book is essentially obsolete.

467. Lundwall, N. B., compiler. *Masterful Discourses and Writings of Orson Pratt.* Salt Lake City: Bookcraft, 1962. 656 pp.

Pratt, the noted Mormon theologian of the 19th century, and an apostle, expounds upon most of the beliefs, teachings and practices of the church.

468. —————, compiler. *Temples of the Most High.* Salt Lake City: Bookcraft, 1968. 437 pp.

Compilation of dedicatory prayers of the Mormon temples, including histories and descriptions, as well as manifestations from deceased persons. This is a revised and enlarged edition.

469. Lythgoe, Dennis and Marti Lythgoe. *You're a Mormon Now!* Salt Lake City: Olympus Publishing Company, 1983. 104 pp.

A handbook of basic beliefs and practices written specifically for new members.

470. Mabey, Rendell N. and Gordon T. Allred. *Brother to Brother.* Salt Lake City: Bookcraft, Inc., 1984. 169 pp.

The story of the first Mormon missionaries to black Africa— sent in 1978 just after the announcement that blacks would be permitted to receive ordination to the priesthood.

471. Madsen, Brigham D., editor. *Studies of the Book of Mormon—B. H. Roberts.* Urbana/Chicago: University of Illinois Press, 1985. 406 pp.

Three of Roberts' unpublished works which investigate the circumstances surrounding the establishment of the church. Roberts grapples with problems in the Book of Mormon; and includes a frank discussion of parallels between the Book of Mormon and Ethan Smith's "View of the Hebrews," which many critics claim was the basis for the Book of Mormon.

472. Madsen, Truman G. *Defender of the Faith: The B. H. Roberts Story.* Salt Lake City: Bookcraft, 1980. 469 pp.

Detailed biography of one of the foremost and prolific Mormon theologians and historians.

473. —————, editor. *Reflections on Mormonism*. Provo, Utah: Religious Studies Center, Brigham Young University, 1978. 263 pp.

Twelve renowned scholars analyze and compare Judeao-Chrisian parallels in a Mormon context.

474. Malan, Robert H. B. *H. Roberts: A Biography*. Salt Lake City: Deseret Book Company, 1966. 151 pp.

Brief, official biography of Roberts.

475. Martin, David C., editor. *Deseret Discourses,* in 3 volumes. Provo, Utah: Martin, 1975. 437 pp.

Contains selected sermons by Mormon leaders from the *Deseret News* for 1889. Attempted to fill the gap between the official *Journal of Discourses* which ceased publication in the late 1880s, and the *Conference Reports* which began in the 1890s.

476. Matthews, Robert J. *A Plainer Translation: Joseph Smith's Translation of the Bible*. Provo, Utah: Brigham Young University Press, 1975. 495 pp.

Detailed and extensively documented history, commentary and analysis of the revision of the Bible done by Joseph Smith in the 1830s, which is published by the RLDS Church as the "Inspired Version." Includes detailed comparisons with the text of the King James Version.

477. —————. *A Burning Light: The Life and Ministry of John the Baptist*. Provo, Utah: Brigham Young University Press, 1972. 143 pp.

Utilizing texts from the KJV and the Inspired Version, as well as recent discoveries, the author sheds light on the life and works of John the Baptist.

478. McLaws, Monte Burr. *Spokesman for the Kingdom*. Provo, Utah: Brigham Young University Press, 1977. 271 pp.

Detailed and copious study of Mormon journalism, focusing on the *Deseret News*, a paper begun in Salt Lake City in the early 1850s. Covers 1830-1898.

479. McConkie, Bruce R. *Doctrinal New Testament Commentary, Volume 1.* Salt Lake City: Bookcraft, 1969. 876 pp.

Provides a Mormon perspective on the contents and teachings of the four gospels.

480. ――――――. *Doctrinal New Testament Commentary, Volume 2.* Salt Lake City: Bookcraft, 1971. 544 pp.

Includes the New Testament from Acts to Philippians.

481. ――――――. *Doctrinal New Testament Commentary, Volume 3.* Salt Lake City: Bookcraft, 1973. 595 pp.

Continues from Colossians to Revelation.

482. ――――――. *Doctrines of Salvation: Sermons and Writings of Joseph Fielding Smith,* in three volumes. Salt Lake City: Bookcraft, 1954-1956. 1086 pp.

Detailed dissertations on all aspects of Mormon belief. Smith, a grandson of Hyrum Smith, became an apostle as a young man when his father was church president. He served the church the balance of his life, finally as president, until his death in 1972.

483. ――――――. *The Holy Ghost Speaks Again.* Salt Lake City: The Church of Jesus Christ of Latter-day Saints, nd. 20 pp.

Argues that the gifts of the spirit, as described in the Bible, are neither sought after nor accepted by most Christians.

484. ――――――. *The Millennial Messiah: The Second Coming of the Son of Man.* Salt Lake City: Deseret Book Company, 1982. 749 pp.

Detailed examination and dissertation, from a Mormon perspective, of the prophecies and events to take place attending the Second Coming of Christ.

485. ――――――. *The Mortal Messiah,* in four volumes. Salt Lake City:

Deseret Book Company, 1979-1981. 1940 pp.

Details the life of Christ from Bethlehem to Calvary, including exhaustive dissertation on Christ's mission and its meaning.

486. ————. *The Promised Messiah.* Salt Lake City: Deseret Book Company, 1978. 655 pp.

Analysis and commentary on the ancient prophecies concerning the coming of Christ.

487. ————. *Mormon Doctrine.* Salt Lake City: Bookcraft, 1966. 856 pp.

Encyclopedic compendium of Mormon belief. Exhaustive and comprehensive. First edition published in 1958 met with concern from church leaders and was removed from the market. Numerous corrections were made in the 2nd edition. Continues to be a major reference work on Mormonism.

488. ————. *A New Witness for the Articles of Faith.* Salt Lake City: Deseret Book Company, 1985. 735 pp.

Detailed examination and commentary on the thirteen points of belief which were written by Joseph Smith in 1842. First printing contains an error on the copyright page stating that the first printing was in 1984, rather than in 1985.

489. ————. *The Truth About God.* Salt Lake City: The Church of Jesus Christ of Latter-day Saints, nd. 30 pp.

490. ————. *What the Mormons Think of Christ.* Salt Lake City: The Church of Jesus Christ of Latter-day Saints, nd. 40 pp.

Argues that although critics claim Mormons do not believe in Christ, the Mormons are actually more Christian than others.

491. McConkie, Joseph Fielding. *Gospel Symbolism.* Salt Lake City: Bookcraft, 1985. 312 pp.

Explains the purpose and symbolism of similes, metaphores and other figures of speech found in the scriptures. Illustrates what Mormons believe to be divine parallels between Joseph Smith and Joseph of Egypt. Argues that false traditions and interpretations

have confused such doctrines as the Fall, the Creation and the Atonement.

492. —————. *The Spirit of Revelation*. Salt Lake City: Deseret Book Company, 1984. 144 pp.

Detailed exposition of the Mormon beliefs on revelation.

493. ————— and Robert L. Millet. *Sustaining and Defending the Faith*. Salt Lake City: Bookcraft, 1985. 154 pp.

Argues that "anti-Mormonism" is, in fact, opposition from the adversary. Such opposition is viewed as proof that the Mormon church is God's only true church.

494. McConkie, Oscar W. *Aaronic Priesthood*. Salt Lake City: Deseret Book Company, 1977. 134 pp.

Analysis of the scriptural and doctrinal teachings of Mormonism concerning the Aaronic priesthood and what it is, what it means, what its responsibilities are.

495. —————. *Angels*. Salt Lake City: Deseret Book Company, 1975. 136 pp.

Argues that angels exist and function among church members and leaders to guide and direct the affairs of the church.

496. McGavin, E. Cecil. *Mormonism and Masonry*. Salt Lake City: Bookcraft, 1956. 200 pp.

Argues that Masonry and Mormon temple ceremonies came from a common source, and that Masonry is nothing but an apostate version of true temple worship.

497. McKay, David O. *Communism: A Statement of the position of The Church of Jesus Christ of Latter-day Saints*. Salt Lake City: Deseret Book Company, nd. 2 pp.

No Mormon can be a good church member if they support Communism. Church members are encouraged to participate with various organizations, including the FBI in the investigation of Communism.

498. —————. *The Purpose of the Temple.* Salt Lake City: The
 Church of Jesus Christ of Latter-day Saints, nd. 11 pp.

 Argues that in order to receive salvation, one must conform to
 certain principles and ordinances, available in the Mormon church
 and its temples.

499. McMurrin, Sterling M. *The Theological Foundations of the Mormon
 Religion.* Salt Lake City: University of Utah Press, 1965. 161 pp.

 Argues that Mormon theology "incorporates a liberal doctrine
 of man and a radically unorthodox concept of God."

500. *Melchizedek Priesthood Handbook.* Salt Lake City: The Church of
 Jesus Christ of Latter-day Saints, 1975. 34 pp.

 Official handbook of policies and procedures for local church
 officials.

501. Millet, Robert L. *The Perfected Millennial Kingdom.* Salt Lake City:
 Hawkes Publishing, Inc., 1974. 128 pp.

 Explains the Mormon beliefs pertaining to the kingdom of God,
 the millennium, Zion, and the concepts of economic principles
 pertaining thereto; and also how church members are to prepare
 for this coming time.

502. Millet, Robert L. and Kent P. Jackson, editors. *The Doctrine and
 Covenants: Studies in Scripture, Volume 1.* Sandy, Utah: Randall
 Book Company, 1984. 615 pp.

 Contains 52 chapters written by prominent Mormon scholars
 providing commentary on the documents contained in the *Doctrine
 and Covenants.*

503. ————— and —————. *The Pearl of Great Price: Studies
 in Scripture, Volume 2.* Salt Lake City: Randall Book Company,
 1985. 446 pp.

 Scholarly analysis and commentary, in 26 chapters, on the history
 and teachings of the *Pearl of Great Price.*

504. Morgan, John. *The Plan of Salvation.* Salt Lake City: The Church
 of Jesus Christ of Latter-day Saints, nd. 35 pp.

In describing Mormon beliefs regarding the nature of spirits, faith, repentance, baptism and future existence, argues that Mormon belief is in accord with the Bible, while the beliefs of most Christians are not.

505. Morley, Frank S. *What We Can Learn from The Church of Jesus Christ of Latter-day Saints, by a Protestant Minister.* Salt Lake City: The Church of Jesus Christ of Latter-day Saints, nd. 18 pp.

Presbyterian minister argues that the Mormons' health laws and church practices are worth emulating.

506. Murphy, Steven M. *Index to the Journal of Discourses Containing Unique Doctrinal Themes.* Salt Lake City: author, 1974. 143 pp.

Detailed index to numerous fundamentalist doctrines once taught by the church, but denounced by current leaders, such as Adam being God, Blood Atonement, polygamy, etc. The *Journal of Discourses* contained the approved texts of sermons delivered by noted church leaders, such as Brigham Young, Heber C. Kimball, etc., between 1851 and 1886.

507. Nelson, Leland R., compiler. *The Journal of Brigham.* Provo, Utah: Council Press, 1980. 233 pp.

Contains transcripts of Brigham Young's diaries from 1801 to 1847.

508. Nibley, Hugh. *Abraham in Egypt.* Salt Lake City: Deseret Book Company, 1981. 299 pp.

Based on scientific and archaeological discoveries, the author argues that the *Book of Abraham* contained in the *Pearl of Great Price* is an authentic autobiography.

509. ————. *An Approach to the Book of Mormon.* Salt Lake City: Deseret Book Company, 1978. 416 pp.

Argues for the truthfulness of the Book of Mormon utilizing recent discoveries in the Middle East to support the culture, history and theology contained in the book. This is the second edition, the first being issued in 1964.

510. ————. *Lehi in the Desert and the World of the Jaredites.* Salt

Lake City: Bookcraft, 1952. 280 pp.

Provides commentary from scholarly sources on the history and customs contained in the *Book of Mormon* texts known as "1 Nephi" and "Book of Ether."

511. ——————. *The Message of the Joseph Smith Papyri: An Egyptian Endowment.* Salt Lake City: Deseret Book Company, 1975. 305 pp.

Argues that the papyrus found in the mid-1960s in New York City was not the papyrus from which Joseph Smith "translated" the Book of Abraham, but rather an Egyptian burial document known as the "Book of Breathings," even though these documents were in Smith's possession. Suggests that there are many parallels between ancient Egyptian temple worship and Mormon temple worship.

512. ——————. *The Myth Makers.* Salt Lake City: Bookcraft, 1961. 293 pp.

Argues that the "anti-Mormons" constantly contradict each other and use half-truths in their accusations.

513. ——————. *Since Cumorah.* Salt Lake City: Deseret Book Company, 1967. 460 pp.

Argues that Joseph Smith could not have written the *Book of Mormon* because it contains too many truths concerned with ancient Hebrew, Egyptian and Christian customs and beliefs which were unknown in the early 1800s.

514. Norris, Elwood G. *Be Not Deceived.* Bountiful, Utah: Horizon Publishers, 1978. 141 pp.

Argues that Brigham Young's teachings regarding Adam being God were only his personal opinions, and refutes the theory with scriptural arguments. Does not actually deal with the hundreds of recorded sermons and teachings on the concept by Brigham Young and other church leaders.

515. Nyman, Monte S., editor. *Isaiah and the Prophets.* Provo, Utah: Religious Studies Center, Brigham Young University, 1984. 190 pp.

Ten papers by Mormon scholars on the meaning of the book of Isaiah in a Mormon theology.

516. ————— and Robert L. Millet, editors. *The Joseph Smith Translation: The Restoration of Plain and Precious Things.* Provo, Utah: Religious Studies Center, Brigham Young University, 1985. 331 pp.

Nine Mormon scholars provide detailed insights into the version of the Bible revised by Joseph Smith, Jr., known as the "Inspired Version." Argues that Smith restored many things that had been lost from the texts during their centuries-long transmission, based on current theological and manuscript discoveries of the ancient texts.

517. O'Dea, Thomas F. *The Mormons.* Chicago/London: University of Chicago Press, 1957. 301 pp.

A classic analysis of Mormonism by a noted non-Mormon scholar.

518. Pace, George W. *What It Means to Know Christ.* Provo, Utah: Council Press, 1981. 235 pp.

Argues that each church member can gain a special relationship with Christ and that more intense prayer is an important aspect of one's life. Bruce R. McConkie of the Twelve Apostles, denounced this book in a March 2, 1982 speech at Brigham Young University saying that the book was unwise and taught incorrect doctrine. McConkie also stated that it was possible to pray too much.

519. Packer, Boyd K. *The Holy Temple.* Salt Lake City: Bookcraft, 1980. 284 pp.

Comprehensive dissertation examining all aspects of Mormon temple beliefs, practices and implications for church members. Argues that the work of the temple was conducted among the ancient Hebrews, and that Elijah and Malachi prophesied regarding the restoration of temple practices in the last days.

520. Palmer, David A. *In Search of Cumorah: New Evidences for the Book of Mormon from Ancient Mexico.* Bountiful, Utah: Horizon Publishers, 1981. 254 pp.

Argues that the final battles described in the latter pages of the

Book of Mormon were fought at a hill southeast of Mexico City. Based on archaelogical discoveries and analysis performed by Mormon scholars.

521. Palmer, Lee A. *Aaronic Priesthood Through the Centuries.* Salt Lake City: Deseret Book Company, 1964. 441 pp.

Comprehensive history of the priesthood, traced from Biblical and Book of Mormon times, to the present-day Mormon beliefs.

522. Palmer, Richard F. and Karl D. Butler. *Brigham Young: The New York Years.* Provo, Utah: Charles Redd Center for Western Studies, 1982. 115 pp.

Chronicles the early life of Brigham Young from his birth to his conversion to Mormonism in 1832. Utilizes many previously unused sources. Well-documented.

523. Palmer, Spencer J. *The Church Encounters Asia.* Salt Lake City: Deseret Book Company, 1970. 201 pp.

A history of the Mormon church in China, Japan, Korea, The Philippines, Thailand, Vietnam, India, Singapore and Indonesia up to 1970.

524. ————. *The Expanding Church.* Salt Lake City: Deseret Book Company, 1978. 241 pp.

Utilizing stories of modern-day Mormons, examines the growth of the church outside the U.S. and discusses how the church is designing programs to reach church members in other parts of the world.

525. ————, editor. *Mormons and Muslisms.* Provo, Utah: Religious Studies Center, Brigham Young University, 1983. 225 pp.

Various scholars analyze similarities between Islam and Mormonism: belief in God, physical resurrection, importance of family, social concerns, and parallels between Joseph Smith and Muhammad.

526. Pearson, Glenn L. *The Old Testament: A Mormon Perspective.* Salt Lake City: Bookcraft, 1980. 232 pp.

An overview of the Old Testament, with a summary of its messages, relating it to Mormon beliefs.

527. Persuitte, David. *Joseph Smith and the Origins of the Book of Mormon.* Jefferson, North Carolina: McFarland and Company, Inc., Publishers, 1985. 295 pp.

Argues that the *Book of Mormon* was written by Smith based on Ethan Smith's earlier work entitled "A View of the Hebrews."

528. Petersen, Gerald A. *More Than Music.* Provo, Utah: Brigham Young University Press, 1979. 103 pp.

A history of the Mormon Tabernacle Choir, drawn from newspaper and magazine articles and personal experiences of choir members.

529. Petersen, Mark E. *Which Church Is Right?* Salt Lake City: The Church of Jesus Christ of Latter-day Saints, nd. 25 pp.

Argues that the Bible states clearly the true church must have prophets, apostles, revelation, bishops, etc.—only the Mormon church has these.

530. ————. *Why Mormons Build Temples.* Salt Lake City: The Church of Jesus Christ of Latter-day Saints, nd. 18 pp.

Argues that Mormon temple rituals are of ancient origin and were practiced by the Hebrews in the same manner as is done in modern Mormon temples.

531. ————. *A Word of Wisdom.* Salt Lake City: The Church of Jesus Christ of Latter-day Saints, nd. 16 pp.

Argues that in order to obtain salvation a person must refrain from using alcohol and tobacco. Details the Mormon health codes.

532. Peterson, H. Donl. *Moroni: Ancient Prophet, Modern Messenger.* Bountiful, Utah: Horizon Publishers, 1983. 196 pp.

In-depth commentary on the book of Moroni, contained in the Book of Mormon. Explains why Moroni's likeness is placed atop Mormon temples.

533. Pratt, Parley P. *Autobiography of Parley P. Pratt.* Salt Lake City:
 Deseret Book Company, 1938. 471 pp.

> Parley P. Pratt, an early apostle and missionary, was assassinated
> in 1857. His story is a unique chronicle of the establishment and
> rise of the Mormon church. The first edition was published in
> 1873.

534. Quinn, D. Michael. *J. Reuben Clark: The Church Years.* Provo,
 Utah: Brigham Young University Press, 1983. 350 pp.

> Detailed biography of Clark from 1933 when he was appointed
> to be counselor to Mormon church president Heber J. Grant, to
> 1961 when he died, having served two additional presidents as
> a counselor.

535. ————. *On Being a Mormon Historian.* Salt Lake City: Modern
 Microfilm Company, 1982. 26 pp.

> Quinn expresses concerns that Mormon church officials are con-
> ducting a campaign to discredit professional historians and factual
> history.

536. *Read the Book of Mormon: It Can Change Your Life.* Salt Lake City:
 The Church of Jesus Christ of Latter-day Saints, 1975. 16 pp.

> Argues that the *Book of Mormon* contains the word of God, and
> that it would be a "tragedy to live a lifetime and never read such
> a book." Briefly reviews the story contained in the book, and its
> coming forth in 1830.

537. Reynolds, George. *A Complete Concordance of the Book of Mormon.*
 Salt Lake City: Deseret Book Company, 1976. 852 pp.

> Photo-reprint of original 1899 edition of this monumental con-
> cordance, containing all major words and topics of the *Book of
> Mormon*.

538. ———— and Janne M. Sjodahl. *Commentary on the Book of
 Mormon*, in seven volumes. Salt Lake City: Deseret Book
 Company, 1955. 2742 pp.

> Exhaustive commentary on the entire contents of the Book of
> Mormon. Includes theological and historical issues.

539. —————— and ——————. *Commentary on the Pearl of Great Price.* Salt Lake City: 1965. 403 pp.

Complete commentary on the fourth book accepted by Mormons as scripture.

540. Reynolds, Noel B., editor. *Book of Mormon Authorship.* Provo, Utah: Religious Studies Center, Brigham Young University, 1982. 244 pp.

Nine Mormon scholars analyze the authorship of the *Book of Mormon* utilizing history, literature, statistics and ancient near-eastern studies, to dispute the claim that it was fabricated by Joseph Smith or his contemporaries.

541. Rich, Russell R. *Ensign to the Nations.* Provo, Utah: Young House/ Brigham Young University Press, 1972. 696 pp.

Descriptive history of the Mormon church from 1846 to 1972.

542. Richards, LeGrand. *Israel! Do You Know?* Salt Lake City: Deseret Book Company, 1954. 254 pp.

Argues that the Jews and the Mormons are prophetically connected, and that both peoples have a unique role to play in the latter days.

543. ——————. *A Marvelous Work and a Wonder.* Salt Lake City: Deseret Book Company, 1976. 440 pp.

Basic but detailed explanation of Mormon history and beliefs. First edition published in 1950. There have been numerous revised editions since. Widely used by the church's missionaries.

544. Richards, Stephen L. *Contributions of Joseph Smith.* Salt Lake City: The Church of Jesus Christ of Latter-day Saints, nd. 9 pp.

Outlines Smith's teachings concerning God, priesthood, revelation, exaltation, temples, marriage, etc.

545. Roberts, Brigham H. *A Comprehensive History of the Church of Jesus Christ of Latter-day Saints, Century 1,* in six volumes. Salt Lake City: The Church of Jesus Christ of Latter-day Saints, 1957. 3457 pp.

Originally the text of a series appearing in "Americana" from June 1909 to July 1915, this set was revised, indexed and scheduled to be published in 1930 as part of the centennial celebration of the organization of the church.

546. ———————. *The Falling Away*. Salt Lake City: Deseret Book Company, 1931. 267 pp.

Argues that the world lost the true church and true Christian religion sometime after the death of the original twelve apostles. Chronicles abuses of religion by various denominations through the ages, and finally the restoration of the true church by Joseph Smith.

547. ———————. *The Lord's Day*. Salt Lake City: The Church of Jesus Christ of Latter-day Saints, 1972. 14 pp.

Argues that Sunday is the correct day of worship.

548. Ruf, Hermann O. *The Fall of Lucifer and the Establishment of Zion Foreseen*. Springfield, Missouri: Zion Publishing Company, 1976. 228 pp.

Argues that the members of the Mormon church are God's instruments to fulfill the prophecies which pertain to the last days and Zion.

549. ———————. *Three Days in the Holy City Zion*. Springfield, Missouri: Eden Publishing Company, 1964. 211 pp.

Fictional account of visiting Zion after the second coming of Christ, describing the conditions.

550. ———————. *Zion: A Place of Safety and Happiness*. Springfield, Missouri: Zion Publishing Company, 1978. 128 pp.

Warns non-Mormons to repent and accept the truth before the Second Coming and the establishment of Zion.

551. Sackett, Charles C. *A Mormon Temple Worker Asks Some Questions*. Issaquah, Washington: Saints Alive in Jesus, nd. 8 pp.

Forty questions regarding alleged doctrinal and procedural errors in Mormon temple ceremonies.

552. Salisbury, Frank B. *The Creation.* Salt Lake City: Deseret Book Company, 1976. 329 pp.

 Scientific examination of the process of creation, reconciling science with Mormon beliefs.

553. *The Salt Lake City Messenger.* Salt Lake City: Modern Microfilm Company, 1964. 3 pp.

 Periodical newsletter by Jerald and Sandra Tanner. Frequency and number of pages is not constant. Contains current research on a variety of issues of interest to Mormonism.

554. Scharffs, Gilbert W. *The Truth About "The God Makers."* Salt Lake City: Publishers Press, 1986. 428 pp.

 Rebuts each argument made by J. Edward Decker and Dave Hunt in their classic "anti-Mormon" book and film entitled "The God Makers." Argues that Decker and Hunt have misinterpreted, misconstrued, made factual mistakes and have promoted historical inaccuracies in their work.

555. Schindler, Harold. *Orrin Porter Rockwell: Man of God, Son of Thunder.* Salt Lake City: University of Utah Press, 1966. 399 pp.

 Highly acclaimed biography of one of the most colorful figures in Mormon history.

556. Schnibbe, Karl-Heinz. *The Price: The True Story of a Mormon Who Defied Hitler.* Salt Lake City: Bookcraft, 1984. 126 pp.

 The true story of several young Mormons in Nazi Germany and the resistance effort they promoted. Because of their activities they were excommunicated from the Mormon church. Several of them were executed by the Nazi regime.

557. Seaich, Eugene. *Ancient Texts and Mormonism.* Sandy, Utah: Mormon Miscellaneous, 1983. 147 pp.

 Attempts to prove that Mormonism is a genuine restoration of ancient Christianity by utilizing numerous ancient documents.

558. —————. *Mormonism, the Dead Sea Scrolls, and the Nag Hammadi Texts.* Murray, Utah: Sounds of Zion, 1980. 64 pp.

Argues that there are many important parallels between modern
Mormonism and these ancient texts, thus lending credence to the
claim that Mormonism is a genuine restoration of the primitive
church.

559. Sessions, Gene A. *Mormon Thunder: A Documentary History of
 Jedediah Morgan Grant.* Urbana/Chicago/London: University
 of Illinois Press, 1982. 430 pp.

 Chronicles the life of the first mayor of Salt Lake City, and
 counselor to Brigham Young, from his birth in 1816 to his death
 in 1856.

560. Shapiro, R. Gary. *An Exhaustive Concordance of the Book of Mormon,
 Doctrine and Covenants, and Pearl of Great Price.* Salt Lake
 City: Hawkes Publishing, Inc., 1977. 1094 pp.

 Major reference to three of the books accepted by the Mormon
 church as scripture.

561. Shipps, Jan. *Mormonism: The Story of a New Religious Tradition.*
 Urbana/Chicago: University of Illinois Press, 1985. 225 pp.

 A noted non-Mormon scholar carefully examines the *Book of
 Mormon*, church history and beliefs. Shipps argues that Mormonism
 is not a denominational, heretical or fraudulent version of Chris-
 tianity, but a new religious tradition.

562. Skousen, W. Cleon. *The First 2,000 Years.* Salt Lake City: Bookcraft,
 1953. 401 pp.

 Detailed commentary of the Old Testament up to the time of
 Isaac.

563. —————. *The Fourth Thousand Years.* Salt Lake City: Bookcraft,
 1966. 846 pp.

 Exhaustive commentary on biblical history from the time of
 David to the birth of Christ.

564. —————. *Isaiah Speaks to Modern Times.* Salt Lake City: The
 Ensign Publishing Company, 1984. 788 pp.

 Verse-by-verse commentary on the book of Isaiah, based in Mor-

mon theology.

565. ————. *The Third Thousand Years.* Salt Lake City: Bookcraft, 1964. 704 pp.

Commentary on the Bible from Isaac through King Saul. Utilizes photos from Cecil B. DeMille's "The Ten Commandments" for illustrations.

566. Smith, Hyrum M., III and Scott G. Kenney, editors. *From Prophet to Son.* Salt Lake City: Deseret Book Company, 1981. 141 pp.

Personal insights into the life of Joseph F. Smith, sixth Mormon church president, through the letters he wrote to his sons.

567. Smith, John L. *Brigham Smith.* Clearfield, Utah: The Utah Evangel Press, 1969. 164 pp.

A novel about a young man who rises quickly in the ranks of church leadership to become an apostle, who later discovers the church is in error, resigns his position and membership and becomes a Baptist.

568. Smith, Joseph, Jr. *The Book of Mormon.* Salt Lake City: The Church of Jesus Christ of Latter-day Saints, 1981. 535 pp.

First major revision since the 1920s, this new edition's text was carefully compared with previous editions and manuscripts. Bruce R. McConkie anonymously wrote new chapter headings. Since 1982 the church has included the subtitle "Another Testament of Jesus Christ."

569. ————. *The Doctrine and Covenants/The Pearl of Great Price.* Salt Lake City: The Church of Jesus Christ of Latter-day Saints, 1981. 773 pp.

This new edition includes new section headings by McConkie, and exhaustive index.

570. Smith, Joseph Fielding. *Essentials in Church History.* Salt Lake City: Deseret Book Company, 1979. 603 pp.

Popular, although one-sided, single volume history of the church. Since the first printing in 1922, it has had twenty-seven printings

and several revisions. Anonymous editors have brought the volume up-to-date by including material on two church presidents since Smith's death in 1972.

571. —————. *The Restoration of All Things.* Salt Lake City: Deseret Book Company, 1945. 338 pp.

Argues that the Mormon church has, is or will fulfill every prophecy contained in the Bible. Subjects include many uniquely Mormon doctrines such as baptism for the dead, eternal marriage, and man attaining godhood.

572. —————. *Succession in the Presidency of The Church of Jesus Christ of Latter-day Saints.* Salt Lake City: The Church of Jesus Christ of Latter-day Saints, nd. 30 pp.

Refutes the RLDS Church's position on the succession in church leadership. Claims that the RLDS Church teaches Joseph Smith became a fallen prophet. Maintains that the Mormon church is the only true church.

573. —————, compiler. *Teachings of the Prophet Joseph Smith.* Salt Lake City: Deseret Book Company, 1938. 410 pp.

Collection of sermons and writings delivered by the founder of the Latter Day Saint movement, on a variety of doctrinal subjects of importance to Mormon theology.

574. Sonne, Conway B. *Saints on the Seas.* Salt Lake City: University of Utah Press, 1983. 230 pp.

Extensively researched history of Mormon migration across the oceans between 1830-1890. Chronicles the voyages of some 85,000 converts and 325 ships.

575. Sorenson, John L. *An Ancient American Setting for the Book of Mormon.* Salt Lake City/Provo, Utah: Deseret Book Company/ Foundation for Ancient Research and Mormon Studies, 1985. 436 pp.

Proposes a credible model for *Book of Mormon* geography in Central America. The first scholarly work, based on detailed archaeological and anthropological studies of Mesoamerica, with the entire spectrum of cultural and historical information from the

Book of Mormon itself.

576. Sperry, Sidney B. *Answers to Book of Mormon Questions.* Salt Lake City: Bookcraft, 1967. 261 pp.

Presents scholarly and thorough answers to questions proposed by critics of the Book of Mormon. Originally published in 1964 as "Problems of the Book of Mormon," this edition is revised and enlarged.

577. —————. *Book of Mormon Compendium.* Salt Lake City: Bookcraft, 1968. 588 pp.

Detailed study of the Book of Mormon, which explores its writers and teachings, with insightful commentary to aid in understanding.

578. —————. *Doctrine and Covenants Compendium.* Salt Lake City: Bookcraft, 1960. 790 pp.

Thorough topical study of the contents of the Doctrine and Covenants.

579. —————. *The Message of the Twelve Prophets.* Independence, Missouri: Zion's Printing and Publishing Company, 1941. 256 pp.

Detailed study of the twelve minor prophets of the Old Testament, relating their teachings to Mormon beliefs.

580. —————. *Paul's Life and Letters.* Salt Lake City: Bookcraft, 1955. 324 pp.

Synthesis of the essential facts of Paul's life and teachings, explaining their meaning and importance to Mormons.

581. Stewart, John J. *Brigham Young and His Wives.* Salt Lake City: Mercury Publishing Company, Inc., 1961. 114 pp.

A brief history and explanation of the practice of polygamy, with special focus on Brigham Young. Includes documented list of Young's wives, with many photos.

582. Taggart, Stephen G. *Mormonism's Negro Policy: Social and Historical Origins.* Salt Lake City: University of Utah, 1970. 76 pp.

Argues that the Mormon policy of denying the priesthood to blacks evolved out of a number of social experiences, particularly the political climate of the United States in the 1840s-60s.

583. Talmage, James E. *The House of the Lord.* Salt Lake City: Deseret Book Company, 1976. 239 pp.

In-depth explanation of Mormon temples and the attendant doctrinal implications for church members. First issued in 1912, with many subsequent editions, this is a revised version, and contains color photos of the interiors of some temples.

584. ————. *The House of the Lord.* Salt Lake City: The Church of Jesus Christ of Latter-day Saints, 1979. 30 pp.

Adapted from the text of previous item, this is a brief introduction used in orientating those going through the temple for the first time.

585. ————. *Jesus the Christ.* Salt Lake City: The Church of Jesus Christ of Latter-day Saints, 1974. 804 pp.

Since the first edition in 1915, this classic exposition of the life and ministry of Jesus Christ has undergone numerous editions and printings. Commissioned by the church, much of the writing was done in the temple at Salt Lake City.

586. ————. *A Study of the Articles of Faith.* Salt Lake City: The Church of Jesus Christ of Latter-day Saints, 1974. 536 pp.

First issued in 1890, this standard work of Mormon theology has undergone numerous printings and editions. This is one of the foremost theological expositions of Mormon belief ever to be written.

587. Tanner, Jerald and Sandra Tanner. *The Case Against Mormonism,* in three volumes. Salt Lake City: Modern Microfilm Company, 1967-1971. 538 pp.

Extensively documented treatise of problems with Mormonism as perceived by the authors. Includes a treatment of church censorship, the Book of Mormon, the Book of Abraham, and several unique teachings of the church: Adam-God, origin of the Indians, word of wisdom.

588. —————— and ——————. *The Changing World of Mormonism.* Chicago: Moody Press, 1980. 592 pp.

An updated, condensed version of the authors' "Mormonism: Shadow or Reality?"

589. —————— and ——————. *Joseph Smith and Polygamy.* Salt Lake City: Modern Microfilm Company, 1967. 124 pp.

590. —————— and ——————. *Mormonism: Shadow or Reality?* Salt Lake City: Utah Lighthouse Ministry, 1982. 576 pp.

A revised, updated version of the Tanner's long-time classic in "anti-Mormon" literature. This is the fourth edition, revised and enlarged. Additional pages are inserted between previous pages and noted with "A, B, C etc." Contains 38 chapters detailing virtually every aspect of Mormon faith and practice. Extensive documentation; comprehensive in scope. First edition published in 1964.

591. —————— and ——————. *The Mormon Kingdom,* in two volumes. Salt Lake City: Modern Microfilm Company, 1967-1971. 341 pp.

Details the Danites, blood atonement, the 1838 "war" in Missouri, temple ceremonies, Masonic influence on the Mormon church, counterfeiting, the Mountain Meadows Massacre, and murders in early Utah.

592. Taves, Ernest H. *Trouble Enough: Joseph Smith and the Book of Mormon.* Buffalo, New York: Prometheus Books, 1984. 280 pp.

Argues that contrary to Mormon claims a computer-based study of the text of the *Book of Mormon* reveals no evidence of multiple authorship.

593. Taylor, Samuel W. *The Kingdom or Nothing.* New York: Macmillan Publishing Company, 1976. 406 pp.

Chronicles the life of John Taylor, third president of the Mormon church. Details how Taylor directed the church from secret headquarters during his defiance of federal law which prohibited plural marriage. Author is grandson of John Taylor.

594. ——————. *Rocky Mountain Empire: The Latter-day Saints Today.*

New York: Macmillan Publishing Company, 1978. 273 pp.

Narrative history of how the Mormon church survived the abandonment of polygamy, and rose to become a powerful financial and political force in the U. S.

595. —————— and Raymond Taylor. *The John Taylor Papers: The Apostle, Volume 1.* Redwood City, California: Taylor Trust, 1984. 363 pp.

Uniquely constructed biography of this colorful Mormon leader, woven from his personal writings.

596. —————— and ——————. *The John Taylor Papers: The President, Volume 2.* Redwood City, California: Taylor Trust, 1985. 553 pp.

Continuation of previous item, covering the years Taylor was Mormon church president.

597. Terry, Keith. *Great Moments in Mormonism, Volume 1.* Santa Barbara, California: Butterfly Publishing, Inc., 1980. 135 pp.

Contains faith-promoting vignettes from church history.

598. Thomas, R. M. Bryce. *My Reasons for Joining the Church of Jesus Christ of Latter-day Saints.* Salt Lake City: The Church of Jesus Christ of Latter-day Saints, 1972. 32 pp.

Author outlines the doctrinal inconsistencies in the Church of England, and presents his logic in determining the Mormon church to be correct. Originally published in 1897, a second edition was issued in 1902.

599. Tiffin, Dalton A. *The Origin of LDS Proxy Baptisms for their Dead.* Cookstown, Ontario: author, nd. 4 pp.

Argues that baptism for the dead is unscriptural.

600. *Times and Seasons, Volume 7.* Nauvoo, Illinois: Times and Seasons, Ltd., 1971. 24 pp.

Modern revival of the earlier 1840s church periodical. Four issues were published between September and December. This was

strictly a commercial venture dealing with church history and news of the work being conducted in Nauvoo in restoring the old buildings.

601. *A Topical Guide to the Scriptures of The Church of Jesus Christ of Latter-day Saints.* Salt Lake City: Deseret Book Company, 1977. 500 pp.

Exhaustive topical index to the scriptures, based on years of work by scripture committee of the church. This first edition was issued for members to use and make suggestions for improvement. The improved version is included with the new editions of the scriptures published in 1979 and 1981.

602. Tullis, F. LaMond, editor. *Mormonism: A Faith for all Cultures.* Provo, Utah: Brigham Young University Press, 1978. 391 pp.

Collection of papers from scholars and church leaders around the world, discussing the history and place of the Mormon faith in various cultural expressions.

603. Turner, Rodney. *Woman and the Priesthood.* Salt Lake City: Deseret Book Company, 1972. 333 pp.

Argues that in lieu of ordination, the women of the church hold the priesthood with their husbands as wives, mothers, teachers and comforters.

604. Turner, Wallace. *The Mormon Establishment.* Boston: Houghton Mifflin Company, 1966. 343 pp.

605. VanWagoner, Richard S. *Mormon Polygamy: A History.* Salt Lake City: Signature Books, 1986. 313 pp.

The first comprehensive survey of Mormon polygamy from 19th to 20th century Utah. Extensively documented. All relevant contemporary accounts are examined and interpreted.

606. —————— and Steven C. Walker. *A Book of Mormons.* Salt Lake City: Signature Books, 1982. 454 pp.

Biographical sketches of 78 prominent Mormons. Documentation provides sources for more detailed information.

607. Vestal, Kirk Holland and Arthur Wallace. *The Firm Foundation of*

Mormonism. Los Angeles: LL Company, 1981. 318 pp.

Argues that the Book of Mormon proves the Bible; that the Mormon church is a complete restoration of the gospel of Christ, for which there is a "myriad of tangible evidence."

608. VonWellnitz, Marcus. *Christ and the Patriarchs.* Bountiful, Utah: Horizon Publishers, 1981. 200 pp.

Examines new information from apocryphal literature and tradition regarding Adam, Moses, Abraham, Noah, and Christ.

609. Wallace, Arthur. *Can Mormonism Be Proved Experimentally?* Los Angeles: Wallace, 1973. 170 pp.

Argues that by utilizing tangible evidence readily available, scientifically based experiments can easily prove Mormon claims.

610. Washburn, J. Nile. *Book of Mormon Lands and Times.* Bountiful, Utah: Horizon Publishers, 1974. 304 pp.

A detailed *Book of Mormon* geography, constructed independently of maps of the world.

611. Watson, Elden J. *Manuscript History of Brigham Young, 1846-1847.* Salt Lake City: Watson, 1971. 672 pp.

A typescript of Young's holograph diaries for 1846 and 1847. Chronicles the Mormon exodus from Illinois to Utah.

612. Wells, Merle W. *Anti-Mormonism in Idaho, 1872-1892.* Provo, Utah: Brigham Young University Press, 1978. 214 pp.

Detailed history of the rise and fall of this organized movement against Mormonism.

613. Wells, Robert E. *We Are Christians Because...* Salt Lake City: Deseret Book Company, 1985. 119 pp.

Argues that Mormons are indeed Christians because they profess belief in commonly accepted Christian teachings. Twenty points of belief are enumerated and explained.

614. Whalen, William J. *The Latter-day Saints in the Modern Day World.*

Notre Dame, Indiana: University of Notre Dame Press, 1964. 319 pp.

615. Widtsoe, John A. *The Message of the Doctrine and Covenants.* Salt Lake City: Bookcraft, 1969. 191 pp.

Noted Mormon theologian and apostle discusses the theological and religious contents of the *Doctrine and Covenants*, including its literary merits.

616. —————. *Priesthood and Church Government.* Salt Lake City: Deseret Book Company, 1939. 424 pp.

Authorized by the church, and prepared under the direction of the Council of the Twelve Apostles, this is the most detailed and comprehensive handbook to all aspects of the priesthood and the policies and procedures of the church.

617. Wirth, Diane E. *A Challenge to the Critics.* Bountiful, Utah: Horizon Publishers, 1986. 153 pp.

Using non-Mormon scholarly evidences, the author refutes twelve claims against the Book of Mormon made by critics of the church.

618. Witte, Bob and Gordon H. Fraser. *What's Going on in Here?* Gordon H. Fraser, Publisher, nd. 48 pp.

Verbatim transcription of the Mormon temple ceremonies, with explanations of what takes place inside a Mormon temple. Written by former temple workers.

619. Woodruff, Wilford. *Wilford Woodruff's Journal,* in nine volumes. Midvale, Utah: Signature Books, 1983-1985. 5254 pp.

Typescript of this important Mormon leader's diaries from December 29, 1833 to September 2, 1898. Contains valuable material relating to church history, beliefs and practices.

**Church of Jesus Christ of Latter Day Saints
(Gibson)**
Walter Murray Gibson joined the Mormon church in 1860 and served briefly as a missionary in New York. Upon returning to Utah from New York, he was called on a mission to Japan. He left in 1861, but never made it past

the Hawaiian Islands, where he hoped the church would move its head-quarters. He assumed leadership over the Mormon colony on Lanai, and raised funds for the church operations there by selling priesthood offices to the natives. When word finally reached Salt Lake City that the things taking place there were not in accord with previous missionaries' work, a team of leaders was sent to investigate. Their discoveries in 1864 led to Gibson's excommunication.

Gibson remained in Hawaii, and was known as the "Shepherd Saint of Lanai." In 1882 he became the Prime Minister of the Kingdom of Hawaii, a position he filled until the 1887 revolt which forced his resignation and flight to San Francisco. Gibson died in 1888.

620. Barrett, Gwynn. "Walter Murray Gibson: The Shepherd Saint of Lanai Revisited." *Utah Historical Quarterly*, 40 (Spring 1972), pp. 142-162.

Detailed, well-researched story of Gibson. Utilizes Gibson's personal papers and letters.

621. Gibson, Walter M. *Prison of Weltervreden, and a Glance at the East Indian Archipelago.* New York: J. C. Riker, 1855. 495 pp.

Unrelated, except that it contains valuable information on Gibson's earlier life.

622. ───────. *The Shepherd Saint of Lanai.* Honolulu: Thomas G. Thrumm, 1882. 47 pp.

Contains extracts of Gibson's early writings and revelations.

Church of Jesus Christ of Latter Day Saints
or Church of the First Born
(Morris)

Joseph Morris joined the Mormon church in England and came to Utah in 1853. After being cast out of the first community he settled in because of some questionable teachings, he eventually moved to Provo, Utah in 1857, where he received his first revelation which made it known to him that he was to replace Brigham Young as the prophet.

Excommunicated from the Mormon church, Morris moved to the South Weber area, near Ogden, and settled at Kingston's Fort. He began publicly receiving and teachings his revelations. On April 6, 1861 he formally organized his church and by 1862 had gained more than 500 believers.

In the summer of 1862, after a disagreement with a former member of his church, Morris was served with a writ of arrest which he refused to obey.

The Utah militia attacked the fort and Morris was killed. Morris' church fragmented into several movements, which scattered throughout the west.

623. Anderson, C. LeRoy. *For Christ Will Come Tomorrow: The Saga of the Morrisites.* Logan, Utah: Utah State University Press, 1981. 263 pp.

Extensively researched, detailed history of the Morris church, its teachings and the groups which developed after Morris' death. Uses many original sources, and includes an extensive bibliography.

624. Morris, Joseph. *Pearls, or, Selected Paragraphs from the Revelations of Jesus Christ given through Joseph Morris.* San Francisco: George S. Dove, 1891. 74 pp.

Essentially a missionary tract, published by later Morris believers.

625. ————. *The Spirit Prevails.* San Francisco: George S. Dove, 1886. 684 pp.

Revelations, articles and important letters written by Joseph Morris during his short religious career.

The Church of Zion
Late in 1868, William S. Godbe and others became receiving spiritual manifestations and revelations directing them in their efforts opposing Brigham Young and the economic policies being enforced by the church in Utah. Godbe and his followers believed in a more liberal, free enterprise system. The church disappeared almost as quickly as it appeared.

626. Godbe, William S. *Manifesto from W. S. Godbe and E. L. T. Harrison...* Salt Lake City: Godbe and Harrison, 1869. 4 pp.

Proposes reforms in the economic policies of the Mormon Church, as well as the power wielded by Brigham Young.

627. ————. *Polygamy; its solution in Utah—A question of the Hour.* Salt Lake City: Salt Lake Tribune, 1871. 16 pp.

628. ————. *To the public, and especially the Mormon portion of it. Highly Important Communication from W. Godbe.* Salt Lake City: Salt Lake Tribune, 1872. 2 pp.

629. *Utah Magazine.* Salt Lake City: Godbe, et. al., 1868.

> Official magazine of the Church of Zion. First issue released January 1, 1868, ceased December 25, 1869. Contains information vital to understanding this movement: history, theology and commentary.

630. Walker, Ronald W. "The Commencement of the Godbeite Protest: Another View." *Utah Historical Quarterly.* 42 (Summer 1974), pp. 216-244.

> Detailed historical analysis of the movement, its people, and its tenets.

Barnet Moses Giles

In the mid-1870s, Barnet Moses Giles announced that the Mormon Church was wrong because Brigham Young was a false prophet. According to his claims, the leader of the church should be a literal descendant of a tribe of Israel. Giles claimed to be this person, the "one mighty and strong" to set the house of God in order.

631. Giles, Barnet Moses. *The Jews in Jerusalem and the Jews in Utah.* np, nd. 5 pp.

> Unorthodox doctrinal exposition of Israel.

632. ————. *The Pure Testimony to the Church of Jesus Christ of Latter Day Saints and unto all nations of the world.* Salt Lake City: author, 1875. 45 pp.

> Giles sets forth his claims to the prophetic office as a literal descendant of Israel.

633. ————. *The Pyramid. The Pyramid Again, which is in Upper Egypt, by Barnet Moses Giles, the Israelite Prophet of the Tribe of Ephraim.* (Salt Lake City): author, (1879). 7 pp.

634. ————. *A Voice from Our Father and God in Heaven. A Call from His Son, our Lord and Savior, Jesus Christ of Nazareth...* (Salt Lake City): author, (187?). Broadside.

635. ————. *Voice of Warning to the Church of Jesus Christ of Latter Day Saints.* Salt Lake City: author, 1874. 37 pp.

Giles proclaims that he is a literal descendant of the house of Israel.

Church of the First Born
(Dove)

George S. Dove was successful in uniting many of the Joseph Morris movement, who had been scattered at Morris' death in the early 1860s. Dove and others began a more formal church association in the mid-1870s. George Dove's father James had been an Apostle in the earlier movement. George began receiving spiritual communications in 1873 which directed his efforts. The movement seems to have disappeared with George's death, after a considerable contribution to the bibliographic record.

636. Blakely, Albert. *Thus Saith the Lord.* Chicago: author, nd. 4 pp.

637. Dove, George S. *Roll of Membership.* San Francisco: G. S. Dove and Company, 1886. 8 pp.

 Contains the names of persons who accepted baptism into the fullness of the gospel.

638. —————. *Voice from the West to the scattered people of Weber and all the seed of Abraham.* San Francisco: Jos. A. Dove, 1879. 40 pp.

 Exposition of the claims of George Dove in his attempt to unite the Morrisite movement.

639. Dove, James. *Articles of Faith.* San Francisco: Church of the First Born, 1887. 16 pp.

 Basic beliefs published by a committee of the church, which was organized in San Francisco on July 2, 1876.

640. —————. *A Few Items in the History of the Morrisites.* San Francisco: Church of the First Born, c. 1890, 20 pp.

641. —————. *The Man of Sin in the Old and New Church.* San Francisco: Dove and Taylor, Printers, 1893. 51 pp.

642. —————. *Present Knowledge and Past Revealments Combined.* San Francisco: James Dove, 1884. 38 pp.

643. ————. *The Resurrection by Regeneration Compared with a Resurrection from the Grave.* San Francisco: J. Dove, 1891. 44 pp.

644. ————. *A Treatise on Reincarnation or Re-embodiment.* San Francisco: Dove and Taylor, 1892. 46 pp.

645. ————. *A Treatise on the Priesthood by Spiritual Birthright, Reproduction and Election.* San Francisco: J. Dove and Company, 1891. 58 pp.

646. *For a Good Work We Are Stoned.* Detroit, Michigan?: Church of the First Born, nd. 4 pp.

The Priesthood Groups

A number of formally as well as informally organized groups continue to carry out the practice of polygamy, along with a number of other doctrines no longer a part of the Mormon church's theology. The assorted groups in this category generally accept the Mormon church as the correct organization, but claim a higher priesthood authority and prophetic insight which permits them to "retain" the true teachings of the church.

In addition to polygamy, these groups usually accept the concept once taught by Brigham Young that Adam is God. These two distinctives set the "priesthood groups" or fundamentalists apart from the mainstream Mormon church.

Tracing their heritage to the time of John Taylor, who was Mormon church president in the 1880s, the priesthood groups claim that Taylor ordained several men with a special priesthood authority which would permit them to carry on practicing polygamy, even though the public church might give up the unique marital practice.

Several different groups have emerged over the years, each with similar beliefs and practices, but in disagreement over which holds the authentic authority. Prominent leaders have included LeRoy S. Johnson, Rulon C. Allred, Joseph W. Musser.

647. Allred, B. Harvey. *A Leaf in Review.* Draper, Utah: Review and Preview Publishers, 1968. 321 pp.

Argues that, after a careful study of its doctrines and practices, the Mormon church has apostatized from the true gospel. Promotes a fundamentalist viewpoint. A detailed compendium of most doctrines which set the fundamentalist groups apart from the mainstream. The first edition was published at Caldwell, Idaho in 1933. This second edition includes cross references, index, biographical

data about the author, and several appendices including a revelation in John Taylor's handwriting, a visitation by Christ and Joseph Smith to Taylor in 1886, which includes the special priesthood ordinations upon which the fundamentalists base their claims. Also included is a detailed exposition of beliefs regarding an Indian Messiah.

648. Allred, Rulon C. *Treasures of Knowledge,* two volumes. Hamilton, Montana: Bitterroot Publishing Company, 1981. 747 pp.

Covering a period from 1961 to 1977, this is a collection of teachings given by Allred in various church gatherings. Allred was a prominent leader in the fundamentalist movement, heading the Apostlic United Brethren in Salt Lake City. He was gunned down in his Murray, Utah medical office in 1977 by a rival sect. Includes comprehensive index.

649. Anderson, J. Max. *The Polygamy Story: Fiction and Fact.* Salt Lake City: Publishers Press, 1979. 166 pp.

Justifies the Mormon position in opposition to polygamy, and condemns the fundamentalist arguments. Anderson presents his evidence that the fundamentalist claims do not present all the facts.

650. Baird, Mark J. and Rhea A. Baird. *Reminiscences of John W. Woolley and Lorin C. Woolley,* in 3 volumes. np, c. 1975. 172 pp.

Various individuals record their remembrances of these two prominent fundamentalist founding fathers.

651. Bishop, Lynn L. *The Infallible Key to Survival.* Draper, Utah: Bishop, 1974. 23 pp.

Argues that eternal survival is dependent upon one's receipt of the spirit of God and personal revelation.

652. ————. *Preparation for the Setting in Order.* Draper, Utah: Bishop, 1974. 16 pp.

Briefly discusses basic beliefs on plural marriage, consecration, and the one mighty and strong who is believed to be coming in the last days to "set the house of God in order."

653. ———— and Stephen L. Bishop. *The Keys of the Priesthood*

Illustrated. Draper, Utah: Review and Preview Publishers, 1971. 382 pp.

Detailed and extensively documented exposition of the fundamentalist beliefs regarding priesthood authority. Explains the system of priesthood and leadership; how the fundamentalists received their authority; and how the fundamentalist organizations differ from the mainstream church.

654. Black, Robert R. *The Second Anointing, The Patriarchal Priesthood and the Melchizedek Priesthood.* West Jordan, Utah: Mormon Underground Press, 1977. 9 pp.

655. Callear, Clark E. *The Falling Away of the Latter-day Saints.* West Jordan, Utah: Callear, 1979. 149 pp.

Argues that the Mormon church has fallen away from the principles restored by Joseph Smith. Promotes a return to the "old" (or fundamentalist) teachings. Discusses and examines such issues as the *Journal of Discourses*, plural marriage, eternal progression, Adam-God, the Negro, the temple, blood atonement, the united order and the law of tithing. Reminds the reader that although current church leaders want members to "blindly" follow their guidance, early church leaders taught the opposite.

656. Christensen, Culley K. *The Adam-God Maze.* Scottsdale, Arizona: Independent Publishers, 1981. 333 pp.

In-depth analysis of the Adam-God teachings of early church leaders. Presents a favorable presentation of the veracity of this doctrine.

657. *The Coming Crisis: How to Meet It.* Salt Lake City: Truth Publishing Company, nd. 24 pp.

Reprinted from the *Millennial Star* of April 30, 1853, volume 15, pages 273-276, 289-292. This discourse forecasts the end of the world, and discusses such issues as the anti-Christ, natural disasters as the judgements of God and argues that only the Latter-day Saints will be saved because they are the only persons who possess the spirit of revelation.

658. Darter, Francis M. *All Churches and Nations of the the World versus The Kingdom of God.* Salt Lake City: Darter, 1958. 8 pp.

Argues that even though the Mormon church claims to be the Kingdom of God, they have abandoned the true teachings and no longer represent God's work.

659. ———————. *Amazing LDS Prophetic Dates.* Salt Lake City/Salem, Utah: Darter, 1959. 6 pp.

Presents a detailed mathematical formula taking important dates and calculating that the Millennium would begin in 1967.

660. ———————. *Armageddon: Bear versus Lions.* Salt Lake City: Darter, 1943. 40 pp.

Detailed explanation of Darter's prophetic dates and their meaning in the scriptures and in the near future.

661. ———————. *Celestial Marriage.* Salt Lake City: Darter, 1937. 78 pp.

Argues that polygamy is the true order of God's marital covenants with man. Darter was excommunicated from the Mormon church because of his teachings in this booklet.

662. ———————. *The Choice Seer.* Salem, Utah: Darter, nd. 8 pp.

The choice seer, or the one mighty and strong, is to be a "racially marred" Indian from Central America.

663. ———————. *Did Joseph Smith Borrow Masonry?* Salt Lake City: Darter, 1947. 4 pp.

Argues that the Mormon temple ceremonies are a restoration of the original; that Masonry is a corrupted form.

664. ———————. *End of Our Generation or Christ's Coming in Glory.* Salt Lake City: Darter, 1947. 16 pp.

Argues that a prophetic generation is different from a human generation, and lasts up to 1,000 years. This is a third edition, the first was in 1940, the second in 1946.

665. ———————. *End of the Gentile 120 Year Gospel Period Restoration of Israel.* np, 1966. 8 pp.

Argues that the time for the prophecies to be fulfilled is at hand and that the United States is on the verge of being overthrown. The Indian Messiah will soon come forth.

666. —————. *Ensign of Nations.* Salt Lake City: Darter, 1946. 41 pp.

Argues that Wales is the "cradle of liberty" and is the true parent of the United States. Darter claims that the first Christian church was built in Wales by Joseph of Arimathea, Christ's mother, and others who fled Palestine; that a Welsh prince, not Columbus, first discovered America.

667. —————. *The Four Rejected Revelations.* Salt Lake City: Darter, 1948. 24 pp.

This third edition contains the texts of an 1880 revelation to Wilford Woodruff, an 1882 revelation to John Taylor, an 1886 revelation to Taylor, and an 1889 revelation to Woodruff. These revelations deal with the practice of polygamy and were never published by the Mormon church in the United States.

668. —————. *The Gift of the Holy Ghost.* Salem, Utah: Darter, nd. 8 pp.

Argues that contrary to Mormon practice, the priesthood cannot give a person the gift of the Holy Ghost, but can merely ask in the confirmation prayer that a baptized person receive this gift from God.

669. —————. *The Great Pyramid and Its Divine Message.* np, 1936. 1 p.

This large chart presents a diagram of the great Egyptian pyramid and relates all of its engineering calculations to world history and Biblical prophecy.

670. —————. *The Holy Ghost is Who and What.* Salt Lake City: Darter, nd. 20 pp.

Argues that Joseph Smith is the Holy Ghost.

671. —————. *The Holy Priesthood, Temple, "Marriage Garment."* Salem, Utah: Darter, 1961. 16 pp.

Argues that the Mormon church has committed a grave error by modifying the style of the sacred underclothing that Mormons who have participated in the temple are supposed to wear.

672. ————. *Indian Messiah.* Salt Lake City: Darter, 1947. 4 pp.

Records a story that Christ visited with a group of Indians in 1890 after the Mormon church rejected polygamy.

673. ————. *Jesus Christ Versus Lucifer.* Salem, Utah: Darter, 1957. 32 pp.

Argues that the name of Christ's priesthood office is "serpent" and that he was anciently represented as such. Thus, Lucifer once held the same priesthood office, but denied it and now opposes Christ. Darter argues that race segregation is divinely planned.

674. ————. *Keys of the Kingdom—Where?* np, 1945. 8 pp.

Reprints the story of John W. Woolley and his account of receiving a special priesthood authority from John Taylor.

675. ————. *The Kingdom of God.* Salt Lake City: Darter, 1941. 64 pp.

Suggests that the House of Judah is the British Empire and the House of Joseph is the United States; that these two comprise the Kingdom of God.

676. ————. *Michael Adam God.* Salt Lake City: Darter, 1949. 32 pp.

Argues that God became mortal again as Adam and is the literal father of the human race.

677. ————. *The Mormon Proclamation.* np, 1963. 16 pp.

Reprints a proclamation issued by the Twelve Apostles in 1845, wherein they proclaim the existence of the Kingdom of God.

678. ————. *A Mysterious Preacher.* Salt Lake City: Darter, nd. 8 pp.

Recounts several experiences of a minister whom Darter believes

to be one of the ancient Nephite (Book of Mormon) apostles who was promised never to die.

679. ————. *Oh America: Stop and Think, Christ or Chaos.* Long Beach, California: Darter, 1935. 80 pp.

Argues that the world has rejected God's prophets and that God's judgments are about to fall upon the nation.

680. ————. *The Origin of the Temple Veil.* Salem, Utah: Darter, 1955. 24 pp.

Discusses the veil worn by women in Mormon temples and claims this is done to remind them of their secondary place, behind the man. Argues that Adam had more than one wife, and that his first wife, Lillith, was the mother of Cain.

681. ————. *Our Bible in Stone.* Salt Lake City: Deseret News Press, 1931. 183 pp.

Darter, a civil engineer, shows that the pyramids of Egypt were built according to the Bible story, and presents his formula for interpreting the pyramid.

682. ————. *The Testament of Levi.* Salt Lake City: Darter, 1937. 24 pp.

Discusses Darter's belief that prophecy states the Mormon church would have only seven mortal presidents but that the eighth leader would be special, and from without the hierarchy; who would gather the lost tribes.

683. ————. *The Time of the End.* Los Angeles: Wetzel Publishing Company, Inc., 1928. 295 pp.

Darter discusses Mormon beliefs regarding the apostasy of the ancient Christian church, the restoration of the gospel, the ten lost tribes, the American Indian, and Mormon temples.

684. ————. *This Is It.* Salem, Utah: Darter, 1965. 20 pp.

Argues that the Mormon church has changed Joseph Smith's teachings; that Lucifer was the first Christ, Jesus of Nazareth the second.

685. ————. *World's Calendar.* Long Beach, California: Darter, 1934. 1 p.

A detailed chart explaining prophetic dates.

686. ————. *Zion's Redemption.* Salt Lake City: Deseret News Publishing Company, 1933. 224 pp.

Detailed discussion of the last days and the coming of Christ. Major portion of the book focuses on the "one mighty and strong" concept.

687. *The Economic Order of Heaven.* Salt Lake City: Truth Publishing Company, nd. 64 pp.

Sets forth the early teaching of a system of communism known as the United Order, and claims that by having all things common, the people of the world can receive true economic salvation.

688. Fessier, Michael, Jr. "Jessica's Story, The Fundamental Things Apply...," *New West* 4, 27 (December 31, 1979), pp. 17-43.

689. *Follow the Living Prophet...And Excommunicate Joseph Smith?* West Jordan, Utah: Star of Truth Publishing, nd (c. 1980) 35 pp.

"Exposes" the current state of the Mormon church by critiquing a February 2, 1980 speech given by a Mormon leader at Brigham Young University. Claims that if the concepts in the speech were adhered to, and if Joseph Smith were a member of the present-day church, he would be excommunicated.

690. Hone, Richard L. *The History and Theology of Mormon Polygamy.* Provo, Utah: Hone, 1984. 253 pp.

Explains in detail the history and theology of the practice of polygamy, as well as shows how the Mormon church has denied itself of its own heritage and now persecutes those who still believe and practice plural marriage. Detailed and extensively documented.

691. Johnson, Price W. *An Open Letter to All Latter Day Saints on Plural Marriage.* St. George, Utah: Johnson, 1969. 24 pp.

Argues that the Mormon church is in error by claiming, but not believing or practicing, a need for the scriptures and living prophets.

Claims that plural marriage is essential for salvation.

692. Kraut, Ogden. *Adam: Who is He? He is God.* (Salt Lake City):
 Pioneer Press, 1980. 17 pp.

693. ——————. *Blood Atonement.* Salt Lake City: Pioneer Press,
 nd (c. 1981). 215 pp.

 Detailed explanation of this doctrine and the history of its prac-
 tice in the Mormon church dominated state of Utah.

694. ——————. *Following the Leaders/Following the Lord.* (Salt Lake
 City): Pioneer Press, 1980. 16 pp.

695. ——————. *The Gift of Dreams.* Dugway, Utah: Pioneer Press,
 nd. 164 pp.

 Argues that God uses dreams to communicate with persons.
 Explains different kinds of dreams and how to interpret them.

696. ——————. *Polygamy in the Bible.* Salt Lake City: Pioneer Press,
 1983. 295 pp.

 Argues that plural marriage is a plain and simple fact of biblical
 history.

697. ——————. *The Priesthood Garment.* np: Pioneer Press, 1971.
 21 pp.

698. ——————. *Revelation and Worthy Male Members/Revelation and
 the Holy Priesthood.* np: Pioneer Press, 1978. 12 pp.

699. ——————. *Revelations 1880-1890.* np: Pioneer Press, 1979. 58 pp.

 Contains 11 revelations given through John Taylor and Wilford
 Woodruff.

700. ——————. *The Segregation of Israel.* Salt Lake City: Pioneer
 Press, 1979. 220 pp.

 Condemns the Mormon church for ordaining negroes to the
 priesthood. Argues that God created the races and intended them
 to remain segregated.

701. —————. *Seven Deadly Heresies/Did Brigham Young Teach Deadly Heresies?* np: Pioneer Press, 1980. 8 pp.

702. —————. *The United Order.* Salt Lake City: Pioneer Press, 1983. 283 pp.

703. Kunz, Rhea A. *Voices of Women Approbating Celestial or Plural Marriage, Volume 1.* Draper, Utah: Review and Preview Publishers, 1978. 517 pp.

Presents a history of plural marriage through the personal views of many women who have lived this principle.

704. *Marriage.* Salt Lake City: Truth Publishing Company, nd. 107 pp.

Transcript of correspondence between Mormon church apostle Melvin J. Ballard and fundamentalist Eslie D. Jenson. During the mid-1930s these two men debated both sides of the polygamy issue.

705. Merrill, Melissa. *Polygamist's Wife.* Salt Lake City: Olympus Publishing Company, 1975. 168 pp.

The biography of Merrill, recounting her personal experiences and struggles with modern day polygamy.

706. *The Most Holy Principle,* in four volumes. Murray, Utah: Gems Publishing Company, 1970-1975. 1967 pp.

Comprehensive history of polygamy, with extensive documentation and detailed index. Gilbert A. Fulton is the anonymous complier/editor.

707. Musser, Joseph W. *Celestial or Plural Marriage.* Salt Lake City: Truth Publishing Company, 1944. 154 pp.

Compilation of teachings on the subject by early church leaders, with commentary by Musser, a prominent fundamentalist leader.

708. —————. *The Law of Plural Marriage.* Salt Lake City: Truth Publishing Company, nd. 9 pp.

709. —————. *Michael, Our Father and Our God.* Salt Lake City: Truth Publishing Company, 1963. 139 pp.

Detailed explanation of the Mormon concept of deity, focusing on the belief that Adam is God. This is the fourth edition.

710. Newson, Robert C. *Our Vanishing Liberties.* Salt Lake City: np, nd. 44 pp.

711. Openshaw, Robert R. *The Notes, Volume 1.* Pinesdale, Montana: Bitterroot Publishing Company, 1980. 616 pp.

Detailed reference encyclopedia on dozens of beliefs from a fundametalist viewpoint.

712. *A Priesthood Issue and the Law of Plural Marriage.* Salt Lake City: Truth Publishing Company, nd. 39 pp.

Explains how priesthood, including the practice of polygamy, is one of the cornerstones of Mormonism.

713. Reimann, Paul E. *Plural Marriage Limited.* Salt Lake City: Utah Printing Company, 1974. 286 pp.

Argues that people have misunderstood the intent and the extent of the practice of plural marriage. Analyzes the claims of the fundamentalists and refutes their basis, claiming they are misquoting and misrepresenting facts.

714. *A Response to Seven Deadly Heresies.* West Jordan, Utah: Star of Truth Publishing, nd (c. 1980), 16 pp.

Exposes "falsehoods" contained in the June 8, 1980 speech at Brigham Young University by an un-named Mormon apostle (Bruce R. McConkie).

715. Solomon, Dorothy A. *In My Father's House.* New York/Toronto: Franklin Watts, 1984. 312 pp.

Autobiography, detailing life in a modern-day polygamist setting, of one of the daughters of noted fundamentalist leader Rulon C. Allred. Solomon rejected the teachings of her childhood and became involved with mainstream Mormonism.

716. *The Star of Truth.* Salt Lake City: Star of Truth, 1953. 28 pp.

After the main body of fundamentalists split in the early 1950s

over the authority issue, Musser's new group published this monthly periodical. The first issue was volume 1, number 1, January 1953, and continued for only three or four years.

717. Taylor, John. *The Four Hidden Revelations.* np, nd. 36 pp.

Argues in favor of polygamy and presents four revelations given by John Taylor and Wilford Woodruff, the existence of which were denied for many years by the Mormon church.

718. ————. *Revelations to President John Taylor.* np, nd. 25 pp.

Contains the texts of seven revelations, dated from 1882 to 1884.

719. *Truth.* Salt Lake City: Truth Publishing Company, 1935. 12 pp.

Monthly fundamentalist periodical. First issue June 1935. Originally edited by Joseph Musser. When the group split in the early 1950s over the authority issue, Musser started *Star of Truth.* The final issue was Volume 21, number 12, May 1956.

720. *We Believe.* West Jordan, Utah: Star of Truth Publishing, nd. 16 pp.

James Brighouse

In the 1880s, James Brighouse published a series of booklets outlining his beliefs, at Salt Lake City. The only known copies are in a bound volume. Brighouse claimed that through reincarnation, the Mormons were the same people who had been led out of Egypt by Moses, and that he was Adam, Enoch, George Washington and Joseph Smith reincarnate. Although he apparently had a small following, they do not appear to have continued.

721. Brighouse, James. *The Voice of the Seventh Angel, Proclaiming the end of time!* South Cottonwood, Utah: Brighouse, 1887-1892.

Outlines Brighouse's beliefs.

John H. Koyle

Claiming a visitation from Moroni (a Book of Mormon prophet) in 1894, John H. Koyle, a resident of Spanish Fork, Utah and an active local leader in the Mormon church, began teaching that near his place of residence was an ancient gold mine used by the Nephites. The Relief Mine, as Koyle

named it, was supposed to contain sacred records engraved on metal plates, as well as the richest gold ore deposits in the world.

Koyle devoted 55 years of his life, until his death, digging a shaft and erecting a mill--which still stands--and never discovered any ore. At one time the stock being sold was so popular, and the weekly testimony meetings which were being conducted causing such a stir, that the Mormon church officials publicly denounced the project and cautioned church members against investing in it and attending the testimony meetings. Koyle was finally excommunicated from the Mormon church in 1948, just prior to his death.

722. Kraut, Ogden. *John H. Koyle's Relief Mine.* Dugway, Utah: Pioneer Press, 1978. 204 pp.

 Detailed history of Koyle and his "dream mine."

723. Pierce, Norman C. *The Dream Mine Story.* Salt Lake City: Pierce, 1972. 146 pp.

 History of the project by one of Koyle's most ardent supporters.

724. ⸺⸺⸺. *The Three and One-half Years.* Salt Lake City: Pierce, 1963. 210 pp.

 Discusses various esoteric prophecies relating to the "last days," the Mormon church, and how the dream mine and its shareholders are to save the world from economic collapse.

United Order of Equality

Ephraim Peterson and others organized a religious/economic movement around the turn of this century in hopes of building Zion. Peterson and his group established their base of operations in Independence, Missouri--the place designated by Joseph Smith as the location of Zion. Apparently never large, this movement seems to have disappeared, except for its contributions to the bibliographic record.

725. Peterson, Ephraim. *An Ideal City for an Ideal People.* Independence, Missouri: United Order of Equality, 1905. 134 pp.

 Describes how a city should be built on the principles of equality.

726. ⸺⸺⸺. *Plans and Purposes of the United Order of Equality.* Independence, Missouri: United Order of Equality, 1910. 48 pp.

Contains the constitution and by-laws of the organization. Explains that the association is a fraternal maintenance insurance organization that is to redeem land from its present owners so that it can be given to people free of charge.

727. —————. *Redemption.* Independence, Missouri: Peterson, c. 1909. 140 pp.

728. —————. *The Two Systems or Scientific Economics.* Independence, Missouri: United Order of Equality, 1912. 48 pp.

Nathaniel Baldwin

Organized in 1903, Nathaniel Baldwin led a short-lived polygamist group which had as one of its primary purposes the preaching of the gospel to the American Indians. They believed that by accepting the gospel the Indians would become white-skinned.

729. Baldwin, Nathaniel. *Law of Tithing; The Law of Consecration.* Salt Lake City?: Baldwin, c. 1921. 52 pp.

Discussion, with scriptural references.

730. —————. *Spirit of God, the Holy Ghost.* np, nd. 42 pp.

Discussion, with scriptural references.

731. —————. *Times of the Gentiles: Fulness of the Gentiles.* Salt Lake City: Paragon Printing Company, c. 1917. 42 pp.

Discussion, with scriptural references.

Samuel Eastman

Proclaiming himself to be the ''one mighty and strong'' that was prophesied to come in the latter days, Samuel Eastman claimed to have received a heavenly visitation in the spring of 1904 at Salt Lake City. He was successful in organizing a small following, which was active until his death in the 1930s.

732. Eastman, Samuel. *Addresses Delivered by Samuel Eastman.* Salt Lake City: Eastman, 1927. 36 pp.

Discusses the history of his movement and its claims of authority.

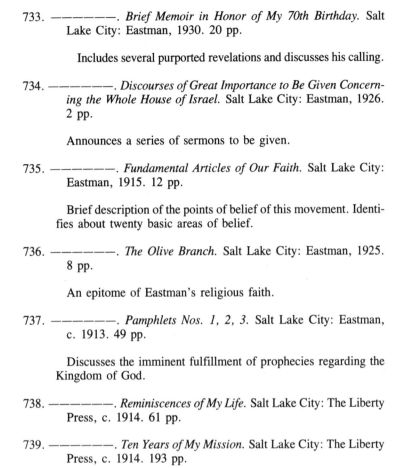

733. ————. *Brief Memoir in Honor of My 70th Birthday.* Salt Lake City: Eastman, 1930. 20 pp.

Includes several purported revelations and discusses his calling.

734. ————. *Discourses of Great Importance to Be Given Concerning the Whole House of Israel.* Salt Lake City: Eastman, 1926. 2 pp.

Announces a series of sermons to be given.

735. ————. *Fundamental Articles of Our Faith.* Salt Lake City: Eastman, 1915. 12 pp.

Brief description of the points of belief of this movement. Identifies about twenty basic areas of belief.

736. ————. *The Olive Branch.* Salt Lake City: Eastman, 1925. 8 pp.

An epitome of Eastman's religious faith.

737. ————. *Pamphlets Nos. 1, 2, 3.* Salt Lake City: Eastman, c. 1913. 49 pp.

Discusses the imminent fulfillment of prophecies regarding the Kingdom of God.

738. ————. *Reminiscences of My Life.* Salt Lake City: The Liberty Press, c. 1914. 61 pp.

739. ————. *Ten Years of My Mission.* Salt Lake City: The Liberty Press, c. 1914. 193 pp.

740. ————. *A Voice in the Wilderness.* (Salt Lake City): Eastman, 1927. 34 pp.

Doctrinal work explaining the reasons for his divergence from the Mormon church.

John Tanner Clark

Clark advocated the restoration of plural marriage, and was excommunicated on May 18, 1905 for this teaching. He claimed to receive angelic

visitations, and that he had been ordained to bring forth the "last records."

741. Clark, John Tanner. *The Lost Records to Come Forth.* (Salt Lake City): Clark, c. 1905. 52 pp.

> Declares the manifesto stopping polygamy to be a "covenant with death and an agreement with Hell."

742. ————. *The One Mighty and Strong.* (Salt Lake City): Clark, c. 1922. 165 pp.

> Presents a fundamentalist view of Mormon belief and history.

Moses Gudmundsen

Moses Gudmundsen, a music professor at Brigham Young University in Provo, Utah, and his brother filed for homestead land at West Tintic, Utah in the spring of 1918. By encouraging friends to do likewise, Gudmundsen was instrumental in establishing a settlement there of about 60 people. A branch of the Mormon church was established, with Gudmundsen presiding. He was later asked to resign because some of his teachings were not in harmony with the church. Gudmundsen began claiming revelation from God.

In the fall of 1920, the principle of "wife sacrifice" was introduced, which permitted men to abandon their wives in favor of a "true" mate.

The colony disbanded in 1921 and Gudmundsen went to California.

743. Culmsee, Carlton. *A Modern Moses at West Tintic.* Logan, Utah: Utah State University Press, 1967. 37 pp.

> Historical and doctrinal essay.

Paul Feil

In September of 1928, Paul Feil claimed to have received a revelation directing him to warn the Mormon church, claiming that its president, Heber J. Grant, had allowed the priesthood to become priest-craft. Close associates claimed that Feil was the "one mighty and strong" and was to be the next president of the Mormon Church.

744. Feil, Paul. *A Solemn Appeal Unto All Israel.* (Salt Lake City): Feil, c. 1929. Broadside.

> Discusses Grant's refusal to read Feil's message to the Mormon conference of October 1928.

745. ————. *The Messenger, The Lord's Servant.* Salt Lake City:
 Feil, 1941.

 Details the doctrines promoted by Feil.

Church of Jesus Christ of Latter Day Saints (Bautista)

Margarito Bautista led this group from The Church of Jesus Christ of Latter Day Saints (Third Convention) in the mid-1930s. The Third Convention had separated themselves from the Mormon Church a short time earlier over disagreements with the Mormon Church leadership in Mexico. Bautista advocated the United Order and polygamy, which led to his separation from the Third Convention. He was later affiliated with the Joseph W. Musser fundamentalist organization as a member of its leading council, but apparently maintained his independence. Many fundamentalists believed that Bautista was the Indian prophet who would be the one mighty and strong.

In addition to the works listed below, Bautista also wrote and published a number of books in Spanish. He died on August 6, 1961.

746. Bautista, Margarito. *A Decree, Covenants and Promises Taken from
 the Earth.* Ozumba, Mexico: Colonia Agricola Industrial Mexi-
 cana, 1959. 39 pp.

 Argues that the Gentiles will reject the gospel. Promotes the
 Book of Mormon, especially as its promises relate to the American
 Indian. Includes correspondence between Bautista and Noel B.
 Pratt, a former leader in the LeBaron movement (below).

747. ————. *In Defence of the Rights of the House of Israel.* Ozumba,
 Mexico: Colonia Agricola Industrial Mexicana, 1958. 48 pp.

 Argues that the American Indians are the true Israelites.

748. ————. *Wilt Thou Restore the Kingdom to Israel?* Ozumba,
 Mexico: Colonia Industrial Mexicana, 1952. 224 pp.

 Extensive doctrinal work explaining the law of consecration,
 polygamy and promoting the Indians as the house of Israel.

Order of Aaron

Although not raised in the Mormon faith, founder Maurice L. Glendenning began receiving spiritual messages, or revelations, at a very young age. He did not understand these and was hesitant about sharing them with others,

including his wife after they were married. Moving to Utah in 1928 in search of employment, the Glendennings came into contact with the Mormon church and were baptized in 1929. He hoped that his revelations would be received by church leaders and explained. However at the April 1931 conference of the church, they were publicly, although not specifically, rejected.

Based on two ancient documents in the Glendenning family, Maurice was raised with the claim that he was a literal descendant of the tribe of Levi, and as such was a Levitical priest. During the 1930s, Glendenning established informal study groups, and claimed that an angel restored the keys of the priesthood to him in 1938. The Order of Aaron was incorporated in 1943, and Glendenning was excommunicated from the Mormon church in 1945.

Although the movement claims they are not a faction or break from the Mormon church, most of its earlier members had been Mormons, and its doctrine and practices were initially influenced by Mormonism.

The group leads a communal society in western Utah, farming and ranching to meet the needs of its members.

749. *Aaron's Star*. Salt Lake City: Order of Aaron.

> Official periodical. Issues are not numbered, and frequency is sporadic. Mailing and printing offices were moved to New Haven, Indiana with the April 1985 issue. Primary source for doctrinal discourses and brief news.

750. Beeston, Blance W. *Now My Servant*. Caldwell, Idaho: Caxton Printers, Ltd., 1957. 216 pp.

> Detailed biography of Maurice L. Glendenning.

751. ————. *Purified as Gold and Silver*. Caldwell, Idaho: Caxton Printers, Ltd., 1966. 315 pp.

> Details the doctrinal foundations of the Order of Aaron.

752. ————. *Some Thoughts for Latter Day Saints to Consider*. Murray, Utah: Aaronic Order, nd. 11 pp.

> Reprints a letter dated January 16, 1960.

753. Childs, Bliss. *The Church of Christ*. np, nd. 19 pp.

754. ————. *The Lord Has Said*. np: The Supreme Council, Utah Division, nd. 12 pp.

755. ————. *We Believe.* Salt Lake City: Order of Aaron, nd. 22 pp.

756. ————. *What Are the Requirements for Eternal Life.* Murray, Utah: Aaronic Order, 1979. 6 pp.

757. *Christian Levites.* Murray, Utah: Aaronic Order, nd. 6 pp.

758. Conrad, Robert J. *General Background of the Aaronic Order and True Church of God.* Murray, Utah: Aaronic Order, 1980. 3 pp.

759. ————. *Levitical Communities and Collective Stewardships.* np: Aaronic Order, 1975. 14 pp.

760. ————. *The Levitical Communities of Shiloh.* Murray, Utah: Aaronic Order, 1980. 4 pp.

761. ————. *What is the Aaronic Order.* Murray, Utah: Aaronic Order, 1980. 4 pp.

762. *Cost of Discipleship.* Murray, Utah: Aaronic Order, 1950. 10 pp.

Argues that the true disciple of Christ consecrates all of his or her possessions to the fellowship.

763. Erickson, Ralph D. "The History and Doctrinal Development of the Order of Aaron." M.A. Thesis. Brigham Young University, 1969. 161 pp.

A complete history to 1969. Includes detailed material on the doctrines of the movement and their unique communal lifestyle. The contents of this thesis were read and endorsed by Glendenning.

764. Glendenning, M. L. *Cost of Discipleship, Part II.* Murray, Utah: Order of Aaron, nd. 8 pp.

765. ————. *Cost of Discipleship, Part III.* Murray, Utah: Aaronic Order, nd. 12 pp.

Written for "LDS inquirers after truth."

766. ————. *Levitical Writings.* EskDale, Utah: Aaronic Order, 1978. 263 pp.

Contains all the revelations received by Glendenning. This is a

new edition, combining a number of smaller works which were previously published. Titles of these works were "Book of Elias," "Book of New Revelations," and "Disciple Book." When first published, Glendenning numbered his revelations beginning with "section 137." At that time, the Mormon Doctrine and Covenants ended with section 136. Glendenning viewed his revelations as a continuation of Joseph Smith's works. This unique numbering system has been lost in this new edition of the revelations.

767. —————— and Helen Glendenning. *An Everlasting Priesthood.* Murray, Utah: Aaronic Order, nd. 13 pp.

Contains a February 7, 1965 letter.

768. *A Letter to Joseph, #1.* Murray, Utah: Aaronic Order, nd. 8 pp.

769. *A Letter to Joseph, #2.* Murray, Utah: Aaronic Order, nd. 13 pp.

770. *A Letter to Joseph, #3.* Murray, Utah: Aaronic Order, nd. 9 pp.

771. *Lineal Israel in the Latter Days.* Murray, Utah: Aaronic Order, nd. 8 pp.

Argues that the House of Levi is to be the gatherer and provide the leadership prior to the coming of Christ.

772. *War, Christianity and Religion.* Murray, Utah: Aaronic Order, nd. 12 pp.

Zion's Order of the Sons of Levi

Organized at Phoenix, Arizona in 1951, Zion's Order has attempted to promote a communal lifestyle on a ranch near Mansfield, Missouri. The founder, Marl V. Kilgore, claimed a call from God in 1938 to work with some of the Latter Day Saint churches in re-establishing the United Order. He joined the Order of Aaron in 1950, but left in 1951.

Kilgore resigned the leadership of his group in 1969 in order to work among the Indians. He claims to have received over 600 revelations which have helped guide his efforts.

773. Kilgore, Marl V. *Equality of the Living Creator, Gods.* np: Zion's Order, 1980. 4 pp.

774. ——————. *Forgiving One Another.* np: Zion's Order, 1980. 1 p.

775. —————. *How Great Our Creator Lord/Is Unity Living Essential?* np: Zion's Order, 1980. 10 pp.

776. —————. *Quantic Poems.* np: Kilgore, 1970. 40 pp.

> Revelations explaining the doctrines of the group, received and recorded in poem.

777. —————. *Reincarnation Scriptures and Comments.* Mansfield, Missouri: Zion's Order of the Sons of Levi, nd. 5 pp.

778. —————. *To Whom It May Concern.* np: Zion's Order, Inc., 1977. 4 pp.

779. —————. *Will You and Your Minister or Teacher Endure Sound Doctrine.* Tularosa, New Mexico/Mansfield, Missouri: Zion's Order of the Sons of Levi, nd. 7 pp.

780. —————. *You Must Forgive, If You are to be Forgiven.* np: Zion's Order, 1981. 2 pp.

781. *Proforma Decree of Incorporation of Zion's Order, Inc.* np: Zion's Order, c. 1967. 5 pp.

Annalee Skarin

Annalee Skarin's first book *Ye Are Gods* was published in 1948. She refers extensively to Mormon doctrine in that volume and became a popular lecturer in the church. However, she was excommunicated for teaching false doctrine in 1952.

Skarin's teachings include a belief that one can become perfected in earth life, and when one overcomes sin he overcomes death. She claims that she has been "translated," that is becoming immortally resurrected without having died.

782. Mercie, Christine. *Sons of God.* Marina del Rey, California: DeVorss and Company, 1954. 159 pp.

> Mercie is a pseudonym for Skarin. Chronicles a visit to heaven, and recites some of Skarin's basic beliefs.

783. Skarin, Annalee. *Beyond Mortal Boundaries.* Santa Monica, California: DeVorss and Company, 1969. 342 pp.

Argues that death is a dreary, back door entrance to the other world; that there is another way for mortals to pass through. Describes the three degrees of glory to which persons will be assigned after this life.

784. ————. *The Book of Books.* Santa Monica, California: DeVorss and Company, 1972. 333 pp.

Contains the doctrines that Christ wanted to teach his disciples at the last supper, but did not.

785. ————. *Celestial Song of Creation.* Santa Monica, California: DeVorss and Company, 1962. 212 pp.

Claims to teach secrets inherent in humans, but unknown by them, which will permit them to attain the full measure of their creation.

786. ————. *The City of the Sun Foundation's Binder, Unpublished Materials of Annalee Skarin.* Columbus, New Mexico: City of the Sun Foundation, 1983. 62 pp.

787. ————. *If Ye Are Prepared Ye Shall Not Fear.* np, nd. 4 pp.

788. ————. *The Light of Christ.* np, nd. 14 pp.

789. ————. *Man Triumphant.* Santa Monica, California: DeVorss and Company, 1966. 253 pp.

Argues that the Kingdom of Heaven is within each person's soul. Presents a way of learning how to use God's power of creation, to achieve the Kingdom of Heaven.

790. ————. *The Mighty Power of Faith.* np, nd. 4 pp.

791. ————. *Overcoming Darkness.* np, nd. 5 pp.

792. ————. *Personal Glimpses.* np, nd. 7 pp.

793. ————. *Purification and Perfection.* North Hollywood, California: David Vine Publishers, nd. 7 pp.

794. ————. *Secrets of Eternity.* Santa Monica, California: DeVorss and Company, 1960. 287 pp.

Argues that love, or the light of Christ, is resident in the soul of each human, and it could bring great healing into the world if man would accept and learn how to use it.

795. ————. *The Temple of God.* Santa Monica, California: DeVorss and Company, 1958. 224 pp.

Argues that anything conceived by human thought can be brought forth into actuality. This creative power is waiting at all times to be made manifest within man.

796. ————. *To God the Glory.* Santa Monica, California: DeVorss and Company, 1956. 196 pp.

Purports to be a divinely inspired message revealing how God's love is being poured out in abundance and if man will accept it, can change his life and lead him into God's kingdom.

797. ————. *Ye Are Gods.* New York: Philosophical Library, 1952. 343 pp.

Skarin's first book, second edition, in which she mentions Moroni—a Book of Mormon prophet. This book shows that man himself creates every condition on earth, and that the eternal source of power is released within man.

798. ————. *You Shall Comprehend Even God.* np, nd. 15 pp.

The Church of the Firstborn of the Fulness of Times

Although they were raised in the Mormon faith, the Alma Dayer LeBaron family claimed a special priesthood authority, which had been passed from generation to generation, beginning with Joseph Smith, Jr. This authority was to be held dormant until the Lord directed its use in reestablishing the church.

Joel F. LeBaron claimed ordination by his father Alma, and officially organized "The Church of the Firstborn of the Fulness of Times" on April 3, 1956, although the full organization was not completed for several years.

In 1958 a number of Mormon missionaries in France became converted to this new church and were sent home. Many of them became apostles. However, since Joel's assassination in 1972, the church has dwindled and none of the former Mormon missionaries are presently affiliated with the church.

Church headquarters is at Colonia LeBaron, in Chihuahua, Mexico.

799. Allred, Harold. *The Scepter, The Church of the Firstborn, John the Baptist, A Defence of Truth, Peter's Authority.* Fruitland, Idaho: Allred, 1958. 13 pp.

800. Burrup, Ray. *Colonia LeBaron.* np: Church of the Firstborn of the Fulness of Times, nd. 1 p.

 A poem about the church's headquarters.

801. Butchereit, John G. *Priesthood and Prophecy.* Colonia LeBaron: Church of the Firstborn of the Fulness of Times, 1962. 68 pp.

 The author, a former fundamentalist leader, explains the doctrinal differences between the Mormon fundamentalists and the Church of the Firstborn of the Fulness of Times. Explains the authority held by Brigham Young and Peter, James and John.

802. Darter, Francis M. *F. M. Darter versus Joel F. LeBaron, Etc.* Salem, Utah: Darter, 1964. 24 pp.

 Darter argues errors in the LeBaron theology.

803. *The Deliverer.* Salt Lake City/Bellflower, California: The Church of the Firstborn of the Fulness of Times, nd. 8 pp.

 Argues that Joel F. LeBaron is the deliverer who was promised in Romans 11:25-27. Presents details of his mission and his authority. Explains that this new leader is needed because the Latter Day Saints have departed from the fullness of the gospel.

804. Denham, James R. *The Law of Consecration.* Salt Lake City/El Paso, Texas/Bellflower, California: The Church of the Firstborn of the Fulness of Times, nd. 10 pp.

 Describes in detail the law of consecration and argues that it is not communistic because the properties are not held in common, but each person receives a stewardship to which legal title is granted.

805. ——————. *Modern Predictions of the Great Latter-day Apostasy.* Salt Lake City/El Paso, Texas/Bellflower, California: The Church of the Firstborn of the Fulness of Times, nd. 8 pp.

 Argues that the Mormon church, in its efforts to become accepted

by and acceptable to the world, has forsaken gospel truths which action places that church in a state of apostasy.

806. ————. *Modern Predictions of the Great Latter-day Apostasy, Supplement.* Salt Lake City/Bellflower, California: The Church of the Firstborn of the Fulness of Times, nd. 2 pp.

Additional information, to be added to the previous item of the same title.

807. Dockstader, George L. *An Epistle to the Blind.* Colonia LeBaron, Mexico: Mexican Mission, The Church of the Firstborn of the Fulness of Times, nd. 41 pp.

808. *Economic Reformation Begins.* Salt Lake City/Bellflower, California: The Church of the Firstborn of the Fulness of Times, nd. 8 pp.

Argues that by strict obedience to the commandments of God, persons might find the most effective means of promoting the welfare and secure happiness of the human race.

809. *The Ensign.* El Paso, Texas: The Church of the Firstborn of the Fulness of Times, 1961. 16 pp.

Official periodical of the church. Volume 1, number 1 carries the date of March, 1961. The publication was monthly, with variations in the number of pages. In March, 1964, publication offices were moved to Bellflower, California. Ceased in the mid-1960s. Primary source for church theology.

810. *God's Political Kingdom and Its Constitutional Law.* np: The Church of the Firstborn of the Fulness of Times, nd. 16 pp.

Argues that the church and the kingdom of God are separate entities, with separate organizational structures. The day is coming when, although men may belong to differing religious denominations, they will be governed under one political system.

811. Jensen, Earl L. *Official Proclamation.* Salt Lake City/El Paso, Texas/Bellflower, California: The Church of the Firstborn of the Fulness of Times, nd. 4 pp.

Declares that Joel F. LeBaron is the deliverer who is to save mankind and the church; that the Mormon church suffers from

pride and is in error.

812. Jordan, Daniel B. *The LDS Church in Prophecy.* Salt Lake City/ Bellflower, California: The Church of the Firstborn of the Fulness of Times, nd. 4 pp.

Argues that the Mormon church errs in believing they are the kingdom of God. The true kingdom will have social and economic programs, as well as religious.

813. ――――――. *A Plot Against Liberty vs A Plan of Life.* Arcadia, California: The Church of the Firstborn of the Fulness of Times, nd. 12 pp.

Describes "fatal steps in Mormon history" to illustrate that the Mormon church has abused the gospel and thus the need for a new leader to re-establish God's programs.

814. LeBaron, Charlotte K. *Events Incident to the Martyrdom and Burial of Joel F. LeBaron.* El Paso, Texas: The Church of the Firstborn of the Fulness of Times, 1973. 16 pp.

815. LeBaron, Ervil M. *Priesthood Expounded.* Colonia LeBaron, Mexico: The Church of the Firstborn of the Fulness of Times, 1956. 56 pp.

Details the church's theology of priesthood, and how it claims proper authority to minister.

816. LeBaron, Floren M. *Open Letter to Ervil M. LeBaron.* np: The Church of the Firstborn of the Fulness of Times, nd. 3 pp.

817. LeBaron, Joel F. *And The Time Came That The Saints Possessed the Kingdom.* Colonia LeBaron: T. J. Liddiard, nd. 8 pp.

Explains that the church and the kingdom of God are two separate and distinct organizations.

818. ――――――. *A Challenge to All Men.* Buenaventura, Chihuahua, Mexico: The Church of the Firstborn of the Fulness of Times, 1957. 4 pp.

Denounces the members of the Mormon church-court who tried LeBaron for his membership in that church.

819. —————. *Kingdom.* El Paso, Texas: Kingdom of God Foundation, 1974. 4 pp.

Argues that most churches uphold and sustain civil kingdoms and governments at the expense of God's kingdom.

820. —————. *The Prophet's Challenge.* np: The Church of the Firstborn of the Fulness of Times, nd. 4 pp.

Presents 60 questions on theology to which LeBaron challenges the Mormon church to debate.

821. —————. *The Separation of Church and State.* Colonia LeBaron: The Church of the Firstborn of the Fulness of Times, 1971.

822. —————. *Thus Saith the Lord.* np, nd. 6 pp.

Contains the text of a 1958 revelation given thru Joel F. LeBaron to Rulon C. Allred, a noted Utah polygamist leader. Allred is called to join with the LeBaron movement.

823. LeBaron, Verlan M. *The Church of The Firstborn Raises a Standard of Peace to Its Attackers.* Colonia LeBaron, Mexico: The Church of the Firstborn of the Fulness of Times, 1985. 1 p.

824. —————. *Economic Democracy Under Eternal Law.* Bellflower, California/Salt Lake City: The Church of the Firstborn of the Fulness of Times, 1963. 76 pp.

Published as the June 1963 issue of *The Ensign*, LeBaron details the church's theology of God's laws in relationship to the economics of life.

825. —————. *The LeBaron Story.* Lubbock, Texas: Verlan LeBaron, 1981. 316 pp.

In-depth history of the church and the LeBaron family. Includes synopsis of beliefs, recent events and photos.

826. —————. *The Restoration of All Things.* Bellflower, California: The Church of the Firstborn of the Fulness of Times, nd. 13 pp.

Rebuts anti-LeBaron publications which were coming out of Salt Lake City, apparently under Mormon church sponsorship.

Specifically singled out are the writings of Henry W. Richards. (See item 835)

827. Liddiard, Thomas J. *The Government of the Church of God.* LeBaron, Mexico: The Church of the Firstborn of the Fulness of Times, 1968. 261 pp.

A detailed response to the publications of Henry W. Richards and the Mormon church. (See item 835)

828. McConkie, Bruce R. *Cultism as Practiced by the So- Called Church of the Firstborn.* np: author, nd. 38 pp.

This is a second, revised edition of the author's "How to Start a Cult." An uncomplimentary criticism of the LeBaron movement. McConkie later became an apostle in the Mormon Church.

829. Parson, Joseph C. *Inhabitants of Zion Shall Judge All Things.* Chihuahua City: The Church of the Firstborn of the Fulness of Times, c. 1965. 5 pp.

A letter to Henry W. Richards.

830. *The Power of Choice.* El Paso, Texas: The Church of the Firstborn of the Fulness of Times, 1972. 4 pp.

Argues that civil governments have abused their powers.

831. Pratt, Noel B. *An Apology of Conscience.* np: Pratt, 1959. 24 pp.

After Pratt published his beliefs regarding the errors he found in the church, and why he left the organization, he reprints assorted letters from former church associates wherein they defend their position. Pratt responds to their arguments.

832. ————. *An Open Letter to the Juarez Stake.* Buenaventura, Mexico: The Church of the Firstborn of the Fulness of Times, 1956. 2 pp.

833. ————. *To All Members of the Church of the Firstborn of the Fulness of Times.* np, nd. 4 pp.

834. ————, editor. *The Rolling Stone.* Salt Lake City: The Church of the Firstborn of the Fulness of Times, 1957. 4 pp.

Missionary periodical published on behalf of the church. Monthly. First issue June, final issue, number 11, December 1958. With the final issue, Pratt published his reasons for having to leave the church.

835. Richards, Henry W. *A Reply to the Church of the Firstborn of the Fulness of Times.* Salt Lake City: Richards, 1965. 159 pp.

Examines the LeBaron movement in detail and argues that the Mormon church is the true church; that the LeBarons are in error in organization, priesthood authority, apostleship.

836. Shore, David T. *The Lord's Strange Act.* np: The Church of the Firstborn of the Fulness of Times, nd. 1 pp.

837. ————. *Prophecies of the Fulness of Times.* Van Nuys, California: California Mission, The Church of the Firstborn of the Fulness of Times, nd. 3 pp.

838. Silver, Stephen M. *An Account from the Journal of a French Missionary.* Colonia LeBaron: The Church of the Firstborn of the Fulness of Times, nd. 6 pp.

Describes the events of August 1956 to September 1958 while serving in France as a Mormon missionary. He recounts his conversion to the Church of the Firstborn and his excommunication from the Mormon church.

839. Smith, Joseph, Jr. *The White Horse Prophecy.* np: The Church of the Firstborn of the Fulness of Times, nd. 8 pp.

Recounts an alleged 1843 prophecy by Smith which describes the last days, and the final wars at the end of the world. Russia is identified with the forces of evil.

840. Spencer, Hector J. *Why I Returned to the LDS Church.* Colonia LeBaron: The Church of the Firstborn of the Fulness of Times, 1963. 19 pp.

Spencer left the Mormon church and joined the LeBaron movement, then returned to the Mormon church, and finally reunited with the LeBaron movement and became an apostle.

841. Stubbs, Lawrence R. *Celestial Glory.* Hachita, New Mexico: Stubbs,

nd. 19 pp.

842. —————. *Freedom from Economic Bondage.* Buenaventura, Mexico: Stubbs, nd. 45 pp.

843. —————. *The Kingdom of God.* Hochita, New Mexico: Stubbs, 1975. 107 pp.

844. Tippetts, Harold D. *Mormons Predict the Fall of the U. S.* Estacion Babicora, Mexico: The Church of the Firstborn of the Fulness of Times, nd. 8 pp.

845. Tucker, William P. *In Reply to Bruce R. McConkie.* LeBaron, Mexico: The Church of the Firstborn of the Fulness of Times, 1963. 38 pp.

 Responds to McConkie's "How to Start a Cult." (See item 828)

846. Wakeham, J. Bruce. *Dear Brothers and Sisters.* np: The Church of the Firstborn of the Fulness of Times, 1959. 1 p.

847. —————. *Joseph Smith Curses Present Day LDS Leaders.* Salt Lake City/Bellflower, California: The Church of the Firstborn of the Fulness of Times, nd. 8 pp.

 Compares current Mormon teachings with those of Joseph Smith, Jr. and shows how the present Mormon church has strayed from the truth.

848. —————. *Official Warning to Mormons.* Salt Lake City/ Bellflower, California: The Church of the Firstborn of the Fulness of Times, nd. 4 pp.

 Outlines the basic requirements for membership in the kingdom of God. Those who do not obey will be damned.

849. *Why We Are Leaving the LDS Church.* np: The Church of the Firstborn of the Fulness of Times, nd. 8 pp.

 Open letter written to Mormon church leaders accusing the Mormons of various crimes and errors. Signed by 39 people.

850. Widmar, Siegfried J. *Ensign News, 1984.* El Paso, Texas: The Church of the Firstborn of the Fulness of Times, 1984. 28 pp.

Newsletter outlining current events in the church.

851. —————. *Ensign News, 1985.* El Paso, Texas: The Church of the Firstborn of the Fulness of Times, 1985. 2 pp.

852. —————. *Free Agency and Rights of Conscience.* Salt Lake City, Utah: Widmar, nd. 8 pp.

Outlines perceived abuses by Mormon church officials, including Bruce R. McConkie's "How to Start a Cult" article.

853. —————. *The Political Kingdom of God.* El Paso, Texas: Widmar, 1975. 107 pp.

Expounds the church's theology of the last days and the Second Coming of Christ.

854. —————. *Thus Joel Taught.* Colonia LeBaron: The Church of the Firstborn of the Fulness of Times, 1984. 105 pp.

Collection of revelations, testimonies, and teachings of Joel F. LeBaron.

855. Wright, Lyle O. "Origins and Development of The Church of the Firstborn of the Fulness of Times." MS Thesis. Brigham Young University, 1963. 266 pp.

Extensive analysis of the history and theology of the church, from a Mormon perspective.

856. Wyatt, Clair L. *Some That Trouble You.* Salt Lake City: Bookcraft, 1974. 92 pp.

Condemns the fundamentalist groups and the members of the Church of the Firstborn as being in error. Argues that only Mormons have the truth.

857. Young, W. Ernest. *A Questionnaire for the LeBaron Pretenders.* np: Young, nd. 3 pp.

Mormon writer asserts the error of the LeBaron movement.

The Church of the Firstborn

Ross Wesley LeBaron, an older brother to Joel, asserted that he actually received the special priesthood authority from his father prior to Joel. After a brief period of accepting his brother's leadership, Ross filed for the incorporation of a separate church on December 1, 1955. Because LeBaron never had a church per se, but taught persons as independent members, many of the writers included below are writing from their own understandings, influenced in part by LeBaron.

858. Black, Robert R. *The Second Anointing, the Patriarchal Priesthood and the Melchizedek Priesthood, being a Reply to Dennis Short.* West Jordan, Utah: Mormon Underground Press, 1977. 9 pp.

859. Collier, Fred C. *The Church of the Firstborn and The Holy Order of God.* np: Collier, 1977. 16 pp.

Argues that there are two separate churches—the Church of Jesus Christ and the Church of the Firstborn, both part of God's restoration plan.

860. ————. *The Church of the Firstborn, part 1.* West Jordan, Utah: Mormon Underground Press, 1978. 17 pp.

861. ————. *The Enigma of Book of Mormon Theology.* Salt Lake City: Collier, 1985. 66 pp.

862. ————. *Priesthood and the Law of Succession.* np: Collier, 1978. 6 pp.

Argues the existence of certain "private councils" which were organized at Nauvoo, Illinois in the 1840s by Joseph Smith, Jr., and that the actions of these councils, not the scriptures, dictate succession in priesthood authority.

863. ————. *Re-Examining the Lorin Woolley Story.* Salt Lake City: Collier's Publishing Company, 1981. 17 pp.

A rebuttal to J. Max Anderson's "Polygamy Story: Fiction and Fact."

864. Eaby, Robert W. *The Johnson-LeBaron Story.* Salt Lake City: The Church of the Firstborn, 1958. 3 pp.

865. Hansen, Wendell. *Major Fundamentalist Groups as Outlined by Ross*

LeBaron. Ogden, Utah: Hansen, 1961. 3 pp.

866. Ivins, H. Grant. *Polygamy in Mexico as Practiced by the Mormon Church, 1895-1905.* Salt Lake City: Collier's Publishing Company, 1981. 42 pp.

Documents and discusses the continuation of polygamy after the 1890 "manifesto" which declared that the Mormon church had abandoned its practice.

867. LeBaron, Ross W. *Articles of Faith.* Sandy, Utah: The Church of the Firstborn, 1955. 1 p.

Outlines 13 basic beliefs.

868. ————. *Brigham Young Speaks.* np: The Church of the Firstborn, 1975. 41 pp.

Documents numerous references wherein Brigham Young taught that Adam was God.

869. ————. *The Church of the Firstborn.* LeBaron, Mexico: The Church of the Firstborn, c. 1962. 32 pp.

Contains revelations given to LeBaron between the years 1940 and 1962, with remarks on his experiences.

870. ————. *Official Declaration.* np: The Church of the Firstborn, 1967. 1 p.

871. ————. *Open Letter to F. M. Darter.* Salt Lake City: The Church of the Firstborn, 1968. 1 p.

872. ————. *Proclamation.* np: The Church of the Firstborn, 1968. 8 pp.

Declares that Joseph Smith's dispensation and priesthood authority have been terminated, and that LeBaron holds all authority to act for God.

873. ————. *Prophecy of Our Time.* np: The Church of tne Firstborn, nd. 1 p.

874. Young, Brigham. *Unpublished Discourse of Brigham Young, 1854.*

np: The Church of the Firstborn, 1974. 31 pp.

Provides several accounts of this important discourse expounding the belief that Adam is God, including the official church report, recorded by G. Watt. Never before published.

United Outcasts of Israel/American Indian Restoration Enterprises/ Praetorian Press

Noel B. Pratt was once associated with the LeBaron movement, but left that organization in 1958 after discerning what he felt were problems with the leadership and doctrinal errors.

Pratt worked with a number of projects over the years. The United Outcasts of Israel was an organization which promoted a barter system. After this dissolved in 1960, he founded the American Indian Restoration Enterprises, which was dedicated to the preservation and eventual coming forth of the American Indian as true Israelites.

Today Pratt publishes his beliefs through the Praetorian Press. He is still a firm advocate of the Book of Mormon and its promises to the native Americans.

875. Pratt, David Leon. *The Fall of the Mormon Empire, Volume 1.* Salem, Massachussetts: The Praetorian Press, 1985. 47 pp.

Argues that the Mormon Church has departed from the truth. Present numerous scriptures and compares them with present-day Mormon teachings and practices.

876. ————. *The Fall of the Mormon Empire, Volume 2.* Salem, Massachussetts: The Praetorian Press, 1985. 61 pp.

Argues that although God warned the early Mormons they did not heed his call. Presents Pratt's views of what God intended for the Book of Mormon and the church.

877. ————. *The Fall of the Mormon Empire, Volume 3.* Salem, Massachussetts: The Praetorian Press, 1986. 48 pp.

878. ————. *God's Standard.* Salem, Massachussetts: The Praetorian Press, nd. 5 pp.

879. ————. *Grandfather's Purse.* Salem, Massachussetts: The Praetorian Press, 1985. 3 pp.

Presents a message to all North American Indians in the form of an ancient Indian legend. Without so saying, presents the Book of Mormon as a history of that race.

880. ――――――. *The Messiah.* Salem, Massachussetts: The Praetorian Press, 1985. 4 pp.

Expounds views on the mission of the Messiah.

881. ――――――. *The Prehistoric Hebrews of New England.* Salem, Massachussetts: The Praetorian Press, 1985. 180 pp.

An edition of the Book of Mormon, without so saying, paraphrased and commented upon by Pratt.

882. ――――――. *Prehistorics.* Salem, Massachussetts: The Praetorian Press, 1985. 9 pp.

Proposes that the entire drama of the Book of Mormon was played out in the New England area of the United States, rather than in Central and South America, as some theories suggest.

883. ――――――. *Priesthood.* Salem, Massachussetts: The Praetorian Press, 1985. 55 pp.

Detailed exposition of the doctrine of priesthood, with a scriptural framework for proper beliefs about the godhead, baptism, confirmation.

884. Pratt, Noel B. *AIRE Bulletin.* Alexandria, Virginia: American Indian Restoration Enterprises, 1961. 6 pp.

Periodical devoted to the interests of the American Indians in relationship to the prophecies regarding their future in the Book of Mormon. First issue dated July 15, 1961, final issue July, 1962.

885. ――――――. *The Bank of the Covenants.* Alexandria, Virginia: Pratt, 1959. 2 pp.

Explains Pratt's barter system of exchange.

886. ――――――. *Credit News.* Alexandria, Virginia: The Credit Association, 1959. 6 pp.

Newsletter whereby members could offer items for trade. Ceased about 1960.

887. ————. *Crier.* Independence, Missouri: Pratt, 1966. 2 pp.

Proposed weekly newsletter publishing the events of the final gathering to Zion, which Pratt was promoting. First issue January 16, 1966. Approximately 8 issues were published, issue 8 appearing on May 8, 1966.

888. ————. *Dear Friend.* Alexandria, Virginia: Pratt, 1960. 2 pp.

Announces the dissolution of the Credit Association.

889. ————. *The Freedom of Exchange.* Alexandria, Virginia: Bank of the Covenants, nd. 2 pp.

Argues that people are free to choose the freedom from using U. S. currency.

890. ————. *Government of the United Outcasts of Israel.* np: United Outcasts of Israel, 1958. 3 pp.

891. ————. *The Hopi Message.* Alexandria, Virginia: The American Indian Restoration Enterprises, 1961. 34 pp.

Reports of various historical incidents and spiritual manifestations among the Hopi tribe, from 1959 to 1961.

892. ————. *Interchange Directory.* Alexandria, Virginia: The Bank of Interchange, 1962—seventh edition, 16 pp.

Directory of members wishing to trade items.

893. ————. *Repent.* Alexandria, Virginia: Pratt, 1961. 2 pp.

Proposed biweekly newsletter promoting the cause of repentance. Eight issues were published between January 1961 and April 1961.

894. ————. *Satan's Finest Hour.* Unity, Maine: The Praetorian Press, 1986. 197 pp.

Detailed doctrinal exposition of the state of the Mormon church, declaring impending doom.

895. ————. *The Star of Mount Zion.* Alexandria, Virginia: The
Armies of Zion, 1961. 10 pp.

Proposes the raising of a holy army to proceed to Independence,
Missouri to "redeem Zion."

896. Zenor, David. *The Gospel, Number 1.* Salem, Massachussetts: The
Praetorian Press, 1986. 6 pp.

Perfected Church of Jesus Christ of Immaculate Latter Day Saints

William C. Conway, presenting himself as spokesman for a group of In-
dians, published his open letter in 1958, describing his experiences with
Moroni, Joseph Smith, Jr., and other deceased Latter Day Saint personalities.
Conway claimed that Christ visited a special group of Indians on May 3,
1958 in Central America to prepare them to lead the way before His Second
Coming.

897. Conway, William C. *An Open Letter.* Redondo Beach, California:
Perfected Church of Jesus Christ of Immaculate Latter Day
Saints, 1958. 10 pp.

Claims the Mormon church lost the truth in 1890, and that a
special group of Indians was given the keys of the priesthood.
One unique belief that is described: the Indian women have done
away with menstruation and conceive all of their children without
sexual intercourse.

The Divine Word Foundation

Organized in the 1960s at Salt Lake City by Hans N. Von Koerber. Present-
ly headquartered at Warner Springs, California.

898. *And the Lord Jesus Christ Spoke.* Warner Springs, California: Divine
Word Foundation, 1967. 56 pp.

899. Bunger, Fred S. and Hans N. Von Koerber. *A New Light Shines
Out of Present Darkness.* Philadelphia: Dorrance and Company,
1971. 337 pp.

900. *The Evangelical Cure.* Warner Springs, California: Divine Word
Foundation, nd. 2 pp.

901. *God's Proclamation to the Dying World.* Salt Lake City: Divine Word Foundation, 1968. 49 pp.

902. *Has the Word of God Ended with the Bible?* Warner Springs, California: Divine Word Foundation, c. 1980. 2 pp.

903. Lorber, Jakob. *The Three-Days-Scene at the Temple at Jerusalem.* Bietigheim, Wurttemberg: Neu-Salems Society, 1932. 93 pp.

904. Seidel, Hans. *The Great Apostasy and Its Disastrous Consequences.* Warner Springs, California: Divine Word Foundation, 1984. 12 pp.

905. *Spiritual Authority of Man.* Warner Springs, California: Divine Word Foundation, 1970. 55 pp.

906. Von Koerber, Hans Nordewin. *A New Revelation? Why?* Warner Springs, California: Divine Word Foundation, 1965. 13 pp.

907. *What is the "New Revelation"?* Warner Springs, California: Divine Word Foundation, nd. 2 pp.

908. *Who Are the New Revelation Translators?* Warner Springs, California: Divine Word Foundation, 1962, 1978. 12 pp.

LDS Scripture Researchers/Believe God Society
Founded in the 1960s by Sherman Russell Lloyd, this organization claimed that Joseph Smith, Jr. had returned to the earth in preparation for the Second Coming.
This group utilized, in addition to the Mormon scriptures, the writings of Emmanuel Swedenborg. The extent of this group's success or longevity is not known.

909. *Has the LDS Church Completely Apostatized from the Gospel of Jesus Christ as it was Restored Through Joseph Smith?* np: LDS Scripture Researchers, nd. 36 pp.

 Presents "proof" of the Mormon church's departure from the gospel.

910. *This Is That Day.* np: LDS Scripture Researchers, nd. 132 pp.

 Argues that Joseph Smith is to return as a resurrected being

and set the church in order.

Bruce David Longo

Known by several other names including Immanuel David, Bruce David Longo and his family created a sensation in downtown Salt Lake City, Utah, on August 3, 1978. Longo had driven to a nearby canyon and asphyxiated himself with carbon monoxide fumes from an automobile earlier in the week. Upon learning of this his wife pushed their seven children from the 11th floor balcony of a downtown hotel, then jumped off herself.

Longo joined the LDS Church in 1960 and served as a missionary to Uruguay. After proclaiming himself to be the Holy Ghost he was excommunicated from the church. He disappeared for about one year in 1972/73 and later reappeared claiming to be God.

911. Bauman, Joe, Ray Boren and David Croft. "Mom, 5 Children die in plunge from 11th floor of S. L. Hotel." *Deseret News* (August 3, 1978): 1.

Reports bizarre murder-suicide of the Longo family.

912. Bernick, Bob, Jr. "Longos say David changed in 1950s." *Deseret News* (August 5, 1978): 1.

Details interview with other family members on Longo's past.

913. ——————. "Rachel saw no alternative but death." *Deseret News* (August 4, 1978).

Explains family beliefs.

914. Croft, David. "Plunge leaves mass of questions." *Deseret News* (August 4, 1978): 1.

915. Hancock, Janetha. "From Bruce Longo to Immanuel David." *Deseret News* (August 4, 1978): 6.

Details history of Longo from his birth in 1938.

916. ——————. "Rachel obeyed." *Deseret News* (August 8, 1978): B1.

Describes obedience of Longo's wife.

917. Hicks, Christopher. "None screamed: Family was obedient to the

last.'' *Deseret News* (August 4, 1978): A1.

Describes Longo's unique religious beliefs.

918. Peterson, Corey and Christopher Hicks. ''Davids buried side by side.'' *Deseret News* (August 10, 1978): B1.

Chronicles funeral service of Longo family, describing the unique burial arrangement.

919. Sneed, Michael. ''The final tragedy of a zealot's private kingdom.'' Chicago Tribune (August 6, 1978): 17.

Describes the Longo tragedy, and recites recent family history.

920. Sorenson, George. ''Cultist's Family Termed Secretive and Loners.'' Salt Lake Tribune (August 4, 1978): 8.

Interviews residents of eastern Utah community of Duchesne where Longo had previously resided.

The Church of the Lamb of God
Sometime after his removal from Joel F. LeBaron's Church of the Firstborn of the Fulness of Times about 1971, Ervil M. LeBaron, Joel's brother, founded his own organization. This movement's distinctive has been its literal belief in the Mosaic law, and has been either accused of or tried in the courts on several counts of murder. This church officially warns all ''false prophets.'' Ervil LeBaron was convicted as the mastermind behind the murder of rival leader Rulon Allred. LeBaron was committed to the Utah State Penitentiary, where he was found dead in his cell on August 16, 1981 of a heart seizure. His movement is still continued by associates.

921. Andrus, Jack W. *Defense of a Champion of Liberty.* South Pasadena, California: Society of American Patriots, nd. 12 pp.

922. Bradlee, Ben, Jr. and Dale Van Atta. *Prophet of Blood.* New York: G. P. Putnam's Sons, 1981. 350 pp.

Detailed story of Ervil LeBaron and his movement, describing its beliefs and the various murders the group has been accused of. Authors are investigative reporters.

923. Crocker, Alan D. *Fellow Patriots.* Chicago/San Francisco, California:

Society of American Patriots, nd. 3 pp.

924. Hafen, DeWayne. *Dear Brethren.* np: Church of the Lamb of God, 1971. 13 pp.

925. Jordan, D. B. *In Answer to a Challenge.* np: Church of the Lamb of God, 1971. 9 pp.

926. ————. *Open Letter to Verlan M. LeBaron.* np: Church of the Lamb of God, 1972. 26 pp.

927. ————. *Priesthood of the Gods.* np: Church of the Lamb of God, 1971. 18 pp.

928. ————. *Dear Brothers and Sisters.* np: Church of the Lamb of God, 1971. 7 pp.

929. LeBaron, Ervil M. *Causes of the Great Conflict.* np: Church of the Lamb of God, 1973. 12 pp.

930. ————. *False Witnesses in Conflict.* np: Church of the Lamb of God, 1973. 11 pp.

931. ————. *False Witnesses in Conflict, part 2.* np: Church of the Lamb of God, nd. 7 pp.

932. ————. *Freedom's Rising Banner.* np: Church of the Lamb of God, 1973. 8 pp.

933. ————. *From the Court Record.* np: Church of the Lamb of God, 1973. 5 pp.

934. ————. *The Law of Liberty.* np: Church of the Lamb of God, 1972. 30 pp.

935. ————. *An Open Letter to a Former Presiding Bishop.* np: Church of the Lamb of God, 1972. 6 pp.

936. Leeds, Elbert J. *Open Letter to R. C. Allred.* South Pasadena, California: Society of American Patriots, c. 1976. 2 pp.

937. Payne, D. W. *Open Letter to the American Press.* South Pasadena, California: Society of American Patriots, nd. 8 pp.

938. *Questions and Answers for Priesthood Study.* np: Church of the Lamb of God, nd. 38 pp.

939. *Response to an Act of War from the Church of the Lamb of God to its Attackers.* np: Church of the Lamb of God, nd. 18 pp.

940. *Saints of the Latter Days: Their Rise and Power at the Last Time.* Colton, California: Church of the Lamb of God, nd. 23 pp.

Proclaims that the church will have civil power and violent judgments are to be poured out upon all sinners.

941. Sullivan, Lloyd V. *Open Letter to Floren, Mother LeBaron and All Members of the Church of the Firstborn of the Fulness of Times.* Denver: Sullivan, 1977. 3 pp.

942. Walcott, A. Dean. *Open Letter to Citizens of America.* San Francisco: Walcott, 1976. 1 p.

Church of Jesus Christ of Latter Day Saints

Michail Krupenia organized this movement in New Zealand about 1972. He claims to have been ordained by Christ to take over the Mormon church.

943. Krupenia, Michail. *The Word of God the Father and His Son Jesus Christ.* Lower Hutt, New Zealand: Church of Jesus Christ of Latter Day Saints, 1982. 55 pp.

Records a vision given to the author, in which he was commanded to take charge of the Mormon church and prepare for the Second Coming.

The Watchmen on the Towers of Latter Day Israel

A small group of individuals, dedicated to a fundamentalist theology, formed this association (not a church organization) in the early 1970s, and began published a number of items explaining their beliefs.

944. Braun, Henry. *"Celestial" Marriage: For Time and All Eternity.* Salt Lake City: Braun, c. 1984. 87 pp.

Detailed explanation of the theology of polygamy.

945. ————. *Thoughts of a Mormon Convert, Pro and Con,* in

in three volumes. Salt Lake City: Watchmen on the Towers of
Latter Day Israel, 1974-1976. 210 pp.

Theological work detailing Mormon beliefs on the restoration of
the gospel through Joseph Smith. Proposes that Mormonism is an
Israelitish Christian system of life and belief.

946. *Mormon Fundamentalism and the LDS Church, Volume One, The
"Milk."* Salt Lake City: Watchmen on the Towers of Israel,
c. 1975. 35 pp.

Details the differences between the church and the kingdom, and
various positions on plural marriage, based on the 1886 meetings
with John Taylor.

947. *Mormon Fundamentalism and the LDS Church, Volume Two, The
"Meat."* Salt Lake City: Watchmen on the Towers of Israel,
c. 1975. 45 pp.

Argues that the Mormon church gradually apostatized from the
truth, and that the 1890 manifesto stopping plural marriage separated
the kingdom from the church.

The Church of Jesus Christ in Solemn Assembly
Formerly associated with the Apostolic United Brethren (a fundamentalist
movement under the leadership of Rulon C. Allred), Alex Joseph founded
his own church in 1974. Presently located in Big Water, Utah--near the Glen
Canyon Dam--Joseph also serves as mayor of the city.
 In 1978 Joseph founded the Confederate Nations of Israel, a governmen-
tal organization which is proposed to someday govern the earth in peace and
justice. Many of the positions in this government are slated to be filled by
prominent fundamentalist writers and leaders.

948. Joseph, Alexander. *Dry Bones.* Glen Canyon City, Utah: University
of the Great Spirit Press, 1979. 208 pp.

Detailed exposition of the Book of Abraham in the *Pearl of
Great Price.* Argues that Joseph Smith restored many ancient
understandings about science.

949. Short, Dennis R. *Nickel's Worth: A TV Interview with Polygamist
A. Joseph.* Salt Lake City: Short, 1977. 36 pp.

Transcript of interview in which Joseph defends his theological and practical position.

Church of Christ (Patriarchal)/Evangelical Church of Christ

John W. Bryant broke with the Apostolic United Brethren in 1974 and formed his own church, claiming divine revelation. Bryant had joined the Mormon church in 1964 and served as a missionary in Japan before becoming affiliated with the fundamentalist movement in the early 1970s. The church is currently located in Oregon, where its unique marital practices have gained media attention.

950. *Are You a Member of Christ's Restored Church.* Las Vegas, Nevada: Church of Christ (Patriarchal), nd. 4 pp.

Missionary tract arguing that the Mormon church is not Christ's restored church.

951. Bryant, John W. *Message from the World of the Spirits.* Mesquite, Nevada: Church of Christ (Patriarchal), 1981. 14 pp.

Recounts various spiritual experiences and visions received by Bryant.

952. ————. *The Way of Life.* Woodburn, Oregan: Evangelical Church of Christ, 1985. 144 pp.

Collection of sermons on various doctrinal subjects.

953. ————. *The Writings of Abraham/Book of the Order.* Salt Lake City: Church of Christ (Patriarchal), 1978. 109 pp.

Purports to be a translation of the writings of Abraham and of Elijah.

954. *Charismatic Mormons.* Salt Lake City: Church of Christ (Patriarchal), 1978. 23 pp.

Describes various gifts of the spirit as experienced and practiced by the church.

955. *The Church of Christ (Patriarchal).* np, nd. 1 p.

Argues that the church is not a new church, but only a provisional

organization that will not be needed after Joseph Smith (as a resurrected being) sets the Mormon church in order.

956. *Church of the Firstborn.* Salt Lake City: Church of Christ (Patriarchal), nd. 5 pp.

Argues that there are three priesthoods, the Aaronic, Melchizedek and Patriarchal. The patriarchal priesthood belongs to the church of the Firstborn, not the church of Christ.

957. *Covenants and Commandments of the Evangelical Church of Christ*, in four volumes. Woodburn, Oregon: Evangelical Church of Christ, 1983. 91 pp.

Records revelations received by various church leaders between 1982 and 1985.

958. *A Declaration of Faith and Practice.* Mesquite, Nevada: Church of Christ (Patriarchal), 1981. 23 pp.

Brief synopsis of beliefs and practices of the church.

959. *A Divine Warning.* Mesquite, Nevada: Church of Christ (Patriarchal), 1981. 2 pp.

A February 23, 1981 revelation given to the church calling its members to repentance.

960. *Doctrine and Covenants*, in two volumes. Mesquite, Nevada: Church of Christ (Patriarchal), 1981. 100 pp.

Volume one contains excerpts from the Mormon Doctrine and Covenants. Volume 2 includes revelations given to church leaders from 1971 to 1981.

961. *Do You Hold the Priesthood of the Living God?* Salt Lake City/Las Vegas: Church of Christ (Patriarchal), nd. 4 pp.

Argues that the church is limited by the level of priesthood it holds; that the Mormon church does not hold the highest priesthood, therefore is limited in its ministry.

962. *The Evangelical Church of Christ.* Salem/Woodburn, Oregon: Evangelical Church of Christ, nd. 3 pp.

963. *Faith.* Salt Lake City: Church of Christ (Patriarchal), nd. 12 pp.

Faith, as a gift from God, is the first principle of the gospel.

964. *The Fulness of the Gospel.* np, nd. 84 pp.

Quotations from early Mormon church leaders supporting polygamy.

965. Freeborn, Leland F. *A Special Group Predicted.* Las Vegas, Nevada: Church of Christ (Patriarchal), nd. 13 pp.

Argues that the scriptures prophesy the coming forth of this church attesting to its validity.

966. ————. *What the Scriptures Say About Plural Marriage.* Parowan, Utah: Zion's Press, nd. 23 pp.

Scriptural quotes with commentary supporting the practice of polygamy.

967. *The Gathering of Israel.* Las Vegas, Nevada: Church of Christ (Patriarchal), nd. 7 pp.

Explains that true believers are to be gathered together by God, and that this church is being so gathered.

968. *How Far Would You Go to Please the Lord Jesus Christ?* Salt Lake City: Church of Christ (Patriarchal), nd. 4 pp.

Argues that a cleansing must be performed of the Mormon church, by this group.

969. *The Judgments of God.* Mesquite, Nevada: Church of Christ (Patriarchal), 1981. 11 pp.

Argues that various natural disasters in current events are actually judgments of God against the wicked.

970. *Law of Consecration and United Order.* Las Vegas, Nevada: Church of Christ (Patriarchal), nd. 28 pp.

The united order and law of consecration are explained as God's true economic order.

971. *Let's Talk About You and Your Eternal Progression.* Salt Lake City: Church of Christ (Patriarchal), nd. 4 pp.

 Argues that God ceased to work with the Mormon church at the time of their seventh president.

972. *The Need for Living Prophets.* np: Church of Christ (Patriarchal), nd. 2 pp.

 Argues that God has sent his prophets to help society deal with the chaos and confusion prevalent.

973. *The New Revelation.* Parowan, Utah: Zion's Press, nd. 32 pp.

 Collection of sayings by various prophets from the scriptures and early Mormon leaders.

974. *Our Economic Crisis and God's Answer.* Mesquite, Nevada: Church of Christ (Patriarchal), 1981. 7 pp.

 Discusses Ronald Reagan's economic program and proposes consecration and united order as the answer to America's economic ills.

975. *Repentance.* Las Vegas, Nevada: Church of Christ (Patriarchal), nd. 6 pp.

 All must repent and feel sorry for their sins, then change their lives in order to fellowship with Christ.

976. *Resurrection.* Salt Lake City: Church of Christ (Patriarchal), nd. 13 pp.

 Discusses mortal probation and the future possibility of resurrection to immortality.

977. *Sacrament of the Lord's Supper.* Salt Lake City: Church of Christ (Patriarchal), nd. 19 pp.

 Provides a history of this sacrament and expounds its particular meanings to the church.

978. *Samuel, The Man at the Veil.* np, nd. 8 pp.

Samuel, pseudonym for John Bryant, explains his revelations and visions and describes how he was called to this work.

979. *The Setting in Order Has Begun.* Salt Lake City: Church of Christ (Patriarchal), nd. 4 pp.

Proposes that Joseph Smith is living and working among this church's people.

980. *The Testimony of Mary.* Mesquite, Nevada: Church of Christ (Patriarchal), 1981. 12 pp.

Purports to be a translation, through the "stone of Ephraim" of a testimony written by Mary Magdalene. Claims to contain certain teachings which Christ taught only to a select group of people.

981. *Up Awake Ye Defenders of Zion.* Salt Lake City: Church of Christ (Patriarchal), nd. 5 pp.

Proclaims that Joseph Smith is resurrected and working with this church.

982. *Voice of Zion.* Mesquite, Nevada: Church of Christ (Patriarchal), 1976. 16 pp.

Official publication of church. Primary source of history, revelations and doctrine. Publication is sporadic. Moved to Woodburn, Oregon in 1981.

983. *What is the Church of Christ (Patriarchal)?* Salt Lake City: Church of Christ (Patriarchal), nd. 4 pp.

Brief theological statement supporting the basis for the church's existence.

984. *Who i\ our Father and our God?* Mesquite, Nevada: Church of Christ (Patriarchal), nd. 2 pp.

Argues that Adam is actually God.

Affirmation

About 1975 a group of gay Mormons organized this group for the pur-

pose of ministering to one another in the face of the official church's casting them out. Currently headquartered in California, the group sponsors many local organizations around the United States.

985. *Affirmation Newsletter.* Los Angeles: Affirmation, 1980. 4 pp.

> Published monthly, with volume 1, number 1 dated March 1980. Name changed to "New Times and Seasons" September 1980. Final issue October 1980.

986. *A Frank Discussion for LDS Adults.* San Francisco: Affirmation, 1983. 4 pp.

> Argues that homosexuality is not condemned by the scriptures.

987. *The National Affinity.* Los Angeles: Affirmation, 1981. 4 pp.

> Monthly newsletter, first issue February 1981. Name changed to "Affinity" December 1981.

LDS Freedom Foundation

Douglas Wallace gained national attention when he baptized a black man in a Portland, Oregon swimming pool and then ordained him to the priesthood in 1976. Wallace was excommunicated from the Mormon Church on April 11, 1976 for the action, and the black man's ordinances were not recognized by the church. Wallace has been involved in a number of lawsuits against the Mormon church since that time. The foundation was organized as a means for "exposing" the false doctrine of the Mormon church.

988. Wallace, Douglas A. *The Millennial Messenger.* Vancouver, Washington: LDS Freedom Foundation, 1977.

> Monthly periodical promoting Wallace's beliefs that negroes should receive the Mormon priesthood, Mormon women should receive the priesthood, and the Equal Rights Ammendment should be supported by the Mormon church. Changed to bi-monthly in March 1978, with volume 2, number 3. Continued for a few more issues.

989. —————. *What Is the Latter Day Saint Freedom Foundation?* Vancouver, Washington: LDS Freedom Foundation, nd. 1 p.

> Flyer explaining the purposes of the foundation.

Christ's Church, Inc.

Gerald W. Peterson, Sr., in accordance with claimed revelation, organized this church at Provo, Utah on April 6, 1978. Peterson had been a leader in Rulon C. Allred's Apostolic United Brethren. Claims were made that the purpose of the church was not to replace the Mormon church, but to set that church in order.

990. *Answers and Quotations to Did You Know.* Provo, Utah: Christ's Church, nd. 8 pp.

991. *The Branch.* Provo, Utah: Christ's Church, Inc., 1979. 28 pp.

Official periodical of church, volume 1, number 1 dated January 1979. Continued to volume 4, number 1, October 1982, but sporadic after the first year of monthly issues.

992. *Did You Know?* Provo, Utah: Christ's Church, nd. 5 pp.

993. *A Message to Zion.* Provo, Utah: Christ's Church, Inc., nd. 6 pp.

Brief introduction to the establishment and beliefs of the church.

994. *A Tragedy of Errors.* Provo, Utah: Christ's Church, Inc., nd. 1 p.

Argues that the Mormon church is false because of permitting Negroes to hold the priesthood.

Church of Jesus Christ

Art Bulla joined the Mormon church in the early 1970s, but after a series of revelations, organized his own church in the late 1970s.

995. Bulla, Art. *Revelations of Jesus Christ.* np: Church of Jesus Christ, c. 1983. 234 pp.

Collection of revelations received by Bulla.

996. —————. *Teachings of the Prophet Art Bulla.* Salt Lake City: Bulla, c. 1984. 145 pp.

Twenty additional revelations.

997. *Zion's Messenger and Advocate.* Salt Lake City: The Church of

Jesus Christ, 1984. 7 pp.

Official periodical. Only the July 1984 issue was published.

The Restorers/School of the Prophets

The Restorers were organized in 1979 by Joseph J. Dewey and Curtiss Harwell after coming into contact with Robert C. Crossfield. Crossfield, the prophet Onias, had published a book of his revelations in 1969.

Recently renamed the School of the Prophets, the movement states they are not a church, but that they are a facility through which God can set the Mormon church in order.

998. Crossfield, R. C. *The Book of Onias.* New York: Philosophical Library, 1969. 62 pp.

Contains 22 revelations, dated from 1961 to date of publication.

999. ————. *The Book of Onias.* Salem, Utah: United Order Publications, 1985. 222 pp.

Contains complete text of previous item, with 92 additional revelations up through June 1985. Many of the revelations (since the first edition of this book) were initially published as separate booklets.

1000. Dewey, Joseph J. *Journey's End.* Boise, Idaho: United Order Publications, 1979. 83 pp.

1001. Lowther, Ervin Lee. *The Organization of Zion.* Boise, Idaho: United Order Publications, 1982. 37 pp.

1002. ————. *The Organization of Zion.* Garland, Texas: School of the Prophets, 1985. 65 pp.

1003. *The Purpose of the Restorers.* Boise, Idaho: The Restorers, nd. 3 pp.

Explains that the organization is not a church, but a movement through which God will set the Mormon church in order.

1004. *The Restorers.* Boise, Idaho: The Restorers, 1980. 7 pp.

First issue dated January 1980, volume 1, number 1. Continued monthly (with few exceptions) to May 1983, volume 3, number 8.

Sons Ahman Israel

Davied Israel, the presiding patriarch, organized this movement with five members on January 25, 1981. The church does not proselytize, feeling it more important to perform special ordinance work. Israel and other founding members were previously affiliated with John Bryant's Church of Christ (Patriarchal).

1005. Israel, Davied. *The Oracles of Mohonri.* Washington, Utah: Sons Ahman Israel, 1983. 194 pp.

Purports to be an abridgement of the sealed portion of the plates from which the Book of Mormon was translated. Israel, the translator, states that the full text is not available for general publication due to its sacred nature.

1006. *The Sacred Scrolls, Volume One.* np: Sons Ahman Israel, c. 1986. 156 pp.

Contains various sacred writings of the church, including parts of the Oracles of Mohonri. Many of the sections are purported translations of ancient documents.

1007. *SAI Beliefs.* Washington, Utah: Sons Ahman Israel, nd. 6 pp.

Twenty-two brief points of belief and practice.

1008. *A Scriptural Introduction to the Beliefs, Practices, Philosophy and Doctrine of the Spiritual Society of Sons Ahman Israel.* Washington, Utah: Sons Ahman Israel, nd. 45 pp.

1009. *The Stone.* Washington, Utah: Sons Ahman Israel, 1983. 58 pp.

Official periodical. First issue numbered volume 1, number 1, dated "First Month." The group follows a non-standard calendar. Regular issues for one year, but extremely sporadic following.

The Millennial Church of Jesus Christ

Affiliated with Ervil LeBaron's movement until LeBaron's death, Leo Peter Evoniuk claims a revelation calling him to continue the work of LeBaron under a new organization. This movement proposes a return to a strict observance of the Mosaic civil code.

1010. Evoniuk, Leo P. *Knowledge of Human Rights.* np: The Millennial

Church of Jesus Christ, 1983. 6 pp.

Argues that humans uphold God's laws, otherwise they are not
human.

1011. ———————. *The Patriarchal Proclamation and Decree*. Monterey,
California: The Millennial Church of Jesus Christ, 1981. 13 pp.

Declares all earthly kingdoms as parts of the Kingdom of God.
Ronald Reagan is to be anointed as the king of the United States.

1012. ———————. *Sealing of the 144,000 Patriarchs of the Twelve Tribes
of Israel*. Monterey, California: The Millennial Church of
Jesus Christ, 1984. 29 pp.

1013. ———————. *Universal Eternal Law Neutralizes Star Wars*. np:
Millennial Church of Jesus Christ, nd. 7 pp.

Argues that the arms race (as of 1985) is the biggest "prostitute"
on earth.

1014. *Presiding Patriarchs of the 144,000 and the House of Israel*. Scottsdale,
Arizona: The Millennial Church of Jesus Christ, 1981. 11 p.

The Peyote Way Church of God
A movement organized by Immanuel P. Trujillo, which uses peyote as
a psychedelic sacrament. This movement bases their faith and practice on
the Mormon scriptures and history, and has a highly developed priesthood
structure.

1015. *Revised Bylaws*. Willcox, Arizona: The Peyote Way Church of God,
Inc., 1984. 27 pp.

Includes the rules of membership.

The Church of Jesus Christ of All Latter-day Saints/
Restoration Church of Jesus Christ
Organized by Antonio A. Feliz and others on August 14, 1985 at Los
Angeles, California, this movement attempts to provide a formal church set-
ting for homosexuals who have become outcasts from mainline Latter Day
Saint churches. The name change was effected in an effort to make a clear
distinction between this movement and the Mormon church.

1016. Feliz, Antonio A. *General Epistle to the Church of Jesus Christ of All Latter-day Saints.* Los Angeles: Church of Jesus Christ of All Latter-day Saints, 1985. 8 pp.

Explains the priesthood, with a brief history of the movement.

1017. ——————, A. LaMar Hamilton and John R. Crane. *Invitation and Call to Service.* Los Angeles: The Church of Jesus Christ of All Latter-day Saints, 1985. 12 pp.

Contains the articles of faith of the church, with a treatise detailing the doctrine of women in the priesthood. Invites gay Mormons to join.

1018. *Hidden Treasures and Promises.* Los Angeles: Restoration Church of Jesus Christ, 1985. 44 pp.

Contains revelations received by Feliz and other church leaders.

The Church of Christ of Latter-day Saints

Robert Madison organized this church in November 1982, but had no real activity until November 1985, after Madison had joined, then left the Mormon church. As of December 1986, this church ceased functioning. Headquarters were in Milwaukee, Wisconsin.

1019. *Apostasy of the Elijah Message Church.* np: Church of Christ of Latter-day Saints, nd. 6 pp.

Argues that Otto Fetting and W. A. Draves promoted false revelations; that their "messenger" was not from God.

1020. *Apostasy of the Reorganised Church.* np: Church of Christ of Latter-day Saints, nd. 6 pp.

Claims that the RLDS Church began to apostatize in 1886 when they allegedly rejected the temple ordinances. This apostasy was completed with Frederick M. Smith in 1925 when that RLDS president received supreme directional control over the church.

1021. *Apostasy of the Strangites.* Milwaukee: Church of Christ of Latter-day Saints, nd. 6 pp.

Argues that James J. Strang's "letter of appointment" is not

authentic, and that the Strangite church is in error in believing that today's society is still bound by the Mosaic law.

1022. *Apostasy of the Temple Lot Church.* np: Church of Christ of Latter-day Saints, nd. 6 pp.

Argues that Granville Hedrick was an illegal usurper of the presidency of the church; that Joseph Smith III was the legitimate successor of Joseph Smith, Jr.

1023. *The Book of Mormon.* np: Church of Christ of Latter-day Saints, nd. 6 pp.

Suggests that lies have been told about the Book of Mormon by its supposed supporters.

1024. *Doctrine and Covenants, Volume II.* Milwaukee: Church of Christ of Latter-day Saints, 1986. 43 pp.

Acknowledging the Mormon church *Doctrine and Covenants* as legitimate scripture (with a few exceptions), Madison has added in volume two, sections 136 to 160, which include revelations given to Joseph Smith III and some given to Frederick M. Smith, as well as two by Madison.

1025. *Doctrine Compared.* np: Church of Christ of Latter-day Saints, nd. 6 pp.

Compares the beliefs of the Mormon church, RLDS church, Temple Lot, Strangite, Catholic, New Testament and Church of Christ of Latter-day Saints.

1026. *Joseph Smith, Jr.: 19th Century Prophet.* np: Church of Christ of Latter-day Saints, nd. 6 pp.

Rehearses a brief history of the church, and a history of Joseph Smith.

1027. Madison, Robert. *Apostasy of the Mormon Church.* np: Church of Christ of Latter-day Saints, nd. 6 pp.

Argues that Brigham Young falsely attached polygamy to Joseph Smith; that the Mormons believed slavery was a divine institution.

1028. —————. *Articles of Faith and Belief of the Church of Christ of Latter-day Saints.* np: Church of Christ of Latter-day Saints, nd. 6 pp.

> 36 points of belief.

1029. —————. *Temples of the Lord.* np: Church of Christ of Latter-day Saints, nd. 6 pp.

> Gives a brief history of temple building by Joseph Smith, Jr. Argues that Brigham Young deformed the temple and that the RLDS reject it.

1030. —————. *Who Was Jesus Christ?* np: Church of Christ of Latter-day Saints, nd. 6 pp.

> Argues that Christ was but mortal, and became divine through his death on the cross.

Siegfried Widmar
Once a prominent leader with the Church of the Firstborn of the Fulness of Times, Siegfried Widmar and others left that association over leadership disagreements in 1985.

1031. Widmar, Siegfried J. *The Principle of Peace.* Mesa, Arizona: Widmar, 1985. 20 pp.

> Argues that civil authority from God is needed to establish lasting peace in the world.

The Work of Better Truth
Organized at Salt Lake City by Eskel Peterson.

1032. *As You Sow, So Shall Ye Reap.* np: Work of Better Truth, nd. 46 pp.

1033. *The Better Truth About the Garden of Eden.* Salt Lake City: Work of Better Truth, 1984. 83 pp.

1034. *The Better Truth as Revealed From Heaven.* Salt Lake City, nd. 17 pp.

1035. *The Government of Liberty.* np: Work of Better Truth, nd. 30 pp.

1036. Peterson, Eskel. *The Work and Church of Better Truth.* Salt Lake City: Peterson, nd. 27 pp.

1037. *Prophecies Against the Mormons by Joseph Smith.* np: Work of Better Truth, nd. 23 pp.

1038. *Who is the Serpent?* Salt Lake City: Work of Better Truth, 1984. 20 pp.

1039. *Who Made God?* Salt Lake City: Work of Better Truth, 1984. 7 pp.

The Church of Jesus Christ
(Alpheus Cutler)

One of the early members of the Latter Day Saint movement, Alpheus Cutler was baptized in New York state in 1833. After enduring many hardships with the church, he settled in what was to be Nauvoo, Illinois in 1839 and was called to a position on the Nauvoo Stake High Council--a high-ranking ecclesiastical position in the local church organization.

Initially, Cutler followed Brigham Young from Nauvoo in 1846, but remained in western Iowa rather than proceeding to Utah. In 1853 Cutler saw a sign in the heavens which he was told he would witness when the time came for him to re-organize the church. Cutler claimed ordination to a special council of seven high priest apostles, which gave him the authority to do so.

The Church of Jesus Christ was re-organized on September 19, 1853 at Manti, Iowa—a settlement of about 30 families. The formal re-organization of the church under the leadership of Joseph Smith, III in 1860 caused many to leave Cutler and unite with the RLDS Church. After Cutler's death in 1864, the community moved north and settled at Clitherall, Minnesota.

In the late 1920s a group of church members was sent to Independence, Missouri to establish headquarters and erect a church building. Due to a leadership dispute in the mid-1950s, the two branches operated as separate churches. The Missouri church added the prefix "true" to their name to distinguish between the two. Since the two groups have reconciled their differences—mainly due to the death of the leader in Minnesota—the church has dropped the prefix. There are approximately 30 members in Missouri and 2 or 3 in Minnesota.

1040. *The Book of Commandments and Covenants.* Independence, Missouri: The Church of Jesus Christ, 1978. 604 pp.

> Contains a reprint of the 1835 first edition of the Doctrine and Covenants, with additional materials of a theological nature. Short-time church member Eugene O. Walton was in charge of the project, and in the church's opinion added materials which did not have church approval. Walton was removed from the church, and the book has been withdrawn from circulation.

1041. Fletcher, Daisy W. *Alpheus Cutler and the Church of Jesus Christ.*

np: author, 1970. 56 pp.

Briefly recites the history of the church. A revised and enlarged version was included in a later work by the same title.

1042. Fletcher, Rupert J. *About Zion.* Independence, Missouri: author, 1965. 6 pp.

Argues that God will overcome all obstacles, and Zion will be established according to the scriptures.

1043. ————. *The Priesthood Lineage.* Independence, Missouri: The Church of Jesus Christ, nd. 5 pp.

Presents the church's argument on their belief regarding Alpheus Cutler's ordination and the legality of his claim to succession in the leadership of the church.

1044. ————. *The Scattered Children of Zion.* Independence, Missouri: author, 1959. 90 pp.

Doctrinal treatise, discussing various beliefs of the church. Argues that other Latter Day Saint churches are in error in many beliefs, especially in succession to the presidency.

1045. ————. *The Trinity.* Independence, Missouri: The Church of Jesus Christ, nd. 4 pp.

Argues that God and Christ are distinct and separate individuals.

1046. ————. *The Way of Deliverance.* Independence, Missouri: author, 1969. 53 pp.

Discusses several beliefs of the church including modern revelation, the kingdom of God, and the New Jerusalem.

1047. ———— and Daisy W. Fletcher. *Alpheus Cutler and the Church of Jesus Christ.* Independence, Missouri: The Church of Jesus Christ, 1974. 350 pp.

Detailed history of the church, and comprehensive doctrinal dissertation of the beliefs of the church. Fletcher was president of the church at the time of publication.

1048. *Sacred Hymns.* Salt Lake City, Utah: Deseret News Press for the Church of Jesus Christ, 1942. 365 pp.

Essentially a reprinting of the older style Mormon church hymnal (words only, no music), but includes 34 hymns at the end written by members of the Cutler movement.

1049. Walton, Eugene O. *No Celestial Law—No Zion.* Independence, Missouri: The Church of Jesus Christ, nd. 11 pp.

Argues that persons must consecrate their possessions to the church in order to bring about Zion. Published about 1978, just prior to Walton's removal from the church, it is no longer used by the Cutler group, but by Walton's own organization.

The Restored Church of Jesus Christ

Eugene O. Walton was a convert to the RLDS Church, and served in the ministry as a seventy. However, in the late 1960s he became concerned over what some saw as a liberalization of that church. For a short time he associated with an organization known as World Redemption, which later became the New Jerusalem Church of Jesus Christ. When that church rejected the Restoration about 1976, Walton joined with the Cutler movement.

In a 1977 revelation, Walton made it known that he had been called as Joseph Smith's successor--the"one mighty and strong." Because this was not acceptable to the members of the Cutler church, Walton and an associate established"Restorationists United"which was later formed into a church, based on revelations received by Walton.

1050. *Holy Priesthood Is Not From Father to Son!* Independence, Missouri: Restored Church of Jesus Christ, nd. 8 pp.

Argues that the RLDS Church is wrong in claiming that presidential succession is from father to son. The prophet must always be appointed by revelation.

1051. *The Keys of the Kingdom.* Independence, Missouri: Restorationists United, nd. 10 pp.

Argues that a president of the church must be appointed by revelation in order to receive authority.

1052. *Let's Together Set the Church in Order.* Independence, Missouri: Restored Church of Jesus Christ, nd. 14 pp.

Compares the beliefs of other Latter Day Saint churches, and argues that they are all "out of order."

1053. *No Man Taketh this Honor.* np, nd. 14 pp.

Argues a scriptural basis for the office of high priest apostle.

1054. *Priesthood Authority Where?* Independence, Missouri: Restorationists United, nd. 64 pp.

Argues that the legitimate priesthood authority was transferred by Joseph Smith, Jr. to Alpheus Cutler, then to Eugene O. Walton; Walton is the "one mighty and strong."

1055. Rouse, James B. *The Restored Church of Jesus Christ answers the Church of Christ (Temple Lot).* Independence, Missouri: Restored Church of Jesus Christ, nd. 44 pp.

Presents the texts of several letters of correspondence written between Rouse and one of the leaders of the Temple Lot movement, comparing beliefs of the two churches.

1056. Smith, Joseph, Jr. *The Stick of Joseph.* Independence, Missouri: Restored Church of Jesus Christ, 1984. 590 pp.

Photo-reprint of 1830 edition of the Book of Mormon, with additional information by Walton. The title of the book was changed by Walton in response to a revelation.

1057. *Statement of Belief.* Independence, Missouri: Restored Church of Jesus Christ, nd. 5 pp.

Itemizes 15 basic points of belief.

1058. *Stick of Joseph: What Is It?* Independence, Missouri: Restored Church of Jesus Christ, nd. 32 pp.

Introduces the reader to the Book of Mormon. Argues that archaeological discoveries in Central and South America support the record.

1059. Walton, Eugene O. *The Revelations of Jesus Christ.* Independence, Missouri: Restored Church of Jesus Christ, 1983. 26 pp.

Contains 15 revelations given through Walton from June 1977 to November 1981.

1060. —————. *The Revelations of Jesus Christ, Part II.* Independence, Missouri: Restored Church of Jesus Christ, 1985. 32 pp.

Contains revelations numbers 16 through 30, dated March 1982 to April 1985.

1061. *What Is His Name?* Independence, Missouri: The Restored Church of Jesus Christ, nd. 16 pp.

Argues that the Savior's name is "Jesus Christ," not one or the other. Invites the reader to take His name and join the church.

1062. *Why Must I be Re-Baptized?* Independence, Missouri: Restored Church of Jesus Christ, nd. 16 pp.

Argues that all persons must receive baptism by proper authority, which only the Restored Church of Jesus Christ has.

1063. *Zion's Trumpet.* Independence, Missouri: Restored Church of Jesus Christ, 1984. 20 pp.

Monthly official newsletter of the church. Volume 1, Number 1 dated April, 1984.

PART FOUR
The Reorganized
Church of Jesus Christ of Latter Day Saints

When the church fragmented in 1844 at Joseph Smith's death, many Latter Day Saints looked to the time when Joseph Smith, III would assume the leadership of the church. He had been designated as his father's successor no less than four separate times.

Many church members began uniting in the early 1850s and established a pro-forma church organization called the "New Organization" of the Church of Jesus Christ of Latter Day Saints. In April of 1860, Joseph Smith, III, accepted a call which he stated came to him from "a power not my own" and became president-prophet of the "Reorganized" Church of Jesus Christ of Latter Day Saints.

This church is the second largest of the Latter Day Saint churches, and maintains headquarters in Independence, Missouri. The church is established in many nations. Independence was made the official headquarters in 1921, after several years in Illinois, followed by a stay in southern Iowa.

1064. Anderson, Mary Audentia Smith. *Joseph Smith III and the Restoration.* Independence, Missouri: Herald Publishing House, 1952. 639 pp.

Anderson edited Joseph Smith III's memoirs, which had been dictated by Smith over a period occupying several months. This publication was condensed by Bertha Audentia Anderson Hulmes. Contains essential information on Smith's administration of the church, and much of its early history.

1065. Baker, Robert E. *As It Was in the Days of Noah!* Independence, Missouri: Old Path Publishing, Inc., 1984. 156 pp.

Argues that the RLDS Church has apostatized from the true gospel of Christ, and that the world is on the verge of destruction, just as at the time of Noah and the biblical flood.

1066. —————. *RLDS New Age Theology Exposed.* Independence, Missouri: Old Path Publishers, Inc., 1986. 233 pp.

Claims that the RLDS Church is promoting and supporting a new

world order, with justice for all and secure peace. Argues that this is error, and attempts to show how the RLDS Church has apostatized from the truth.

1067. Bingman, Margaret. *Encyclopedia of the Book of Mormon.* Independence, Missouri: Herald Publishing House, 1978. 405 pp.

Reference book providing descriptions of people, places and events contained in the Book of Mormon.

1068. Bird, Merva. *Women's Ordination? No!* Independence, Missouri: Cumorah Books, 1980. 38 pp.

Argues that the ordination of women to priesthood office is unscriptural and false doctrine. Written and published prior to the 1984 RLDS revelation permitting just such action.

1069. Bradley, John W. *Marriage and Authority.* Independence, Missouri: Reorganized Church of Jesus Christ of Latter Day Saints, nd. 7 pp.

Explains the RLDS belief that marriage should be monogamous. Argues that the Mormon church has erred and promoted a false doctrine: polygamy.

1070. ————. *Zion and Authority.* Independence, Missouri: Reorganized Church of Jesus Christ of Latter Day Saints, nd. 8 pp.

Argues that the Mormon church could not be the "true" church because it has "moved" Zion and taught that Utah, not Missouri, is now Zion.

1071. Brunson, L. Madelon. *Bonds of Sisterhood.* Independence, Missouri: Herald Publishing House, 1985. 170 pp.

Presents a detailed history of the RLDS women's organizations, from the women's relief society at Nauvoo in 1842 through 1983. Carefully documented scholarly presentation.

1072. Bryant, Verda E. *Between the Covers of the Old Testament.* Independence, Missouri: Herald Publishing House, 1965. 400 pp.

Story version of the Old Testament written for youth. Quotes heavily from actual scripture texts.

1073. Butterworth, F. Edward. *Pilgrims of the Pacific.* Independence, Missouri: Herald Publishing House, 1974. 144 pp.

Presents several theories on the origins of the peoples and cultures of the south sea islands. Suggests that Book of Mormon peoples were the source population.

1074. —————. *Roots of the Reorganization: French Polynesia.* Independence, Missouri: Herald Publishing House, 1977. 266 pp.

Chronicles the history of the RLDS church in Polynesia from the original church in 1844 through 1944. Includes photos of people and places through publication date. Taken from original records and letters.

1075. —————. *The Sword of Laban,* in four volumes. Independence, Missouri: Herald Publishing House, 1969-1972. 560 pp.

Novelized version of the Book of Mormon.

1076. Caywood, Charles, Sr. *I Was a Protestant Minister.* Independence, Missouri: Herald Publishing House, nd. 23 pp.

Caywood describes his search for truth, which he found in the RLDS Church. Missionary tract.

1077. Chaney, Eugene R. *Questions Many Friends Ask Us.* Independence, Missouri: Reorganized Church of Jesus Christ of Latter Day Saints, nd. 11 pp.

Seven questions, with answers, commonly asked by members of the Mormon church.

1078. —————. *Reorganization History Speaks to Our Day.* Independence, Missouri: Reorganized Church of Jesus Christ of Latter Day Saints, nd. 19 pp.

Argues that the original church lost its attitude of Christ-like love in the early 1840s. This was a contributing factor in confusion over doctrine, and the eventual death of Joseph Smith and the break up of the church. Recites early RLDS history as a new revival of of the restoration.

1079. —————. *Restoration Truth Survives Nauvoo.* np, nd. 39 pp.

Argues that many false doctrines were introduced into the original church during the Nauvoo era, but the true church survived and is continued in the RLDS Church.

1080. Cheville, Roy A. *The Book of Mormon Speaks for Itself.* Independence, Missouri: Herald Publishing House, 1971. 203 pp.

Explores the teachings found in the Book of Mormon and their relationship to persons in today's world.

1081. ————. *Did the Light Go Out?* Independence, Missouri: Herald Publishing House, 1962. 261 pp.

Argues that God did not abandon the world during the "dark ages" but was working with many people in many places.

1082. ————. *The Field of Theology.* Independence, Missouri: Herald Publishing House, 1959. 144 pp.

Argues that theology is essential for effective living.

1083. ————. *My Endowing Experiences in the Kirtland Temple.* Independence, Missouri: Herald Publishing House, 1983. 68 pp.

Describes personal spiritual experiences in the Kirtland Temple in Ohio, and reflects on the purposes of the temple in the RLDS Church theology.

1084. ————. *Scriptures From Ancient America.* Independence, Missouri: Herald Publishing House, 1964. 368 pp.

Attempts to find a place and meaning for the Book of Mormon in the library of the world's scriptures.

1085. ————. *They Made a Difference.* Independence, Missouri: Herald Publishing House, 1970. 350 pp.

Biographies of 30 prominent figures in Latter Day Saint history from 1830 to the present.

1086. ————. *They Sang of the Restoration.* Independence, Missouri: Herald Publishing House, 1955. 267 pp.

A history of RLDS hymnody, tracing the stories of Latter Day

Saint hymns from the original church hymnal of 1835 to the 1956 RLDS hymnal.

1087. *Children's Hymnal*. Independence, Missouri: Herald Publishing House, 1957. 200 pp.

225 hymns selected for the children of the church.

1088. Clinefelter, William R. *The Covenant and the Kingdom*. Independence, Missouri: Herald Publishing House, 1964. 138 pp.

Examines the covenant made with Abraham and the Jews and relates it to the early Christians and the Restoration.

1089. Cole, Clifford A. *Faith For New Frontiers*. Independence, Missouri: Herald Publishing House, 1956. 156 pp.

Argues that faith in God is necessary in order to deal with the problems of the modern world.

1090. ————. *The Priesthood Manual*. Independence, Missouri: Herald Publishing House, 1985. 422 pp.

Detailed handbook describing details of church administration, procedure and policy for lay ministers of the RLDS Church.

1091. ————. *The Mighty Act of God*. Independence, Missouri: Herald Publishing House, 1984. 192 pp.

Theological discussion expressing the author's Christology in the RLDS context.

1092. ————. *The Prophets Speak*. Independence, Missouri: Herald Publishing House, 1954. 199 pp.

Commentary introducing Old Testament prophets and their writings.

1093. ————. *The Revelation in Christ*. Independence, Missouri: Herald Publishing House, 1963. 346 pp.

Discusses the deeper theological meaning of Christ's mission, rather than his life and ministry.

1094. Collins, Barbara Lee and Hale Collins. *A Concordance to Hymns of the Saints.* Independence, Missouri: Herald Publishing House, 1983. 385 pp.

Topical guide to hymns contained in the RLDS hymnal, "Hymns of the Saints."

1095. *Commission.* Independence, Missouri: Reorganized Church of Jesus Christ of Latter Day Saints, 1972. 32 pp.

Periodical publication for local church leaders. James C. Cable first editor. Volume 1, Number 1 dated January 1972. Frequency, staff and size has changed.

1096. *Compendium of the Scriptures.* Independence, Missouri: Herald Publishing House, 1951. 352 pp.

Topical index to scriptures of the church.

1097. *Courage: A Journal of History, Thought and Action.* Lamoni, Iowa: editors, 1970. 64 pp.

Scholarly periodical. Pilot issue dated April 1970. Proposed quarterly. Final issue Volume 3, Numbers 2/3 dated Winter/Spring 1973. Contains articles of historical and theological significance to the RLDS church.

1098. Crinzi, Debbie. *Principles of Discipleship.* Independence, Missouri: Herald Publishing House, 1984. 102 pp.

Argues that a disciple of Christ emulates qualities of caring and sharing, forgiveness, teamwork, disciple vision, servant ministry, becoming accountable, and world community.

1099. Curtis, J.F. *Our Beliefs Defended.* Independence, Missouri: Herald Publishing House, 1928. 160 pp.

Defends basic beliefs of the church regarding the revelations of Joseph Smith, leadership and priesthood offices in view of criticism raised by the Church of Christ (Temple Lot), or Hedrickites, another Latter Day Saint church.

1100. Davis, Inez Smith. *The Story of the Church.* Independence, Missouri: Herald Publishing House, 1981. 664 pp.

One volume, parochial overview of RLDS Church history. This printing is the tenth edition, updated to publication date. First edition was issued in 1934.

1101. DeLapp, G. Leslie. *In the World...* Independence, Missouri: Herald Publishing House, 1973. 250 pp.

Focuses on the unique Latter Day Saint beliefs regarding Zion and financial stewardship. Based on author's personal experiences as a leader and minister in the church.

1102. Dempsey, Elbert A., Jr. *Adventuring With God.* Independence, Missouri: Herald Publishing House, 1985. 120 pp.

Argues that each individual can develop a working relationship with God.

1103. *The Department's Journal.* Lamoni, Iowa: Reorganized Church of Jesus Christ of Latter Day Saints, 1927. 16 pp.

Periodical for church leaders. Volume 1, Number 1 dated April 1927. Moved to Independence, Missouri with June 1927 issue. Size increased. Final issue at conclusion of volume 4 in 1930.

1104. *Dimensions.* Independence, Missouri: Reorganized Church of Jesus Christ of Latter Day Saints, 1969. 32 pp.

Volume 1, number 1 dated Spring 1969. Final issue volume 4, number 2, Summer 1972.

1105. Doty, Harry L. *Prayer Meetings: Helps For Priesthood.* Independence, Missouri: Herald Publishing House, 1979. 150 pp.

Complete guidebook describing the purposes and uses of the prayer meeting in the church's worship life.

1106. Draper, Maurice L. *Christ's Church Restored.* Independence, Missouri: Herald Publishing House, 1974. 31 pp.

Argues that the RLDS church is a genuine restoration of the original church established anciently by Christ.

1107. —————. *Credo: I Believe.* Independence, Missouri: Herald Publishing House, 1983. 307 pp.

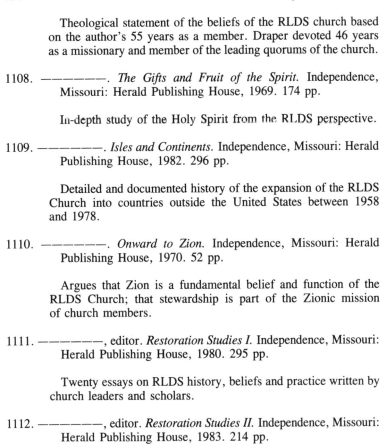

Theological statement of the beliefs of the RLDS church based on the author's 55 years as a member. Draper devoted 46 years as a missionary and member of the leading quorums of the church.

1108. —————. *The Gifts and Fruit of the Spirit.* Independence, Missouri: Herald Publishing House, 1969. 174 pp.

In-depth study of the Holy Spirit from the RLDS perspective.

1109. —————. *Isles and Continents.* Independence, Missouri: Herald Publishing House, 1982. 296 pp.

Detailed and documented history of the expansion of the RLDS Church into countries outside the United States between 1958 and 1978.

1110. —————. *Onward to Zion.* Independence, Missouri: Herald Publishing House, 1970. 52 pp.

Argues that Zion is a fundamental belief and function of the RLDS Church; that stewardship is part of the Zionic mission of church members.

1111. —————, editor. *Restoration Studies I.* Independence, Missouri: Herald Publishing House, 1980. 295 pp.

Twenty essays on RLDS history, beliefs and practice written by church leaders and scholars.

1112. —————, editor. *Restoration Studies II.* Independence, Missouri: Herald Publishing House, 1983. 214 pp.

Nineteen essays.

1113. —————, editor. *Restoration Studies III.* Independence, Missouri: Herald Publishing House, 1986. 355 pp.

Thirty-six essays.

1114. Edwards, F. Henry. *Authority and Spiritual Power.* Independence, Missouri: Herald Publishing House, 1956. 125 pp.

Argues that the authority to function as ministers of Jesus Christ makes spiritual power effective. Discusses the concept of

the priesthood of all believers in an RLDS setting.

1115. —————. *The Edwards Commentary on the Doctrine and Covenants.* Independence, Missouri: Herald Publishing House, 1986. 591 pp.

Detailed section-by-section historical and theological commentary on this book of scripture. First edition published in 1938, with several editions since. This edition extensively revised and up-dated.

1116. —————. *For Such a Time.* Independence, Missouri: Herald Publishing House, 1963. 351 pp.

Collection of writings and speeches from Edwards' forty years as a prominent church leader. Ninety-two assorted doctrinal and philosophical topics are included.

1117. —————. *Fundamentals: Enduring Convictions of the Restoration.* Independence, Missouri: Herald Publishing House, c. 1939. 314 pp.

Detailed scriptural statement of twenty basic beliefs of the RLDS Church.

1118. —————. *God Our Help.* Independence, Missouri: Herald Publishing House, 1943. 230 pp.

Attempts to show the reader how to understand one's relation to God. Detailed theological statement.

1119. —————. *The History of the Reorganized Church of Jesus Christ of Latter Day Saints, Volume 5.* Independence, Missouri: Herald Publishing House, 1969. 680 pp.

Detailed chronology of the church from 1890 through 1902.

1120. —————. *The History of the Reorganized Church of Jesus Christ of Latter Day Saints, Volume 6.* Independence, Missouri: Herald Publishing House, 1970. 710 pp.

Church history covering the last years of Joseph Smith III's administration: 1903-1915.

1121. —————. *The History of the Reorganized Church of Jesus Christ*

of Latter Day Saints, Volume 7. Independence, Missouri: Herald Publishing House, 1973. 758 pp.

Presents church history from 1915 to 1925.

1122. —————. *The History of the Reorganized Church of Jesus Christ of Latter Day Saints, Volume 8.* Independence, Missouri: Herald Publishing House, 1976. 476 pp.

Church history from 1926 to 1946.

1123. —————. *The Joy in Creation and Judgment.* Independence, Missouri: Herald Publishing House, 1975. 255 pp.

Detailed theological treatise on the purpose of life, creation, man, God, agency, judgment, the gospel, the incarnation, kingdom of God, repentance and forgiveness, and the atonement.

1124. —————. *Life and Ministry of Jesus.* Independence, Missouri: Herald Publishing House, 1982. 403 pp.

Comprehensive historical and theological commentary detailing the teachings of Christ and their relationship to disciples in the modern world society. This is a revised edition of a study guide which first appeared in 1928 as a church school quarterly, then in book form in 1940. An earlier revision was published in 1950.

1125. —————. *Meditation and Prayer.* Independence, Missouri: Herald Publishing House, 1980. 272 pp.

Argues that prayer life needs to be informed and ennobled by concern for creation, with prayers rooted in the scriptures.

1126. —————. *Students Guide To The Doctrine and Covenants.* Independence, Missouri: Herald Publishing House, 1980. 242 pp.

Fifty-two lesson outlines on this book of scripture designed to accompany Edward's commentary.

1127. Edwards, Paul M. *The Hilltop Where...* Lamoni, Iowa: Venture Foundation, 1972. 190 pp.

History of the RLDS Church's Graceland College. Includes photos and index.

1128. ————. *Preface to Faith: A Philosophical Inquiry Into RLDS Beliefs.* Midvale, Utah: Signature Books, 1984. 124 pp.

A metaphysical study of RLDS theology.

1129. Elser, Otto H., editor. *The Ministry of Health and Healing.* Independence, Missouri: Herald Publishing House, 1986. 256 pp.

Sixteen essays on a wide range of health issues written by noted RLDS health practitioners.

1130. *Empowered to Care: Pastoral Care in the Church.* Independence, Missouri: Herald Publishing House, 1980. 220 pp.

Guidebook for local church leaders. Essays written by various church leaders and members.

1131. Elvin, Margo, Sandra Gilbert and Martha Shaw. *A Reader's Digest of the Book of Mormon.* Apple Valley, Minnesota: LaPaz Press, 1977. 85 pp.

Condensed version of the Book of Mormon, in outline form.

1132. *Exploring the Faith.* Independence, Missouri: Herald Publishing House, 1970. 248 pp.

A series of studies in the beliefs of the church, prepared by a committee on basic beliefs. Nineteen theological topics.

1133. Farrow, Percy E. *God's Eternal Design.* Independence, Missouri: Herald Publishing Hose, 1980 316 pp.

Argues that the present age delineates the "signs of the times" as proclaimed by the ancients, more than any other period of history.

1134. Flanders, Robert Bruce. "The Mormons Who Did Not Go West." M.A. Thesis. University of Wisconsin, 1954. 165 pp.

A study of the emergence of the RLDS Church in its formative period: early 1850s.

1135. Fulk, R. L. *The Fulfillment of Latter-Day Prophecy.* Independence, Missouri: RLDS Church, 1923. 19 pp.

Argues the Mormon church has erred by moving Zion to Utah; that many Latter Day Saints were scattered and led west by false leaders.

1136. *Guidelines for Priesthood: Ordination, Preparation, Continuing Commitment.* Independence, Missouri: Herald Publishing House, 1985. 94 pp.

Outlines the church's policy regarding all aspects of its ministerial program in the local congregations.

1137. Hallier, Sara. ''An Annotated Bibliography and Literature Analysis of Official Publications of the Reorganized Church of Jesus Christ of Latter Day Saints, 1853-1900.'' M. A. Thesis. University of Missouri-Columbia, 1985. 90 pp.

Detailed bibliographical reference work.

1138. Ham, Wayne. *Man's Living Religions.* Independence, Missouri: Herald Publishing House, 1966. 327 pp.

Argues that although there are many religions in the world with many differences, there are also many similarities, the most important of which is that all are children of God attempting to ascertain their relationship to their Creator.

1139. Hartshorn, Chris B. *Commentary on the Book of Mormon.* Independence, Missouri: Herald Publishing House, 1964. 504 pp.

Book-by-book commentary on this book of scripture.

1140. —————. *The Development of the Early Christian Church.* Independence, Missouri: Herald Publishing House, 1967. 341 pp.

Commentary and analysis of the history of the church, based the New Testament accounts in Acts and the Epistles.

1141. —————. *Reorganized Latter Day Saint Distinctives.* Independence, Missouri: Reorganized Church of Jesus Christ of Latter Day Saints, 1958. 16 pp.

Series of questions and answers dealing with the identity, history, social beliefs and program of the RLDS Church.

1142. ————. *A Survey of the Doctrine and Covenants.* Independence, Missouri: Herald Publishing House, 1961. 168 pp.

Summarizes the contents of the Doctrine and Covenants and categorizes into twelve topics.

1143. Hettrick, Ric and Marcia Hettrick. *From Among Men.* Independence, Missouri: Herald Publishing House, 1976. 220 pp.

Biographies of twenty-six apostles of the RLDS church.

1144. Hield, Charles R. *We Believe in Jesus Christ.* Independence, Missouri: Herald Publishing House, 1964. 32 pp.

Collection of proof texts on Christ's godhood, creatorship and millennial reign.

1145. Hinckley, Helen. *Columbus: Explorer for Christ.* Independence, Missouri: Herald Publishing House, 1977. 115 pp.

History of Columbus based on prophecies contained in Isaiah and the Book of Mormon.

1146. Holm, Francis W., Sr. *The Mormon Churches: A Comparison from Within.* Kansas City: Midwest Press, 1970. 238 pp.

Comparison of history, beliefs and practices of the RLDS church and Mormon church.

1147. Holmes, Reed M. *The Church in Israel.* Independence, Missouri: Herald Publishing House, 1983. 163 pp.

History of the RLDS Church's work in Israel, from the mid-1800s to the present.

1148. ————. *The Patriarchs.* Independence, Missouri: Herald Publishing House, 1978. 173 pp.

Examines the office of patriarch and its meanings to the RLDS Church. Various authors have contributed essays.

1149. Howard, Richard P., editor. *The Memoirs of President Joseph Smith III (1832-1914).* Independence, Missouri: Herald Publishing House, 1979. 501 pp.

Photo-reprint of a series of articles which appeared in the church periodical, Saints Herald, from November 1934 to July 1937.

1150. ————. *Restoration Scriptures: A Study of Their Textual Development.* Independence, Missouri: Herald Publishing House, 1969. 278 pp.

Detailed study of the original manuscripts of the scriptures of the church, focusing on various textual changes and revisions which were made.

1151. Hughes, Richard and Joe Serig, editors. *Evangelism: The Ministry of the Church.* Independence, Missouri: Herald Publishing House, 1981. 299 pp.

Various RLDS leaders write on this topic.

1152. Hunt, Larry E. *F. M. Smith: Saint as Reformer.* Independence, Missouri: Herald Publishing House, 1982. 488 pp.

Detailed biography of Frederick Madison Smith, third president of the church. Outline's Smith's modernization of the church. In two volumes.

1153. Huskey, Hyrum H., Jr. *Counseling Skills for Church Leadership.* Independence, Missouri: Herald Publishing House, 1980. 135 pp.

Guidebook to assist lay ministers in developing helpful counseling skills.

1154. *The Hymnal.* Independence, Missouri: Herald Publishing House, 1956. 508 pp.

538 hymns.

1155. *Hymns of the Saints.* Independence, Missouri: Herald Publishing House, 1981.

501 hymns, reflecting a wide variety of hymnody from different Christian traditions.

1156. *In the Manner Designed of God.* Independence, Missouri: Presiding Bishopric, nd. 64 pp.

Outlines the stewardship principles and their historical relationship to the church, with questions and answers on the financial programs of the church.

1157. *Journal of History.* Lamoni, Iowa: Board of Publication of the Reorganized Church of Jesus Christ of Latter Day Saints, 1908. 128 pp.

Quarterly church history periodical. First issue Volume 1, Number 1, dated January 1908. Moved to Independence, Missouri in April 1921. Ceased with Volume 18, number 4, 1925. Important resource for church thought and historical discussion.

1158. Judd, Peter A. *The Sacraments: An Exploration Into Their Meaning and Practice in the Saints Church.* Independence, Missouri: Herald Publishing House, 1978. 174 pp.

From scripture and history, a discussion of the eight sacraments of the RLDS Church: baptism, confirmation, the Lord's Supper, blessing of children, ordination, marriage, patriarchal blessings, and administration to the sick.

1159. —————. *The Worshiping Community.* Independence, Missouri: Herald Publishing House, 1984. 178 pp.

Discusses the basic dimensions of congregational worship in the RLDS Church. Resource book for local leaders.

1160. ————— and Clifford A. Cole. *Distinctives Yesterday and Today.* Independence, Missouri: Herald Publishing House, 1983. 168 pp.

Argues that church members need to evaluate and interpret the ways in which they express their faith and respond to God's call. Discusses various doctrinal items which are unique to Latter Day Saint tradition, and provides interpretation for their place and meaning in the church.

1161. ————— and A. Bruce Lindgren. *An Introduction to the Saints Church.* Independence, Missouri: Herald Publishing House, 1976. 228 pp. with 108 pp. user's guide.

Presents basics of church history and beliefs for a general audience.

1162. —————— and ——————. *Who Are the Saints?* Independence,
Missouri: Herald Publishing House, 1985. 32 pp.

Brief introduction to the history and faith of the RLDS Church.
Condensed from authors' "Introduction to the Saints Church."
First edition published in 1977, this is the revised edition to
reflect new understanding of women in the ministry.

1163. Koury, Aleah G. *The Truth and the Evidence.* Independence,
Missouri: Herald Publishing House, 1965. 112 pp.

In an attempt to compare the doctrine of the RLDS Church and
the Mormon Church, argues that the former is the legal and true
successor to the original church, while the latter is apostate.

1164. Landon, Don. *The Book of Mormon is Christian.* Independence,
Missouri: Herald Publishing House, 1959. 26 pp.

Argues that modern archaeological findings in South and Central
America provide tangible evidence in support of the Book of
Mormon. Presents teachings of the book which are in agreement
with Christian beliefs.

1165. *The Latter Day Saints: A Question of Identity.* np, nd. 6 pp.

Presents brief differences between the RLDS Church and the
Mormon Church, focusing on an 1880 and an 1894 court decision
in which the judges declared the RLDS Church the legal successor
to the original church.

1166. *The Life and Service of W. Wallace Smith.* Independence, Missouri:
np, 1978. 55 pp.

Photo-essay of the history of the fifth president of the RLDS
Church, published on his retirement in 1978. Covers the 20 years
he served as prophet.

1167. *Manual on Marriage.* Independence, Missouri: Herald Publishing
House, 1971. 131 pp.

Guidelines for policies, procedures and counseling couples
planning to be married.

* Matthews, Robert J. *A Plainer Translation: Joseph Smith's Translation*

of the Bible: A History and Commentary. Provo, Utah: Brigham Young University Press, 1975. 495 pp.

Cited above as item 476.

1168. McDowell, F. M., editor. *Guidelines for Leadership.* Independence, Missouri: Reorganized Church of Jesus Christ of Latter Day Saints, 1942. 32 pp.

Quarterly leadership magazine. First issue volume 1, number 1, October/December 1942. F. M. McDowell, first editor. Frequency and staff changed. Final issue volume 18–10, December 1960.

1169. McKiernan, F. Mark, Alma R. Blair and Paul M. Edwards, editors. *The Restoration Movement: Essays in Mormon History.* Lawrence, Kansas: Coronado Press, 1973. 357 pp.

Collection of papers on various aspects of the history of the Latter Day Saint movement from various perspectives. Well-known scholars from both RLDS and Mormon backgrounds are included.

1170. Mesle, C. Robert. *Fire In My Bones.* Independence, Missouri: Herald Publishing House, 1984. 253 pp.

Argues that the "character of faith" is the "ultimate concern which unites depth of commitment with intellectual integrity."

1171. Morris, Bonnie. *A Wounding Truth.* Issaquah, Washington: Saints Alive in Jesus, nd. 20 pp.

Based on a comparison of twelve points of RLDS belief and the Bible, argues that the RLDS Church is a false religion.

1172. Mulliken, Frances H. *First Ladies of the Restoration.* Independence, Missouri: Herald Publishing House, 1985. 153 pp.

Biographical essays of the eight women who have been the wives of the RLDS church presidents. Includes numerous photos.

1173. —————— and Margaret Salts. *Women of Destiny in the Bible.* Independence, Missouri: Herald Publishing House, 1978. 187 pp.

Novelized biographies of 17 prominent women who are mentioned in the Bible.

1174. Njeim, George A. *He Saw History in the Making*. Independence, Missouri: Herald Publishing House, 1952. 104 pp.

Criticizes writers (namely Vardis Fisher and Fawn M. Brodie) who are said to be making money by "besmirching" the character of Joseph Smith, Jr. Argues that Joseph Smith was indeed truthful, and that these so-called historians have misinterpreted facts.

1175. ————. *Insights Into the Book of Revelation*. np: author, 1970. 247 pp.

First published attempt by an RLDS minister at interpreting this biblical writing. Njeim attempts to shed "light" on the meaning of the Revelation of John from the Book of Mormon.

1176. ————. *The Sacrament of the Lord's Supper*. Independence, Missouri: Herald Publishing House, 1978. 260 pp.

Detailed analysis of this sacrament from the book of John and the Book of Mormon. Argues that these two scriptures are in harmony; that the Book of Mormon restored the details that were lost in the modern version of the Bible.

1177. Oakman, Arthur A. *Belief in Christ*. Independence, Missouri: Herald Publishing House, 1964. 187 pp.

Analyzes beliefs in Christ from the early Jewish background, through history, to the Latter Day Saint movement.

1178. ————. *He Who Is*. Independence, Missouri: Herald Publishing House, 1963. 136 pp.

Argues that the Creator is outside of time; the love of God restores humans to Himself.

1179. ————. *Resurrection and Eternal Life*. Independence, Missouri: Herald Publishing House, 1959. 256 pp.

Argues that the doctrine of the resurrection holds tremendous mortal power.

1180. Phillips, A. B. *Latter Day Saints and What They Believe*. Independence, Missouri: Herald House, 1970. 32 pp.

Brief introduction to the beliefs of the RLDS church.

1181. ——————. *The Sabbaths of the Covenants.* Independence, Missouri: Herald House, nd. 32 pp.

Discussion of the Mosaic law and its fulfillment by Christ as a reason Christians observe Sunday as the sabbath.

1182. Phillips, Emma M. *33 Women of the Restoration.* Independence, Missouri: Herald Publishing House, 1960. 197 pp.

Biographical sketches of prominent women in the history of the church.

1183. Price, Richard. *Action Time.* Independence, Missouri: Price Publishing Company, 1985. 224 pp.

Argues that the RLDS Church is the Lord's true church, but that the current leaders are in a state of apostasy.

1184. ——————. *The Saints at the Crossroads.* Independence, Missouri: author, 1974. 260 pp.

Argues that current trends in the RLDS church are bringing it into the ecumenical movement which is requiring the church to drop its unique Latter Day Saint beliefs.

1185. —————— and Pamela Price. *The Temple of the Lord.* Independence, Missouri: authors, 1982. 142 pp.

Argues that the only correct site for the temple is on the property owned by the Church of Christ (Temple Lot); the RLDS Church is wrong in attempting to build elsewhere.

1186. *Priesthood and Leaders Journal.* Independence, Missouri: Reorganized Church of Jesus Christ of Latter Day Saints, 1961. 40 pp.

Monthly, except July and August, for all leaders of the church. First issue, volume 1, number 1, January 1961. Paul A. Wellington was editor. Later the frequency changed to monthly. Final issue volume 8, number 12, December 1968.

1187. *The Priesthood Journal.* Independence, Missouri: Reorganized Church of Jesus Christ of Latter Day Saints, 1934. 48 pp.

Volume 1, number 1, July 1934. Quarterly publication for lay ministry of church. Leonard Lea, managing editor. Final issue, October 1943, volume 9, number 4.

1188. *The Priesthood Manual.* Independence, Missouri: Herald Publishing House, 1934. 126 pp.

Early handbook containing administrative procedures and policies of the church.

1189. Ralston, Russell F. *Fundamental Differences between the Reorganized Church and the Church in Utah.* Independence, Missouri: Herald Publishing House, 1960. 244 pp.

Argues that major beliefs and historical claims of the Mormon church are in error.

1190. ————. *Succession in Presidency and Authority.* Independence, Missouri: Herald Publishing House, 1958. 64 pp.

Argues that the RLDS is the true church because it follows the correct principle of prophetic succession passed from Joseph Smith, Jr. to his son Joseph Smith III.

1191. Reimann, Paul E. *The Reorganized Church and the Civil Courts.* Salt Lake City: Utah Printing Company, 1961. 308 pp.

Argues that the Mormon church is actually the true church, regardless of claims made by the RLDS church.

1192. *Restoration Witness.* Independence, Missouri: Herald Publishing House, 1963. 16 pp.

Began as a monthly publication for use in witnessing. Continues as a bimonthly. Various staff, format and frequency changes.

1193. Richardson, David A. *Return to Joseph Smith II.* np: author, nd. 21 pp.

Faithful Mormon church member challenges RLDS beliefs by comparing the Mormon version of Joseph Smith, Jr.'s teachings with those of the RLDS.

1194. Ross, Vicki. *Hunger and Discipleship.* Independence, Missouri: Herald Publishing House, 1982. 128 pp.

Discusses the problem of world hunger and proposes ways by which church members can respond.

1195. Ruoff, Norman D., editor. *The Writings of President Frederick M. Smith, volume I: Theology and Philosophy.* Independence, Missouri: Herald Publishing House, 1978. 284 pp.

Collection of essays written by Smith and published in the "Saints Herald" during the years Smith was in the leadership quorums of the church.

1196. —————. *The Writings of President Frederick M. Smith, volume II: Educating, Nurturing and Upholding.* Independence, Missouri: Herald Publishing House, 1979. 286 pp.

1197. —————. *The Writings of President Frederick M. Smith, volume III: The Zionic Enterprise.* Independence, Missouri: Herald Publishing House, 1981. 263 pp.

1198. *Rules and Resolutions.* Independence, Missouri: Herald Publishing House, 1980. 351 pp.

Detailed "constitution" of the church. Contains all legislation passed by the conferences of the church. Final authority for the interpretation of church law.

1199. Rushton, John W. *The President of the Church: The Law of Succession.* Independence, Missouri: Herald Publishing House, nd. 8 pp.

Argues that God, not Brigham Young, had the authority to appoint the president of the church; RLDS church follows the true law of succession.

1200. Russell, William D. *Treasure in Earthen Vessels.* Independence, Missouri: Independence Press, 1973. 315 pp.

Introduces the origins, history and life changing meaning of the New Testament. This is a mass market paperback edition of the 1966 Herald House publication.

1201. —————, editor. *The Word Became Flesh.* Independence, Missouri: Herald Publishing House, 1967. 284 pp.

Sermons on New Testament texts by various RLDS church leaders.

1202. *The Saints' Advocate.* Plano, Illinois: Reorganized Church of Jesus Christ of Latter Day Saints, 1878. 8 pp.

Published in the interests of the Utah mission, most articles deal with items of doctrinal concern between RLDS and Mormon churches. First issue, volume 1, number 1, dated July 1878. Continued to volume 8, number 12, June 1886.

1203. *The Saints' Hymnal.* Independence, Missouri: Herald Publishing House, 1933. 372 pp.

442 hymns.

1204. Sarre, Winifred. *Perce Judd: Man of Peace.* Independence, Missouri: Herald Publishing House, 1983. 176 pp.

Biography of Judd, an RLDS church member who became a high ranking official in the United Nations.

1205. Schneebeck, Harold N., Jr. *The Body of Christ.* Independence, Missouri: Herald Publishing House, 1968. 158 pp.

Discusses the nature of the church: fellowship, servanthood, to give persons hope for the future.

1206. Selden, Eric L. *The God of the Present Age.* Independence, Missouri: Herald Publishing House, 1981. 170 pp.

Argues that the RLDS Church is one with people of other faiths, moving toward the fulfillment of God's purposes.

1207. Shields, Steven L. *Latter Day Saint Beliefs.* Independence, Missouri: Herald Publishing House, 1986. 104 pp.

Objectively stated comparison of the RLDS Church and the Mormon Church on nine points of belief: God, Christ, revelation and scripture, priesthood, church administration, salvation, marriage, temple, tithing, Zion. Includes Book of Mormon and Doctrine and Covenants cross reference chart.

1208. —————. *The Restored Church.* Bountiful, Utah: Restoration Research, 1982. 15 pp.

Briefly stated history and beliefs of RLDS Church.

1209. Shipley, Richard L. "Voices of Dissent: History of the Reorganized
 Church of Jesus Christ of Latter Day Saints in Utah, 1863-
 1900." M. A. Thesis. Utah State University, Logan, Utah,
 1969. 127 pp.

 Extensively documented presentation of the RLDS church's
 first 37 years in Utah.

1210. Smith, Elbert A. *Corner Stones of The Utah Church.* Lamoni, Iowa:
 Herald Publishing House, nd. 19 pp.

 Rebuts a tract of a similar title being circulated by the Mormon
 church. Argues that the Mormon church is actually the one that
 was "reorganized" and lost its claims to succession by requiring
 all members to be rebaptized.

1211. ————. *The Church in Court.* Lamoni, Iowa: Herald Publishing
 House, nd. 15 pp.

 Presents various court decisions in the U. S. and Canadian courts
 regarding the legal stance of the RLDS church.

1212. ————. *Differences That Persist.* Independence, Missouri:
 Herald House, 1943. 62 pp.

 Explains differences in belief between Mormon church and RLDS
 church.

1213. ————. *Exploring the Church.* Independence, Missouri: Herald
 Publishing House, 1942. 95 pp.

 General introduction to the theological basis for the church and its
 procedures.

1214. ————. *Faith in God. Is It Scientific? Is It Biblical?* np:
 Reorganized Church of Jesus Christ of Latter Day Saints, nd.
 14 pp.

 Argues that faith is confirmed by revelation through the Holy
 Spirit. Chapter two in the "angel message series."

1215. ————. *The Latter-Day Glory.* np: Reorganized Church of
 Jesus Christ of Latter Day Saints, nd. 42 pp.

Tells the story of Joseph Smith's first vision and the coming forth of the church. Chapter nine in the "angel message series."

1216. —————. *What Latter Day Saints Believe About God*. Independence, Missouri: Herald Publishing House, nd. 60 pp.

Argues that other Christians, as well as members of the Mormon church, misunderstand God. All three books of scripture used by the church support a living God. This is the second edition.

1217. —————. *Why a First Presidency in the Church?* Independence, Missouri: Reorganized Church of Jesus Christ of Latter Day Saints, nd. 29 pp.

Rebuts claims of the Church of Christ (Temple Lot) that the office of First Presidency was unscriptural.

1218. Smith, Frederick M. *The Higher Powers of Man*. Lamoni, Iowa: Herald Publishing House, 1918. 232 pp.

Smith, third president of the RLDS Church, discusses spiritual energies in various groups of people. This was his Ph.D. dissertation.

1219. Smith, H. Alan. *Our Heritage of Humor*. Independence, Missouri: Herald Publishing House, 1982. 320 pp.

Humorous anecdotes gleaned from over 100 years of church periodicals.

1220. Smith, Israel A. *The Return*. Independence, Missouri: Herald Publishing House, 1958. 28 pp.

1952 conference address. Affirms the legitimacy of the RLDS church's claim to succession.

1221. Smith, Joseph, Jr. and successors. *Book of Doctrine and Covenants*. Independence, Missouri: Herald Publishing House, 1970. 419 pp.

Includes 38 pages of index. New edition with double column format. Includes revelations brought to the church by Smith and his successors in the prophetic office.

1222. ————. *The Book of Mormon.* Independence, Missouri: Reorganized Church of Jesus Christ of Latter Day Saints, 1953. 838 pp.

Authorized edition, first published at Lamoni, Iowa in 1908. That edition was authorized by a conference of the church. The publication committee made extensive comparisons of previously published editions and manuscripts.

1223. ————. *The Book of Mormon.* Independence, Missouri: Independence Press, 1973. 414 pp.

Mass market paperback edition of the 1966 edition of the Book of Mormon. Foreword by Marcus Bach.

1224. ————. *The Book of Mormon.* Independence, Missouri: Reorganized Church of Jesus Christ of Latter Day Saints, 1966. 414 pp.

Contains updated language, but was not approved by the 1966 conference of the church.

1225. ————. *The Holy Scriptures: Inspired Version.* Independence, Missouri: Reorganized Church of Jesus Christ of Latter Day Saints, 1974. 1201 pp.

This edition contains the text of the 1944 edition of Smith's revision of the King James Version of the Bible, but in a new typeface, with some textual corrections. Includes 88 page index.

1226. ————. *Lectures on Faith.* Independence, Missouri: Herald Publishing House, 1952. 56 pp.

Contains seven lectures given at Kirtland, Ohio in 1834 and 1835 by Joseph Smith, Jr. on the basic beliefs of the church.

1227. Smith, Joseph III and Heman C. Smith, editors. *The History of the Reorganized Church of Jesus Christ of Latter Day Saints, volume 1.* Lamoni, Iowa: Herald Publishing House, 1896. 680 pp.

Contains the early history of the church, from 1805 to 1835.

1228. ———— and ————. *The History of the Reorganized Church of Jesus Christ of Latter Day Saints, volume 2.* Lamoni,

Iowa: Herald Publishing House, 1897. 823 pp.

History of the church from 1836 to 1844.

1229. ————— and —————. *The History of the Reorganized Church of Jesus Christ of Latter Day Saints, volume 3.* Lamoni, Iowa: Herald Publishing House, 1900. 826 pp.

Church history from 1844 to 1872.

1230. ————— and —————. *The History of the Reorganized Church of Jesus Christ of Latter Day Saints, volume 4.* Lamoni, Iowa: Herald Publishing House, 1903. 791 pp.

Church history from 1873 to 1890.

1231. Sparkes, Vernone M. *The Theological Enterprise.* Independence, Missouri: Herald Publishing House, 1969. 272 pp.

Describes what theology is, how it relates to the church and the beliefs of the church about revelation, creation.

1232. Starks, Arthur E. *Combined Concordances for the Scriptures.* Independence, Missouri: Herald Publishing House. 966 pp.

Includes "Concordance Supplement for the Inspired Version of the Holy Scriptures," published in 1962; "A Complete Concordance to the Book of Mormon," 1950; and "A Complete Concordance to the Doctrine and Covenants," 1951.

1233. Stevens, Thelona D. *Bible Studies.* Independence, Missouri: Herald Publishing House, 1945. 232 pp.

Fifty-two lessons on the Bible for church school classes, providing basic overview, history and teachings.

1234. —————. *Book of Mormon Studies.* Independence, Missouri: Herald Publishing House, 1948. 196 pp.

Lessons provide an introduction to the story and teachings of the Book of Mormon.

1235. Stewart, Georgia M. *How the church grew.* Independence, Missouri: Herald Publishing House, 1959. 342 pp.

One volume history of the RLDS church for young people.

1236. *The Storehouse Principle and its Implementation in the Stakes of Zion.* Independence, Missouri: Herald Publishing House, 1971. 47 pp.

Explains the program of the church for receiving, managing and utilizing skills and time donated by church members.

1237. *Stride.* Independence, Missouri: Reorganized Church of Jesus Christ of Latter Day Saints, 1956. 24 pp.

Volume 1, Number 1, October 1956. Magazine for youth. Pilot issue, published before number 1, carries no date. Ceased with volume 12, number 12, December 1968.

1238. Tanner, Jerald and Sandra Tanner. *Joseph Smith's Successor.* Salt Lake City: Modern Microfilm Company, 1981. 31 pp.

Analysis of the blessing document of Joseph Smith III. Argues that Joseph Smith, Jr. is not a true prophet.

1239. *The True Latter Day Saints' Herald.* Cincinnati: New Organization of the Church of Jesus Christ of Latter Day Saints, 1860. 28 pp.

Volume 1, number 1 dated January. Has continued to the present, except for name change to "Saints Herald," as the official periodical of the RLDS Church. Offices moved to Plano, Illinois, then Lamoni, Iowa and finally Independence, Missouri. Frequency, size, format and editors have changed periodically.

1240. United States Circuit Court. *Abstract of Evidence, Temple Lot Case.* Lamoni, Iowa: Herald Publishing House, 1893. 507 pp.

Presents the plaintiff's evidence in the case convened to ascertain title to the land in Independence known as the "temple lot." Important because of statements made by persons who were living during the early history of the church, contemporary with Joseph Smith, Jr.

1241. Velt, Harold I. *America's Lost Civilization.* Independence, Missouri: Herald Publishing House, 1949. 183 pp.

1242. *Visiting: A Pastoral Care Ministry.* Independence, Missouri: Herald

Publishing House, 1985. 186 pp.

Comprehensive handbook for church members to learn how to visit others, in a religious setting, in every conceivable situation.

1243. Weeks, Marvin E. *Combined Concordance.* Independence, Missouri: School of Saints, 1984. 122 pp.

Topical reference guide to scriptures of the RLDS Church.

1244. Weldon, Roy. *Other Sheep.* Independence, Missouri: Herald Publishing House, 1950. 113 pp.

Examines archaeological and cultural evidence from Central and South America and relates it to the Book of Mormon.

1245. Wellington, Paul A., editor. *Readings on Concepts of Zion.* Independence, Missouri: Herald Publishing House, 1973. 316 pp.

Various church leaders and scholars write on the theory, definitions and future of the Zionic mission of the church.

1246. ——————. *Joseph Smith's "New Translation" of the Bible.* Independence, Missouri: Herald Publishing House, 1970. 523 pp.

Double column comparison of differences between the King James Version and the Inspired Version.

1247. Wilcox, Pearl G. *Jackson County Pioneers.* Independence, Missouri: author, 1975. 558 pp.

Provides early history of Jackson County, Missouri, focusing on the early trappers and explorers and later settlers and industrialists.

1248. ——————. *Regathering of the Scattered Saints in Wisconsin and Illinois.* Independence, Missouri: author, 1984. 327 pp.

Chronicles the regrouping of the members of the original church who remained in the midwest in the 1850s and 1860s.

1249. ——————. *Saints of the Reorganization in Missouri.* Independence, Missouri: author, 1974. 442 pp.

History of the RLDS church in Missouri from 1860 to 1900.

1250. Yale, Alfred H. *Life and Letters of Paul.* Independence, Missouri: Herald Publishing House, 1959. 304 pp.

Study of the New Testament apostle.

1251. Yarrington, Roger. *Restoration Ethics Today.* Independence, Missouri: Herald Publishing House, 1963. 168 pp.

Discusses the place of the RLDS Church in politics and other problems of the modern world.

1252. *The Zarahemla Record.* McAllen, Texas: Zarahemla Research Foundation, 1978. 8 pp.

Issue 1, February 1978. Published approximately quarterly, focusing on the Book of Mormon and recent archaeological and anthropological discoveries in Central and South America. Moved to Independence, Missouri in 1979 with issue 4. Publication sporadic.

Church of the Christian Brotherhood or
Church of Jesus Christ

One time member of the RLDS Church First Presidency Richard C. Evans became disenchanted with the church and established his own movement in Toronto, Ontario, Canada about 1917. After Evans died in 1928 the church dwindled and eventually disbanded.

1253. Evans, Richard C. *Forty Years in the Mormon Church: Why I Left It.* Shreveport, Louisiana: reprint of 1919 edition. 173 pp.

Evans details his doctrinal and procedural reasons for leaving the RLDS Church and establishing his own church.

1254. ————. *History of the Lawsuit Between Bishop McGuire of the Latter Day Saints Church and Bishop R. C. Evans of the Church of the Christian Brotherhood.* Toronto?, c. 1920. 4 pp.

Evans was charged with diverting various funds of the RLDS Church, while he was a bishop, from different sources of income. Evans claims the RLDS church has falsified information.

1255. ————. *Mormonism or Latter Day Saintism.* Toronto: Church of Jesus Christ, c. 1919. 8 pp.

Argues that the RLDS church is a Mormon church because of its scriptures. Claims that God showed Evans the truth after 40 years of wandering.

1256. ⸻. *Mormonism Unmasked.* Toronto: Church of Jesus Christ, 1919. 16 pp.

Relates Evans' history as a member of the RLDS church, with a denunciation of their "corruption and superstition." Discusses contradictions and problems of the Book of Mormon, and argues that Joseph Smith was involved in polygamy.

1257. ⸻. *Was Joseph Smith a Polygamist?* Toronto: np, 1919. 16 pp.

Recites a brief history of Joseph Smith and discusses troubles at Nauvoo, Illinois in the 1840s, relating to polygamy. Claims that RLDS leaders met and decided in a secret meeting to lie about that fact.

1258. ⸻. *Why I Left the Latter Day Saint Church.* Toronto: Church of Jesus Christ, 1918. 64 pp.

Presents his arguments over doctrine and procedure with the RLDS Church.

1259. Williams, T. W. *Bishop R. C. Evans versus Mr. R. C. Evans.* np, c. 1918. 12 pp.

Discusses the RLDS side of the story and denies the charges made by Evans.

1260. ⸻. *His Back to the Wall.* np, nd. 4 pp.

Argues that Evans' church is unscriptural.

1261. ⸻. *R. C. Evans and the Mormons.* np, nd. 4 pp.

Rebuts Evans' "Mormonism or Latter Day Saintism."

1262. ⸻. *The Toronto Church Bulletin.* Independence, Missouri/Lamoni, Iowa: Ensign Publishing House/Herald Publishing House, 1918. 8 pp.

Rebuts Evans' writings and presents the RLDS side of the story.

The Church of Christ, The Order of Zion

John Zahnd left the RLDS Church circa 1918 because of his feeling that the church should be living the united order, or having all things in common. In addition, he was unable to accept the offices of first presidency or high priest, and claimed them to be unscriptural. Although he recognized that Joseph Smith was a prophet, he claimed the Smith overstepped his bounds. Zahnd's movement, based in Kansas City, Missouri, was no longer functioning within a decade of its organization.

1263. Zahnd, John. *All Things Common.* Kansas City: Church of Christ/ Order of Zion, c. 1919. 68 pp.

Presents various letters, information and commentary on other Latter Day Saint churches, in discussing the beliefs of the united order.

1264. ————. The Old Paths. Kansas City: Church of Christ/Order of Zion, 1920. 28 pp.

Explains the concept of all things common, as well as Zahnd's claims to the priesthood.

1265. ————. *The Old Paths.* New Albany, Indiana: Order of Zion, 1922. 12 pp.

Six numbers were published. Moved to Indianapolis after the first issue.

1266. ————. *The Order of Zion.* Kansas City: Order of Zion, nd. 89 pp.

Argues that common ownership of all things is the only way people can come to the true purpose of Christ.

The Protest Group or
The Church of Jesus Christ

Thomas W. Williams was raised in the RLDS Church and in 1920 became a member of the twelve apostles. He resigned that position in 1924 when the president of the RLDS Church asked the conference for, and received, more managerial control over the total program of the church. This became known as Supreme Directional Control, and for a time was very divisive

for the church.

The protest movement attempted to bring about a change, but when this was determined impossible, a new church was founded. The church was headed by an executive committee, but eventually Williams seemed to lose interest. He moved to Los Angeles and was elected a member of the city council. He died there in 1931, and his movement disbanded. Many of the members united with the Church of Christ (Temple Lot).

1267. *The Messenger.* Independence, Missouri: The Protest Group, 1925. 8 pp.

Monthly periodical of the Church of Jesus Christ. Volume 1, number 1 dated October 1925. Continued to 1932.

1268. Williams, T. W. *Clearing the Deck.* np, c. 1926. 18 pp.

Sermon preached on March 14, 1926 wherein Williams claims that the true priesthood is within the protest movement and not the RLDS Church.

1269. ————. *The Protest Movement, Its Meaning and Purpose.* Independence, Missouri: The Church of Jesus Christ, 1926. 28 pp.

Argues that the RLDS Church has departed from the true beliefs and correct procedures outlined in the scriptures. Claims that the protest movement is a fellowship of true followers of Christ who are not trying to organize a new church, but to establish the kingdom of God.

1270. ————. *Supreme Directional Control in Operation.* np, nd. 7 pp.

Reprints an article from the "Saints Herald" for August 20, 1924, explaining two different views of church government.

1271. ————. *A Vision of the Future.* np, nd. 18 pp.

Text of a sermon delivered in the summer of 1924 relating stories of religious freedom from world history to the Supreme Directional Control controversy in the RLDS Church in an indirect and parable form.

The New Jerusalem Church of Jesus Christ

In 1969 Barney Fuller and others formed a group called World Redemption. Its purpose was to expose what they perceived as a dangerous liberalism in the RLDS Church.

The movement became a formal church in April of 1975 at Independence, Missouri. However, after Fuller renounced all aspects of the Latter Day Saint movement the church quickly disintegrated.

1272. Fuller, Barney R. *Stick of Joseph*. Pasadena, California: Tri Tech Publications, 1969. 118 pp.

Brief overview of the Book of Mormon.

1273. ⸻, Glen Stout and William Spilsbury. *Have You Received the Holy Ghost?* La Mirada, California: np, 1967. 81 pp.

Argues that the Holy Ghost has withdrawn from the RLDS Church.

1274. *Zion's Warning*. Whittier, California: Zion's Warning, 1970. 8 pp.

Bimonthly periodical "exposing" the liberalism of the RLDS Church. Volume 1, Number 1, February, 1970. Final issue, Volume 7, number 3, 1976.

Church of Jesus Christ Restored

On April 26, 1970, a group of members of the RLDS Church in Owen Sound, Ontario, Canada, began holding meetings separate from the church. Stanley M. King claimed he was called by God to preside over the newly organized church on June 6, 1970. King died in 1986. His son, Frederick, was appointed to succeed to the prophetic office.

1275. *The Church of Jesus Christ Restored*. Owen Sound, Ontario: Church of Jesus Christ Restored, nd. 3 pp.

Brief statement of beliefs of the church.

1276. King, Stanley M. *Excerpts from Letters Written by President S. M. King*. np, nd. 13 pp.

King writes on various issues of doctrine and practice.

1277. ————. *In My Father's House.* np: The Restoration Press, 1977. 75 pp.

> Argues that Christ organized only one church, and that church today is the Church of Jesus Christ Restored.

1278. ————. *Supplement to the Doctrine and Covenants.* np: Church of Jesus Christ Restored, 1976. 38 pp.

> Contains 14 revelations claimed by King from 1970 through 1974.

1279. *The New Times and Seasons.* Owen Sound, Ontario: Church of Jesus Christ Restored, 1974. 14 pp.

> Volume 1, number 1, January, 1974. Proposed bimonthly, five issues were published in 1974. Frequency was changed to quarterly in 1975. After releasing three issues in 1977, publication ceased.

The Loyal Opposition

Howard Liggett attempted to form an opposition movement within the church in 1970.

1280. Liggett, Howard. *TLO Bulletin.* np: The Loyal Opposition, 1970. 7 pp.

> First issue dated April. Argues that the RLDS Church leaders are unlawfully liberalizing the church. Publication sporadic. The RLDS Church library has to issue number 11, dated June 1971.

Church of Christ Restored

Later in 1976 the RLDS Church revoked the license to minister from Paul E. Fishel of Vancouver, Washington. The resulting furor in the Vancouver branch of the church led the church to disorganize the branch. Church members who upheld Fishel, but denounced the official church, organized their own branch and have recently purchased property and built a building of their own.

This movement claims the RLDS Church has apostatized from the truth and acted illegally. The Church of Christ Restored claims to have the true priesthood, and that it is actually the true RLDS church.

1281. Fishel, Ruby M. *What Happened in the Vancouver WA Branch.* Vancouver, Washington: Church of Christ Restored, 1982. 25 pp.

Presents a one-sided history of the events of the RLDS Church in Vancouver from 1976 to 1982.

1282. Fishel, Russ. *The Vancouver Story.* Vancouver, Washington: author, 1978. 63 pp.

A history of the Church of Christ Restored explaining its claims to authority.

1283. *New Life.* Vancouver, Washington: Church of Christ Restored, 1978. 16 pp.

First issue March 1978, continues bimonthly. Official publication of church.

Lamanite Ministries for Christ

In 1983 a group of RLDS Church members, wanting more emphasis on taking the Book of Mormon to the American Indian, organized a small movement for this purpose. The name was changed in 1984 to "New Covenant Ministries for Christ."

1284. *Clarification Statement.* Independence, Missouri: Lamanite Ministries for Christ, 1983? 1 p.

Explains purpose of the movement.

Restoration Branches Movement

With the 1984 announcement by Wallace B. Smith, RLDS Church president, of a revelation permitting women to hold the priesthood, some in the church unable to accept this began to look elsewhere for their religious expressions.

Believing that the RLDS Church is the true church, many of these dissatisfied people have organized branches outside the church, at the same time claiming to be the RLDS Church. These separatist movements are led by men who have been removed from priesthood ministry by the RLDS Church for their actions.

At the time this volume was prepared, no one person has emerged as the leader of a unified movement. Without a unified movement, these independent branches are likely doomed to extinction.

1285. *Hymns of the Restoration.* Independence, Missouri: Restoration Hymn Society, Inc., 1984.

Conservative RLDS members, dissatisfied with the official church hymnal, constructed their own version containing 402 hymns.

1286. *Join None of Them.* Independence, Missouri: Cumorah Books, Inc., nd. 8 pp.

1287. Leutzinger, Rudy. *Branch Organization and a History of the Independence Branch.* Independence, Missouri: Restoration Foundation, 1985. 16 pp.

Relates the story of an independent branch organized in 1984, and includes the articles of organization with policy statement.

1288. Ludy, Paul V. *Zionic Endeavors--1976.* Independence, Missouri: Cumorah Books, 1976. 64 pp.

1289. *Position Papers.* Independence, Missouri: Cumorah Books, nd. 127 pp.

Photographically reproduces documents written at the direction of the RLDS First Presidency outlining the program of the church for the coming years.

1290. *Presidency Confirms Presidential Papers.* np, nd. 8 pp.

1291. Price, Richard. *The Polygamy Conspiracies.* Independence, Missouri: Cumorah Books, 1984. 32 pp.

Argues that the RLDS church leadership is conspiring to prove Joseph Smith a false prophet. Denies Smith's involvement with polygamy, regardless of the volume of evidence which points to that fact.

1292. —————. *Restoration Branches Movement.* Independence, Missouri: Price Publishing Company, 1986. 36 pp.

Argues that the Restoration branches movement is helping to preserve the RLDS Church. Explains how to organize a branch outside of the legal procedures of the official church.

1293. *Restoration Festival Report.* Independence, Missouri: Restoration Festival, Inc.

One of the earliest organized efforts to unite the conservative members of the RLDS Church. This monthly newsletter began

c. 1981, and was published occasionally until late 1984, when the primary advocate of organization left the RLDS Church.

1294. *Restoration Festival Hymn Book.* Independence, Missouri: Restoration Festival, Inc., 1982. 48 pp.

95 hymns, without music, for conservative RLDS.

1295. *Restoration Foundation Quarterly Report.* Independence, Missouri: Restoration Foundation, 1984. 4 pp.

Several members of the Restoration Festival, unhappy with the direction of that organization, left and organized their own movement. The quarterly report has increased in size, and reports events taking place in various independent branches, and serves as a forum for conservative writers to expound on their beliefs.

1296. *Restoration Voice.* Independence, Missouri: Cumorah Books, Inc., 1978. 32 pp.

Volume 1, number 1 dated January. Bimonthly periodical published by conservative RLDS members who do not agree with the church.

PART FIVE
The Church of Jesus Christ
(William Bickerton)

Claiming direct ministerial authority from God, William Bickerton organized the Church of Jesus Christ in July, 1862, at Green Oak, Pennsylvania. Bickerton had been a member of Sidney Rigdon's movement, having joined in 1845. Rigdon was formerly a counselor in the First Presidency of the original church, and claimed leadership authority over the church at Joseph Smith's death.

The movement under Bickerton sought to unite many Latter Day Saints who had belonged to Rigdon's now-disbanded church, as well as reaching out and finding others with whom the message of the Restoration could be shared.

The Church of Jesus Christ actively prosecutes its missionary work in North America, Africa, India and many other places in the world.

1297. Ashton, Charles, Alma B. Cadman and William H. Cadman. *A Brief History of the Origin of The Church of Jesus Christ with Headquarters at Monongahela, Pennsylvania.* Monongahela, Pennsylvania: The Church of Jesus Christ, 1967. 9 pp.

Briefly recites the history of the church, explaining its connection with the Latter Day Saint movement, Brigham Young and Sidney Rigdon. Includes William Bickerton's first vision.

1298. Benyola, Joseph. *Pocket Reference Book of the Bible and the Book of Mormon.* Monongahela, Pennsylvania: The Church of Jesus Christ, 1956. 44 pp.

Summarizes the contents, in outline form, of the two books accepted by the church as scripture.

1299. Bickerton, William, T. Bickerton, J. Stranger. *Hymns and Spiritual Songs, Original and Selected. For the use of the Church of Jesus Christ of Latter Day Saints.* West Elizabeth, Pennsylvania: Church of Jesus Christ of Latter Day Saints, 1855. 314 pp.

First hymn book published by the church, before it was formally

organized. Contains 339 hymns.

1300. Bickerton, William, Charles Brown, George Barnes, William Cadman, Joseph Astin. *The Ensign: or a Light to Lighten the Gentiles, in which the Doctrine of The Church of Jesus Christ of Latter-Day Saints, is Set Forth, and Scripture Evidence Advanced to Establish it. Also, a Brief Treatise upon the Most Important Prophecies Recorded in the Old and New Testaments, which related to the Great work of God of the Latter Days.* Pittsburgh: Church of Jesus Christ of Latter-Day Saints, 1863. 26 pp.

Contains minutes of church conferences between 1861 and 1863; an undated revelation appointing Bickerton as a seer, translator, prophet and apostle; a declaration against polygamy.

1301. Brook, Zadoc. *Introduction to the Book of Mormon.* Monongahela, Pennsylvania: Church of Jesus Christ, nd. 4 pp.

Brief introductory message printed in the Book of Mormon and as a separate tract. Brook[s] was the leader of a short-lived faction at Kirtland, Ohio in the 1850s.

1302. Bucci, Timothy Dom. *Apostasy and Restoration.* Monongahela, Pennsylvania: Church of Jesus Christ, 1952. 20 pp.

Presents scripture-based arguments that the church established by Christ apostatized and had to be restored. Recites the history of Joseph Smith, Jr. and includes a testimony written by William Bickerton.

1303. —————. *Jew and the American Indian.* Monongahela, Pennsylvania: The Church of Jesus Christ, 1968. 36 pp.

Argues that the true origin of the American Indian is from the Jewish nation, through the Book of Mormon peoples. Presents a theological discussion of the gathering of the Jews. Third edition.

1304. Cadman, A. B. *The Seventh Day of Rest.* Monongahela, Pennsylvania: The Church of Jesus Christ, 1938. 16 pp.

Argues that the millennium will begin in 1970.

1305. Cadman, Sadie B. *Scriptural Lessons.* Monongahela, Pennsylvania: The Church of Jesus Christ, 1927. 56 pp.

Fifty-seven short lessons from the Bible. For use in various study classes.

1306. Cadman, William. *Daniel's Little Horn.* Monongahela, Pennsylvania: The Church of Jesus Christ, 1950. 20 pp.

Argues it is the United States prophesied in Daniel 7:8 (Bible); that the United States is where the Kingdom of God will be built. First edition published at West Elizabeth, Pennsylvania in 1894.

1307. —————. *Personal Observations of William Cadman.* Monongahela, Pennsylvania: The Church of Jesus Christ, 1970. 51 pp.

Writings by Cadman, who served as church president from 1880 until his death in 1905, on a wide variety of doctrinal topics.

1308. —————. *Pre-Millennial.* Monongahela, Pennsylvania: The Church of Jesus Christ, 1960. 16 pp.

Series of letters originally published in church periodical in 1879. Argues that the Kingdom of God will be established in the United States.

1309. —————. *Religious Experiences and Expectations.* Monongahela, Pennsylvania: The Church of Jesus Christ, 1962. 24 pp.

Conference sermon of 1899, reciting Cadman's personal experiences and history in association with the church.

1310. Cadman, William H., compiler. *Book of Sermons.* Monongahela, Pennsylvania: The Church of Jesus Christ, 1963. 146 pp.

Forty-three sermons, delivered by eleven ministers of the church, on a wide variety of doctrinal and philosophical topics. These were originally used as addresses on a church-sponsored radio broadcast.

1311. —————. *A History of The Church of Jesus Christ.* Monongahela, Pennsylvania: The Church of Jesus Christ, 1945. 413 pp.

Comprehensive history of the church from its early roots with Joseph Smith, to publication date. Includes details of all church activities, as well as biographical information on prominent leaders.

1312. —————, editor. *A Manual of Marriage Ceremonies.* Monongahela, Pennsylvania: The Church of Jesus Christ, 1950. 15 pp.

1313. —————. *What is the Indian Mission?* np: The Church of Jesus Christ, 1924. 4 pp.

Argues that the American Indians and Jews are related; the church is to redeem both groups.

1314. ————— and Charles Ashton. *The Way of Salvation.* Monongahela, Pennsylvania: The Church of Jesus Christ, 1965. 7 pp.

Expounds upon themes of faith, repentance and baptism. This edition is the fifth printing. First printing was in 1920.

1315. ————— and Thurman S. Furnier. *Retrogression of the Primitive Church.* Monongahela, Pennsylvania: The Church of Jesus Christ, 1956. 4 pp.

Argues that the church established by Christ gradually departed from the truth. First edition in 1923.

1316. Calabrese, Joseph. *The Divine Continuity of The Church of Jesus Christ.* Monongahela, Pensylvania: The Church of Jesus Christ, 1973. 12 pp.

Briefly recites the establishment of the Latter Day Saint movement, arguing that The Church of Jesus Christ is the legitimate successor to the original church. Briefly compares the beliefs of the church with some other Latter Day Saint groups.

1317. —————. *Questions and Answers.* Monongahela, Pennsylvania: The Church of Jesus Christ, 1977. 51 pp.

188 commonly asked questions, with answers explaining the beliefs of the church. Arranged by topic.

1318. —————, editor. *William Bickerton's Testimony.* Monongahela, Pennsylvania: The Church of Jesus Christ, 1975. 7 pp.

Presents Bickerton's personal history regarding the establishment of the church and his claims to authority.

1319. Cherry, Alexander and Charles Ashton. *Article on "Book of Mormon and Latter Day Work."* Monongahela, Pennsylvania: The Church of Jesus Christ, 1936. 6 pp.

Cherry began this introduction to the Book of Mormon, but died before its completion. Ashton completed the article. First edition published in 1924.

1320. *Constitution and By-Laws of the MBA.* Roscoe, Pennsylvania: Roscoe Ledger Print, 1906. 8 pp.

MBA stands for Missionary Benevolent Association. This is the missionary organization of the church.

1321. *Constitution and By-Laws of the MBA.* Washington, Pennsylvania: Ward Printing Company, 1942. 12 pp.

Revised version of item 1320.

1322. Cowdery, Oliver. *Reproduction of a Series of Letters Written by Oliver Cowdery.* Monongahela, Pennsylvania: The Church of Jesus Christ, 1965. 44 pp.

Cowdery, an early leader in the original church, discusses his views on the history and events of that time period. Several printings have been issued.

1323. D'Amico, Ishmael. *My Testimony.* Rochester, New York: author, 1945. 36 pp.

An Italian convert expresses his personal spiritual experiences in the church.

1324. *Faith and Doctrines of the Church of Jesus Christ.* Monongahela, Pennsylvania: The Church of Jesus Christ, 1969. 10 pp.

Enumerates 27 points of belief.

1325. *The Gospel News.* Monongahela, Pennsylvania: The Church of Jesus Christ, 1938. 4 pp.

Unnumbered issue, dated March 1938. Renewed attempt at a church periodical. The next attempt was in March 1945, with an 8 page, unnumbered issue, followed by another in April 1945.

Publication began monthly in June, 1945, with this issue numbered Volume 1, Number 3. Continues monthly.

1326. *The Gospel Reflector.* Roscoe, Pennsylvania: The Church of Jesus Christ, 1905. 4 pp.

Official periodical of church. First issue volume 1, number 1, dated August 1905. Continued monthly until August 1910, with volume 3, number 13 (24 numbers in each volume).

1327. *Hymns and Spiritual Songs. Original and Selected.* Pittsburgh, Pennsylvania: The Church of Jesus Christ, 1864. 376 pp.

Second hymnal of the church.

1328. *Hymns and Spiritual Songs.* Greensburg, Pennsylvania: Press of Greensburg Press Company, nd. 407 pp.

1329. *Law and Order of The Church of Jesus Christ.* Monongahela, Pennsylvania: The Church of Jesus Christ, 1978. 59 pp.

Detailed guidebook of church policies and procedures. Earlier editions were published in 1905, with three variant editions, and 1925.

1330. *Law and Order of The Ladies Uplift Circle of The Church of Jesus Christ.* Washington, Pennsylvania: Ward Printing Company, 1936. 8 pp.

Constitution of the women's organization of the church.

1331. *The Last Witness Dead.* Monongahela, Pennsylvania: The Church of Jesus Christ, 1958. 4 p.

Recites a brief history of David Whitmer, a leader in the original church and a witness to the Book of Mormon. Earlier editions published in 1929 and 1936.

1332. Lovalvo, Joseph. *Study Guide for Ministers.* Monongahela, Pennsylvania: The Church of Jesus Christ, 1980. 19 pp.

Eleven brief lessons on such topics as preaching, conducting services, scripture research and beliefs.

1333. ————— and V. James Lovalvo. *Ephraim and Manasseh.* Monongahela, Pennsylvania: The Church of Jesus Christ, 1977. 12 pp.

Argues that members of these two Israelite tribes were brought to America by God. This is recorded in the Book of Mormon.

1334. Lovalvo, V. James. *The Choice Seer.* Monongahela, Pennsylvania: The Church of Jesus Christ, nd. 6 pp.

Argues that Joseph Smith, Jr. is not the choice seer that was prophesied in the Book of Mormon. The choice seer will come from among the American Indians.

1335. —————. *In Defense of the Book of Mormon.* Bridgewater, Michigan: The Church of Jesus Christ Print House, 1983. 46 pp.

Attempts to answer criticisms published against the Book of Mormon.

1336. —————. *It Is Written Truth Shall Spring Out of The Earth.* Fresno, California: Author, 1980. 325 pp.

Lovalvo, one of the twelve apostles, provides an extensive dissertation on the apostasy of the church which was established during Christ's mortal ministry and the restoration of the gospel through Joseph Smith, Jr. and William Bickerton.

1337. —————. *The Sabbath Day.* Monongahela, Pennsylvania: The Church of Jesus Christ, 1973. 5 pp.

Official statement of the church, with scriptural argument, that Sunday is the proper day of worship.

1338. Moraco, J. Dominic and Carl J. Frammolin. *Scriptural References on the Establishment, Apostasy, and Restoration of The Church of Jesus Christ.* Monongahela, Pennsylvania: The Church of Jesus Christ, 1966. 46 pp.

Collection of scriptures supporting the beliefs of the church.

1339. Ross, John and Thomas Ross. *Scriptural Lessons from the Book of Mormon.* Monongahela, Pennsylvania: The Church of Jesus Christ, 1949. 95 pp.

60 lessons for use in various study settings for the church.

1340. *The Resurrection of the Dead.* Monongahela, Pennsylvania: The Church of Jesus Christ, 1958. 2 pp.

Official statement supporting a literal, physical resurrection.

1341. *The Saints' Hymnal.* Monongahela, Pennsylvania: George Ashworth, 1919. 165 pp.

200 hymns.

1342. *Saints Hymnal of the Church of Jesus Christ.* Monesson, Pennsylvania: Goodlow Thomas, 1923. 120 pp.

New edition.

1343. *The Saints Hymnal.* Pittsburgh, Pennsylvania: Herbic and Held Printing Company, 1931. 117 pp.

This hymnal was reprinted in 1937.

1344. *Saints Hymnal of the Church of Jesus Christ.* Monongahela, Pennsylvania: The Church of Jesus Christ, 1943.

First hymnal with music. Contains 498 hymns. Continues as the official hymnal of the church, and has been reprinted several times.

1345. Smith, Joseph, Jr. *The Book of Mormon.* Monongahela, Pennsylvania: The Church of Jesus Christ, 1934. 519 pp.

The first publication by the church of its own edition of the Book of Mormon. Chapters and verses essentially follow those of the Mormon church edition. Text is based on the 1899 publication which was published by David Whitmer's church. See item 116.

1346. —————. *A Prophecy by Joseph Smith.* Monongahela, Pennsylvania: W. H. Cadman, 1940? 1 p.

Contains Smith's 1832 prophecy about the Civil War.

1347. Smith, Joseph A. and Kenneth J. Surdock. *A Study Guide for Members of the Church of Jesus Christ.* np, nd. 34 pp.

Various topics of belief, organized for use in study classes.

1348. VanAllsburg, Phillip W., Jr. *Book of Mormon Dictionary.*
Modesto, California: author, 1981? 160 pp.

Reference guide to this book of scripture, written especially
for young people.

1349. Watson, Robert, Jr. *The Church's Divine Commission.* Monongahela,
Pennsylvania: The Church of Jesus Christ, 1980. 39 pp.

Argues the importance of revelation, Zion, the New Jerusalem,
Indian movement, and other matters.

Reorganized Church of Jesus Christ

At the 1907 general conference of the Church of Jesus Christ, a pamphlet
concerning the millennium which had been written by Allen Wright, one
of the apostles, was publicly condemned. Six of the twelve apostles refused
to sustain the church in this action, withdrew, and re-organized the church.
These men were Allen Wright, Solomon Van Lieu, Thomas Dixon, James
Skillen, J. L. Armbrust and William T. Maxwell. There is some evidence
to indicate that shortly after the action of organizing a new church, disagree-
ment broke out and the re-organized movement split into two or three other
separate organzations. By 1935 the organization was virtually extinct.

1350. Armbrust, J. L. *Reformation or Restoration, or Which is the Church?*
Jesus Christ Established but One Visible Church. Armbrust,
Pennsylvania?: Reorganized Church of Jesus Christ, 1929. 4 pp.

Argues that existing churches lack authority, so a restoration
was needed.

1351. Maxwell, W. T. *A Statement Issued by the Re-Organized Church*
of Jesus Christ July 4th, 1908. Youngwood, Pennsylvania:
Re-organized Church of Jesus Christ, 1908. 6 pp.

The official statement of the position taken by Allen Wright and
the others who separated from the church. Reviews the events
which led to the organization of this new church.

1352. *What Must We Do To Be Saved.* np: Re-Organized Church of Jesus
Christ, 19??. 1 p.

Ten articles of faith.

1353. Van Lieu, Solomon. *A Trace of Prophecy, on the Second Coming of Christ. Or the Little Stone Kingdom, and the end of the Gentile Rule or Reign--the begining (sic) of the Great Antitypical Jubilee in 1914.* St. John, Kansas: The County Capital, 1908. 36 pp.

Sets forth the formal doctrinal position of the new organization.

1354. Wright, Allen. *A Conversation on the Thousand Years' Reign of Christ.* St. John, Kansas: The County Capital, 1907. 24 pp.

Argues that blood life will exist during the time of Christ's return. This is the pamphlet which was condemned as being contrary to the faith of the church.

The Primitive Church of Jesus Christ

Contending that the Church of Jesus Christ had fallen from the truth for not strictly following the Bible and the Book of Mormon, James Caldwell and others re-organized the church in 1914. Although members believed that the correct name of the church was the "Church of Jesus Christ" Pennsylvania law prohibited more than one church from operating under identical names. When state law was later modified, the name was amended to "Church of Jesus Christ with headquarters at Erie, Pennsylvania."

Although the movement under Caldwell's leadership does not appear to have published any materials, his successor Laurence C. Dias wrote and the church published at least three items. When Dias died in 1963, his son Frederick carried on the work of the church for a few years, but the movement was not successful in continuing.

1355. Dias, Laurence C. *It is Written.* Erie, Pennsylvania: Church of Jesus Christ, nd. 44 pp.

Argues that the Bible and the Book of Mormon prove that Jesus is Christ and God.

1356. ————. *The One True God Revealed.* Erie, Pennsylvania: Church of Jesus Christ, nd. 26 pp.

Argues that Jesus Christ is God the Father.

1357. ————. *To the Restored Gospel People.* Erie, Pennsylvania:

Church of Jesus Christ, nd. 47 pp.

Argues that the Book of Mormon is the book referred to by Ezekiel, Isaiah and John the Revelator.

PART SIX
The Church of Christ (Temple Lot)

After the death of Joseph Smith, the members of several branches (local congregations) of the original church in southern Illinois: Half Moon Prairie, Bloomington and Crow Creek, remained in their homes, unwilling to hastily follow any of the leaders claiming succession. In 1857 these saints sent Granville Hedrick and Jedediah Owens to represent them at a meeting conducted by the "New Organization" (later the RLDS) of the church to explore the possibility of uniting with them. These Illinois saints were unable to accept the call for Joseph Smith III to succeed to the presidency, so did not unite with this movement.

In 1863, Granville Hedrick was ordained as the President of the High Priesthood and the church under the hands of John E. Page, one of the twelve apostles under Joseph Smith, Jr. An 1864 revelation called this body to return to Jackson County, Missouri, where they became the first Latter Day Saints to return to the once hostile area. In 1869 they purchased the first lots of what has become known as the "temple lot" in Independence, Missouri.

Over the years this church organization has progressively returned from the understandings of the movement in the 1840s back to the early basics of the movement in the 1830s. Hence, they accept the revelations promulgated by Joseph Smith in a very limited manner, opting for the first printing known as the "Book of Commandments" rather than the "Doctrine and Covenants." They maintain that Joseph was out of order and changed many of the revelations. In addition, the offices of high priest and first presidency are not a part of the church—even though they initially recognized these priesthood positions.

After starting out as a small handful of members, the church received a large influx of new members during the 1920s when the Supreme Directional Control controversy was brewing in the RLDS Church. Today, the church claims about 3,000 members.

1358. Allen, Arthur. *Comprehensive Comparison of Changes to the Revelations.* Independence, Missouri: Church of Christ (Temple Lot), 1978. 28 pp.

Parallel double column comparison of the texts of Joseph Smith's revelations which are common to the "Book of Commandments" used by the Temple Lot group, and the "Doctrine and Covenants" used by other Latter Day Saint churches.

1359. Anderson, William F. *Apostasy or Succession—Which?* Independence, Missouri: Church of Christ (Temple Lot), 1956. 6 pp.

 Briefly discusses Christian history beginning with the New Testament church and continuing to the Catholic church and the Protestant reformation.

1360. *Are You Satisfied?* Independence, Missouri: Church of Christ (Temple Lot), 1974. 4 pp.

 Presents a series of eleven questions, oriented to theological and social issues, challenging the reader to investigate the church if he or she cannot answer each question with a positive "yes."

1361. *Articles of Faith and Practice.* Independence, Missouri: Church of Christ (Temple Lot), 1981. 6 pp.

 First promulgated in the 1920s, and reprinted in various formats since, this tract enumerates 25 basic doctrinal points of belief.

1362. *Articles of Faith and Practice, Number 9.* Independence, Missouri: Church of Christ (Temple Lot), 1970. 6 pp.

 Explains that the Bible and the Book of Mormon are companion volumes witnessing of Christ. Argues the early law, "in the mouth of two or three witnesses shall every word be established," supports the existence of the Book of Mormon.

1363. *Articles of Faith and Practice, Number 20.* Independence, Missouri: Church of Christ (Temple Lot), 1970. 6 pp.

 Argues that monogamy is the law of marriage for all Christians and that only in the case of adultery may the innocent party remarry; otherwise divorce is forbidden.

1364. *A Brief History of The Church of Christ.* np, nd. 1 p.

 Claims that the Temple Lot church did not organize or reorganize as did other Latter Day Saints, but continued the organization effected in 1830 by Joseph Smith.

1365. Campbell, Robert. *Church of Christ Danger!* np, 1929. 5 pp.

 Argues that all who come into the Temple Lot church must be

rcbaptized as it holds the only legitimate priesthood authority. This tract seems to have been published as a warning to the church regarding its practice of accepting members of the RLDS church without re-baptism.

1366. Case, James M. *The Stones.* np, nd. 4 pp.

Briefly recites the story of two stones found on the temple lot believed to have been placed by Joseph Smith in 1831 marking the site for the building of a temple.

1367. *The Evening and Morning Star.* Independence, Missouri: Church of Christ (Temple Lot), 1900. 4 pp.

Official periodical of the church, named for the periodical of the original church which had been published at Independence in the early 1830s. First number dated May, 1900, volume 1, number 1. Dimensions, number of pages and staff changes. Final issue August 1916, volume 18.

1368. Flint, B. C. *The Book of Mormon.* Independence, Missouri: Church of Christ (Temple Lot), nd. 13 pp.

Provides a brief synopsis of the story and teachings of the Book of Mormon.

1369. —————. *The Latter Day Restoration.* Independence, Missouri: Church of Christ (Temple Lot), nd. 20 pp.

Argues that the Temple Lot church is the only true church with the fulness of the gospel, as set forth by the scriptures.

1370. —————. *An Outline History of the Church of Christ (Temple Lot).* Independence, Missouri: Church of Christ (Temple Lot), 1953. 160 pp.

Provides a history of the church, from its establishment in 1830 to events taking place just prior to publication. This is a second edition, which was revised from an earlier version. The only history of the church available.

1371. —————. *Principles of the Gospel "Baptism."* Independence, Missouri: Church of Christ (Temple Lot), 1973. 16 pp.

Reviews highlights from the scriptures arguing the necessity of baptism.

1372. ————. *Principles of the Gospel "Faith" and "Repentance."* Independence, Missouri: Church of Christ (Temple Lot), 1954. 15 pp.

Argues that faith and belief are two entirely different topics. Explains church belief that repentance is necessary in order to receive a remission of sins.

1373. ————. *Principles of the Gospel "The Laying on of Hands."* Independence, Missouri: Church of Christ (Temple Lot), 1972. 15 pp.

Argues that the laying on of hands is a necessary principle of the gospel which is used to bestow the Holy Spirit on church members.

1374. ————. *What About Israel?* Independence, Missouri: Church of Christ (Temple Lot), 1967. 43 pp.

Presents a scriptural discussion of the Israelites and the prophecies regarding their future.

1375. Haldeman, John R. *Origin of Polygamy Among Latter Day Saints.* Independence, Missouri: Church of Christ Publishing House, 1904. 48 pp.

Argues that Joseph Smith was responsible for polygamy. Published in response to the 1904 U.S. Senate investigation of Reed Smoot, elected from Utah, to determine his fitness to sit in that house.

1376. Housknecht, Gary. *An Introduction to the Book of Commandments.* np, 1977. 16 pp.

Provides a brief history of the first attempt by the original church at publishing some of the revelations brought by Joseph Smith. Includes a chapter-by-chapter synopsis of the contents of this book of scripture. Claims that the publication of the book was completed, contrary to what is stated by other Latter Day Saint churches.

1377. *An Invitation.* Independence, Missouri: Church of Christ (Temple

Lot), 1974. 8 pp.

Missionary tract extolling the benefits of belonging to Christ's "true" church.

1378. Jordan, T. J. *I Beheld a Book.* Regina, Saskatchewan: author, nd. 20 pp.

Advocates the use of the Inspired Version of the Bible. Jordan claims a spiritual manifestation attesting to the truthfulness of Joseph Smith's Bible revision.

1379. MacGregor, Daniel. *Changing of the Revelations.* Independence, Missouri: Church of Christ (Temple Lot), nd. 35 pp.

Argues that revelation is vital to the church and a part of the gospel, but that Joseph Smith changed his revelations and thus became a fallen prophet.

1380. ――――――. *First Presidency...Why?* Independence, Missouri: Church of Christ (Temple Lot), 1973. 8 pp.

Argues that a first presidency in the church administration is unscriptural and not needed.

1381. ――――――. *A Marvelous Work and a Wonder.* Independence, Missouri: Church of Christ (Temple Lot), 1971. 250 pp.

Doctrinal treatise on biblical prophecy concerning the "last days" and the establishment of the kingdom of God. Espouses the 1260 year theory of the duration of the apostasy, after which the gospel was to be restored. This is a reprint of the 1923 edition which was published by the RLDS publishing house. MacGregor switched his affiliation from the RLDS to the Temple Lot church during the Supreme Directional Control controversy in 1925.

1382. *Plain and Precious Things.* Independence, Missouri: Church of Christ (Temple Lot), 1956. 32 pp.

Study guide to the basic doctrinal teachings of the Book of Mormon.

1383. *The Searchlight.* Independence, Missouri: Church of Christ (Temple Lot), 1896. 4 pp.

Official monthly church periodical. First issue dated February 1, 1896, volume 1, number 1. Continued until March 1900.

1384. Sheldon, William A. *Baptism for the Dead.* Independence, Missouri: Church of Christ (Temple Lot), 1975. 8 pp.

Argues that baptism for the dead is an unscriptural belief and not necessary for salvation.

1385. —————. *Is Marriage for Time and Eternity?* Independence, Missouri: Church of Christ (Temple Lot), 1975. 12 pp.

Argues that the Mormon belief in the eternity of the marriage covenant is false and unscriptural.

1386. —————. *Priesthood—Divine Authority.* Independence, Missouri: Church of Christ (Temple Lot), 1967. 19 pp.

Argues that priesthood is given by God through revelation and the laying on of hands by others who previously received authority. There are two orders or classifications of priesthood: Melchisedec (comprising the offices of apostle and elder) and Aaronic.

1387. —————. *A Synopsis of The Church of Christ Beliefs and Practices.* Independence, Missouri: Church of Christ (Temple Lot), 1974. 4 pp.

Briefly compares basic beliefs of the church with those of the Mormon and RLDS churches.

1388. —————. *Zion and the Temple of the Lord.* Independence, Missouri: Church of Christ (Temple Lot), 1974. 12 pp.

Scriptural dissertation on the concepts of Zion and the Temple. Argues that Jackson County, Missouri is the location of Zion and that the Temple Lot church will build the temple to which Christ will return.

1389. Sills, Evalina. *Cut From the Rough.* Phoenix, Arizona: author, 1984. 200 pp.

Life story of James E. Yates, prominent missionary in the church in the first half of the 20th century.

1390. —————. *Fifth Decade.* Phoenix, Arizona: Phoenix Arizona Church of Christ, 1979. 142 pp.

> History of the Phoenix local congregation of the Temple Lot church from 1968 to 1978. Church was first established in Arizona in the 1920s.

1391. Smith, Arthur M. *A Brief History of the Church of Christ (Temple Lot).* Independence, Missouri: Church of Christ (Temple Lot), 1966. 14 pp.

> Recites the origins of the church and explains differences between it and other Latter Day Saint movements.

1392. —————. *Temple Lot Deed.* Independence, Missouri: Church of Christ (Temple Lot), 1973. 20 pp.

> A complete record of all legal transfers of the property known as the "temple lot."

1393. Smith, Joseph, Jr. *A Book of Commandments.* Independence, Missouri: Church of Christ (Temple Lot), 1960. 127 pp.

> New edition of the 1833 attempt at publishing the revelations.

1394. —————. *The Book of Mormon.* Independence, Missouri: Church of Christ (Temple Lot), 1957. 838 pp.

> Special printing of the 1953 edition of the RLDS 1908 Authorized Edition. Published by special arrangement with the RLDS church.

1395. Smith, Willard J. *What the Restoration Movement Teaches Concerning God.* Port Huron, Michigan: author, 1935. 111 pp.

> Rebuttal to Samuel Wood, formerly an apostle of the Temple Lot church. Wood was removed from the church for teaching a unitarian belief about God.

1396. —————. *Whitmerism Unmasked.* Ontario, Canada?, nd. 25 pp.

1397. —————. *Why a First Presidency.* Port Huron, Michigan: Otto Fetting, nd. 36 pp.

> Response to J. W. Peterson and Elbert A. Smith of the RLDS

church. Argues that the office of first presidency has no foundation in the scriptures and is therefore not a part of the "true" church.

1398. Starks, Arthur E. *A Complete Concordance to the Book of Mormon.* Independence, Missouri: Church of Christ (Temple Lot), 1950. 501 pp.

> RLDS publication, printed with Temple Lot imprint by special arrangement.

1399. *That Sacred Spot is Definitely Located.* Independence, Missouri: Church of Christ (Temple Lot), nd. 4 pp.

> Argues that the property in Independence owned by the church is the only correct place for the temple to be built.

1400. *The Truth Teller.* Bloomington, Illinois: Church of Christ, 1864. 16 pp.

> Monthly publication of the church. First issue dated July, 1864, volume 1, number 1. Twelve numbers were published in Bloomington, then publication was suspended while the church relocated. Volume 2, number 1, June 1868, resumed at Independence and continued until December, when publication ceased.

1401. *Supplement to Zion's Advocate.* Independence, Missouri: Church of Christ (Temple Lot), 1942. 1 p.

> Several members of the apostles of the church appeal for funds and explain difficulties with the business manager of the church, which was then in litigation. The problem had split the twelve apostles with those not signing this document on the side of the accused business manager. During this period of time, the courts had placed the church in the hands of a receiver. The signatories appealed to the members to donate funds directly to them, at their home addresses, in order that they might continue their missionary work.

1402. *What the Articles of Faith and Practice Teaches Concerning God.* Independence, Missouri: Church of Christ (Temple Lot), 1972. 6 pp.

> Doctrinal statement. Actually recites a history of the founding of the Latter Day Saint movement in the 1820s.

1403. Wheaton, Brad L. *Gentiles Weighed and Wanting*. Independence, Missouri: Church of Christ (Temple Lot), 1974. 12 pp.

> Argues that natural disasters are actually the signs of the times forecasting the end of the world. Calls people to return to God.

1404. —————. *The Sealed Book of Isaiah 29*. Independence, Missouri: Church of Christ (Temple Lot), 1974. 16 pp.

> Argues that the coming forth of the Book of Mormon was prophesied in the Bible.

1405. Wheaton, Clarence L. *A First Presidency or First Apostles?* Independence, Missouri: Church of Christ (Temple Lot), 1974. 6 pp.

> Presents the church's belief that apostles are the leading officers of the church; not a first presidency.

1406. —————. *Historical Facts Concerning the Temple Lot*. Independence, Missouri: Church of Christ (Temple Lot), 1972. 56 pp.

> First published in 1952, Wheaton recites the history of the temple lot, and argues the church's belief that the land it owns is the very spot on which a temple to which Christ will return at his second coming is to be built. This second edition is revised.

1407. —————. *Is Any Sick Among You?* Independence, Missouri: Church of Christ (Temple Lot), nd. 6 pp.

> Expounds James 5:14, with a testimony of healing by the author.

1408. —————. *The New Translation or Inspired Revision of the Holy Scriptures*. Independence, Missouri: author, 1957. 30 pp.

> Presents a brief history of Joseph Smith's revision of the Bible. Argues that he never used his own revision; that the manuscript was changed; that the Book of Mormon contains no provision for such a version of the Bible. The Temple Lot church finds the King James Version adequate.

1409. —————. *Sermonettes on the Teachings of Jesus*. Independence, Missouri: Church of Christ (Temple Lot), 1970. 18 pp.

> Briefly discusses faith, repentance and baptism.

1410. —————. *That Interesting Spot of Land West of the Courthouse.*
Independence, Missouri: Church of Christ (Temple Lot), 1928.
16 pp.

Presents the text of a historical sermon delivered on April 27,
1928, regarding the land known as the "temple lot." Argues
that only the small portion owned by this church is the spot
for the temple, rather than the entire 63 acres which were pur-
chased by the original church in 1831.

1411. —————. *The Voice of Zion.* Independence, Missouri: Missionary-
in-charge, State of Missouri, Church of Christ (Temple Lot),
1957.

Wheaton published this monthly periodical, beginning about
May 1957. Contents mainly concerned with news and events of
the church for its members in Missouri. Duration unknown.

1412. ————— and Angela Wheaton. *The Book of Commandments
Controversy Reviewed.* Independence, Missouri: Church of
Christ (Temple Lot), 1950. 83 pp.

Argues in favor of the Book of Commandments over the Doctrine
and Covenants. Presents arguments that Joseph Smith changed
the texts of the revelations as they appear in the Doctrine and
Covenants. Advocates a postion of plenary, rather than conceptual,
inspiration.

1413. ————— and —————. *Whispers From the Dust.* np, 1975.
32 pp.

1414. *The Wheaton-Curtis Debate.* Independence, Missouri: Duplicraft
Company, Printers, 1970. 446 pp.

1415. Yates, James E. *The Saturday Sabbath Delusion.* Independence,
Missouri: Church of Christ (Temple Lot), nd. 12 pp.

Presents 51 questions and answers on this much debated topic,
advocating Sunday as the correct sabbath day.

1416. —————. *The Torch of Truth.* np: author, 1925. 4 pp.

Sporadic missionary periodical. First number dated May 7, 1925,
volume 1, number 1. Final issue in September 1947, v. 9, no. 3.

1417. *Zion's Advocate.* Independence, Missouri: Church of Christ (Temple Lot), 1922. 8 pp.

> Official monthly publication of the church. Continuing source of events and theological discussions of the church.

1418. *Zion's Hymnal.* Independence, Missouri: Church of Christ (Temple Lot), 1975. 376 pp.

> First hymnal published by the church. Contains 419 hymns.

Church of Christ, Independent, Informal

Frank F. Wipper, formerly a member of the RLDS church, was ordained an apostle in the Temple Lot church in the spring of 1926. He resigned the following September, and developed the Church of Christ, Independent, Informal in 1927. Since he advocated no formal church organization, much like David Whitmer had in the late 1800s, there was little hope for longevity. This movement spawned a number of independent writers, and later the Book of Mormon Foundation, which was devoted to the study of the Book of Mormon.

1419. Archambault, Hubert J. *The Book of Mormon and the Bible.* Rock Island, Illinois: author, nd. 11 pp.

> Denounces Jerald and Sandra Tanner and others for finding errors in the Book of Mormon.

1420. ————. *Book of Mormon Tested.* Rock Island, Illinois: author, nd. 24 pp.

1421. ————. *The Devil, A Fallen Angel from Heaven.* Rock Island, Illinois: author, nd. 31 pp.

1422. ————. *Glory and Splendor of the First Resurrection.* Rock Island, Illinois: author, nd. 22 pp.

> Discusses the resurrection from Biblical texts.

1423. ————. *Great Value of the Book of Mormon.* Rock Island, Illinois: author, nd. 27 pp.

> Briefly discusses the RLDS, LDS and the Messages to Otto Fetting and W. A. Draves.

1424. —————. *Index.* Rock Island, Illinois: author, nd. 32 pp.

> Argues that the Mormon church teaches false doctrine. Discusses the devil and secret societies.

1425. —————. *One God.* Rock Island, Illinois: author, nd. 24 pp.

1426. —————. *The One True God Revealed.* Rock Island, Illinois: author, nd. 12 pp.

> Argues that God has a body; Christ is the creator.

1427. —————. *The Sabbath.* Rock Island, Illinois: author, nd. 22 pp.

1428. —————. *The True Church of Christ.* Rock Island, Illinois: author, nd. 24 pp.

> Advocates an independent organization of the church, based strictly on the Bible and the Book of Mormon.

1429. —————. *True Church of Christ: Built on the Teaching of Christ.* Rock Island, Illinois: author, nd. 28 pp.

> Discusses David Whitmer's "Address to All Believers in Christ." Advocates no formal church organization.

1430. Maley, Robert L. *Dear Friend of the Book of Mormon.* Tulsa, Oklahoma: Book of Mormon Foundation, 1975. 3 pp.

> Explains that the Book of Mormon Foundation is not an organization or a church. Wipper organized this independent study association as an outgrowth of his beliefs that there should be no formal church organization.

1431. Snell, Jim. *An Open Book.* Kansas City, Kansas: Snell Printing, 1970. 22 pp.

> Issue number 1, dated January. Occasionally published. Argues that the Book of Mormon is of God and its translation was divinely inspired. Presents a position that there is to be no organized religion until Christ returns. Final issue number 37, May 1982.

1432. Whitmer, David. *An Address to All Believers in Christ.* Kansas City, Kansas: Snell Printing, nd. 75 pp.

One of many reprints of Whitmer's classic.

1433. Williams, D. T. *Is It A Case of Vacillation?* np, nd. 4 pp.

Argues that Wipper vacillates regarding his personal beliefs.

1434. Wipper, F. F. *An Analysis of the Doctrine and Covenants.* Fresno, California: author, nd. 42 pp.

1435. ————. *Is It a Case of Vacillation or Vaccination?* Lansing, Michigan: author, c. 1925. 4 pp.

Rebuts item 1433. Attempts to make himself "immune" from the effects of the Supreme Directional Control controversy.

1436. ————. *Jerald Tanner's Brochure on Mormonism Re- examined.* Fresno, California: author, c. 1963. 8 pp.

1437. ————. *Nephite Record Texts.* np, nd. 109 pp.

Condensed scripture texts from the Book of Mormon, arranged by topic.

1438. ————. *Translation of the Book of Mormon.* Fresno, California: author, nd.

1439. ————. *Why I Left the Reorganized Church.* np, nd. 6 pp.

Presents a point-by-point defense of the author's actions.

The Church of Christ (Otto Fetting)

A life-long member of the RLDS Church, Otto Fetting was ordained to the office of high priest in 1920. However, during the Supreme Directional Control controversy in 1924-25, Fetting transferred his membership to the Church of Christ (Temple Lot). He was one of seven men called and ordained as apostles in that church in the spring of 1926.

In February 1927 Fetting received what was to be the first of a series of thirty visitations from a heavenly messenger. Fetting later learned that this messenger was the resurrected John the Baptist. Over the next two years, Fetting received 11 more messages. In accordance with the practice of the Temple Lot church, these revelations were duly considered and accepted. Even his call to begin building the temple in Independence in 1929 was accepted with excitement and work was begun. The temple was never finished.

Events soon took another course, for with the twelfth message, received July 18, 1929, the doctrine of re-baptism was introduced and became divisive. Fetting and about 1,400 followers were either ejected or removed themselves from the church on the Temple Lot. This was about one-third of the total membership of that body. The Church of Christ was officially established in 1929. Headquarters are maintained at Independence, Missouri.

1440. *Articles of Faith and Practice.* Independence, Missouri: Church of Christ, nd. 4 pp.

> These 25 points of belief are identical to those of the Temple Lot church. They were written in 1925 by Clarence L. Wheaton, Alma Frisby and Thomas J. Sheldon. A message from John the Baptist to Fetting told him not to change these points of belief as they had been given of God.

1441. Bronson, S. T. *The History and Origin of the Church of Christ.* Independence, Missouri: Church of Christ, nd. 12 pp.

> Provides brief historical background, with arguments in favor of this church being the only one established in accordance with scripture.

1442. ————. *The Sabbath.* Independence, Missouri: Church of Christ, nd. 16 pp.

> Argues that Saturday is the proper sabbath and day of worship. This church had recognized Sunday initially, but after many years of debating the issue a change was made to Saturday in 1956.

1443. Fetting, Otto. *The Word of the Lord.* Independence, Missouri: Church of Christ, 1933. 93 pp.

> Contains the texts of the thirty messages received by Fetting. Considered one of the books of scripture by the church, along with the Bible and Book of Mormon.

1444. *Fulfillment of Prophecy.* Independence, Missouri: Church of Christ, nd. 4 pp.

> Argues that the scriptures indicate that John the Baptist was to return prior to the Second Coming of Christ; that he had indeed returned: to Otto Fetting.

1445. Smith, Willard J. *Fetting and His Messenger's Messages.* Port Huron, Michigan, nd. 45 pp.

> Argues that the messenger bringing the messages to Fetting taught wrong principles, particularly the doctrine of re-baptism.

1446. *The Voice of Warning.* Niagra Falls, New York: Church of Christ, 1930.

> Official monthly periodical of the church. Volume 1, number 1 dated July, 1930. Publishing offices moved to Independence, Missouri with issue number 2 where they continue today. Primary source of historical and doctrinal information.

Samuel Wood

Samuel Wood was an apostle in the Church of Christ (Temple Lot). Sent to England by the April 1930 conference of the church to ordain a church member there to the office of apostle, Wood began teaching a unitarian position regarding God, which was not acceptable to the majority of the church. Wood and others were dismissed from the council of apostles and Wood was removed from the church. He continued publishing his beliefs on a variety of topics for several years. Wood died in 1970.

1447. *TM.* (Truth's Message) Carmel, California: Samuel Wood, c. 1944, 16 pp.

> Independent periodical discussing various topics, including Wood's religious beliefs. Continued on a sporadic basis for about 20 years.

1448. Wood, Samuel. *The Infinite God.* np: author, nd. 12 pp.

> Argues that God and Christ are one and the same. Wood was expelled from the Temple Lot church for espousing this belief.

1449. ————. *The Infinite God.* np: Lambert Moon Printing Company, 1934. 112 pp.

> Details Wood's beliefs, as outlined in item 1448.

1450. ————. *Why We Transferred to the Church of Christ.* np, nd. 16 pp.

> Wood affirms his beliefs in the Latter Day Saint movement, but

explains that he transferred from the RLDS church to the Temple Lot church because of supreme directional control.

Church of Christ (Restored)

In 1936 A. C. DeWolf, a missionary from Otto Fetting's church, was laboring in Mississippi and Louisiana. Many were baptized and several branches of the church were organized. Later, in 1937, W. A. Draves, a young elder in the church, announced that the messenger had now come to him and delivered a message. Fetting had died in 1933. Although the main body of the church initially accepted these new messages, the southern members could not do so on the grounds of a statement in the thirtieth message, which in some interpretations would seem to indicate that the thirtieth message was the final one that would be given.

The church maintains business offices at Morton, Mississippi, and holds annual assemblies--in Independence, Missouri and other locations--to govern the church. There are about 200 members.

1451. *The Gospel Herald.* Independence, Missouri: Church of Christ (Restored), 1959.

Official monthly periodical of the church. Only source for history and doctrinal information. First issue in July 1959. Size varies, and volume numbering is inconsistent.

1452. Irwin, C. E. *Belief and Faith.* np: Church of Christ, nd. 6 pp.

Argues that belief and faith are inseparable and important to salvation.

1453. *What Must I Do to Be Saved in the Kingdom of God?* West Plains, Missouri: np, nd. 8 pp.

Discusses the basic beliefs of repentance, baptism, and laying on of hands.

Church of Christ (E. E. Long/Thomas Nerren)

Elmer E. Long and others, including Thomas Nerren, led a break from the Church of Christ (Temple Lot) in 1936. The Temple Lot church, after a delay of many years, finally rejected some of the messages that Fetting had issued while an apostle in that organization. Long and Nerren could not accept this, and Nerren claimed to have begun receiving visitations and messages from John the Baptist. They formally organized the Church of Christ

in 1938, with the Denver, Colorado branch of the Temple Lot church as the nucleus.

A 1940 revelation moved the church to Halley's Bluff, near Schell City, Missouri where a temple was constructed. In the 1960s Long and Nerren broke with each other; and circa 1973 the church at Halley's Bluff was once again split by dissension.

1454. *The Arimat.* Independence, Missouri: Arimat Association, 1938. 16 pp.

> Official publication of the church, later moved to Denver, Colorado, and in 1940 near Schell City, Missouri. First issue volume 1, number 1, dated April 1938. Ceased publication in 1946.

1455. *Zion's Restorer.* Schell City, Missouri: Church of Christ, 1964.

> Sporadic periodical, official publication of the church. Publication specifics are undetermined as no complete file has been located.

The Church of Christ with the Elijah Message

Just four and one-half years after Otto Fetting's passing, the church he had organized once again began receiving visitations from the messenger. A young elder in the church residing at Nucla, Colorado, W. A. Draves, received his first visit and message on October 4, 1937. In the six years that were to follow, Draves would receive thirty more messages before a disastrous division would occur.

Not all members of the church were willing to accept the messages received by Draves. This growing factionalism came to a head at the June 1943 annual assembly of the church. Draves and his followers filed a lawsuit claiming they were the legal organization of the church. The court ruled against Draves, and in June 1944 the new movement sustained nine apostles at their assembly.

During the time the lawsuit was in litigation, both the original Fetting movement and the Draves movement were publishing a church paper, with the same name: "The Voice of Warning" and following the same volume and issue numbers. When the matter was settled, the Draves paper became known as the "Voice of Peace," and volume and issue numbering began again. Church headquarters is at Independence, Missouri.

1456. *And If Ye Will Receive It.* Independence, Missouri: Church of Christ with the Elijah Message, nd. 8 pp.

> Questions and answers regarding the Second Coming of Christ.

1457. *Articles of Faith and Practice.* Independence, Missouri: Church of Christ with the Elijah Message, nd. 4 pp.

 25 points of belief. These are the same as used by the Church of Christ (Temple Lot).

1458. *Belief and Faith.* Independence, Missouri: Church of Christ with the Elijah Message, nd. 6 pp.

 Compendium of scriptural quotations on these two topics.

1459. *Brief Historical Background of The Church of Christ with the Elijah Message.* Independence, Missouri: Church of Christ with the Elijah Message, nd. 6 pp.

 Outlines the basics of the 1820-1830 establishment of the Latter Day Saint movement.

1460. *The Church of Christ: Her Apostasy and Restoration.* Independence, Missouri: Church of Christ with the Elijah Message, nd. 6 pp.

 Argues that the scriptures forecast that the original church established by Christ would depart from the faith. The restoration through Joseph Smith was essential to re-establish the true church.

1461. *Concerning the Record of the Nephites.* Independence, Missouri: Church of Christ with the Elijah Message, nd. 12 pp.

 Excerpts from the Book of Mormon which explain what that book is.

1462. Draves, W. A. *Authority.* Independence, Missouri: Church of Christ with the Elijah Message, nd. 6 pp.

 Argues that God alone chooses His servants; there are many who claim to serve God, but are not authorized to do so.

1463. ————. *Footprints in the Sands of Time.* Independence, Missouri: Church of Christ, 1942. 201 pp.

 Forty articles on assorted theological topics. Published by the Fetting organization before the 1943 split. The publication is now disclaimed by that movement.

1464. —————. *Sixty-Six Questions Covering the Greatest Problems of Biblical Lore and Coming Events Answered and Explained.* np, nd. 4 pp.

Tract announcing series of lectures on theological topics. Date and time is blank, to be filled in on specific occasions.

1465. —————. *Visit of the Nephite and Vision.* np: Church of Christ with the Elijah Message, nd. 4 pp.

Describes a visit in November 4, 1940 near Bemidji, Minnesota with a personage from the Book of Mormon.

1466. —————. *A Word to the Wise.* Independence, Missouri: Church of Christ with the Elijah Message, nd. 4 pp.

Discusses the messenger and warns the reader of several signs of the last days.

1467. Fetting, Otto and W. A. Draves. *The Word of the Lord.* Independence, Missouri: Church of Christ with the Elijah Message, 1980. 292 pp.

Includes Fetting's thirty messages, and those received later by Draves. There have been numerous editions and printings. This edition contains the 99 messages received through 1980. Draves has received several additional messages since this edition was published.

1468. *The Great Awakening.* Independence, Missouri: Church of Christ with the Elijah Message, nd. 4 pp.

Argues that God has made contact with man through an angel.

1469. Hills, L. E. *Geography of Mexico and Central America from 2234 B. C. to 421 A. D.* Independence, Missouri: Church of Christ with the Elijah Message, nd. 18 pp.

Overlays the Book of Mormon narrative and geography with a modern map of Mexico and Central America. This edition, of an early 1900s work, was revised by Leonard H. Draves.

1470. Leighton-Floyd, Howard. *Why the Church of Christ Was Established Anew in 1929.* Independence, Missouri: Church of Christ with

the Elijah Message, nd. 19 pp.

Written for members of the Latter Day Saint movement to show that the Church of Christ is the only true church. Second edition.

1471. *Prophecy Now Being Fulfilled.* Independence, Missouri: Church of Christ with the Elijah Message, nd. 4 pp.

Argues that mankind is living in the end of times, and that John the Baptist has returned to set the way before Christ.

1472. Smith, Joseph, Jr. *The Record of the Nephites.* Independence, Missouri: Church of Christ with the Elijah Message, 1957. 850 pp.

This is the "Restored Palmyra Edition" (the 1830 version) of the Book of Mormon. The preface states that it was the Angel Nephi (not Moroni) who visited Joseph Smith and delivered the plates from which the record was translated.

1473. *The Voice of Peace.* Independence, Missouri: Church of Christ with the Elijah Message, 1944. 16 pp.

The first issue, official publication, was volume 1, number 1, dated June 1944. Issue misnumbered as volume 15, number 6, with the volume and number corrected with the second issue in July. Continues to the present.

1474. *The Voice of Warning.* Independence, Missouri: Church of Christ, 1943. 16 pp.

Official monthly of the church, published concurrently with the same issue numbering as the identically-named periodical of the Fetting church. The first issue published by the Draves group is dated July, 1943, volume 14, number 7. The final issue was May, 1944, volume 15, number 5.

1475. *What Must I Do to Be Saved in the Kingdom of God.* np: Church of Christ with the Elijah Message, nd. 8 pp.

Argues that repentance and baptism are essential for salvation.

1476. Whitmer, David. *An Address to All Believers in Christ.* Nucla, Colorado: Church of Christ, 1942. 114 pp.

Reprint of Whitmer's 1887 classic, with preface and additional material added by Draves.

1477. ———————. *The Solution of the Mormon Problem.* Independence, Missouri: Voice of Warning, 1942. 24 pp.

Reprint of Whitmer's 1887 "An Address to All Believers in the Book of Mormon." Additional information has been added by Draves.

1478. Wood, Samuel. *Is Jesus God?* Independence, Missouri: Church of Christ with the Elijah Message, 1986. 112 pp.

Reprint of item 1449, with new title.

Church of Christ (Pauline Hancock)

Having left the Protest Group with T. W. Williams, then later joining the Temple Lot church, Pauline Hancock became dissatisfied with that relationship about 1946 and organized a Bible and Book of Mormon study group with several friends. The group gradually developed into a church, with Hancock claiming ministerial authority. By 1973 this church ceased using the Book of Mormon.

In March 1984, in response to dwindling membership, the church voted to disband and sell the church properties.

1479. *Are All Church Members Children of Christ?* Independence, Missouri: Church of Christ, nd. 3 pp.

Argues that church membership is not enough for salvation. One must join the Lord in order to become a new creature.

1480. *Authority. What Is It? Who Has It?* Independence, Missouri: Church of Christ, nd. 20 pp.

1481. *Do The Latter Day Saints' Teachings Agree With the Book of Mormon?* Independence, Missouri: Church of Christ, nd. 11 pp.

Presents scriptures in argument that the teachings of the RLDS and LDS churches are not in harmony with the Book of Mormon.

1482. *Do You Consider What God Says About You?* Independence, Missouri: Church of Christ, nd. 3 pp.

Argues that all mankind are sinners and lost.

1483. *Do You Know That the Bible Teaches....?* Independence, Missouri: Church of Christ, nd. 15 pp.

Presents 23 points of belief, with supportive Bible verses.

1484. *Do You Know That the Book of Mormon Teaches?* Independence, Missouri: Church of Christ, nd. 10 pp.

Presents 14 points of belief, with supportive statements from the Book of Mormon.

1485. *Do You Realize According to God's Word, America is Ripening for Destruction?* Independence, Missouri: Church of Christ, (1961). 4 pp.

Argues that the United States has turned from God and will be destroyed unless the nation repents.

1486. *The Fall of Man.* Independence, Missouri: Church of Christ, nd. 10 pp.

Argues that all are fallen because of Adam and Eve's sin in the garden of Eden.

1487. *The Godhead.* Independence, Missouri: Church of Christ, (1961). 19 pp.

Argues that the popular account of Joseph Smith's 1820 vision is fraudulent, and that the Mormon church is covering this fact up. Declares that there is but one God only, not several different members of a "godhead."

1488. *God's Plan for Our Salvation.* Independence, Missouri: Church of Christ, nd. 15 pp.

Man must repent and be baptized into Christ in order to obtain salvation.

1489. Hancock, Pauline and Israel A. Smith. *Correspondence Between Israel A. Smith and Pauline Hancock on Baptism for the Dead.* Independence, Missouri: Church of Christ, 1955. 28 pp.

Reproduces a series of letters and articles debating the history and theology of the practice of baptism for the dead.

1490. Hancock, Pauline. *Does God Call Women to Preach and Minister?* Independence, Missouri: Church of Christ, (1961). 4 pp.

Hancock relates a vision wherein she was taken back in time to view the crucifixion of Christ. It was from this vision that she learned of her call as a minister.

1491. *How Does the Natural Man Become a Christian?* Independence, Missouri: Church of Christ, nd. 4 pp.

All must be baptized by water and by the Spirit in order to become Christian.

1492. *How Do We Receive an Increase in our Faith?* Independence, Missouri: Church of Christ, (1961). 3 pp.

Argues that faith is a firm relying trust on Christ and His word.

1493. *Is the God You Worship, the God Revealed in the Scriptures?* Independence, Missouri: Church of Christ, nd. 4 pp.

Argues that most professed Christians have a misconception of God.

1494. *Joseph Smith's First Vision: Fact or Fiction?* Independence, Missouri: Church of Christ, nd. 8 pp.

Argues that LDS history has been falsifed and many so-called facts have been fabricated.

1495. *Know the Truth.* Independence, Missouri: Church of Christ, nd. 23 pp.

1496. *What Does the Word of God Teach Us Concerning Who Christ Is?* Independence, Missouri: Church of Christ, nd. 3 pp.

Argues that Christ is God.

1497. *Whence Came the Book of Mormon.* Independence, Missouri: Church of Christ, nd. 56 pp.

1498. *Where Will You Spend Eternity? Eternity You Must Spend.* Indepen-

dence, Missouri: Church of Christ, nd. 4 pp.

Proclaims that all mankind will be resurrected and judged to determine whether a person will receive eternal life or be damned.

The New American's Mount Zion
Incorporated in 1956 as the "Antarctica Development Interests," John Leabo believes that Zion must be brought about through the political process. When the first corporation was allowed to lapse, Leabo reincorporated under the current name. This organization is not a church, but promotes candidates for president of the United States on its own political platform.

Leabo was raised in the RLDS Church, but has had affiliations with a number of other Latter Day Saint groups. He claims divine direction in his work. He is a firm believer in UFOs, and believes that they are evidence of the lost tribes.

1499. *The Christian Zion Advocate.* Port Angeles, Washington: New American's Mount Zion, 1974. 4 pp.

Tabloid newspaper, official publication of the organization. Publication is sporadic, many issues carry no date. Size and format has varied. Main source of information regarding this organization.

1500. *The Christian Zion Equalitarian.* Neah Bay, Washington: John Leabo, c. 1957. 4 pp.

Several issues were published of this first periodical. Articles discuss various Latter Day Saint beliefs, as well as UFOs and hidden habitations in Antarctica.

1501. *God's Freedom for the People in 1984.* Port Angeles, Washington: The New American's Mount Zion, c. 1984. 28 pp.

Presents several theological articles arguing the depraved situation of the United States. Proposes Roy Woodward as a presidential candidate. Includes complete copy of Leabo's 1980 work "The Science of God," item number 1509.

1502. Leabo, John. *Are You Satisfied with Present Prospects of Outcome for the 1980 Election?* Port Angeles, Washington: The New American's Mount Zion, nd. 1 p.

Argues for a new political organization comprised of twelve

nations in a Christian United Nations.

1503. ——————. *The Harmonizing of Science and the Bible.* Port Angeles, Washington: The Christian Zion Advocate, 1971. 148 pp.

Argues that prophecies from the scriptures support UFOs, the coming forth of the lost tribes, and the establishment of a utopian society.

1504. ——————. *How the Temple of the Lord Can Be Built Now at Independence, Missouri.* Port Angeles, Washington, c. 1984. 4 pp.

Argues that Leabo can assist in bringing about a merger of all the Latter Day Saint churches in order for the temple to be built.

1505. ——————. *Index to the 1833 Book of Commandments.* np, 1971. 12 pp.

Topical guide to this collection of Joseph Smith's revelations.

1506. ——————. *The Lord is Soon Coming, in Person, to Unite the Church of Christ for His Zion and Temple Building.* Port Angeles, Washington: The New American's Mount Zion, 1986. 4 pp.

Discusses his visits with various Latter Day Saint churches, with theological discussions of their beliefs.

1507. ——————. *The Lord's Kingdom for America In '85.* Port Angeles, Washington: The New American's Mount Zion, 1984. 4 pp.

Political tract, reciting theological reasons for the superiority of America.

1508. ——————. *The Lord's Power Came.* Port Angeles, Washington: The New American's Mount Zion, 1985. 4 pp.

Claims that Christ's power came to the earth on April 5, 1985 to bring His kingdom to America. Most of the contents are identical with item 1507.

1509. ——————. *The Science of God.* np, 1980. 20 pp.

A revision and condensation of item 1503.

1510. ————. *Work of the Levites, and Aaronites of Levi, For the New Jerusalem, and the Kingdom.* Port Angeles, Washington: The New American's Mount Zion, nd. 44 pp.

Provides scriptural background for the Levitical priesthood; discusses M. L. Glendenning's Order of Aaron and argues they have been prepared by God as the nucleus for the gathering of all Aaronites.

1511. ————. *Your Economic, War, Energy and All Problems Are Solved.* Port Angeles, Washington: The New American's Mount Zion, 1985. 4 pp.

Details Old Testament prophecies regarding the imminent advent of God's Kingdom.

1512. *Repent or Die; for UFO and Scriptures, Show God's Kingdom is Very Nigh.* Port Angeles, Washington: The New American's Mount Zion, 1986. 4 pp.

Argues that UFOs are actually from a hidden nation on earth who are related to the American Indians.

1513. *You Do Not Have to Elect Reagan or Mondale in November, but Can Choose Freedom, Prosperity, and Peace By Writing in God's Man for Pres. & Vice Pres.* Port Angeles, Washington: The New American's Mount Zion, 1984. 4 pp.

Presents political arguments for a write-in campaign for Roy Woodward as president and Harold Cosand, Sr. for vice president.

Church of Christ (Howard Leighton-Floyd/H. H. Burt)

At the 1965 general assembly of the Church of Christ with the Elijah Message (W. A. Draves) in Independence, Missouri, one-half of the members of the twelve apostles withdrew from the church, as did three of the members of the quorum of bishops. Prominent in this action were apostle Howard Leighton-Floyd and Bishop H. H. Burt.

Two problems were behind this situation. First, between the 1964 and 1965 assemblies, W. A. Draves re-incorporated the church and changed the name from "Church of Christ, Established Anew" to the "Church of Christ with the Elijah Message." Secondly, and perhaps more importantly, Draves

received what is known as the 80th message in August 1964, which was presented at the 1965 assembly. Leighton-Floyd and others could not accept this message because they felt it contradicted previous messages received by Otto Fetting.

Howard Leighton-Floyd has since joined the Church of Christ (Temple Lot), and this organization is now governed by a council of elders. Many members of this church are located in Holden, Missouri, and some are in Colorado.

1514. *The Banner of Truth.* Independence, Missouri: Church of Christ, 1965. 16 pp.

> Volume 1, number 1 is dated September 1965. However a preliminary issue, dated July 1965, is also numbered volume 1, number 1. Monthly publication was suspended with volume 4, number 1, September 1968. A quarterly newsletter has since been published. This is the sole source of published information regarding this church.

The Church of Israel

Originally part of the E. E. Long/Thomas Nerren Church of Christ, this movement began in the early 1970s when two factions of the church located near Schell City, Missouri disagreed to the point of a court battle over the directions the church should take. Dan Gayman was awarded a small portion of the church properties and the Church of our Christian Heritage was founded. The name was later changed to the Church of Israel. Almost no trace of Latter Day Saintism has survived in this church as it promotes a white supremacist viewpoint.

1515. *Faith of Our Fathers.* Schell City, Missouri: Church of Israel, nd. 20 pp.

> Argues that all so-called Christian churches have misunderstood and misinterpreted the Bible.

1516. Gayman, Dan. *America: The Promised Land of Bible Prophecy.* Nevada, Missouri: Church of Our Christian Heritage, nd. 12 pp.

> Interprets various Old Testament scriptures as referring specifically to the United States.

1517. ————. *Articles of Faith and Doctrine for the Churches of Israel.* Schell City, Missouri: Church of Israel, nd. 18 pp.

Thirteen points of belief.

1518. —————. *The Bible Doctrine of Love and Hate.* Nevada, Missouri: author, 1978. 8 pp.

Argues that pacifism is a disease; Christians must learn who to love and who to hate.

1519. —————. *The Bible Road to Vibrant Health.* Schell City, Missouri: author, 1977. 8 pp.

Advocates a Mosaic health code, and the consumption of health foods. Condemns junk food.

1520. —————. *Do All Races Share in Salvation?* Schell City, Missouri: Church of Israel, 1985. 28 pp.

Argues there is a difference between redemption and salvation; only members of the white race will be saved.

1521. —————. *The Holy Bible: The Book of Adam's Race.* Nevada, Missouri: Church of Our Christian Heritage, 1978. 20 pp.

Argues that the Bible is the history of only one race, the white race or Adam's family. Claims there is no recorded history of other races which existed previously to Adam.

1522. —————. *Jesus Christ is Keeping His Promise to America.* Nevada, Missouri: Church of Our Christian Heritage, 1977. 16 pp.

Argues that the U. S. is the promised land and when white Christians become worldly they turn from Christ.

1523. —————. *Key Words To Unlock Our Understanding of the Holy Bible.* Schell City, Missouri: author, 1977. 12 pp.

Provides detailed theological definitions of the words Hebrew, gentile, Israel, Judah, Jew man, bastard, seed, kill.

1524. —————. *One True and Living Church.* Schell City, Missouri: Church of Israel, c. 1982. 32 pp.

Argues that the church is to be militant because it is at war with Satan; all non-whites are enemies of Christ's church.

1525. ————. *Order of Service/Hymnal.* Schell City, Missouri: Church of Our Christian Heritage, nd. 48 pp.

1526. ————. *Tenets of Faith.* Schell City, Missouri: Church of Our Christian Heritage, 1978. 6 pp.

 23 points of belief, including the racial views of the church.

1527. ————. *Tracing Our Ancestors.* Schell City, Missouri: author, nd. 16 pp.

 Claims that the white race is being polluted by interracial marriage. Argues that only white caucasians are true Israelites.

1528. ————. *The Two Seeds of Genesis 3:15.* np: Church of our Christian Heritage, c. 1980. 56 pp.

 Argues that the whites are of Adam's race, while Cain—the seed of the serpent—is the father of all other races.

1529. ————. *White Christian Roots.* Schell City, Missouri: author, 1978. 11 pp.

 Argues that only those descended from Anglo-Saxon, Celtic, Germanic or Scandinavian races have Bible roots.

1530. *Heirs of the Promise.* Schell City, Missouri: Church of Our Christian Heritage, 1983. 16 pp.

1531. Jenista, Dwain A. "The Church of Christ at Halley's Bluff." Term Paper. Nevada, Missouri, 1977. 27 pp.

 Recites the history and dissent which has fractured the Long/Nerren church.

1532. *The Middle East in Prophecy.* Schell City, Missouri: Church of Our Christian Heritage, nd. 16 pp.

1533. *Songs of the Kingdom.* np: Church of Our Christian Heritage, nd. 40 pp.

1534. *Zion's Watchman.* Schell City, Missouri: Zion's Watchman Publications, 1971. 12 pp.

Official periodical of the church. Publication frequency has varied.

Church of Christ with the Elijah Message (Daniel Aaron Rogers)

Although he adamantly claims that he does not have a church, Daniel Aaron Rogers was removed from the W. A. Draves church by the same name in 1976. He continued to practice the ministry, and used church publications with the Draves address obliterated and his own inserted. Even the letterhead he used listed the name of the church, with Rogers as the "minister." He was readmitted to the Draves group in 1983, but has since been once again removed from membership.

Rogers made the news in March of 1978 when he unsuccessfully attempted to resurrect his deceased mother, whose body he had kept frozen for more than a month.

1535. *The Missionary Newsletter.* Harrison, Arkansas: Daniel Aaron Rogers, 1976. 40 pp.

> Periodical newsletter, containing doctrinal dissertations and news of Rogers' activities. No complete file located.

1536. Rogers, Daniel Aaron. *The Angel Spoken of in Rev. 14:6 Speaks, Warning All People of the Second Coming of Christ.* Harrison, Arkansas: author, nd. 6 pp.

> Argues that John the Baptist is once again serving as Christ's forerunner, and continues to visit W. A. Draves.

1537. *The Standard.* Harrison, Arkansas: Daniel Aaron Rogers, 1978. 40 pp.

> Similar to number 1535. Several issues were published at St. Louis, Missouri. No complete file.

Tracy J. Pittman

Formerly an apostle in the Draves movement, Pittman was disciplined by his fellow apostles for preaching ideas that were not in agreement with the church. For some time he had been publishing a newsletter in which he expounded his thoughts, and continues to do so, but has announced no intention of forming a following or church.

1538. *The Ingathering News.* Helper, Utah: Tracy J. Pittman, 1983. 19 pp.

Volume 1, number 1 dated February 1983. Continues approximately monthly. Offices moved to Cory, Colorado in April 1984.

AUTHOR INDEX